Art in Action

Second Course

Credits

Art in Action

Guy Hubbard

Indiana University

CORONADO PUBLISHERS

San Diego Orlando Dallas Chicago

ACKNOWLEDGMENTS

For permission to reprint copyrighted material, grateful acknowledgement is made to the following:

HARCOURT BRACE JOVANOVICH, INC.: Haiku from *Cricket Songs: Japanese Haiku*, translated and copyright © 1964 by Harry Behn. "To Look at Any Thing" from *The Living Seed* by John Moffitt, copyright © 1961 by John Moffitt.

SY KAHN: "Giraffes" by Sy Kahn.

MACMILLAN PUBLISHING COMPANY, INC.: "Swift Things Are Beautiful" by Elizabeth Coatsworth Beston, copyright 1934 by Macmillan Publishing Company, Inc., renewed 1962 by Elizabeth Coatsworth Beston.

Printed in the United States of America ISBN 0-15-770042-9(8)

2 3 4 5 6 7 8 9 0—92 91 90 89 88 87 86

Table of Contents

Unit III Design, Media, and Technique 85

Unit IV Modeling, Carving, and Construction 117

Unit V Art in the Environment 149

Unit VI Explorations in Self-Expression 181

How to Use This Book

To the Students

As you open this book, you will step into the world of art. Some of the finest artworks from all over the world have been reproduced within these pages. Art pieces by students like yourself are also included. Although art exists all around us, the following lessons offer an opportunity for you to discover, explore, and experience a variety of art forms that you may never have encountered before.

Even if you do not consider yourself an artist, or have no intention of pursuing the study of art in your future career, a knowledge of art forms and skills will broaden your experience, deepen your appreciation of the visual arts, and help you to develop skills that you can put to use in other areas of study. By experiencing various art activities, you will exercise your powers of observation, your problem-solving skills, and your creative imagination. As an added bonus, you will experience the delight of expressing yourself in ways that can be enjoyed by yourself and others. Perhaps most important of all, studying and creating artworks will enable you, as author Leo Tolstoy once remarked, to partake in "a human activity having for its purpose the transmission to others of the highest and best feelings to which men have risen."

This book is divided into six units which organize art learning into categories such as design, drawing, painting, and sculpture. The sixth unit is different from the others in that it allows you a choice of techniques and materials for creating your artwork. These final lessons concentrate on creative expression and the use of your imagination through art. You are encouraged to be creative while doing the art lessons in other units, of course, but Units I through V concentrate on developing your skills and knowledge about art. The lessons in Unit VI, on the other hand, give you an opportunity to think more creatively, use your imagination, make more choices, and express your feelings in your artwork.

The format for following the lessons in this book is based on choices. There are several ways of selecting art lessons to complete. The most obvious method relies on the way the lessons are organized. Each lesson includes a lesson number and title, followed by a brief introduction entitled *Observing and Thinking Creatively*. Essential information which you will need to know in order to complete the lesson is included in the introduction. This section provides background information, defines art terms, describes what you are to do, offers suggestions and ideas, and encourages you to use your own observations, creativity, and imagination to complete the lesson.

Following the introduction are selections of artworks by famous, experienced artists as well as art by students from different parts of the United States and throughout the world. These reproductions offer you visual examples and models that show how various artists work. Observing the artwork produced by other people can help you in improving your own. Spend some time studying these pictures, observing how the artists have used lines, shapes, colors, textures, and so on to produce effective designs. Also read the captions that appear next to well-known artworks. They provide basic information about media and techniques, as well as details about the artist or art piece.

The *Instructions for Creating Art* appear toward the end of each lesson. They clearly explain each step for completing the art activity. The suggested *Art Materials* you are to use are identified in a box following the instructions.

Art Strands

As you look through the book, you will discover that the lessons include diagrams, called *strands*. Each strand is a group of related lessons organized around a particular kind of art learning. The strands offer alternative selections for choosing which art lessons to do, depending upon your personal preferences and the art program your teacher decides to offer. There are two different kinds of strands included in this book, which are explained on the following page.

Unit Strands

Each of the six units includes two or three different strands. These strands organize related lessons within each unit in a sequential order. Instead of completing every lesson in the book, you will choose only those lessons in the unit strand that interest you most. Your teacher, however, may request that you do certain lessons and not others. The following step-by-step instructions and diagram for Strand E explain how to follow unit strands.

Strand E: Painting Styles and Techniques

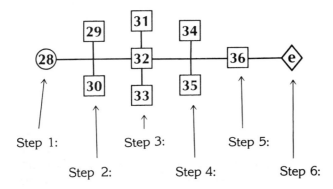

Step 1: In this strand, you must begin at Step 1 by completing Lesson 28.

Step 2: At Step 2, you must complete either Lesson 29 or 30.

Step 3: Now you will choose Lesson 31, 32, or 33 to complete, but you will not do all three of them.

Step 4: Next, you will choose either Lesson 34 or 35.

Step 5: To complete the strand, you will do Lesson 36.

Step 6: At the end of each strand, a diamond shape with an e inside signifies evaluation of your artwork. At this step, you should review the lessons you have completed in connection with the **Learning Outcomes** listed at the back of this book. (See the explanation of **Learning Outcomes** that follows for further directions on how to use them.)

Learning Outcomes

The **Learning Outcomes** for each lesson are listed in a section of that title at the back of the book. They are to be used to determine whether or not you have met the objectives for each lesson and to evaluate your work. The **Learning Outcomes** are divided into three categories: *Understanding Art*, *Creating Art*, and *Appreciating Art*. The items listed for *Understanding Art* require you to explain and define specific art terms, materials, techniques, and basic information about art presented in each lesson. For *Creating Art*, you are to

consider how you actually produced your artwork and whether you used the art materials and tools effectively. For example, if you were asked to make a drawing using contour lines, does your artwork reflect this objective? The category of *Appreciating Art* focuses on making judgments about your own artwork as well as that of other artists. You are to respond to art by deciding whether or not the art is effective, what you like or dislike about it, what qualities make it effective, and what you think an artist is expressing in a particular piece of art. In other words, you are to express your personal preferences and judgments about art and give your reasons for them.

You should refer to the **Learning Outcomes** both before and after you complete each lesson. In this way, you will know what is expected of you and whether you have met the objectives for each lesson. When you complete a strand, the diamond shape with an e inside (◈) signifies *evaluation*. At this point, your teacher may direct you to complete a formal evaluation of your work based on the **Learning Outcomes**. You may be asked to review the lessons you have completed for a particular strand in connection with the **Learning Outcomes**. Or you may be asked to select for evaluation one or more examples of your artwork and evaluate them either orally with your teacher or in written form. Use the directions and questions in the **Learning Outcomes** to complete your evaluation.

The How to Do It Section

This section appears at the back of the book. It includes specific directions for how to do certain activities referred to in the lessons, such as mixing colors, preparing clay, or making papier-mâché. The art skills explained in this section are shown in italics and marked with an asterisk in each lesson.

The Glossary

As you read the information in the lessons, you will be introduced to new art terms. These words are identified in heavy type and are defined in the **Glossary** at the end of this book. They are also defined in the text the first time they are used. You may be asked to define these terms in the **Learning Outcomes** and when your work is evaluated.

Artists' Reference

This section precedes the **Index** and lists all the well-known artists and their works that appear throughout the book.

Color Reference

Many lessons in *Art in Action* require the use of color. Basic information about color is presented here so that you may refer to it at different times as you proceed through the book. (See Lessons 21, 22, and 23 for more information on color.)

Characteristics of color

Hue: another word for color, identified by a common name, such as green, red, or yellow-orange.

Value: the lightness or darkness of a color. Adding black, white, or gray to a hue changes its color value. Darker colors are said to be lower in value than brighter colors. The addition of black to a color produces a **shade**. White added to a hue produces a tint. A **tone** is made when gray is added to a color.

Intensity: the brightness or purity of a color. A pure hue is in its brightest form and is most intense. The addition of a **complementary** color (a hue that is opposite another hue on the color wheel) dulls a color's intensity.

Classifying colors

Primary colors: red, yellow, and blue. These colors cannot be produced by combining other hues. (See the colors in the center triangle in the color wheel.)

Secondary colors: orange, green, and violet. These hues are produced by mixing two primary colors. (See the colors between the circle and the triangle in the color wheel.)

Intermediate colors: red-orange, yellow-orange, yellow-green, blue-green, blue-violet, and red-violet. As each name indicates, an intermediate color is produced by combining a primary and a secondary color. (See the colors between the primary and secondary hues on the outer circle of the color wheel.)

COLOR WHEEL

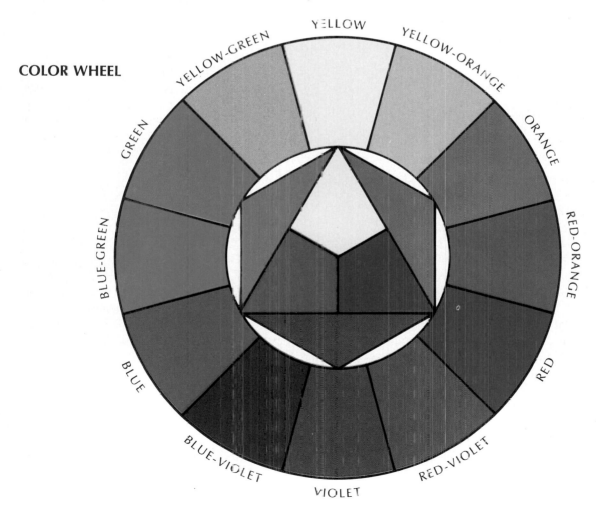

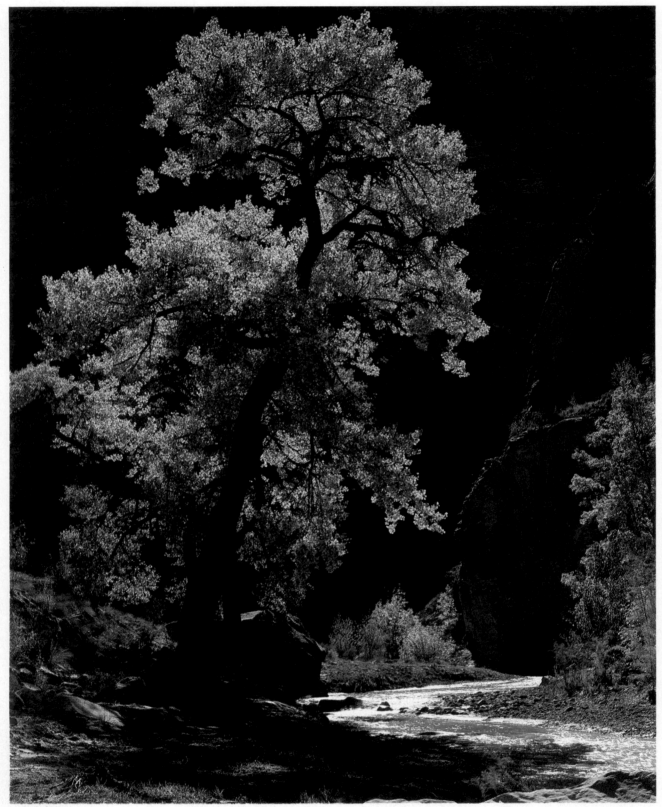

Autumn Advent, Escalante Canyon, Utah. © *David Muench, 1985*

Line, Tone and Value

Drawing is the discipline by which I constantly rediscover the world. . . . I have learned that what I have not drawn, I have never really seen, and that when I start drawing an ordinary thing, I realize how extraordinary it is, sheer miracle.

Frederick Franck

Learning to draw depends on your ability to see—really *see*—in the sense of discovering forms and details and visualizing them in your own unique way. Artists' perceptions of the world around them turn ordinary things into extraordinary creations. To the casual observer, a tree is an ordinary object with a trunk and branches filled with leaves. To the artist, a tree is an extraordinary design of nature consisting of **lines**, **shapes**, **textures**, **colors**, **form**, and **space**—all the elements of design coming together.

Seeing, touching, feeling, and perceiving are as important to the artist as the abilities to draw, paint, sculpt, and create. Throughout this book, you will be encouraged to explore your environment, to observe natural and man-made forms, and to express what you see and feel through art. The first unit introduces you to basic drawing techniques and provides experiences in sketching in an artist's sketchbook. In addition to learning how to apply the elements of design, you will also be able to incorporate the **principles of art—unity**, **emphasis**, **balance**, **variety**, **proportion**, **rhythm**, and **movement**—in your own artistic creations.

As you work through the following unit, you may choose to complete each lesson in order. Or you may select those lessons that are most interesting to you by following the art strand at the end of each lesson. Further instructions for using the strands appear at the beginning of this book.

1 Contour Drawing

Observing and Thinking Creatively

If you recall the first drawings you did as a young child, you will probably remember scribbling lines all over a sheet of paper. The drawings of very young children usually include simple lines and shapes that represent what they see. As children grow older, their drawings usually become more detailed and realistic. Their use of lines also changes.

In art, lines can do much more than simply define forms; they can also add character to a subject and convey moods and emotions. In *A Maid Preparing to Dust*, for example, the Japanese artist Hokusai used thin, delicate lines to indicate fine details, and bold, flowing lines to define the folds of the kimono. The feeling expressed by the lines is one of tranquillity and gracefulness. In its very simplicity, Hokusai's drawing has great power.

In this lesson, you will combine two skills that are essential to an artist—keen observation and skillful use of lines in drawing. You will select an interesting object to observe, and then draw only the **contours**, the lines that define the edges or boundaries of shapes.

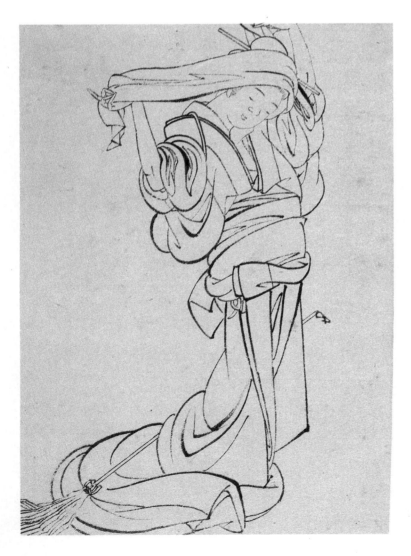

An everyday event becomes a work of art in Hokusai's elegant contour drawing of a Japanese woman fixing her headdress. Drawings are sometimes done in preparation for a painting or sculpture or, like this sensitive brush line drawing, they may stand alone as finished works of art.

Hokusai, A Maid Preparing to Dust. Courtesy of the Freer Gallery of Art, Smithsonian Institution, Washington, D.C.

Gompers Secondary School. San Diego, California　　　*San Diego High School. San Diego, California*

Instructions for Creating Art

1. Select a familiar object to draw, such as a baseball glove, tennis shoe, typewriter, wristwatch, seashell, bird cage, or musical instrument. Place the object in front of you. Take a minute or so to observe it closely, following all of its contours with your eyes.

2. First, try an experiment using a technique called **blind contour drawing**. Closely observe the object, and trace its contours with your finger. Without moving your eyes from the object, slowly begin to draw its contours, following every line and curve. Try not to lift your pencil and do *not* look at your paper. Make a continuous line, weaving back and forth, around and around, to form the shape of the object. You can double back, retrace, redo, or emphasize any part of your drawing by using continuous lines and by varying the pressure on your pencil. Try several blind contour drawings of the same object. The objective of this technique is not to render a realistic drawing, but to realize the significant form and shape of your subject. Look at your paper only when you have finished.

3. Sketch the object again, using **modified contour drawing**. This time, you can occasionally glance at the paper as you draw, but your eyes should still focus on the object most of the

time and not on your paper. Tape down a clean sheet of drawing paper and begin to draw the contours of the object again. Look at your drawing only to note relationships of one part to another and to check the proportions of the objects.

　The blind contour drawing will have served as a warm-up exercise and made you more sensitive to the shape and contours of the object you are drawing.

Art Materials

Pencil, pen, or markers for drawing	2 sheets of drawing paper
An object to draw	Tape

Strand A: Lines, Shapes, and Details

To evaluate your artwork, turn to the Learning Outcomes section at the back of this book.

2 Outside and Inside Shapes

Observing and Thinking Creatively

Look at an object such as a lamp or telephone receiver. Notice the outer edge of the whole shape. The line that defines this outside edge is called the **external contour**. If you turn the object so that you can see another part of it, a different external contour becomes visible. The edges you saw earlier are now out of sight. **Internal contours** that lie inside shapes are seen most easily when they have edges with sharp corners that catch light and shadow. These edges are most often drawn with lines. The contours of humps and hollows are more difficult to see and are usually indicated with **shading**.

One way of studying contours is to wrap an object tightly with string. The string shows up all the curves and corners of the object. As you draw the lines made by the string, the internal contours of the object become clear.

In this lesson, you will practice drawing the external and internal contours of an object.

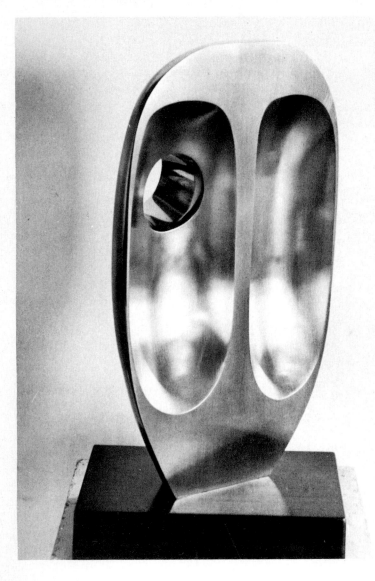

Internal contours provide contrast and interest in the way they reflect the light in this smooth, polished bronze sculpture. How would you shade each of these contours to show their light and shadowy areas if you drew this sculpture with a pencil?

Vertical Form (St. Ives). *Polished bronze, 1969. Height 18½ inches. Barbara Hepworth Museum, St. Ives, Cornwall. By permission of the Trustees of the Late Dame Barbara Hepworth.*

8

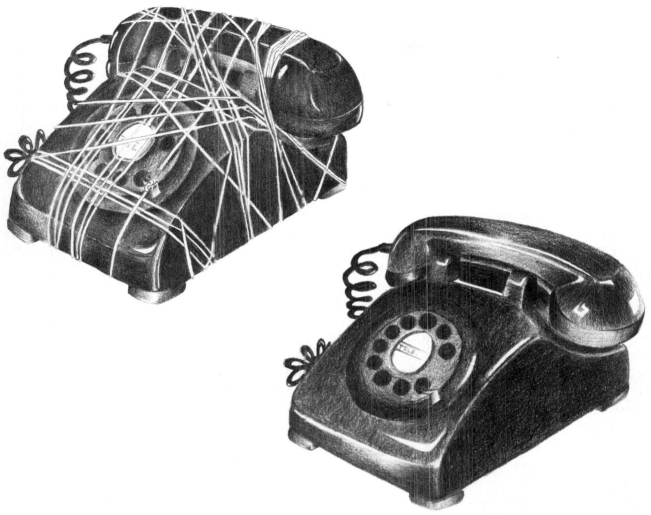

Instructions for Creating Art

1. Wind some thick string around a simple but interesting-looking object. Choose an object that has both outside and inside curves—like a decorative vase or a large bottle. Be sure you can see plenty of space between the lines made by the string.

2. Draw the outlines and the string as it curves around the object. Be sure that you draw the lines made by the string exactly as you see them, especially where the string disappears around the outside contours of the object. The string shows what the contours of the shape are like.

3. Now draw the same object again without the string. Show the inside contours of the object with shading, using very fine pencil lines or the side of your pencil. (See page 219 for more information on shading.)

Art Materials

Two sheets of drawing paper	A simple object with interesting contours
Thick string or yarn	Pencil and eraser

Strand A: Lines, Shapes, and Details

To evaluate your artwork, turn to the Learning Outcomes section at the back of this book.

9

3 Shading Round Surfaces

Observing and Thinking Creatively

Look around your environment for rounded or curved objects. Observe how the light hits these **three-dimensional forms**, creating light and dark areas. Note that when light hits round surfaces, the areas closest to the light source appear lighter than the areas farther away, which remain in shadow. Curved or rounded forms are more difficult to draw than flat surfaces because changes in shading occur more gradually. This gradual change from light to dark is called **gradation**. You can show changes on curved surfaces by using dark and light **values** to indicate differences in **tone**. These tonal changes are achieved through shading, and they range from pure white to pure black, with hundreds of gradations in between. In pencil drawing, the white paper represents the lightest value, while the areas shaded with the heaviest lines represent the darkest value. Other tones can be achieved by various pencil methods, such as solid shading with the side of the pencil, or by using varying degrees of thin and thick lines spaced close together or far apart. The technique of **cross-hatching** can also be used to indicate shaded areas. Cross-hatching is a method of shading using crisscrossing lines of varying thicknesses. Such shading techniques help make solid forms look three-dimensional.

In this lesson, you will draw a group of curved objects showing value differences through various methods of shading with your pencil.

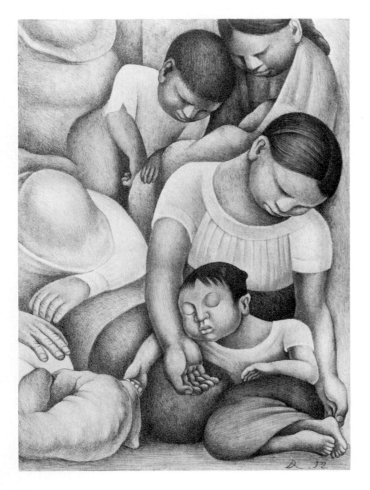

How can you tell where the light is coming from in Mexican artist Diego Rivera's *Sleep*? Look closely at all the different shading techniques used to show light, shadow, and roundness. Where do you see cross-hatching? Note how shading defines the contours of noses and mouths and shows different hair textures.

Diego Rivera, Sleep. The Metropolitan Museum of Art, Harris Brisbane Dick Fund, 1933. (33.26.4). All rights reserved.

10

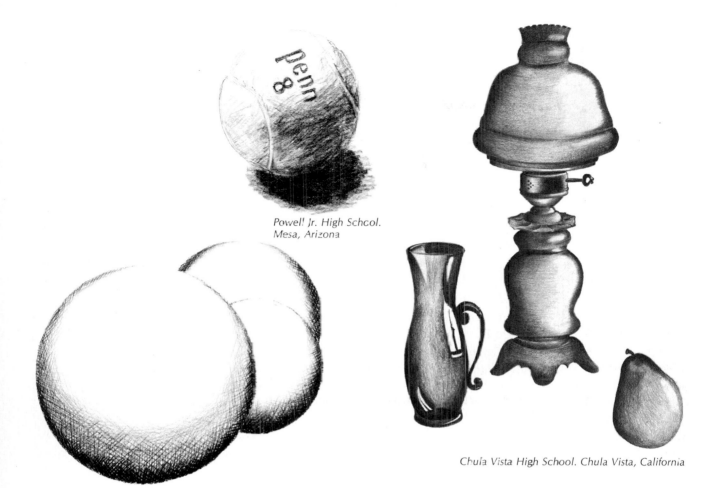

Powell Jr. High School. Mesa, Arizona

Chula Vista High School. Chula Vista, California

Chula Vista High School. Chula Vista, California

Instructions for Creating Art

1. Arrange three curved objects so that they will overlap in your drawing. Select things that are different in size and shape. Sketch the **contour**, or the edges and boundaries, of each shape, and the parts that overlap other shapes. Visualize a light center guideline down the middle of each object to help you define the two halves and keep them alike if they are **symmetrical**.

2. Using a soft lead pencil or charcoal, start shading each object, pressing heavily for darker areas, and gradually getting lighter and lighter. This simple shading technique will make the objects appear solid and **three-dimensional**. You might also use fine pencil lines or cross-hatching to achieve special shading effects. Shadows placed beneath the objects create an additional feeling of depth (See page 219 for more information on shading techniques.)

3. To finish your picture, look carefully at your objects. Is there a spot of bright reflected light along the curve where the light hits each object? To create the effect of these highlights on curved surfaces, let the white paper show through, or use an eraser to define these lighter areas. Then, for a striking display, *mount** your picture on a dark background.

*For an explanation, turn to the How to Do It section at the back of this book.

Art Materials

Soft lead drawing pencils and eraser	Groups of rounded objects: vases, cans, bowls, balls, etc.
Drawing paper	

Strand A: Lines, Shapes, and Details

To evaluate your artwork, turn to the Learning Outcomes section at the back of this book

11

4 Dots . . . Dots . . . Dots

Observing and Thinking Creatively

Have you ever tried using dots instead of lines to draw a picture? Most people draw with lines. They sometimes use lines for shading as well. Lines are very useful, but dots can also create interesting effects in a drawing or painting.

A dot by itself doesn't do very much, but lots of dots placed one after another can make a line. Dotted lines can also be used to outline and fill shapes. Dots placed closer together give the appearance of rounded surfaces and solid shapes and forms.

If you use a strong magnifying glass to look closely at the black and white pictures in this book, you will see that they consist of thousands of tiny black dots. The darkest areas consist of dots that are very close together. Shades of gray are made by spacing dots farther apart. This same method is used for the colored pictures printed in this book; in addition to black dots, red, yellow, and blue dots are used to achieve the effect of full color. When you look at a colored picture made with dots, they appear to blend together before your eyes, creating the illusion of many different colors. This method of printing full-color pictures is related to a painting technique, called **pointillism**, developed by Georges Seurat in the 1880s. He applied paint in tiny dots of pure color to a white background so that, when the picture was viewed from a distance, the colors would seem to blend together.

In this lesson, you will use dots instead of lines to create a drawing.

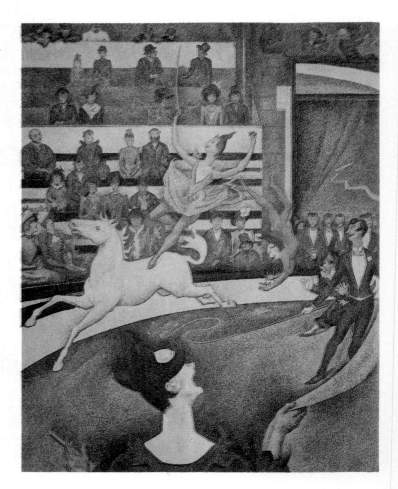

Tiny dots of color appear to blend together in Georges Seurat's *The Circus.* Try viewing this painting with a magnifying glass. How are value differences shown in different areas of the ring floor? How many different colored dots do you see there?
Georges Seurat, *Le Cirque,* 1890-91, Oil on canvas. Scala/Art Resource.

Instructions for Creating Art

1. Select an object or an animal subject for a picture drawn with dots. You can use something in the schoolroom—a jar, vase, paint can, student sculpture, or old shoe. You may want to bring something from home.

2. When you have decided on an object or an animal subject, make a very faint outline sketch of it. Sketch very lightly, filling most of the space with your drawing. If you think your sketch lines will show through the dots, lightly erase your outlines.

3. Start making dots, using a fine-tip marker or pen and ink. Making the dots the same size will achieve the illusion of shapes and masses. Fill in the shapes with dots. Place the dots closer together to show parts that are darker. Leave them farther apart for lighter areas. You will be able to show the **value** differences in the light and dark areas by varying the distance between dots. This method will make the object appear solid and **three-dimen-**

sional. You may also want to fill in the background with dots.

Art Materials

Pencil and eraser	Drawing paper
An object or photograph to use as a model	Fine-tip marker, or pen and ink

Strand A: Lines, Shapes, and Details

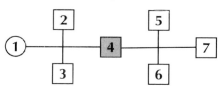

To evaluate your artwork, turn to the Learning Outcomes *section at the back of this book.*

5 Drawing Details and Close-ups

Observing and Thinking Creatively

If you have bought something that you had to put together, such as a video set, game, or appliance of some kind, you probably had to read instructions and follow an artist's drawings to assemble the object. Advertising artists, technical illustrators, and **graphic designers** often make detailed drawings in order to show a product or explain a process through **visuals**. These artists quickly learn the value of careful observation. They practice sketching specific parts and distinctive details before making final drawings.

In this lesson, you will focus on details as you draw a man-made object. By observing the object carefully, you will be able to add details such as lines, **textures**, highlights, and shadows.

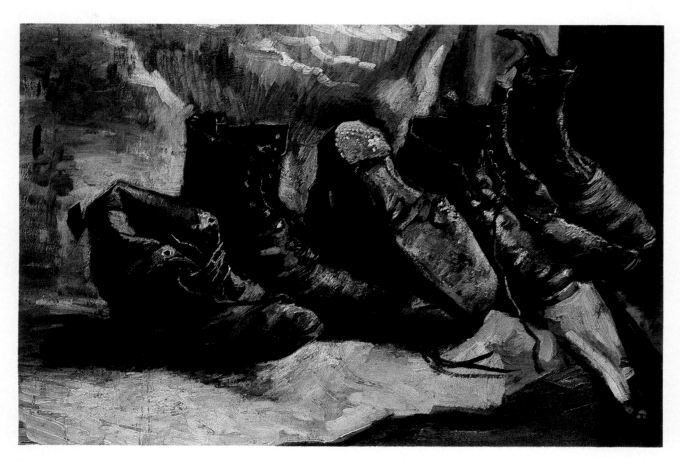

Vincent van Gogh did not decide to become an artist until he was 27 years old, and he only lived to be 37. Although he completed more than 800 paintings in the last five years of his life, he received no recognition while he was still alive. His slashing brushstroke style accentuates the well-worn appearance of these *Three Pairs of Shoes.* Note the exactness of detail shown.

Vincent van Gogh, Three Pairs of Shoes, 1887, oil on canvas, 19½ x 28".
Courtesy of the Fogg Art Museum, Harvard University. Bequest—Collection of Maurice Wertheim, Class of 1906.

Whittle Springs Middle School. Knoxville, Tennessee

Keystone Middle School. Indianapolis, Indiana

Instructions for Creating Art

1. Select a man-made object that you find interesting to draw, such as a bicycle, typewriter, roller skate, baseball mitt, football helmet, kitchen appliance, or an old shoe. Observe the object from several different angles. Decide which position or part of the object you want to draw. Then draw the main lines and features quite darkly by applying more pressure with your pencil. Concentrate on the line quality of your drawing. Draw the object so that it fills the paper.

2. Next, look at the same object again using your eyes to search out details such as fine lines, shapes, bumps and ridges, textures, highlights, and shadows. Add the details you see to your drawing.

3. Observe the drawings in this lesson and notice how the artists added details.

Art Materials

Man-made object for drawing

Soft pencil and eraser

Drawing paper

Strand A: Lines. Shapes, and Details

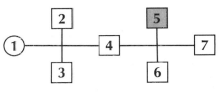

To evaluate your artwork, turn to the Learning Outcomes section at the back of this book.

6 Sketching and Drawing Natural Objects

Observing and Thinking Creatively

Have you ever picked up a stone that caught your eye, rolled it in the palm of your hand, and felt its surface?

The **texture** of the stone may have felt smooth, rough, or grainy. Perhaps you noticed pieces of shells or flecks of rock that sparkled. Both artists and scientists learn about such things as plants, animals, and rocks by observing and studying their every detail. They study their colors, shapes, patterns, and textures, and sometimes make detailed drawings to record their findings. Artists often use sketchbooks to make drawings of things they observe. Not only does the process of observing and sketching improve their drawing abilities, but it also sharpens their **visual memories**. Use of visual memory enables artists to not only remember what things look like, but to recreate the basic lines and shapes, adding details as well.

Start using a sketchbook in this lesson to sketch things around you. Then use one of your sketches as the basis for a more detailed drawing. For this lesson, you are to draw a natural object based on your observations. Then, in a few days, you should try drawing it from memory to exercise your visual memory.

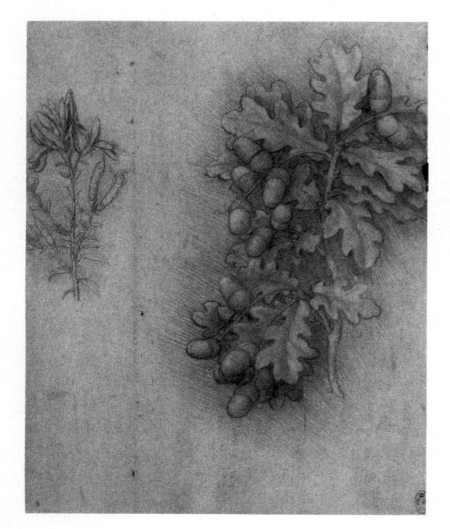

This is a drawing from one of Leonardo's sketchbooks. Great artists often draw simple, everyday objects from nature. Note how Leonardo filled in the background with short strokes of his chalk to make every detail of the leaves and nuts stand out.

Leonardo da Vinci, Oak Leafs with Acorns and a Spray of Greenwood. *Reproduced by gracious permission of Her Majesty Queen Elizabeth II. The Royal Library, Windsor Castle, England.*

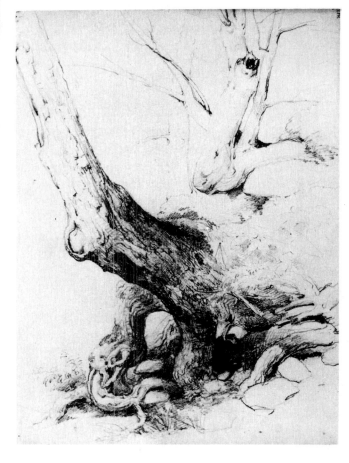

Rich textures, darker shading, and more precise details focus our attention on the base of this gnarled tree and its weather-twisted roots. Note how the fainter lines give a suggestion of surrounding shrubbery.

Instructions for Creating Art

1. Start by being observant. Take a sketch pad and study the natural things in your environment—the gnarled branches of a tree, a bird's feather, grains of wheat, cattails, or a snail creeping up the stalk of a plant. Observe natural objects such as these and make quick sketches of them. Include brief notes about colors, shapes, and textures.

2. Choose one of your sketches to develop into a detailed drawing. Begin drawing the outlines, and then include all the details. To make the object appear solid and **three-dimensional**, add shading using some of the techniques you learned in Lessons 2 and 3. Textures can also be created through shading or by adding various lines or dots. Drawing textured surfaces is another way of adding details.

3. In a few days, draw the same object from memory. Do not look at the object, your initial sketches, or your detailed drawing. Trust your visual memory to help you recall the shape and details of the object. When you have completed your drawing from memory, compare it to the first one you drew.

Art Materials

Sketch pad or sketch paper

Drawing paper

Pencil and eraser

Natural objects to draw: feather, fern, pinecone, log, seashell, etc.

Strand A: Lines, Shapes, and Details

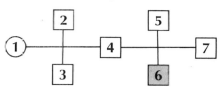

To evaluate your artwork, turn to the Learning Outcomes section at the back of this book.

7 Train Your Visual Memory

Observing and Thinking Creatively

If you have ever tried to play a piece of music, you probably had to read the notes and practice until you memorized the piece. Artists also practice remembering how things look in order to draw them. The ability to remember shapes and forms is called **visual memory**.

One way of improving your visual memory in art is to study the subject to be drawn, and then close your eyes to see if you can visualize it in your mind. Try this experiment with an object in the room. You may find that you need to refresh your memory by observing parts of the object several times before you are able to recall the entire **form** and all its details.

This lesson will help you train your visual memory so that you will be able to form an **image,** or a mental picture, of what you want to draw by recalling specific details such as lines, shapes, and **textures.**

Student Art Workshop. Los Angeles, California

Student Art Workshop. Los Angeles, California

18

Student Art Workshop. Los Angeles, California

Instructions for Creating Art

1. Decide on a subject to draw. Look carefully at the lines and shapes. Close your eyes and visualize the subject in your mind. Look again at the parts that you can't visualize.

2. Remove the subject from view and draw it from memory on a sheet of drawing paper. Include every detail you can remember—lines, shapes, textures, shading, and highlights.

3. Compare your completed drawing with the actual subject. Look for details that you remembered as well as parts that you left out. If there are details that you did not include, practice sketching just those areas as you observe the subject again. Keep observing and sketching specific details and parts of the subject until you feel that you have improved your memory of the whole.

4. Make a final drawing of the whole subject again without looking at it. Compare your finished artwork with your original drawing. How are they different? Find specific areas where you have improved. Did you include details such as various lines and textures, as well as shade light and dark areas? If your second drawing shows many more details than your first, you are improving your visual memory.

Art Materials	
Two sheets of thick drawing paper	Pencil and eraser
	Objects to draw

Strand A: Lines, Shapes, and Details

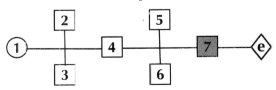

To evaluate your artwork, turn to the Learning Outcomes *section at the back of this book*

19

8 A Three-Quarter View Portrait

Observing and Thinking Creatively

Drawing faces can be challenging and interesting, since everyone's face is unique. A **profile,** or side view of the head, is similar to a **contour** drawing. Other views of the head create a different challenge since they require more extensive use of shading. A three-quarter view of the face shows part of the front and part of the side, exposing both sides.

Study the portraits in this lesson and notice how the artists drew facial features. Observe the different ways shading is used to indicate light and dark areas. Find places where an artist may have used the side of the pencil to show **value** differences. Do these techniques make the portraits appear solid and **three-dimensional**? In this lesson, experiment with some of these methods to draw a **portrait** of someone you know.

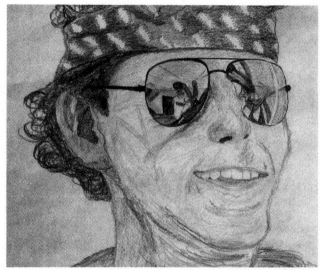

Gompers Secondary School. San Diego, California

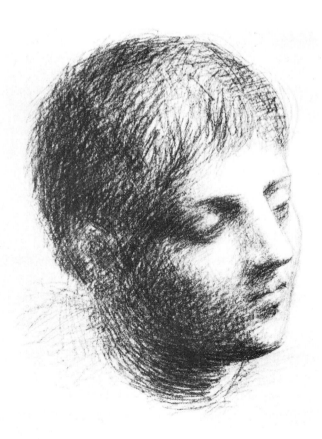

One way of adding interest to a portrait is to draw it from an unusual angle with strong diagonal lighting. Not only is this a three-quarter profile, but we are looking down on the head. A bright light spotlights part of the face, leaving the rest in deep shadows.

Pablo Picasso, Head of a Young Man, *1923, Conte Crayon, 24½ × 18⅝". Courtesy of The Brooklyn Museum, Carll H. DeSilver Fund.*

20

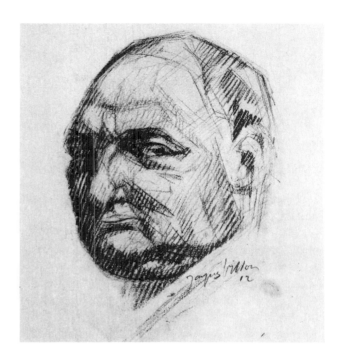

Jacques Villon has used strong, forceful lines and bold shading techniques to create this three-quarter view *Portrait of Felix Barre.* Study how the darker shaded areas, produced with heavy parallel lines, contrast with lighter areas, indicated with finer lines. How do these dynamic drawing methods help the face look three-dimensional and create an expression that captures the essence of the man's character?

Jacques Villon, French, 1875-1963, Portrait of Felix Barre, Black chalk over slight traces of blue pencil, 14¾" by 13¹⁵⁄₁₆". The Metropolitan Museum of Art, Rogers Fund, 1963.

Instructions for Creating Art

1. Ask a friend to pose for you. Find the exact side view, and then the exact front view. Move to a position that is halfway between the two. This is a three-quarter view. Have your model hold that position while you sketch.

2. First study the main shape of the head. Make a light outline sketch of this shape so that it fills most of your paper. Then observe the position of the eyes in relation to the top of the head and the chin. Also note where the bridge and the bottom of the nose appear. Lightly draw just the main lines of these features. As you draw, continually compare their **proportions,** or the relationship of the parts to each other and to the face as a whole. Note the placement of the features in your drawing with their actual positions on the person's face. Make any necessary adjustments.

3. Next, study the placement of the ears and mouth. Where do the ears appear relative to the eyes and nose? About how far is the mouth from the end of the nose and the bottom of the chin? Note all these proportions and sketch these features in your drawing.

4. Study the eyes of your model. Are the lower lids flatter than the upper ones? Now look at the iris, the colored part of the eye. Can you see a complete round circle of color, or does the eyelid cover part of it? Sketch in the details you see, using very light lines. Add eyelashes on the upper and lower lids.

5. The curves of the nose and the lips will give your portrait personality, so look carefully to see how they are shaped. The nose will start at the brow line, come down the bridge to a gentle point. The lips probably do not come together in a straight line, and may dip at the center. Lightly sketch in these features in your portrait.

6. Finally, shade in the portrait with a soft drawing pencil. Use the flat edge of your pencil to shade light and dark areas and to achieve a full range of **values.** Make the whole head look as solid as possible. Add shading for the eyebrows, eyelashes, and the hair.

Art Materials

Pencil and eraser　　　　　　Drawing paper
Model

Strand B: Drawing People

To evaluate your artwork, turn to the Learning Outcomes section at the back of this book.

9 Old and Young People

Observing and Thinking Creatively

Have you ever seen a young child's face full of wonder at discovering a new plaything or seeing something for the first time? The eyes of children seem to dance and fill with excitement. The eyes of older people, too, can sparkle with fun, even though their faces may be worn with wrinkles.

This lesson encourages you to think about and observe the faces of old and young. If you observe the drawings in this lesson, you will see the contrasts. Notice how the young child has a smooth, round face and large eyes. Childrens' heads often look too big for their bodies because their bodies have not yet grown to full size. The faces of older people are often deeply lined with wrinkles, and their bones are more pronounced.

Old and young people can be drawn very beautifully, as you can see in the portraits shown here. In this lesson, you will draw the face of an old person and the face of a child.

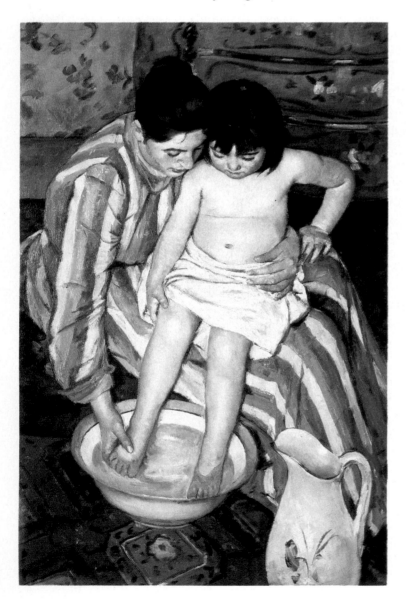

American artist Mary Cassatt is known for her sensitive Impressionistic pictures of mothers and children, painted with delicate colors and strong, clear lines. Compare the features of this mother and child: what differences do you note?
Mary Cassatt, The Bath, c. 1891, Oil on Canvas, 39×26". Robert A. Waller Fund, 1910.2. Courtesy of The Art Institute of Chicago.

Rancho San Joaquin Middle School. Irvine, California

Poignant eyes invite us to imagine the lifetime memories of van Gogh's *Peasant*. Sunken cheeks and wrinkles around the eyes and chin characterize this aged man.

Vincent van Gogh, A Peasant of the Camargue, c. 1888, Quill and reed pen and brown ink over soft graphite on white wove paper. Courtesy of the Fogg Art Museum, Harvard University. Bequest—Grenville L. Winthrop.

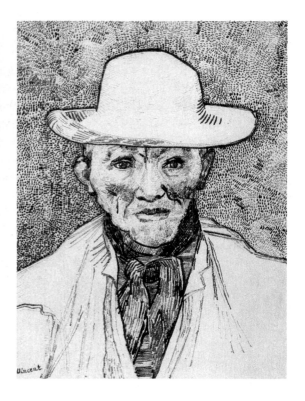

Vincent

Instructions for Creating Art

1. If possible, make your drawings of people you know. You may want to make a preliminary sketch of a young sibling or grandparent. See Lesson 8 for instructions on drawing facial features before you begin.

2. Study the faces of the young and old people you decide to draw. How are their faces different? Notice how the cheeks of children are full and wide and their eyes often open wide with a kind of innocent stare. The eyes are still flat along the bottom, but they arch higher and more of the iris, or colored part of the eye, is showing. Draw the face, keeping it truly childlike by including the special features unique to the child.

3. Study the face of the older person you are drawing. What special features do you observe? How are the eyes and skin tone different from a child's? Are there deep lines from the nose to the mouth and wrinkles around the eyes? Is the skin around the neck loose?

Do the bones under the cheeks, chin, and brow make angular ridges under the skin? See how much of this look you can capture in your portrait. Compare your two portraits when you are finished to note differences.

Art Materials

Drawing paper Model or photograph

Pencil and eraser

Strand B: Drawing People

To evaluate your artwork, turn to the Learning Outcomes *section at the back of this book.*

23

10 Sketching in the Style of Leonardo da Vinci

Observing and Thinking Creatively

Leonardo da Vinci lived over four hundred years ago in Italy. He was a genius—an artist, scientist, and engineer. He had so many ideas that he filled scores of sketchbooks with his notes and sketches. He designed an airplane long before anyone knew how to build a motor to make it fly. He designed bicycles and machine guns, and many other things that were not actually built until hundreds of years later. He also designed buildings, painted pictures, created sculpture, and changed the way art was taught.

As an artist, Leonardo decided that, in order to draw human or animal forms correctly, he had to study the underlying bone and muscle structures. He made numerous sketches of the same subject in various positions, trying to learn all he could through careful examination. He sketched a prancing horse from all angles, studying exactly how it moved. The great variety and range of Leonardo's art can be seen in the reproductions in this lesson. He became a master at drawing both human and animal figures. (Also see the sketches of Leonardo da Vinci's *Cats and Dragons* in the Exploring Art activity on page 47.) Sometimes he depicted realistic figures; at other times, he used a freer style of drawing, as you see in the reproduction of the *Five Grotesque Heads* shown here.

In this lesson, you will use Leonardo's technique of careful study to draw a subject.

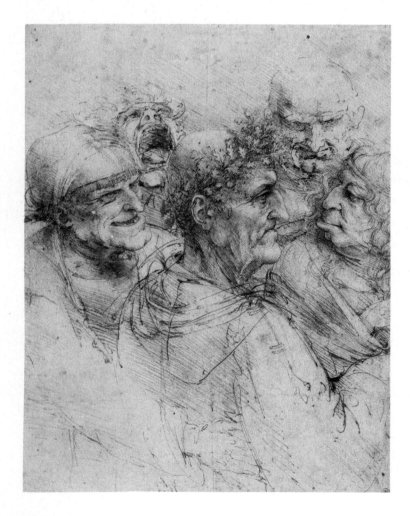

This pen drawing illustrates Leonardo's fascination with studying human nature. Here he has pulled together a most distinctive assortment of physical features into an unusual-looking group of men. Who do you suppose these men may have been?

Leonardo da Vinci, Five Grotesque Heads. 1490. Pen. Royal Library, Windsor Castle. Reproduced by gracious permission of Her Majesty Queen Elizabeth II.

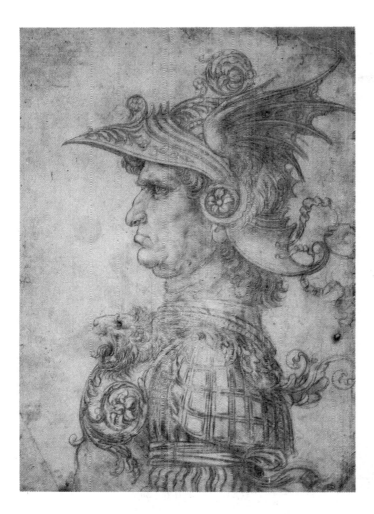

Elaborate ornamentation exaggerates the posture and facial expression of the *Antique Warrior*. Notice how the light shading reveals an understanding of underlying bones and muscles and a close observation of detail.

Leonardo da Vinci, Antique Warrior. *Trustees of the British Museum.*

Instructions for Creating Art

1. You can learn a lot about art by studying the work of great artists. Study the reproductions of Leonardo's drawings. Notice how he used lines and emphasized special features to depict his subjects. If possible, look through other art books to see additional reproductions of his artwork.

2. Select a subject to draw. You may want to draw someone's face showing a certain expression. Perhaps the person you choose to draw might wear an unusual headdress or costume. If you decide to use a person as your subject for this lesson, draw the face and upper body only. Make several sketches of the subject from different angles and in various positions. Let your sketches show that you are learning just how the subject looks.

3. Choose one of your sketches to use as the basis for a finished drawing. Put in as much detail as possible. Look for a lock of hair curling over an ear, patterns or textures of clothing, elaborate jewelry, wrinkled skin, bushy eyebrows, or other specific details to add to your final drawing. Use a **medium** that best expresses the subject matter—pencil, chalk, pen and ink, or charcoal.

Art Materials

Your choice: chalk, pen and ink, or charcoal	Pencil and eraser
	Drawing paper

Strand B: Drawing People

To evaluate your artwork, turn to the Learning Outcomes *section at the back of this book*

25

11 Exaggerated Drawings and Caricatures

Observing and Thinking Creatively

If you look through almost any newspaper or news magazine, you will probably come across a **caricature** of a well-known person. A caricature is a drawing that exaggerates, or **distorts**, certain features of a person, such as the eyes, nose, or mouth. Caricatures of politicians are especially common in the opinion or editorial section of the newspaper. Perhaps you have seen caricatures of famous entertainers whose distinctive facial features have been distorted in exaggerated draw-

ings. The funnier the artist can make the drawing, the more people will look at it. Distortions are common in cartoons, too. The difference is that cartoons show imaginary people or animals, while caricatures are based on real people. Caricatures may be drawn to make a statement about someone's ideas, opinions, or policies. In this lesson, you will draw a caricature of a famous personality, exaggerating his or her features.

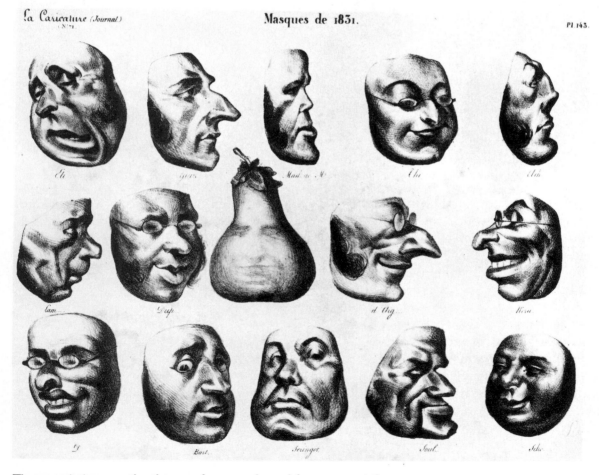

La Caricature (Journal) Masques de 1831. Pl 143.

These variations on the theme of a pear-shaped face suggest the unlimited possibilities for exaggerating features of the human face. Nose, mouth, eyes, eyebrows, chin, teeth, and shape of the head are all fair prey to the imaginative cartoonist. Grimaces, smiles, and stares also make good material for distortion.

Honoré Daumier, Masques de 1831, *Lithograph. Print Collection, The New York Public Library, Astor, Lenox and Tilden Foundations.*

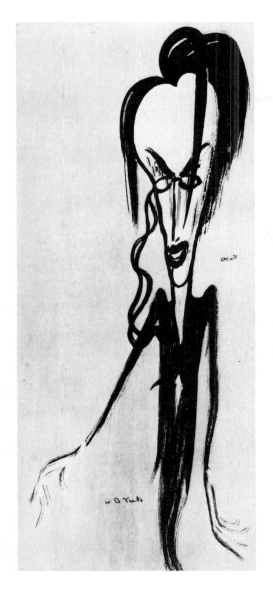

Max Beerbohm drew this caricature of Irish author William Butler Yeats in an elongated pose to emphasize his thinness and straight hair that often fell in his eyes. What other physical characteristics would help identify Yeats if you saw him in a crowd?

Max Beerbohm, W.B. Yeats. Courtesy of the National Gallery of Ireland.

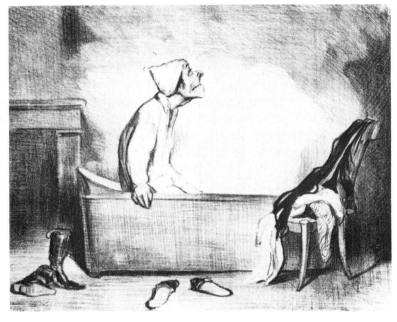

French artist Honoré Daumier created this lithograph over 100 years ago, at a time when many people did not think of bathing as a pleasant, relaxing experience. What features were exaggerated to emphasize this bather's apprehension and distaste?

Honoré Daumier, Le Bain Chaud (The Hot Bath). The Minneapolis Institute of Arts, Gift of Mrs. C.C. Bovey.

Instructions for Creating Art

1. Look through newspapers and magazines for pictures of famous people such as athletes, entertainers, or politicians. Decide on a good subject for a caricature drawing. Does the person have some feature that could be distorted—a bald head, bushy eyebrows, a skinny neck, large lips, an unusual nose, or a dimpled chin?

2. Make several sketches, perhaps drawing the person from different angles and with a variety of expressions. Strive to get a likeness of the person through exaggeration.

3. Perhaps you can add a special caption or clever statement to go with your caricature. Study political caricatures in magazines and newspapers for ideas.

Art Materials

Drawing paper	Pencil and eraser
Pen and ink (optional)	Photographs of famous people

Strand B: Drawing People

To evaluate your artwork, turn to the Learning Outcomes section at the back of this book.

12 Portrait of Hands

Observing and Thinking Creatively

The human hand has fascinated artists for centuries. Many an artist's sketchbook has been filled with studies of hands in various positions, performing various actions. A hand, like the expression on a face, can show tension or relaxation, harshness or gentleness, strength or frailty. Hands have different shapes, sizes, and textures; every hand, like every face, is unique.

The edges, or **contours**, of a hand, as well as the spaces that help to define its form, are visually interesting and can be a source of exciting drawings and designs. In this lesson, you will closely observe your own hand and draw it using the **modified contour drawing** method. You will become aware of how spaces and contours define the shape of your hand, and how the different parts of your hand combine to form an integrated, or **unified**, whole. After you have made a contour drawing of your hand, you will use it as the basis for a finished, detailed drawing.

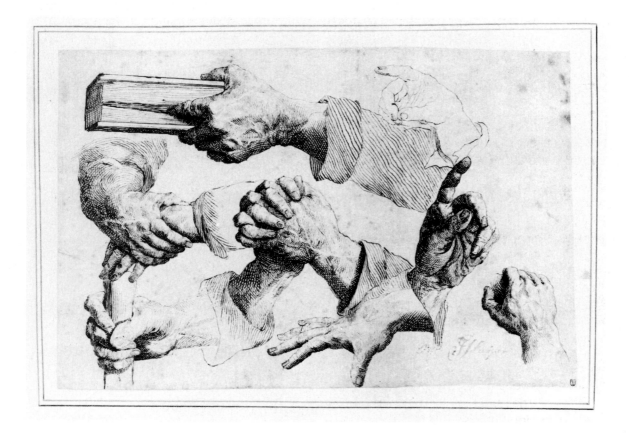

Hands communicate by reaching, grasping, pointing, clasping, and joining together in prayer. Like facial expressions, hand gestures have many meanings. Notice the variety of ways fine lines have been used in this drawing to show the textures and contours of the hands. The overall composition conveys the impression that hands are an extension of the self.

Study of Ten Hands, *Anonymous Dutch or German, c. 1680, Pen and brown ink.*
National Gallery of Canada, Ottawa.

Gompers Secondary School, San Diego, California

Memorial Junior High School, Houston, Texas

Instructions for Creating Art

1. Tape a piece of newsprint or drawing paper to your desk or tabletop. Sit in a comfortable drawing position and hold the hand you do not draw with in front of you so that you can easily observe it. Form your hand into an interesting position, perhaps imagining that you are grasping a doorknob, shaking a hand, or plucking a rose. For an added challenge, actually hold an object in your hand, such as a pencil, magnifying glass, flower, or cup.

2. Take several minutes to intently observe your posed hand by following its edges, or contours, with your eyes. Be aware of the individual shapes that compose your hand, and how these shapes relate to one another. Note how the contours are defined by spaces around and between them. Also note the muscular tension in your hand, its texture, and details such as creases in the skin.

3. Keep your hand in the same position and start to draw, slowly moving your pencil to keep pace with the slow sweep of your eyes as they follow both the external and internal contours of the hand. Do not look at your paper except occasionally to see whether you are drawing the parts of the hand in proper relation to one another and in the correct proportions. Keep your pencil moving; your eyes should be focused on the posed hand ninety percent of the time.

4. When you are finished with your contour drawing, remove it from the tabletop and tape down a clean sheet of drawing paper. Use your contour drawing as a guide to make a finished drawing of your hand. Perhaps you would rather draw the hands of a classmate holding a book, or clasping a pen instead of drawing your own hand.

5. With a pencil, use shading to show the textures and details of the hand, making it appear solid and **three-dimensional**. (See Lesson 3 and page 219 for information on shading techniques.)

Art Materials

Two sheets of drawing paper	Object to hold in hand: cup, flower, magnifying glass, etc. (optional)
Pencil and eraser	
Tape	

Strand B: Drawing People

To evaluate your artwork, turn to the Learning Outcomes section at the back of this book.

29

13 **Human Measurements**

Observing and Thinking Creatively

People come in all sizes and shapes, but with all these differences, you may observe similarities in **proportions,** the relationship of body parts to each other and to the whole. An awareness of body proportions is important if you are including people in your artwork. You can learn these proportions best by carefully observing the people you choose to draw.

Drawing human forms in proportion is especially important for artists who draw figures for advertisements and catalogs. Not only must they practice drawing the figures, but they must also make the clothing appear natural. In this lesson, you will have an opportunity to draw someone you know in special clothing as though you were creating an advertisement.

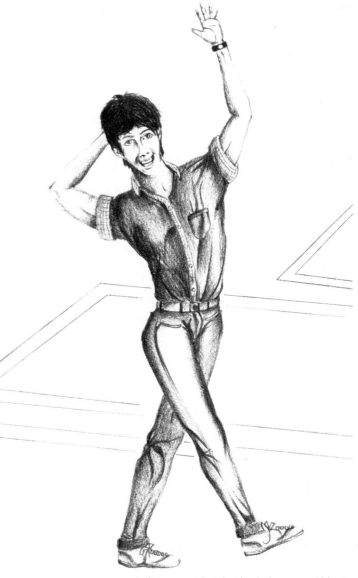

St. Joseph Hill Academy. Staten Island, New York

Chula Vista High School. Chula Vista, California

Instructions for Creating Art

1. Select a person in your class and take turns posing for each other. Create poses that will give you experience in drawing arms and legs in different positions. Look closely at body proportions before you begin. Compare the size of the head to the length of the whole body. Note the length of the arms and legs in relation to the **torso,** the main part of the body excluding head and limbs. Observe the placement of knees and elbows. These observations will help you in drawing the human form in proportion.

2. Think of an unusual attire for your subject to wear as though he or she is modeling for an advertisement. An unusual outfit, a special costume, or a uniform make interesting clothes to draw. Lightly sketch in the human form, carefully noting the body proportions you observe. Compare your drawing and your subject often. Are there any changes in proportions that you need to make?

3. When you are satisfied with your sketch of the basic proportions, sketch in the clothing over the body form. Add special details and shading to make your final figure appear life-like and three-dimensional.

Art Materials

Drawing paper Pencil and eraser

Strand B: Drawing People

To evaluate your artwork, turn to the Learning Outcomes section at the back of this book.

14 People in Action

Observing and Thinking Creatively

The racing quarterback deftly sidesteps the outstretched hands of the frustrated tackler. Grabbing a rebound from an opponent, the basketball player dribbles the ball across the court to slamdunk the winning basket. The highjumper hurls his body in a perfect arc to clear the bar and set a new world record. Almost any sport involves a lot of movement, with bodies weaving and twisting in all sorts of ways. The camera can catch this action right at its high point, and so can you. For in this lesson, you will be drawing *action.*

The best way to draw people in action is to observe them and make quick sketches of bodies turning, twisting, reaching, or lunging. **Gesture** drawing is one method of capturing move-

ment. In gesture drawing, the artist uses quick, continuous lines to catch the total action of the subject. In the example of gesture drawing below, note how the artist has depicted the actions and gestures of the figures through the use of spontaneous lines. As you can see from this example, the emphasis in gesture drawing is upon movement rather than exact form and detail.

The artwork of the *Three Men Digging* on the next page is an example of another way of showing action using lines and shading. In this lesson, you will practice gesture drawing and then use one of your sketches for a finished piece of art showing action.

French artist Daumier used gesture drawing in his depiction of *A Clown* to capture the movement and expression of the figures. Notice how scribbly charcoal lines emphasize the action. Darker areas shaded with thicker charcoal lines and patches of thin watercolor add contrast and make the figures appear solid. What simple techniques did the artist use in the background to complete the drawing?

Honore Daumier, A Clown, Charcoal and water color. The Metropolitan Museum of Art, Rogers Fund, 1927. (27.152.2)

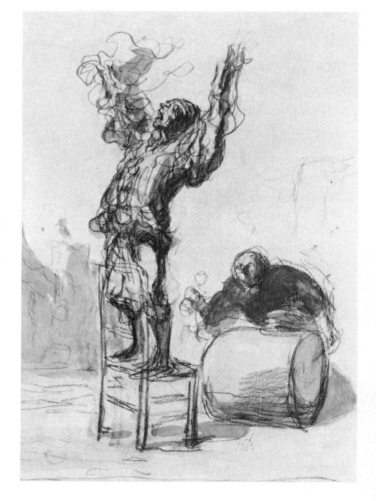

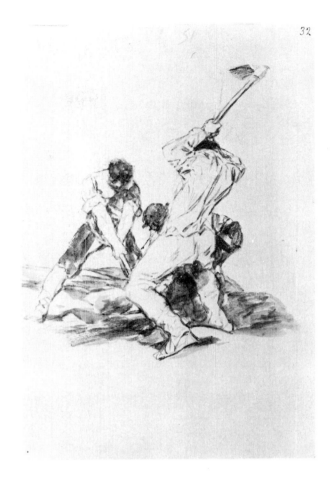

To strengthen the motion of the *Three Men Digging* and show unified effort, Goya repeated parallel diagonal lines in the positions of the men's arms and legs. Major lines of the picture retrace the action by leading from the poised bodies down to the ground.

Francisco José de Goya y Lucientes, Three Men Digging, *Wash drawing in sepia. The Metropolitan Museum of Art, Harris Brisbane Dick Fund, 1935.*

Instructions for Creating Art

1. Use your sketchbook to capture people in action. Observe tennis players, swimmers, cheerleaders, gymnasts, or baseball players. Sketch people working—janitors, cooks, coaches, construction workers, etc. Notice how their bodies move, and sketch what you see. Watching films or movies of people in motion can also be useful.

2. In the classroom, select a classmate to pose for you. Make several gesture drawings of the model in various action positions. To capture the movement of the person, move your pencil rapidly and continuously *without lifting it off the paper.* Have your subject hold an action pose for about a minute as you move quickly from one gesture drawing to another, without concern for precise form or details.

3. Look over the gesture drawings you have completed. Select one that you think captures the action best. Use this drawing as the basis for a finished piece. Make any necessary adjustments in **body proportions**. With a pencil, black crayon, or charcoal, add shaded areas to emphasize the form of the figure and

to accentuate the movement. You may also wish to indicate shapes and objects in the background.

Art Materials

Sketchbook or sketching paper

Drawing paper

Soft pencil and eraser

Your choice: charcoal or black crayon

Strand B: Drawing People

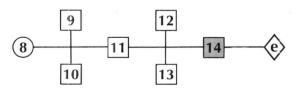

To evaluate your artwork, turn to the Learning Outcomes *section at the back of this book.*

15 *Geometric Shapes*

Observing and Thinking Creatively

When you are drawing a picture, your lines can curve, wander, and meander as you wish, to express the feeling you are after. What do you suppose would happen to your picture if you were told it had to be done in nothing but geometric shapes? Try it, and you'll find that instead of a picture, you have an **abstract** design. It may have some of the original picture idea, but it is more of a design than a realistic picture. It emphasizes the basic shapes that underlie forms.

Study the two pictures shown in this lesson, noting the geometric shapes that underlie the forms and details. In Thomas Hart Benton's *July Hay*, pictured below, what simplified shapes do you perceive in the flowers? Visualize the farmers in terms of geometric shapes, shuch as squares, rectangles, triangles, semicircles, and diamonds. Where do you perceive these shapes? Look at John Marin's city scene on the next page; what geometric shapes do you see?

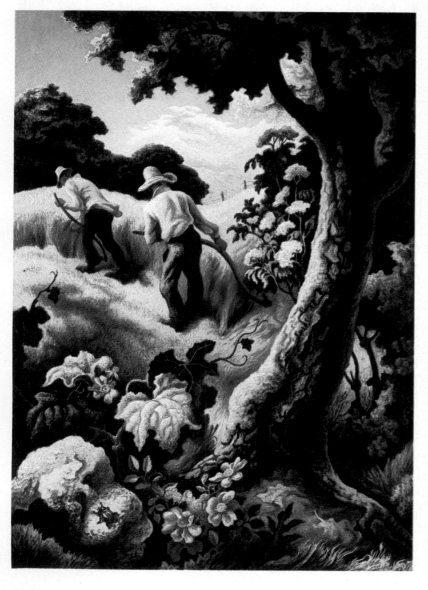

July Hay by Thomas Hart Benton shows great attention to texture, pattern, and intricate details. Can you see beneath the detailed surface elements to find the main geometric shapes? Visualize how this piece would look if done in the style of John Marin's street scene on the next page.

Thomas Hart Benton, July Hay, 1943, Oil and egg tempera on composition board. H. 38 in. W. 26¾ in. The Metropolitan Museum of Art, George A. Hearn Fund, 1943.

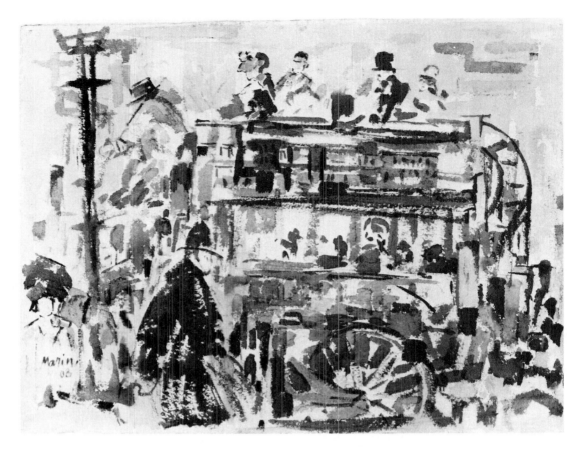

Notice the horizontal and vertical brushstrokes Marin used to tell just enough about the shapes to suggest what they are. The double-deck bus is painted with overlapping strokes, and people are represented with dabs of the brush. Where do you see geometric shapes used abstractly to represent real objects?

John Marin, London Omnibus, 1908. Watercolor. The Metropolitan Museum of Art, The Alfred Stieglitz Collection, 1949. (49.70.99)

Instructions for Creating Art

1. Decide on a scene to sketch for this lesson. Make an original **freehand** drawing of the scene using a pencil. Add details and shading to create a realistic picture.

2. When your drawing is complete, study the picture to find the simplified main shapes. Are there areas that could be represented by geometric shapes? On a separate sheet of drawing paper, recreate your picture in terms of more simplified geometric shapes. You may wish to use drawing instruments, such as a *ruler, compass,* or *protractor.** By simplifying realistic shapes into purely geometric ones, your picture will become more **abstract**.

3. When your second drawing is complete, you may wish to add color to make the abstract shapes even more apparent. Use either crayons, oil pastels, or colored markers.

For an explanation, turn to the How to Do It *section at the back of this book.*

Art Materials

Pencil and eraser

Ruler, compass, or protractor (optional)

2 sheets of drawing paper

Crayons, oil pastels, or colored markers

Strand C: Drawing Styles and Techniques

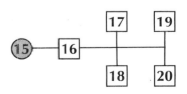

To evaluate your artwork, turn to the Learning Outcomes section at the back of this book.

35

16 *Showing Depth and Distance*

Observing and Thinking Creatively

You have probably noticed how objects look smaller as they get farther away. When you look down a city street, for instance, buildings of the same size seem smaller in the distance. The method for achieving distance and depth in a drawing is called **perspective**. Perspective drawing isn't difficult to do, especially if you begin by studying the lines you can see in a photograph, where the camera has already changed a view of a solid shape to flat paper. This gives you a good start in perspective drawing.

Study the photograph of the building pictured below. Notice how the upright lines of the building remain **vertical**, while the **horizontal** lines slope toward one another and **converge**, or come together, at a single imaginary spot in the distance. This spot is called the **vanishing point**, and is on the **horizon** line—the place where the sky and the earth come together.

You can find the vanishing point on the other side of the building by drawing similar lines. These horizontal lines will converge at a different point on the horizon. This method of showing perspective also works when you are drawing the interior of a room.

In this lesson, you will show perspective by drawing vertical and horizontal lines on top of an actual photograph. Then you will use these lines to guide you as you draw the same object without the help of the photograph.

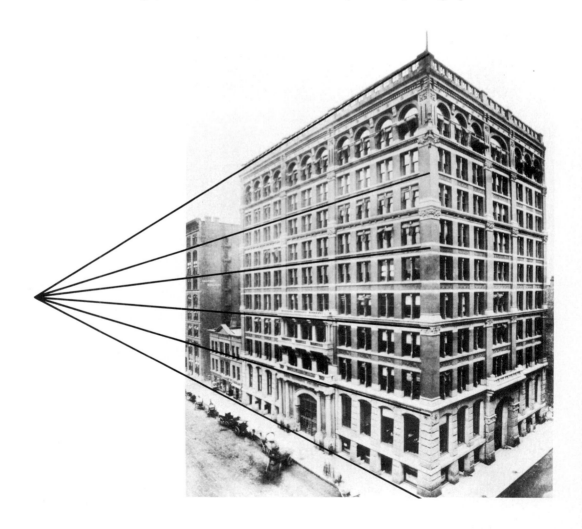

Meridian Middle School. Indianapolis, Indiana

Meridian Middle School. Indianapolis, Indiana

Instructions for Creating Art

1. Look through magazines for a large photograph of a building with simple horizontal and vertical lines. One corner of the building should be near the center of the photograph.

2. Cut out the photograph and glue it to a sheet of white paper. The paper should be about 12 inches bigger than the photograph on each side. You may have to tape two or three sheets of paper together to make a piece that is large enough for drawing perspective lines.

3. Find all the lines in the picture that are perfectly horizontal or level. Using a ruler, draw pencil lines exactly on top of all these lines. Extend each line off the edge of the photograph and all the way to the edge of the paper, as in the example in this lesson.

4. Notice that most of the lines in the photograph showing objects that are horizontal seem to slope up or down, but the vertical lines do not change. Most of these sloping lines come together on the white paper at one side of the picture. Cameras record these sloping lines on film, which is why studying photographs is helpful in learning how to use correct perspective in drawing.

5. Finally, test yourself to see what you have learned about perspective drawings. Make a freehand drawing of a building around your school or community. Lightly sketch in the horizontal and vertical guidelines as you did in the practice activity. When you have achieved the perspective you want for the building, draw in the details, add shading and color.

Art Materials

Magazine photograph of a building (with a corner near the center)	Several sheets of drawing paper
	Ruler
White glue and tape	Pencil and eraser
Scissors	Colored pencils

Strand C: Drawing Styles and Techniques

To evaluate your artwork, turn to the Learning Outcomes *section at the back of this book.*

17 Bird's-Eye View

Observing and Thinking Creatively

Did you ever go to the top of a tall building and look down? If so, you had a bird's-eye view of the town below. Yet, when you went down to the street level and looked up at the building, your view changed dramatically. This is because your eye level, or the distance of your eyes above the ground, had changed. The eye level of a picture also represents the **horizon** line, or place where the sky meets the earth. Your view of the horizon changes as your eye level changes. The horizon line gets higher as your eye level rises.

Artists choose the eye level for their pictures very carefully. If you observe the pictures in this lesson, you will see that each artist has depicted the horizon from the top of tall buildings and structures—a bird's-eye view. In this lesson, you are to show a bird's-eye view of a scene by drawing it on paper.

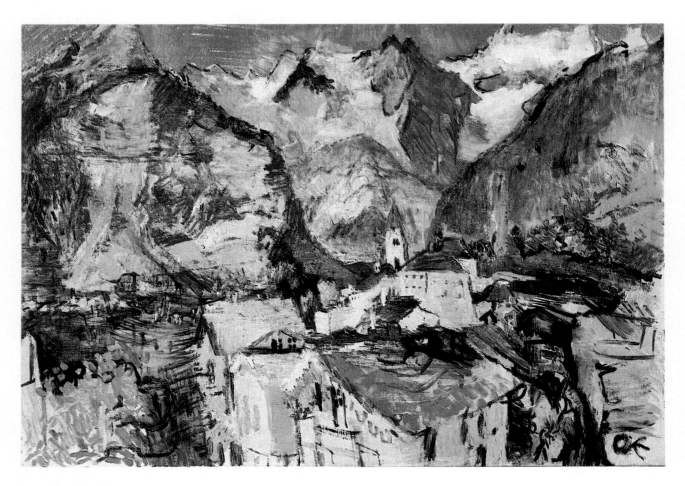

We would have to be at a high vantage point to get this bird's-eye view overlooking the rooftops of Courmayeur, a village nestled among mountains called "the Teeth of Giants." Where is the center of interest? How many ways can you see that Kokoschka draws our attention to it? How do your eyes travel around the picture, and where do they come to rest?

Oskar Kokoschka (Austrian-British), Courmayeur et les Dents des Géants, *1927, Oil on canvas, 35½ × 51 ³⁄₁₆ in. The Phillips Collection, Washington.*

38

Edward Hopper frequently painted realistic city scenes with no people, depicted from unusual angles. This view from a rooftop shows a side of the city we seldom see. How does this viewpoint create a contrast between the city and the landscape beyond it? How does this rooftop view make you feel about the city?

Edward Hopper. El Palacio. 1946. Watercolor. 20¾ × 28⅝ inches. Collection of Whitney Museum of American Art. Purchase (and exchange). Acq#50.2

Finnish student art

Instructions for Creating Art

1. Imagine that you are in a helicopter, hovering over a huge city, trees in a park, or your own backyard. What would your bird's-eye view from the air be like? What might you see? Decide on a bird's-eye view that you would like to draw. It can be of a city, countryside, or even the surface of another planet. Use your imagination to show what a bird might see from the air.

2. Draw a horizon line in the upper half of your paper, as most of your scene will be below it. If you choose to show buildings in your bird's-eye view, refer to Lesson 16 for instructions on drawing perspective lines. To achieve proper perspective with buildings seen from above, start by drawing the vertical front edge of the closest building. Draw the top and bottom edges of your building out to **vanishing points** on the right and left sides of your paper. Make sure that you draw your vertical lines perfectly straight up and down, or you will have leaning buildings.

3. After you have drawn the essential parts of your picture, fill in details that will make your scene come to life. To create a feeling of depth and solidity, darken the shady side of objects. Use a soft pencil and even strokes, building up the dark areas in the parts of your picture that are away from the light. Leave the areas that are in the sun unshaded, as though the sunlight were shining brightly on them.

Art Materials

Drawing paper Soft pencil and
Ruler eraser

Strand C: Drawing Styles and Techniques

To evaluate your artwork, turn to the Learning Outcomes section at the back of this book.

39

18 *Unusual Angles*

Observing and Thinking Creatively

Have you ever seen yourself in a mirror or store window where the glass is bent and your reflection is twisted out of shape? These **distorted** views can be quite humorous and surprising. There are other ways of seeing objects from unusual angles. Try lying at the bottom of a tree, and gazing at the ridges of bark that weave their way up into the branches. Or sit on the floor and get an ant's-eye view of the underside of a chair or table. Look at a pencil so that one end is pointing exactly toward you. These are all uncommon ways of looking at common objects.

Being creative in art includes searching for unusual and interesting views of objects, people, and places. In this lesson, you will draw a view from an unusual angle. Your subject may be something perfectly ordinary, but seen in a way that is different.

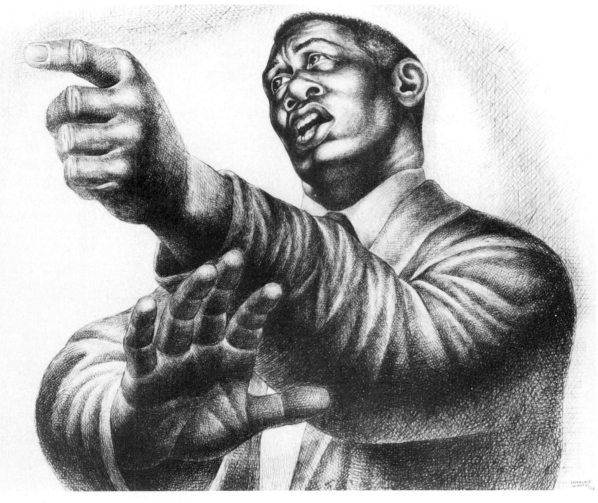

To make someone appear more imposing, an artist may use a low angle, as though the viewer were looking up at the subject. Find cross-hatching and other shading techniques that show contrasting tones.

Charles White. Preacher. 1952. Ink on cardboard. 21⅜ × 29⅜ inches. Collection of Whitney Museum of American Art. Purchase. Acq#52.25.

Into a still-life setting, action and drama are introduced on a diagonal S-curve through the center. Surprise results as our view is extended below ordinary eye level to the floor, where a scurry of activity is taking place.

Robert Jessup, Kitchen Chase, 1984, 36 × 36", Siegel Contemporary Art, NYC.

Escher uses a highly polished sphere to distort the perspective in this unusual lithograph. Note the curious angles produced as your eyes follow the bookcase and wall above it. Rich texture is shown by smooth shading.

B23,432 Hand with Reflecting Sphere, M.C. Escher, National Gallery of Art, Washington; Rosenwald Collection.

Instructions for Creating Art

1. Spend some time looking around to find an unusual view to draw. Put yourself in a place where you can see something from a different angle. Look under a sink, or lie on your back and look at the ceiling or underneath a chair. There are many ways of looking at the world around us. Your task is to find an unusual view of something and draw it.

2. Draw your unusual view so that it fills the paper. Focus on the part that you think will make a good design. Add lines, details, and shading to emphasize its peculiar qualities. Leave the white paper showing through for white areas, but shade in everything else with your pencil in different **values** of gray. Try using some different shading techniques, such as **cross-hatching**, to emphasize contrasting tones. Notice how this technique is used in Charles White's picture, *Preacher.*

3. Write a brief description of the unusual angle you drew and place it on the back of your picture. Then see if students in your class can guess the subject of the drawing before reading your description.

Art Materials

Soft pencil and eraser Drawing paper

Strand C: Drawing Styles and Techniques

To evaluate your artwork, turn to the Learning Outcomes section at the back of this book.

19 Different Styles of Drawing

Observing and Thinking Creatively

Every artist draws differently. Some draw every detail very carefully. Others scribble their ideas down quickly. Most good artists draw in several different ways, in order to match their drawing style and technique to their subject matter. They also know which **media** to use to get different effects—crayon, charcoal, brush, pen and ink, or pencil. If you look at the art in this lesson, you will observe that one artist used dark, heavy crayon lines to illustrate a hamburger, while another artist drew an airy country scene with light, wispy lines using pen and ink.

The best way to learn about different drawing styles and art media is through observation and practice. Begin observing the ways in which famous artists draw. Then practice drawing similar subjects using their techniques. This does not mean copying any of the artists' drawings shown in this lesson. It does mean trying out the drawing techniques of great artists, such as Rembrandt and Toulouse-Lautrec. You might mix the drawing styles of two or three different artists and invent a style of your own.

Notice the light, airy swirls in the treetops, the scribbly pathway, and scratchy fence, as well as the cross-hatching, and other sketching techniques used to show the cottage shaded in a grove of trees. These strokes are characteristic of Rembrandt's pen and ink drawing style as he sketched scenes of the countryside around him. What are some of the advantages and disadvantages of pen and ink?

Rembrandt Harmensz van Ryn (1606-1669), A Cottage Among Trees. The Metropolitan Museum of Art, Bequest of Mrs. H.O. Havemeyer, 1929. The H.O. Havemeyer Collection. (29.100.939)

Henri de Toulouse-Lautrec worked hard to create masterful line drawings and paintings that look like they were done with little effort. This pastel drawing captures the majestic strut of the circus horse and dancing whirl of its rider, accented against a strong diagonal curve.

Henri de Toulouse-Lautrec, Au Cirque Fernando, Ecuyere sur un Cheval Blanc (At the Circus Fernando, Rider on a White Horse), 1888, Pastel and gouache on board, Norton Simon Art Foundation, Pasadena, California.

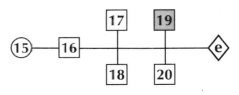

Lithographic crayon gives a soft edge to this whimsical sketch of a generously stacked hamburger. Quick dots, dashes, and curves describe texture and shadow. Can you identify the lettuce, pickle, and tomato? What do you think is good about the composition of this design?

Claes Oldenburg, Hamburger, 1962, 14 × 17 in. Lithographic crayon. Collection, The Museum of Modern Art, New York. Philip Johnson Fund.

Instructions for Creating Art

1. To try out a variety of drawing techniques, select a subject for your experimental sketches. You might like to draw a familiar object like the hamburger shown in this lesson, or perhaps you can sketch something from your environment, such as a tall elm tree or a gnarled oak.

 In addition to observing the drawings in this lesson, look through the book for other ways of drawing.

2. Decide on the **medium** that would be best for the subject you chose—crayon, pencil, pen and ink, charcoal, etc. Then make a sketch in the style of your favorite artist. Note any special ways of drawing that are characteristic of the artist and try using them in your own art. Especially note how the artist has used lines, dots, and shading.

3. Try drawing the same subject in another style. Keep experimenting with different styles to discover which ones you like most. Then make a finished drawing of your subject in the style you like best.

Art Materials

Your choice: pencil, crayon, pen and ink, or oil pastels

Drawing paper

Strand C: Drawing Styles and Techniques

⑮—|16|——|17|———|19|———◇e
 |18| |20|

To evaluate your artwork, turn to the Learning Outcomes section at the back of this book.

20 Drawing Animals

Observing and Thinking Creatively

Almost everyone wonders at the ways of animals. Perhaps you have stood in awe as you watched an eagle gliding with the wind or a deer leaping across a meadow. Animals help preserve the balance of nature, as well as add richness and beauty to life on earth. Some animals also provide companionship as pets. Artists have depicted animals throughout history, ever since the first prehistoric men drew simple animal figures on the walls of their caves.

Because animals are difficult to draw, most artists who draw animals study and sketch them from different angles and in various positions. Some of the sketches pictured here have become famous works of art. Notice the techniques each

artist used to show the **textures** of different animals. Also note how the animals' body forms have been carefully and accurately drawn. These artists observed and studied the bone structure of the animals they drew. Because the surface textures, colors, and bone structures of different animals vary, learning how to draw each animal is a new experience.

This lesson will provide an opportunity for you to observe, study, and draw an animal of your choice. If you choose to draw a wild animal or one that is not in your immediate environment, you may want to visit your community zoo or nature park where you can easily observe and sketch the animal.

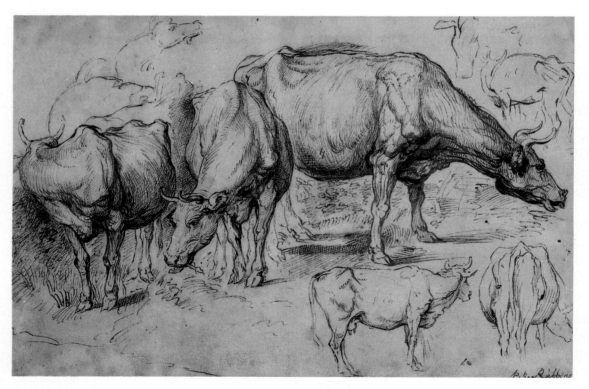

Besides being a skilled diplomat and scholar, Peter Paul Rubens is recognized as the greatest Flemish Baroque painter of the 1600s. In this pen drawing, fine lines detail every curve and contour of bone and muscle, while background lines are more general and sketchy. Note how the overall composition captures the diverse activity among a herd of grazing cows.

Peter Paul Rubens, Study of Cows. © *The Trustees of The British Museum, London.*

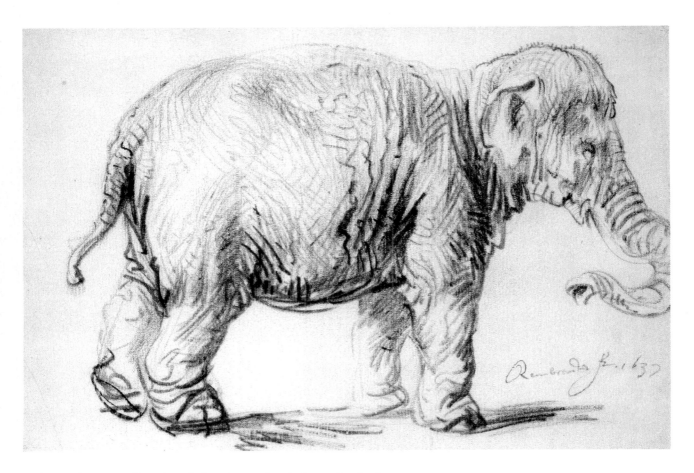

Rembrandt especially enjoyed drawing and painting animals. In this *Study of an Elephant*, heavy curving lines show the deep shadows of the elephant's wrinkles. Why do you think this style of drawing is particularly well suited to its subject?

Rembrandt van Rijn, Study of an Elephant, 1637, Black chalk, 17.8 × 25.6 mm (7 × 10"), The Albertina Collection, Hofburg Esperanto Museum, Vienna, Austria.

Gompers Secondary School. San Diego, California

Muirlands Junior High School. San Diego, California

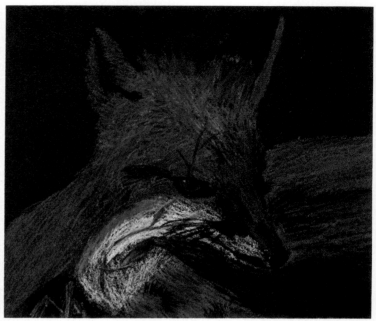

Muirlands Junior High School. San Diego, California

Instructions for Creating Art

1. Decide on an animal that you would like to draw. If possible, observe the animal firsthand, noting visual details and characteristics. Use a sketchbook to make several quick sketches of the animal in various positions. Particularly note the animal's bone structure and body proportions. Also study the texture of the skin, fur, scales, or feathers, and try to achieve this texture in your sketches through lines and shading. If you like, make brief notes about special features such as color, shape, size, and body structure. Use your sketches as studies of the animal, to learn all you can about how it looks.

2. The following tips for drawing animals will help you to create successful sketches.

 a) Lightly draw the basic body shape first, and sketch in the largest features.

 b) Note how the body parts are joined and show the relationships through your use of lines.

 c) Show the movement of the animal and the body parts through the way the lines of the body bend and curve.

 d) Suggest the body weight by using lighter lines for lighter parts and dark, thicker lines for heavier parts.

 e) Draw hair, scales, feathers, etc., the way they grow, from the body outward.

 f) Shade to give an animal shape and to suggest body texture.

 g) Add the smallest details last, and highlight the shine on the eyes, beak, or nose by letting the white paper show through.

3. After you have made several sketches of the animal, choose one to develop into a finished drawing. Add color, if you like.

Art Materials

Magazine pictures of animals	Pencil and eraser
Sketch paper or sketchbook	Your choice: pen and ink, crayons, oil pastels, chalk, etc.
Drawing paper	

Strand C: Drawing Styles and Techniques

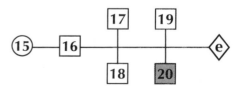

To evaluate your artwork, turn to the Learning Outcomes *section at the back of this book.*

Exploring Art

Sketchbook Animals

If you have tried drawing animals, you have experienced the need for careful observation as you draw. Almost 500 years ago, Leonardo da Vinci made hundreds of animal drawings based on his observations of their underlying bone structure. His *Studies of Cats and Dragons* on this page show how he drew cats in various positions. Why do you think he included the small dragon among these sketches? Leonardo often made several sketches of the same subject and filled scores of notebooks with his drawings and notations. He realized the value of careful observation and the necessity of making many practice sketches in order to know and draw a subject well.

For this activity, find a live animal, fish, or insect to observe and sketch in your sketchbook. You can make a sketchbook by folding and stapling drawing paper together. Ready-made sketchbooks can be purchased from an art supply store.

Carefully study the animal you have chosen before you start to sketch. Observe it in various positions and make notes about its color and the texture of its skin, fur, feathers, etc. Make several loose, quick sketches of your subject on one page of your sketchbook. Show the basic form of the animal and how the body parts join together. Suggest the movements of the animal. Do not worry about creating a finished drawing. Instead, concentrate on filling pages of your sketchbook with studies of one or more animals that you have observed from life. This activity will not only increase your understanding of animal forms and give you added practice in drawing, it will also get you into the habit of keeping and using a sketchbook, a valuable resource for any artist.

In these playful sketches, Leonardo used pen and ink over chalk to capture many characteristic positions of cats. Notice how he shows the correct body proportions based on his keen observation of the animal's bone and muscle structure. How does he use his imagination to transform the body of a cat into the form of a dragon?

Leonardo da Vinci, Studies of Cats and Dragons, c. 1513-14. Pen and ink and wash over black chalk, 10⅝ × 8¼". Royal Library, Windsor Castle. Reproduced by gracious permission of Her Majesty Queen Elizabeth II.

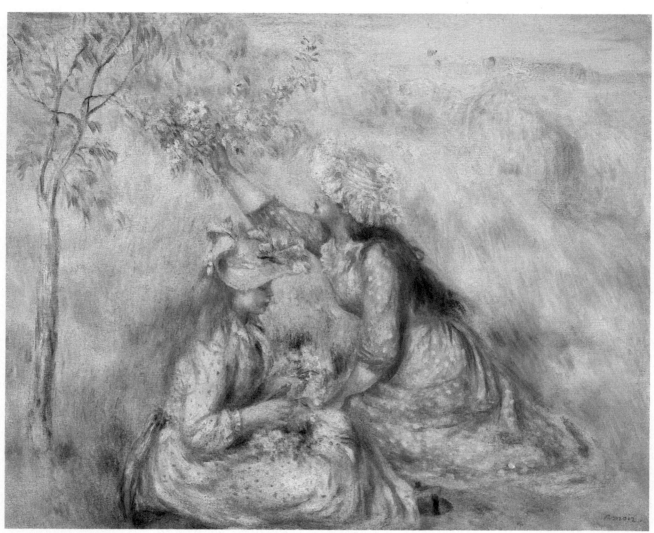

Pierre Auguste Renoir, Picking Flowers, *Oil on canvas, 25¾ x 32 in. Museum of Fine Arts, Boston. Juliana Cheney Edwards Collection. Bequest of Hannah M. Edwards in memory of her mother.*

Unit II

Color and Composition

In painting, one must search rather for suggestion than for description, as is done in music
Think of the highly important musical role which colour will play henceforth in modern painting.

Paul Gauguin

Just as musicians use musical notes and poets use words, artists use colors to communicate deep emotions, conjure forth striking images, and share their ideas and experiences with others. An artist orchestrates colors in an artwork not only to depict the subject matter effectively, but also to prompt certain responses from the viewer. Color can depict mood and action, rhythm and unrest. Brilliant colors may elicit joy, energy, or, sometimes, shock; dark shades may produce quieter, more serious moods; light tints may evoke a sense of peacefulness.

In this unit, you will experiment with color by using different **media** and painting techniques. Sometimes you will paint with dots, dabs, dribbles, and swirls of color. Other times, you will use fine, precise brushwork or broad, rapid strokes. As you paint, you will discover how to mix and combine colors to achieve dramatic contrasts, produce tints and shades, and express moods, messages, and feelings.

The following lessons will acquaint you with many famous painters and help you understand how they achieved certain effects in their artwork. You will observe and study a variety of painting styles, ranging from realistic to **abstract**. By experimenting with different media and techniques, you will increase your skills and gradually develop a painting style of your own.

21 A Study in Color

Observing and Thinking Creatively

Virtually every color you will ever need can be made from combinations of the three **primary colors**, red, yellow, and blue. They can be mixed in various ways to form all other colors except white. However, they themselves cannot be made from any other mixture of colors. Two primary colors can be combined to form a **secondary color**. The three secondary colors are orange (yellow + red), green (blue + yellow), and violet (blue + red).

The primary and secondary colors can be complements of one another. **Complementary colors** are color pairs defined as opposites because each color contains a **hue** that is missing in the other. Violet, for example, is the complement of yellow, because violet contains two of the primary colors, red and blue, but not the third one, yellow. Which secondary colors are the complements of red and blue?

If complementary colors are placed next to each other in a painting, they intensify each other and form bold, dramatic **contrasts**. Every color has its opposite, or complement. Learning about complementary colors will help you to know how to put colors together in pleasing, exciting combinations. In this lesson, you will see how the **repetition** of contrasting colors in a design can create dramatic effects.

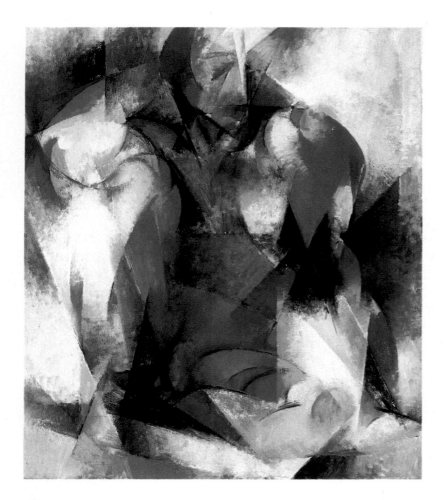

Angular planes of brilliant colors give a prismatic glow to this abstract human form. Can you identify the figure in the painting? Where do you see complementary colors placed together to create dramatic contrasts?

Stanton Macdonald-Wright, Synchromy in Green and Orange, *1916. Oil on canvas. Collection Walker Art Center, Minneapolis. Gift of the T. B. Walker Foundation.*

Chula Vista High School, Chula Vista, California

Chula Vista High School, Chula Vista, California

Instructions for Creating Art

1. Study Stanton Macdonald-Wright's painting, *Synchromy in Green and Orange*. This painting includes different combinations of repeated complementary colors to create a dramatic **abstract** composition.

2. Without copying the painting, use it for ideas on creating your own abstract design with geometric shapes. If you study the picture closely, you will see that a human figure, barely recognizable, is visible through the diamond-like shapes of the design. Try drawing the shape of an object, person, or animal you are very familiar with, then divide the parts of your drawing into smaller, interesting abstract shapes. Fill your paper with the drawing. Make sure that none of the shapes are so small that they would be difficult to paint.

3. Using **tempera** paints, mix bright complementary colors. Practice with the colors on a separate sheet of paper. Use the primary and secondary colors, but experiment with new mixtures, too. Make red-orange, blue-violet, and yellow-green. See how these colors look next to blue-green, yellow-orange, and red-violet. Which contrasts are most exciting?

4. Now that you have practiced mixing colors and have seen which colors look best together, plan your color scheme and paint your

design. The repetition of certain colors will help to achieve **unity** in your design. Do not outline the separate shapes; edges should be defined by the place where two colors meet.

5. When you have finished your painting, write or discuss what you have learned about mixing colors to create contrast, interest, and excitement. Note which color combinations you like best.

Art Materials	
Drawing paper	Paint brushes
Tempera paints	Mixing tray
Pencil and eraser	Water, paper towels

Strand D: Exploring Color

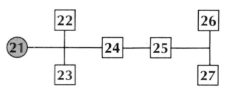

To evaluate your artwork, turn to the Learning Outcomes *section at the back of this book.*

51

22 *Colors, Tints, and Shades*

Observing and Thinking Creatively

A color can be defined by three basic characteristics: **hue**, **value**, and **intensity**. Hue refers to the name of a color, such as red, yellow, or green. Value means the lightness or darkness of a hue in relation to other hues. For example, bright yellow has a lighter value than bright blue. Value also tells about the different degrees of lightness or darkness in **tints** or **shades** of the same hue. Intensity refers to the brilliance of a hue. The intensity of pure red, for instance, is very bright, but mixing any other hue with red results in a duller intensity.

In this lesson, you will learn about value and intensity through a technique called **hard-edge painting**, a style of painting that became popular about twenty years ago. Advertising designers, as well as many painters, use this technique in their work. Hard-edge painting works especially well with geometric designs that have simple curves and straight lines. It is a good way of practicing how to paint up to lines but not over them. As you experiment with hard-edge painting, you will also learn how to make shades and tints, and use them to create patterns of **contrasting** colors.

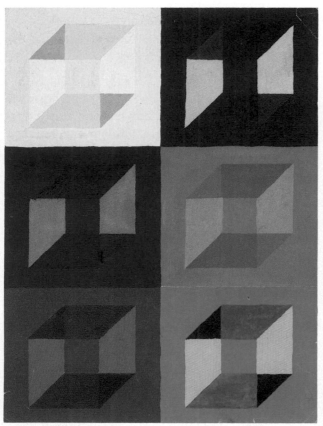

Madison High School. San Diego, California

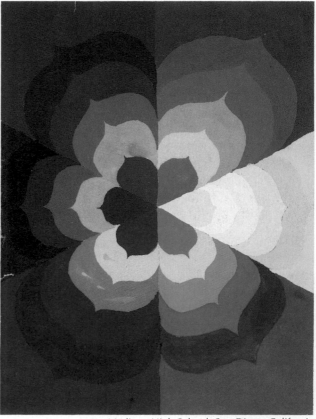

Madison High School. San Diego, California

52

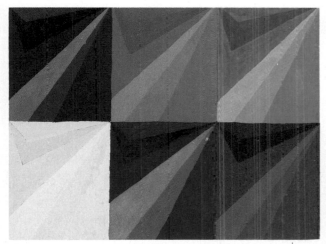

Madison High School, San Diego, California

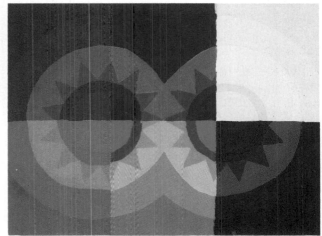

Madison High School. San Diego, California

Instructions for Creating Art

1. In this lesson, you will use the three **primary colors**, red, yellow, and blue, and the three **secondary colors**, green, violet, and orange. You will also need white and black paint. Use tempera paints for your design.

2. Divide your paper into six equal sections, three for the primary colors and three for the secondary colors. **Complementary colors** can be placed exactly opposite each other—red across from green, blue across from orange, and yellow across from violet.

3. Create an interesting design in each of the six sections of your paper, using geometric shapes. The design for each section should also have six parts. You could make the same design in each section, or create one large design that fills all six parts of the paper. Draw your design with pencil.

4. Now mix two tints, two shades, and one intensity of each of the six colors. A tint is made by adding white to a hue. The addition of black to a color produces a shade. To create a different intensity of a hue, add a small amount of its complementary color. Experiment with adding varying amounts of white, black, and a complementary color to each hue.

5. When you have made tints and shades that you like, paint each of the six sections of your paper with a hue, its tints and shades, and an intensity. Try to make a balanced, **unified** pattern, perhaps with lightest to darkest **values**. Paint up to the lines in your design. Study the examples to see how to do this.

6. When your design is finished, notice which colors stand out the most. Which colors are dullest? Write your observations on the back of your artwork.

Art Materials	
Drawing paper	Paint brushes
Tempera paints	Mixing tray
Pencil and eraser	Water, paper towels

Strand D: Exploring Color

To evaluate your artwork, turn to the Learning Outcomes *section at the back of this book.*

23 A Monochrome Painting

Observing and Thinking Creatively

You may have seen old photographs that consist of only brown tones. Perhaps you have also seen paintings that, like these old photographs, do not use a full range of colors but instead use light and dark **values** of a single **hue**. In such paintings, it seems that the artist is looking at the world through a pane of colored glass, shutting out all but one hue and its **tints** and **shades**. Such a painting, made with variations of a single color, is called a **monochrome**.

Great artists have successfully used monochrome painting in their work. Picasso, during what has been termed his Blue Period, produced many paintings done mostly in shades of blue. In this lesson, you will paint your own monochrome painting, using a color of your choice and its various tints and shades. Painting a monochrome picture will help you to see how painters show close objects in their paintings by adding black to a color, and distant objects by adding white. It will also help you to learn how to mix tints and shades and use different values of one hue effectively in the same painting.

Picasso established his first real artistic style at age 20, during his Blue Period. Paintings of this period focused on themes of loneliness and despair. Why do you think the people in the painting look so somber? What different aspects of the work express a sense of tragedy?

The Tragedy; *Pablo Picasso; National Gallery of Art, Washington; Chester Dale Collection 1962. Dated 1903; Wood; 41½ x 27⅛ in.*

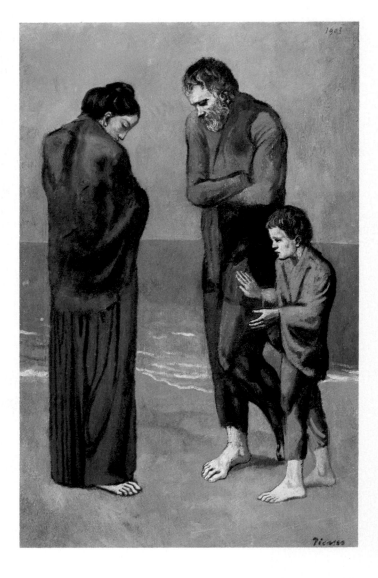

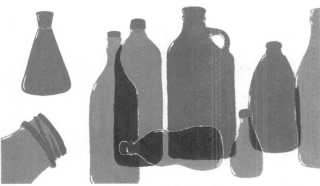

Chula Vista High School. San Diego, California

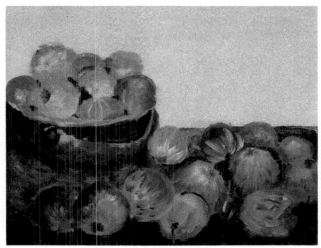

Gompers Secondary School. San Diego, California

Instructions for Creating Art

1. With a pencil, draw a picture featuring the subject of your choice. It can be a figure, **landscape, still life**, night scene, or whatever you want it to be. Fill the paper with your picture.

2. Choose the main color you want your picture to be. Think about which color would be most suitable for your painting. A night scene, for instance, might be best painted in values of blue. A city scene might work best in values of brown. Also think about which color would best show the feeling you want to express.

3. Mix various tints and shades of your color in your mixing tray. To make tints, add white to a color. Shades can be made by adding varying amounts of black to a hue.

4. Paint your picture with the tints and shades you have made. The closest parts of your picture will be the brightest. Distant parts are lighter, since colors fade as they get farther away. Adding more details to the objects in the **foreground** will also make them appear

closer. *Mount** or *mat** your finished monochrome painting, if you wish.

**For an explanation, turn to the* How to Do It *section at the back of this book.*

Art Materials	
Drawing paper	Brushes
Pencil and eraser	Mixing tray
Tempera paints	Water, paper towels

Strand D: Exploring Color

To evaluate your artwork, turn to the Learning Outcomes *section at the back of this book.*

55

24 Showing Distance with Color

Observing and Thinking Creatively

Have you ever viewed a hazy scene in which colors just seem to fade away into the distance? Perhaps you have seen a foggy city with ghostly buildings in the background, mist-covered mountains surrounding a lake, or boats far out in a harbor at dawn. In the distance, hills, trees, and other objects seem to turn a whitish-purple or blue-gray color due to the effects of dust, mist, and smoke in the atmosphere.

A painter must be aware of what happens to colors in the distance in order to show which objects in a picture are farthest away. Because a picture is flat and **two-dimensional,** the only way to show depth and distance is through techniques of **perspective. Linear perspective** is a method of using lines to show depth and distance as you learned in Lesson 16. Painters also rely on **atmospheric perspective,** a technique of using hazy colors in the background of a picture to show distant objects.

In this lesson, you will show atmospheric perspective in your artwork by using **tints** and **shades** of colors.

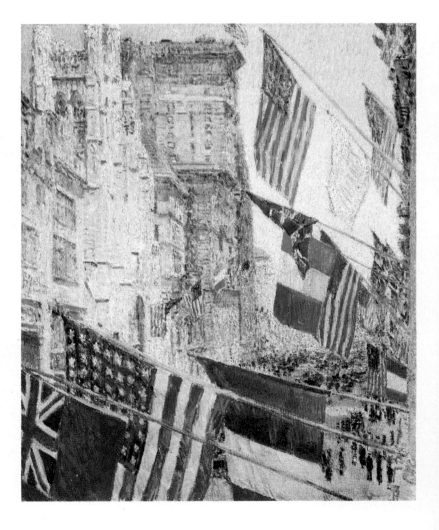

This design surrounds us with flags, drawing us into the celebration. Bold, bright flags in front heighten the misty fade-out of objects farther away. Colors on distant flags have been dulled: how do you think this was done? Note how this painting shows atmospheric perspective with an Impressionist influence.

Allies Day, May 1917; Childe Hassam; National Gallery of Art, Washington; Gift of Ethelyn McKinney in memory of her brother, Glenn Ford McKinney 1943.

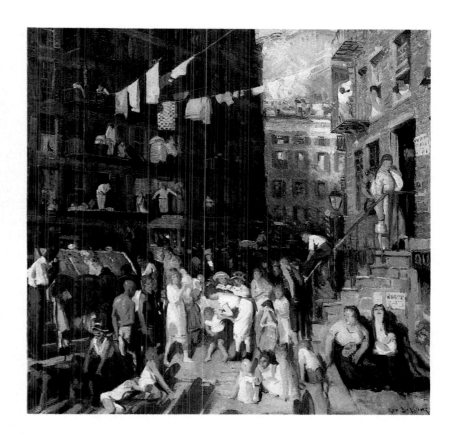

Depth is shown here by painting the closer people brightly to contrast with a hazier, less distinct background. What other techniques of perspective are used? What does the title *Cliff Dwellers* imply?

George Wesley Bellows, Cliff Dwellers, 1913, Oil on canvas. The Los Angeles County Museum of Art: Los Angeles County Funds.

Instructions for Creating Art

1. Make a preliminary sketch of a scene where objects seem to fade into the distance, such as a seacoast, desert forest or city street. In your sketch, show some objects in the **foreground** and others far away. Use size and **overlapping** to suggest depth and distance; nearer objects will be larger and will overlap objects that are farther away. To achieve a **balanced** design, place the **horizon line** so that it is above or below the center of the paper, not right in the middle.

2. When you are satisfied with your drawing, use an eraser to lighten the pencil lines in the **background** of your picture where objects appear to fade into the distance. Use **tempera** to paint your picture. Mix dull shades and hazy tints for background colors. Shades can be produced by adding a small amount of black or a **complementary color** to a hue. Make dull blue, for example, by adding a touch of orange. You can make tints by adding small amounts of white to a hue. Keep the paint thick and creamy as you work. As you start to paint closer to the foreground, your colors should become brighter.

3. Look at your picture. Add more details to the foreground if you wish. Is the background light and hazy, so that details of the objects cannot be seen? Do your colors get brighter as you move closer to the foreground? If so, you have successfully used atmospheric perspective in your painting.

Art Materials

Drawing paper	Mixing tray
Pencil and eraser	Water, paper towels
Tempera paints and brushes	

Strand D: Exploring Color

To evaluate your artwork, turn to the Learning Outcomes section at the back of this book.

25 *A Tempera Batik Landscape*

Observing and Thinking Creatively

Originally developed on the island of Java, **batik** is a method of applying designs to colored fabrics using dyes and wax. A design to be dyed is made on the fabric; those parts of the fabric that are not to be dyed are covered with wax, which will resist the dye. When the wax is removed, the dyed design stands out against the background of the cloth. The process may be repeated one or more times if more colored designs are to be added. Attractive broken lines,

like cracks or wrinkles, are often left in batik designs, caused by dye that penetrated breaks in the wax. These "cracks" give batik cloth its unique, distinctive appearance.

In this lesson, you will create a landscape picture that has many of the qualities of batik cloth, using a fun and fascinating technique known as **tempera batik**. You won't need wax, dyes, or even cloth, but the results you obtain will be as interesting and beautiful as any batik fabric.

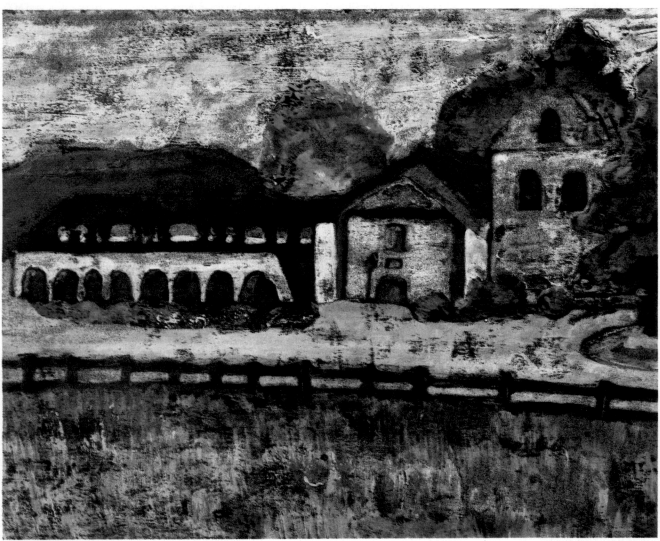

Rancho San Joaquin Middle School. Irvine, California

Instructions for Creating Art

1. On a piece of colored heavyweight construction paper (green, blue, or brown is best), make a **contour** line drawing of a landscape in pencil or chalk. Your landscape should have clearly defined shapes in the **foreground, middle ground,** and **background**. When you are satisfied with your composition, go over your pencil lines with a wide felt-tip black marker. These black outlines will make it easier for you to paint within the shapes.

2. Choose assorted **hues** of thick tempera paints. Light colors are best for tempera batik. Mix **tints** by adding small amounts of white to colors. Very dark colors won't work well, since the success of the batik depends on the contrast of colors against black.

 Put a few drops of white glue into each tempera color you have mixed and start to paint your picture without painting over the black lines. Choose your colors carefully; you can't make changes once the tempera has dried. Feel free to use more than one **value** of a color in different areas of your picture, such as the sky. Any area that is to remain black should not be painted. You must use three coats of paint for each area of your picture.

3. When the paint has completely dried, place your painting on a protective newspaper pad and completely coat the picture with black India ink, using a wide brush and gentle strokes. Don't brush too briskly or scrub the surface. Allow the ink to dry thoroughly for at least several hours.

4. Place the dry ink-coated painting on a flat board (masonite or plastic is best) and, holding it over a sink, run water over the picture. As the water runs, very gently loosen the ink surface with your hand; don't scrub. Keep rinsing and lightly rubbing until you are satisfied with the way the painting looks.

5. When your picture is completely dry, you may treat it with a coat of polymer to increase its brilliance and to protect it.

Art Materials

Pencil and eraser	Newspaper (to cover work area)
Chalk (optional)	
Heavyweight colored construction paper	Large, flat board
	Black India ink and wide, soft brush
Tempera paints and brushes	Water, paper towels
Mixing tray	Polymer or other protective coating (optional)
White glue	
Wide felt-tip black marker	

Strand D: Exploring Color

To evaluate your artwork, turn to the Learning Outcomes section at the back of this book.

26 Using Watercolor Paints

Observing and Thinking Creatively

Have you noticed that sometimes colors in nature seem to spill over into one another, blending and merging like pools of paint? The white clouds in the sky may be tinged with the pinks and lavenders of a setting sun. A wet city street at night may be floating with the reds, greens, and golds of reflecting headlights, traffic lights and neon signs. **Watercolor** paints are an excellent **medium** for capturing such scenes on paper.

Unlike tempera, watercolor paints are **transparent**, which means that they let light through and don't hide the surface on which they are painted. Watercolor works best when it is thinned with plenty of water and applied to damp white paper with quick, free brushstrokes. In watercolor painting, paper quality is very important, because whites and highlights in a picture are created by letting the white paper show through. Also important is the fact that, with transparent paints, light colors can't be painted over dark ones. The watercolor artist must apply the lightest **values** first, working up to the darkest ones.

In this lesson, you will experiment with watercolors to see how they blend and mix. Then you will use what you have learned to make a watercolor painting.

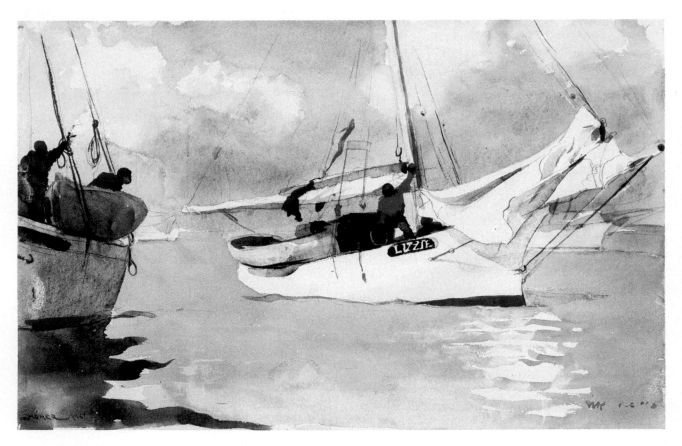

One of Homer's own favorites, this painting balances dazzling reflections of sunlight with dark shadows. We can see the white of the paper shining through, and the pencil lines beneath.
Winslow Homer, Fishing Boats, Key West, 1903, Watercolor on paper. The Metropolitan Museum of Art, Amelia B. Lazarus Fund, 1910.

This picture expresses Cézanne's idea that paintings reflect the sensations or impressions of the artist. Soft, transparent colors in this work give a light, airy feeling to the trees and bridge. Watercolor is a very good medium for this kind of Impressionistic painting.

Paul Cézanne, The Bridge of Trois-Sautets. Cincinnati Art Museum, Gift of John J. Emery.

Meridian Middle School. Indianapolis, Indiana

Instructions for Creating Art

1. Dampen your paper with clean water. Smooth it out and tape it down to a flat surface. Blot up excess water with dry paper towels, but do not rub the paper.

2. Use this paper to experiment with the paints to see the different effects you can achieve by mixing the colors. Try making a watercolor **wash**, blending several colors. Apply watery paint, using quick brushstrokes back and forth across your paper. Add more color only at the end of a brushstroke. Vary the values by using more or less color on your brush. Washes are most effective if they are painted fairly quickly. You may want to use more than one sheet of paper for your experiments.

3. Look at the experiments you have done. Do any of them give you an idea for a picture you could paint? Do the shapes remind you of flowers, animals, or buildings? Decide on a subject to paint. You may want to paint a **still life** picture, animals, people or a scene.

4. Dampen a clean sheet of paper and begin your watercolor painting. Apply your back-ground colors first. When they are dry, add objects and shapes to the middle ground, using lesser amounts of water and brighter colors. Finally, paint details in the **foreground** with thicker paint. Let the white paper show through to give the effect of highlights.

Art Materials	
Two sheets of white paper	Mixing tray
	Water, paper towels
Watercolor paints and brushes	Tape

Strand D: Exploring Color

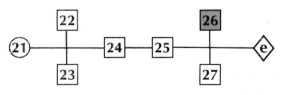

To evaluate your artwork, turn to the Learning Outcomes *section at the back of this book.*

27 Painting from Back to Front

Observing and Thinking Creatively

From a distance, hills, trees, and buildings seem to turn a whitish-purple or blue-gray color. This happens because dust, mist, or smoke changes the colors. Artists often show that things are far away by making their colors fade into the distance. This is a technique of showing depth and distance called **atmospheric perspective**. To make **opaque** colors appear to fade, an artist may mix white, purple, or blue-gray with a pure hue, or use small amounts of its **complementary color** to take away its brightness. An artist may also thin the opaque paint with water.

When thin, watery **transparent** paint is used, the color of the paper shows through the paint. The palest and softest colors are made with paint that has been thinned with a lot of water, while the darkest and brightest colors are made by using very little water and lots of paint. Instead of using white paint, a watercolor artist simply lets parts of the paper show through where white or highlights would be. Because light transparent colors can't be painted on top of dark ones, watercolor artists have to think very carefully about which color to paint next. They can paint dark **values** on top of light ones, but not the other way around. They must start with the lightest values and end with the darkest, making sure to leave unpainted areas for highlights.

In this lesson, you will learn how to show distance in a picture when you are painting with transparent watercolors.

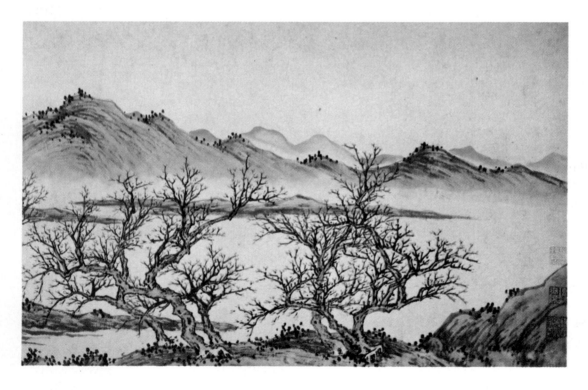

In this almost monochromatic painting by Chinese artist Shen Chou (1427-1509), distant hills have been rendered in soft, pale blue painted with a wet brush. Closer hills are shaded with a drier brush. How does the artist distinguish foreground objects from those in the background? Which parts were probably painted last?
Shen Chou (1427-1509), Peach Blossom Valley. *Trustees of the British Museum.*

62

Light skiers stand out against a dark background of the valley, where shades of blue and red are blended to create the illusion of distance.

Andrew Wyeth, American, b. 1917, From Mount Kearsarge, Watercolor on white paper, 44.55. Indianapolis Museum of Art, Gift of Mrs. James Fesler.

Instructions for Creating Art

1. Draw a picture of an outdoor place you have seen or one that you would like to visit. It could show hills and fields, a meadow, or a valley. This kind of picture is called a **landscape.** Sketch your scene very lightly, so your pencil lines won't show through the transparent paint. Leave out all the details. Show some objects close and some objects far away using **linear perspective.** Perspective can also be achieved by **overlapping** some objects on top of others. To achieve a **balanced** composition, the horizon line in your picture should be either above or below the middle of the paper, not right in the center.

2. Before starting your picture, practice making watercolor **washes.** Tape a sheet of watercolor paper onto a flat surface. To dampen the paper, brush it with water. Blot up any puddles with paper towels, but do not rub the surface of the paper. Using a brush filled with watery paint, start at the top of the paper, sweeping back and forth with long, rapid brushstrokes. If you need to dip your brush again, be sure to mix the watery paint in a mixing tray so that you don't accidentally make a streak of bright paint in the middle of your wash.

3. Try mixing a color with its complement to get a dull color that can be used to show distance. If you are painting a blue sky, for example, you can add a small amount of orange to your blue mixture to get a blue-gray that can be used to paint the sky near the horizon line.

Experiment by making several washes that could be used as the sky.

4. Using watery paint, begin painting the parts of your landscape that are farthest away. Mix your colors to achieve the feeling of distance by adding purple, blue-gray, or a color's complement. After the background colors dry, paint the parts in the middle ground. These colors should be brighter and contain less water. Finally, paint the objects in the **foreground,** using the brightest colors and thicker paint. Add details to the closest objects with a drier brush and very thick paint.

Art Materials	
White paper	Mixing tray
Pencil and eraser	Water, paper towels
Watercolor paints and brushes	Tape

Strand D: Exploring Color

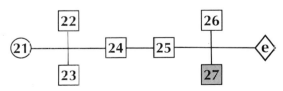

To evaluate your artwork, turn to the Learning Outcomes section at the back of this book.

28 Dry-Brush Painting

Observing and Thinking Creatively

A brush full of wet paint makes a wet-looking painting. Quite a different effect comes from a brush loaded with nearly dry paint, especially on dry paper. The brush even makes a dry, scratching sound as you paint. Painting with nearly dry paint on wet paper gives still another effect that is quite different from working on dry paper.

Dry-brush painting is very useful for creating interesting **textures** in pictures. The rough boards of a fence can be made with single strokes of a dry brush. Grasses can be added to the foreground with a swish. The shady under-foliage of trees can be made by dabbing a brushful of dry paint against the paper. Thin, light strokes, made with pale colors on a dry brush, will give a texture you can see through. This technique can be used for painting such things as curtains, or faint objects in the distance.

In this lesson, you will experiment with different dry-brush techniques and use them to paint a picture showing various textures.

Carefree festival scenes of French artist Raoul Dufy show the influence of Impressionism developed into his own style of simple, sketchy paintings alive with movement and color. In this painting of a horse farm, watercolor has been applied in many ways, from wet-on-wet, watery color to lines of nearly dry paint. Where do you see the driest brushstrokes?

Raoul Dufy, Le Haras du Pin, c. 1932, Watercolor. The Baltimore Museum of Art: Bequest of Saidie A. May. BMA 1951.295

The playful cat is emphasized against a large, empty background, and our eyes are led across the space by the line of string. Notice the variety in the brushstrokes. Can you tell which were made with the dry-brush technique?

Photograph from Daniel J. Boorstin's 2 volume set of The Sketchbook of Hiroshige, *Vol. 2, plate number 11.*

Canadian student art

Instructions for Creating Art

1. Fill one sheet of paper with experiments using nearly dry paint. Find out how many different effects you can create. Make some of your lines thin and others thick. Paint short, straight brushstrokes and long, flowing ones.

2. Decide on a subject that would lend itself to some of the kinds of brushstrokes from your dry-brush experiments. Your subject should include a variety of textures that are appropriate for this painting technique. The pictures in this lesson and throughout this book may give you some ideas of subjects to paint.

3. First, make a light sketch of your picture. Then paint it, using different kinds of dry brushstrokes. You may want to show detailed objects in the **foreground** and other parts in the distance. Some parts of the picture may be painted with wet paint, but most of it is to be done with nearly dry paint.

Art Materials

White paper (12″ × 18″ or larger)

Tempera or water-color paints

Brushes of different sizes

Mixing tray

Pencil and eraser

Newspaper (to cover work area)

Water, paper towels

Strand E: Painting Styles and Techniques

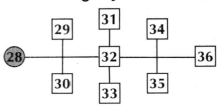

To evaluate your artwork, turn to the Learning Outcomes *section at the back of this book*

65

29 Shadows and Silhouettes

Observing and Thinking Creatively

Artists sometimes use shadows to create dramatic effects in their pictures. Shadows falling on parts of objects that are away from the light may show as darker, shaded areas on the objects themselves, or they may cast dark, interesting shapes on the ground. Shadows made on the ground by objects are called **cast shadows**.

Interesting shadows result when light shines from a place near the ground, such as a table lamp, campfire, or car headlights. A subject lit from beneath will have an eerie, ghostly quality. A slightly higher light source will create long cast shadows. Charles Burchfield used the winter sun

to light his picture, because it is low in the sky and casts dramatic shadows.

Sometimes, when objects appear in front of a strong light source, they show up as **silhouettes**. The dark outline shape of a silhouette often forms a striking contrast when set against a bright background. If you have ever taken a photograph of a subject with the sun in the background, you probably ended up with a silhouette, as in the photograph on page 67.

In this lesson, you will use shadows and silhouettes to compose a picture that shows strong contrasts of light and dark.

Overlapping shadows give unity and balance to this design. Where is the sunlight coming from, to cast these shadows? What colors were mixed to make their different tones of gray?
Charles Burchfield. Ice Glare. 1933. Watercolor. 30¾ x 24¾ inches. Collection of Whitney Museum of American Art. Purchase. Acq#33.64.

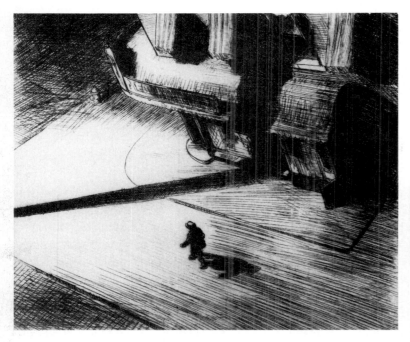

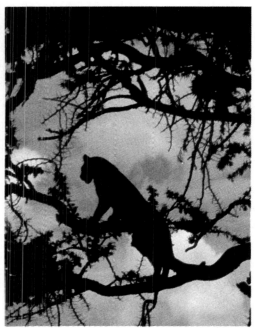

Where would you have to be to get the above view of a solitary man walking into the light of a street lamp? By extending the lines of the shadows off to an imaginary point on the left, you can determine where the light is coming from. Note that the angle of a shadow depends both on the location of the light source and the position of an object in relation to it.

Edward Hopper, Night Shadows, *1921, Etching. Collection of Whitney Museum of American Art, New York. Acq#31.691*

Instructions for Creating Art

1. Imagine you are looking toward a strong light source, such as an open doorway, a full moon, or the glare of a lightning flash.

2. Sketch the dimly lit scene you imagine. You might also arrange a scene by darkening a room and using a small reading lamp, a flashlight, or sunlight streaming in from a window to create shadows. Add people and objects to make the picture interesting or to tell a story. These shapes will all be dark against the strong light source. If the light source is very bright, they may appear as solid, dark shapes, or silhouettes. The shadows cast by these shapes will extend away from the light source. As you compose your picture, be sure to make the shapes of the shadows a part of your total design.

3. After you select your color scheme, darken the colors to be used for your shadows and silhouettes by adding a little black or a **complementary hue** to each color. Use these

shades to paint your picture, showing a striking contrast between the strong light and the silhouetted forms and their shadows.

Art Materials	
Drawing paper	Brushes
Pencil and eraser	Mixing tray
Tempera or water-color paints	Water, paper towels

Strand E: Painting Styles and Techniques

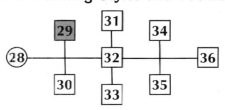

To evaluate your artwork, turn to the Learning Outcomes *section at the back of this book.*

67

30 *Showing Reflections*

Observing and Thinking Creatively

A mirror-image reflection on water can have the dramatic effect of doubling the beauty of a spectacular scene. Reflections on quiet water impart a sense of peacefulness to a painting or photograph. Blurred reflections on water lightly rippled by a faint, passing breeze convey a dreamy quality of unreality.

Observe the pictures in this lesson and notice how they show reflections on water. In the reproduction of *Maligne Lake, Jasper Park,* the artist has used bold lines, shapes, and colors to depict the peaceful tranquillity of majestic mountains.

The reflection forms an integral part of the abstract design of the composition. The photograph of balloons dramatically rising above a lake shows how reflections can create **symmetry** and **balance** in a picture. Properly handled, reflections can add interest to a picture and become an important part of the total composition. They can also add greatly to the overall mood created by the picture.

In this lesson, you will paint reflections to achieve one of these effects in your own artwork.

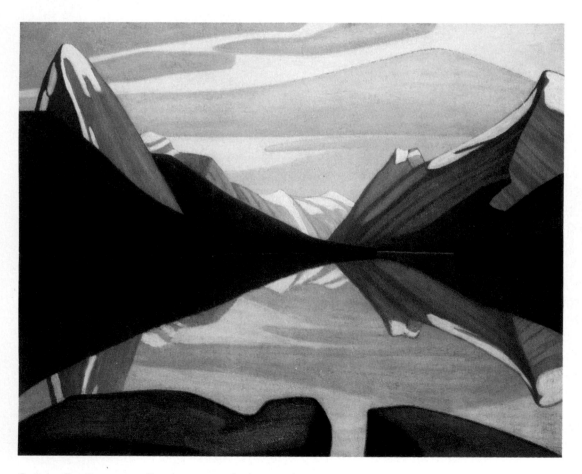

Quiet reflections on still water magnify the timeless majesty of the mountains and cold serenity of the sky in Lawren Harris's stylized painting of the northern Canadian wilderness.

Lawren S. Harris, Canadian, Maligne Lake, Jasper Park, 1924, Oil on canvas.
National Gallery of Canada, Ottawa.

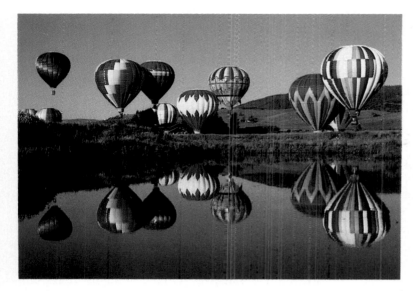

Instructions for Creating Art

1. Imagine you are looking across a river or a small lake. It is a sunny, still day, and you are impressed with the view of majestic mountains, graceful trees, or stately buildings rising from the water's edge on the opposite shore. Think of one word to describe the feeling of this scene reflected on the water.

2. Lightly sketch your view so that the **horizon line** is either above or below the halfway point on your paper, but not in the middle. Draw in the outlines of the main shapes on the top part of the paper. Use principles of good design—**balance, contrast, emphasis, pattern, rhythm**, and **unity**. Keep in mind that the reflected shapes will make up the lower part of your design.

3. Draw your shoreline and a faint outline of the reflections, extending vertically across the water towards you. The reflections will usually be fainter than the real objects.

4. Select a color scheme and paint your picture. Paint the larger objects first, using thick paint. When these are dry, add details with even thicker paint and a smaller brush. For your reflections, use the same colors as the real objects, but dull the **intensity** of each color in the reflected objects by adding more water and a small amount of a complementary color. To show ripples in the water, paint a few thin horizontal lines in white or a lighter color than you have used for the water.

5. Sign your work, and use the single word you thought of in Step 1 as its title.

Art Materials

Drawing paper	Mixing tray
Pencil and eraser	Newspaper (to cover work area)
Tempera or water-color paints and brushes	Water, paper towels

Strand E: Painting Styles and Techniques

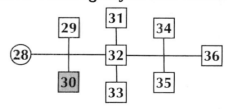

To evaluate your artwork, turn to the Learning Outcomes *section at the back of this book.*

31 *Oriental Art Styles*

Observing and Thinking Creatively

Oriental artwork reveals an admiration for nature and mankind. To Oriental artists, art is an expression of the spirit residing in every form. In order to capture the life force in the subjects they paint, Oriental artists often observe and concentrate on their subjects for a long period of time and then render the art from memory. Because they perceive nature as emptiness and form, their designs show use of spaces and simple, bold shapes. The fine brushwork in Oriental paintings is also considered an essential part of the overall design. A variety of brushstrokes is often used to indicate the main shapes and forms of a remembered experience, rather than every detail the eye might see. Bold, simple shapes and forms delicately balanced with intricate details and eye-catching designs are characteristic of most Oriental art. See if you can identify these qualities in the artwork of Oriental artists shown here. Then you will have an opportunity to paint a picture using a similar style and technique.

The human spirit exists in fine harmony and balance with the elements of nature, according to Oriental beliefs, and this is a frequent theme in Japanese art. These paintings were intended to be carefully studied to appreciate their subtle color and grace. How do you see these ideas expressed in the work above? Where is the path of vision in *Moonlit Night?*

Ando Hiroshige (1797-1858), Moonlit Night. *Trustees of the British Museum.*

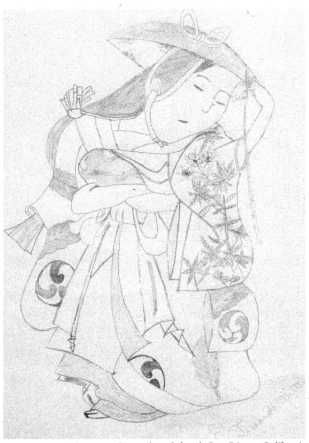

Instructions for Creating Art

1. Look at the pictures shown here. Also study Chinese and Japanese pictures throughout this book and in other art books. Chinese painting shows carefully executed lines and dabs made with a soft brush. The colors are usually soft and grayish. Japanese prints usually have large, colorful spaces with interesting black outlines.

2. Draw a scene or a figure similar to an Oriental painting. It could have distant mountains outlined in black and be filled in with soft colors. You might want to paint a bold, simple line drawing of a figure in the Oriental style.

 Oriental artists are masters of design, so whatever you do, design your picture carefully. Keep it light and airy with lots of movement and well-planned spacing.

3. Before you start painting colors, you may wish to go over your pencil lines with India ink. The ink will give you exact outlines to fill in with color. Use very soft tones of watercolor paint to fill in the picture.

4. In order to display your artwork, you may wish to *mount** your painting on fine paper, a reed mat, or on cloth which can be hung from a rod to make an attractive wall hanging.

For an explanation, turn to the How to Do It section at the back of this book.

Art Materials

Art books showing Oriental art	Soft brush with pointed tip and a broad, soft brush
Drawing paper	
Pencil and eraser	Mixing tray
Watercolor paint	Water, paper towels
India ink and pen (optional)	Materials for mounting artwork

Strand E: Painting Styles and Techniques

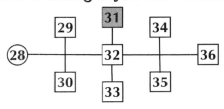

To evaluate your artwork, turn to the Learning Outcomes section at the back of this book.

32 The Renaissance

Observing and Thinking Creatively

The **Renaissance** began in Italy in 1300 and lasted for 300 years. During this time, many artistic ideas from ancient Greece and Rome were revived. In this period of "rebirth," some exciting changes took place in art. Artists began to make their work look more realistic. Sculptors carved statues that showed realistic details. Painters experimented with contrasts of light and dark and became aware of how forms are defined by light shining on them. They started to portray people in more lifelike ways, and began to pay attention not just to people's physical individuality but to their expressions of emotion as well, in a way that earlier artists had not done.

Their paintings and drawings took on a new realism. Artists began to study human anatomy in order to depict correct body **proportions**. Methods of **linear perspective** also came into use.

Even the **architecture** of buildings changed. Homes were designed to fit the practical needs of people, and showed more use of decoration and artistic design. It also became customary to show works of art on walls and pillars, adding interest and beauty to man-made environments.

In this lesson, you will observe the art of Renaissance painters and draw a draped garment, showing a contrast of light and dark areas.

Sharp contrasts of light and shadow add emotional intensity to a Biblical scene. Notice the deliberate distortion of the figures and the unusual arrangement of background details.

El Greco (1541-1614), Agony in the Garden. *Reproduced by courtesy of the Trustees, The National Gallery, London.*

72

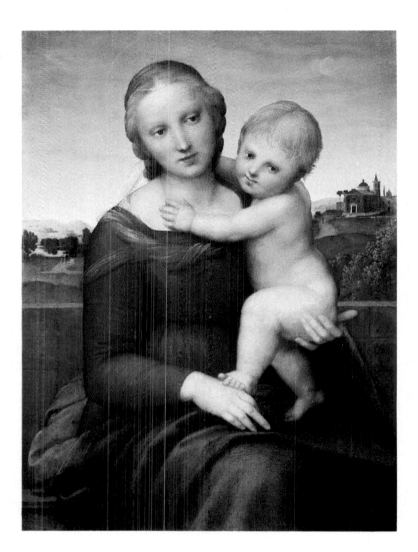

The background of this Renaissance painting is as detailed as the mother and child. Artists of the period often included backgrounds relating to the main subject. Notice the texture of the hair and fabric. Raphael contrasts rough textures with smooth flesh, and dark fabric and landscape with light skin and sky.

The Small Cowper Madonna; Raphael; c. 1505; Wood; 23⅜ x 17⅜ in.; National Gallery of Art, Washington; Widener Collection 1942.

Instructions for Creating Art

1. Study the paintings by Renaissance artists shown in this lesson. Note in particular how the faces are highlighted. Now study the garments. See how the folds catch the light. Notice how important the shadows are in modeling the curves of the material, and also in showing the **contours** of the faces.

2. Drape a garment, such as a robe, shawl, or piece of flowing material over a chair. Shine a light on the garment so that the folds are highlighted, showing light and dark areas. Lightly sketch the form of the draped garment, closely observing the curves and shapes of the folds. Lightly shade the interior folds with your pencil to indicate darker areas.

3. Use tempera paints to complete your study of the drapery. Mix various **tints** and **shades** to paint both the light and dark folds of the garment. (See Lesson 22 for more information on mixing tints and shades.) Use darker shades for shadowed areas and lighter tints for highlights.

Art Materials

Two sheets of draw-ing paper	Paints and brushes
Soft pencil and eraser	Water, paper towels
	Mixing tray

Strand E: Painting Styles and Techniques

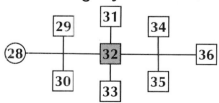

To evaluate your artwork, turn to the Learning Outcomes section at the back of this book.

33 *Great Mexican Artists*

Observing and Thinking Creatively

After the Mexican Revolution of 1910, many Mexican artists portrayed the story of what had happened by painting large **murals** on the walls of buildings. They also painted smaller pictures to hang on walls. Four of the most important of these Mexican artists were José Orozco, Rufino Tamayo, David Siqueiros, and Diego Rivera. Much of their art depicts social themes concerning the history, daily life, work, and struggles of the Mexican people.

These artists often used bold, simple shapes and large, dramatic figures to convey their message or **theme**. While parts of their pictures are realistic, some parts have been changed through **distortion**, as you can see in these examples.

This lesson will give you an opportunity to use Mexican art styles to create a picture or a mural. Before you begin, think about a social theme you would like to depict in your artwork, as Mexican artists have done.

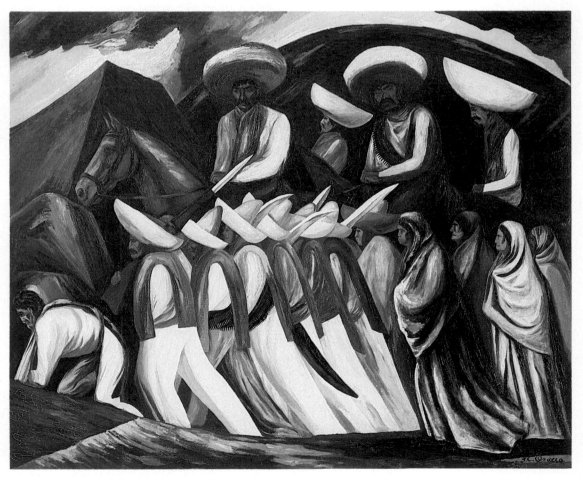

Repeating parallels emphasize the direction and movement of this group of peasant soldiers marching under the watchful eyes of their leaders. Orozco was Diego Rivera's pupil and assistant for years, and was commissioned to do many murals in the U.S.

José Clemente Orozco, Zapatistas, 1931, Oil on canvas, 45 x 55". Collection, The Museum of Modern Art, New York. Given anonymously.

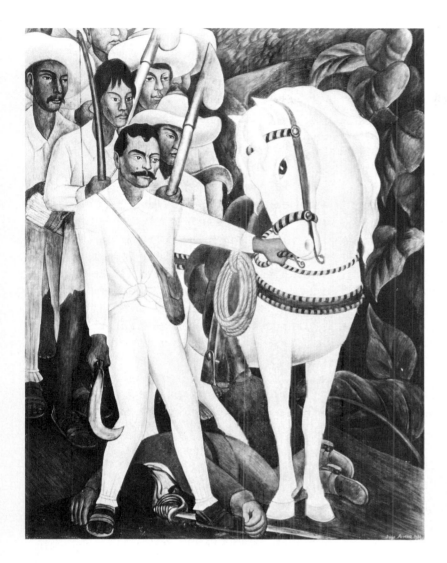

This Diego Rivera painting represents his interpretation of a dramatic event in the life of a political figure.

Diego Rivera, Agrarian Leader Zapata, 1931. Fresco, 7'9¾" x 6'2". Collection, The Museum of Modern Art, New York. Abby Aldrich Rockefeller Fund.

Instructions for Creating Art

1. Study the artwork of the Mexican artists in this lesson. Think of a subject for a picture of your own that is composed of large, simple shapes. The shapes can be distorted, or they may be more realistic. If you wish, make your picture full of action or depict a scene that conveys a message.

2. You may want to work with a friend or a few classmates to make a mural in the Mexican style. Use whatever paper is available that comes in large rolls. Work on the floor if you have to. Plan together where the figures will go. They must be huge to fill the paper. Show lots of action with repeated curves or diagonals. Be sure that all your figures go together in a **unified** design.

3. Paint your picture or mural with a color scheme that is bold and daring. Use bright highlights and deep shadows.

4. Find a wall space to display your work.

Art Materials

Drawing paper or mural paper	Mixing tray
Pencil and eraser	Water, paper towels
Paints and brushes	

Strand E: Painting Styles and Techniques

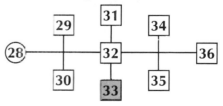

To evaluate your artwork, turn to the Learning Outcomes section at the back of this book.

75

34 *American Painters*

Observing and Thinking Creatively

During the twentieth century, many American artists developed innovative and creative styles of painting. Edward Hopper, Stuart Davis, and Georgia O'Keeffe—the three painters whose artwork is shown here—are all important American artists with unique styles vastly different from one another.

Edward Hopper painted pictures of everyday places. Everything about his pictures is quiet and peaceful, as though he has brought time to a halt. Stuart Davis's pictures are usually composed of bright and cheerful **abstract** shapes. Inspired by various aspects of American popular culture, his paintings are full of action and show

a sense of humor. Georgia O'Keeffe found much of her inspiration in the desert environment of the Southwest. She painted large, simplified shapes, such as cow skulls, flowers, and arid landscapes. The use of hard edges and large expanses of one or two dominant colors is characteristic of her style.

You may want to look through additional art books that show works of various modern American artists. You can often learn how to improve your own artwork and expand your ideas by studying what other artists have done.

The artists discussed in this lesson all work in very individual ways. So should you.

Many of Georgia O'Keeffe's compositions are characterized by large, simple shapes from nature, often shown close up and painted in one or two dominant colors. How do these qualities combine to make this painting a successful design?

Georgia O'Keeffe, Pink Shell with Seaweed, c. 1938, Pastel, 22" × 28". Gift of Mrs. Norton Walbridge, © 1980 San Diego Museum of Art.

Commonplace city scenes and ordinary-looking people illustrate Edward Hopper's recurring themes of loneliness and alienation. Though people are present in this scene, no sense of human warmth and feeling permeates the surrounding buildings and concrete. The eerie light against the dark night and deserted street emphasizes this moment of isolation.

Edward Hopper, Nighthawks, 1942, Oil on canvas, 30" × 60". Collection Friends of American Art. Courtesy of The Art Institute of Chicago.

Stuart Davis developed a unique abstract style which reflected his interest in jazz. His bright colors and innovative shapes remind us of musical patterns.

Stuart Davis, Swing Landscape, 1938, Oil on canvas. Indiana University Art Museum. 42.1

Instructions for Creating Art

1. Look carefully at the pictures by Hopper, Davis, and O'Keeffe that are shown in this lesson. Look through the book for art by other American artists. Think about how you could use the ideas and styles of these artists to make a picture of your own.

2. Paint a picture that is inspired by some of the ideas you have seen in the work of these American artists, but in a style that is uniquely your own. Design your picture so that it is well proportioned, with shapes that harmonize or, if you prefer, shapes that clash. Select a color scheme that fits your style—soft and light, bold and splashy, or something in between.

3. Discuss in class how your own individual style is developing. Write a paragraph telling how your art style is a statement of who you are.

Art Materials

White paper	Pencil and eraser
Paints and brushes	Water, paper towels
Mixing tray	

Strand E: Painting Styles and Techniques

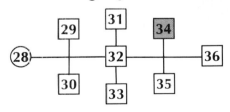

To evaluate your artwork, turn to the Learning Outcomes section at the back of this book.

35 Picturing a Part of America

Observing and Thinking Creatively

From the ghostly swamps and bayous of the South, to the tropical jungles and cascading waterfalls of Hawaii, to the wave-washed, rocky New England coastline, to the lofty peaks of the Rocky Mountains, America is a land with an endless variety of natural wonders. Many famous artists have discovered its diverse landscapes and portrayed them in their art.

Grant Wood painted the rounded hills and trees of the farming country in the Midwest, as you can see in his picture, *Stone City, Iowa.* The countryside that Peter Hurd painted shows one of the great distance views that are characteristic of the Southwest. The giant mountains and deep valleys of Montana painted by the Austrian artist, Oskar Kokoschka, contrast with both of the other landscapes to show yet another very different part of America.

This lesson will give you a chance to recreate a part of America that is special to you.

Expressionists like Austrian Oskar Kokoschka developed a highly personal interpretation of reality. Notice how Kokoschka used light and color to emphasize objects and surfaces in his panoramic *Montana Landscape.*

Oskar Kokoschka, Montana Landscape. *Zurich: Kunsthaus. Giraudon/Art Resource PBC 2750.*

Regionalist Grant Wood arranged simplified shapes to draw us directly into the scene while emphasizing the gently rolling, carefully tended Iowa farmland. How are light and dark areas balanced?

Grant Wood, Stone City, Iowa, 1930, Oil on wood. Joslyn Art Museum, Omaha, Nebraska.

What is beyond the gate? How is the impact of the title strengthened by the country road extending straight out to the vanishing point, and by the subtle colors? Where do you think this is?

Peter Hurd, The Gate and Beyond, 1952, Egg tempera, 47 x 90". Permanent Collection, Roswell Museum and Art Center.

Instructions for Creating Art

1. Decide on a picture to paint that shows a part of America you know something about. The best choice will be a place you have actually visited and can remember. If that is not possible, then try and remember what you have seen in photographs and films. Another way is to think about an interesting place near where you live and make a picture of it.

2. Plan and draw your picture, paying close attention to careful design. Balance large, light areas with small, bright spaces. In a landscape, your eye naturally travels around the picture. It enters along the bottom edge and follows a **path of vision** which usually swings to the left side, then across the top, down the other side, and around, coming to rest at the **center of interest**. Knowing this, artists take care to bring the eye back into a picture with a line that balances any line or shape that leads out. They place clouds or shadows at the corners to turn the path of vision. They add birds or people moving into the picture, not going out of it.

 Whenever you do a painting or design, use this path of vision principle to unify your work.

3. Paint your picture, using a color scheme that is suited to the place you have chosen. Give your picture a title to let people know what part of the country you are showing.

4. Be ready to give a guided tour for your viewers' path of vision around your picture.

Art Materials	
Drawing paper	Mixing tray
Pencil and eraser	Water, paper towels
Paints and brushes	

Strand E: Painting Styles and Techniques

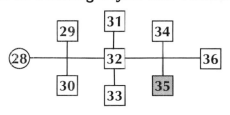

To evaluate your artwork, turn to the Learning Outcomes section at the back of this book.

36 The Fathers of Modern Art

Observing and Thinking Creatively

Art **styles** sometimes continue unchanged for hundreds of years; then something happens. A few artists begin to work in ways that are very different. Gradually, the art style of the whole period begins to reflect these changes. Three artists who introduced new styles to the world of art in the nineteenth century were Vincent van Gogh, Paul Gauguin, and Paul Cézanne. Each one of them developed a unique style. They followed the practices of **Impressionist** painters before them, observing nature directly as they painted to capture the brilliance of shimmering sunlight. Rather than mixing colors, they painted with separate strokes or dabs of pure color. However, because these artists expanded on the techniques of Impressionist painters, they became known as **Postimpressionists**.

Van Gogh painted his best pictures in the sunny south of France, using short brushstrokes and thick, bright colors. His paintings express his feelings about the subjects he painted. Notice his use of bold, dramatic **hues** and the rhythmic movement of his brushwork in the reproductions of his artwork shown in this lesson. Cézanne also worked in the south of France. The objects in his pictures seem to be made of solid planes of color; his hues are soft and quiet. Gauguin went to the tropical Pacific island of Tahiti and painted hot, brightly colored landscapes with beautiful, brown-skinned people.

In this lesson, you will find out more about these artists by studying their artwork and then making a picture of your own in the style of your favorite Postimpressionist.

Gauguin's search for innocence and simplicity in people took him to the Pacific islands of Tahiti. There he painted idealized, romanticized tropical scenes with sharply defined contours, flat forms, and brilliant, rich colors.

Paul Gauguin (1848-1903), Tahitian Landscape, *Oil on canvas. The Minneapolis Institute of Arts, Julius C. Eliel Memorial Fund.*

Thick paint, lively brushstrokes, and vivid colors easily identify van Gogh's style and create an exciting scene that seems alive with movement. Radiating sunlight fills the sky and is reflected in the bright grass. How does the dynamic, vibrant quality of the colors and brushstrokes reflect the artist's feelings?

Vincent van Gogh, Olive Trees, 1889. The Minneapolis Institute of Arts.

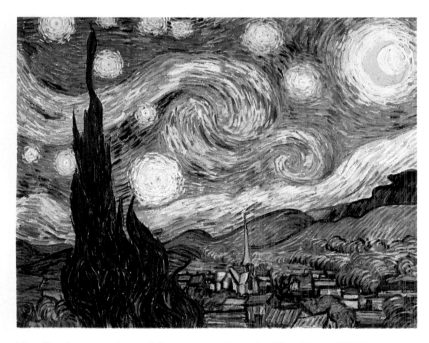

Van Gogh created a swirling atmosphere in *The Starry Night,* largely an expression of his own inner turmoil. Notice how the contrasting colors and forceful lines suggest a feeling of unrest.

Vincent van Gogh, The Starry Night (1889). Oil on canvas, 29 × 36¼".
Collection, The Museum of Modern Art, New York. Acquired through the Lillie P.
Bliss Bequest.

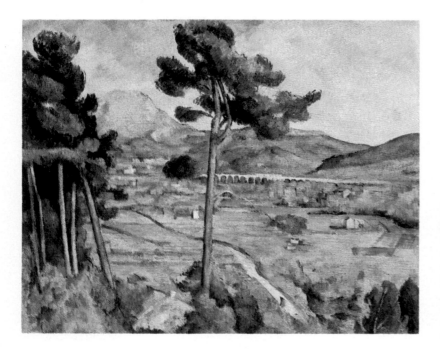

Postimpressionist Paul Cézanne was primarily concerned with the artful composition of his pictures, and he emphasized form over detail. How would you describe Cézanne's style, based on this work?

Paul Cézanne, Mont Sainte-Victoire. Oil on canvas. The Metropolitan Museum of Art, Bequest of Mrs. H.O. Havemeyer, 1929. The H.O. Havemeyer Collection. (29.100.64)

Instructions for Creating Art

1. Look at the pictures in this lesson painted by van Gogh, Gauguin, and Cézanne. Also look at other pictures by these artists in this book and in other art books. Note the brushstrokes they used. Artists before the Impressionists blended their colors so smoothly that you could rarely see the brushstrokes. The Impressionists discovered they could get the shimmer of outdoor sunlight if they did not mix their colors, but used streaks, dabs, or dots of pure color, letting the eye do the mixing instead. The Postimpressionists, whose artwork you see reproduced here, expanded on the techniques of the Impressionist painters and brought feeling and form to their work.

2. Cézanne's paintings are masterpieces of solid mountains, buildings, and forms. He used flat planes of color to get this solid feeling, even when he was painting rolling hills or round objects. Try creating a mountain by using flat strokes of the brush, even for the curves, and you will be painting as Cézanne would.

 Notice the rhythmic brushwork and flowing lines that Vincent van Gogh used. Both the sky and the ground seem to shimmer and move, weaving lines of pure color that undulate in waves across the picture.

 Gauguin used warm colors and native figures in his tropical paintings. The shapes in these paintings almost look like cutout designs against flat areas of pure color.

3. Paint a scene that incorporates some of the techniques of the Postimpressionist artists. You can apply paint using flat strokes of the brush to create solid planes of pure color. If you prefer a more expressive style, use bold, contrasting colors and rhythmic brushstrokes to show movement. Try applying your paint with dabs and strokes of pure color.

Art Materials

Drawing paper	Mixing tray
Pencil and eraser	Water, paper towels
Paints and brushes	

Strand E: Painting Styles and Techniques

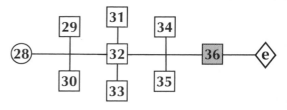

To evaluate your artwork, turn to the Learning Outcomes section at the back of this book.

Exploring Art

Discovering a Painter's Style

In Lesson 36, you studied the paintings of three fathers of modern art, and made your own painting in the style of the artist you liked best. For this activity, you may choose the same painter, or any other painter you like, and explore the elements of his or her style. Then write a composition about that artist's work. Observe the paintings of various artists throughout this book and in other art books before you decide on an artist to write about. If there is an art museum in your city, you may want to visit it to see works of art firsthand before deciding on an artist to study and write about.

In your paper, include a short biography of the artist and tell what art period his or her works represent. Concentrate on a description and analysis of the artist's style, and discuss the techniques he or she used to achieve that style: dramatic use of color, rhythm of line, distortion of shapes, contrast of light and dark, etc. Why do these techniques appeal to you? How could you apply them in your own artwork? Discuss several of the artist's paintings that you particularly like. Conclude your paper with a discussion of what you consider to be the single work of art that best expresses the artist's style.

As the subject of your paper, you may write about one of the following master painters or one whose work you especially admire.

Henri Matisse	Pablo Picasso
Leonardo da Vinci	Mary Cassatt
El Greco	Stuart Davis
Rembrandt van Rijn	Salvador Dali
Michelangelo	Paul Klee
Claude Monet	Marc Chagall
Georgia O'Keeffe	Andrew Wyeth
James McNeil Whistler	Roy Lichtenstein
Pierre Auguste Renoir	Henri Rousseau
Joseph M.W. Turner	Winslow Homer
John Singer Sargent	Edgar Degas

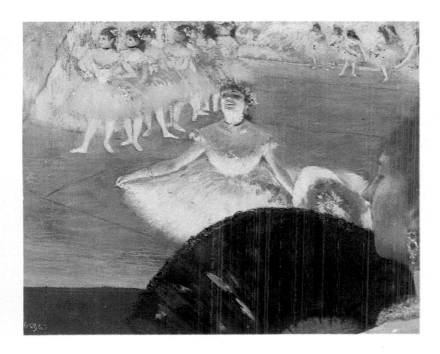

Degas described his own painting style as "bewitching the truth." His paintings were carefully composed in his studio from sketches and photographs made on the scene. This pastel is applied very heavily to make the figures sparkle as if they are in the spotlight.

Edgar Degas, Danseuse au Bouquet, Drawing—pastel over monotype. Museum of Art, Rhode Island School of Design; Gift of Mrs. Murray S. Danforth.

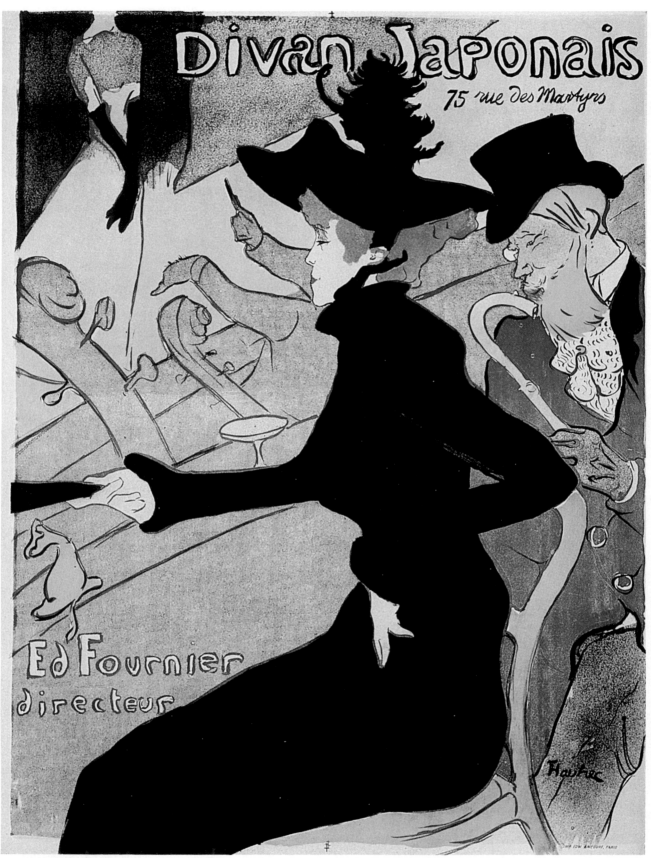

Henri de Toulouse-Lautrec, Divan Japonais, 1892, Color lithograph, 31⅝ ×
23⅞''. Collection, The Museum of Modern Art, New York. Mrs. John D.
Rockefeller Jr. Purchase Fund.

Unit III

Design, Media, and Technique

Good material often stands idle for want of an artist.

Seneca

When you think of types of art, you probably think first of painting, drawing, or sculpture. But there are many other equally expressive art forms, from collage and calligraphy to weaving and stitchery. Used by themselves or as parts of other art forms, these various **media** and techniques will help you to expand your own range of artistic skills. By experimenting with different kinds of art, you will learn to choose the best medium for the expression of your creative ideas.

In this section, you will create original artworks using media and techniques you may not have encountered before. You can make "drawings" by cutting out pieces of colored paper in the style of the great artist Matisse, or "paint" geometric designs on cardboard with stitchery. You can make beautiful prints with linoleum blocks, or be creative with inexpensive beads. Photographs from magazines are useful for making collages, but they can also be cut apart and rearranged to form intriguing distorted pictures. If you have never tried weaving or macramé, you may be surprised to find that these craft forms also allow for a broad range of artistic expression.

The lessons in this section expand on skills you have already learned and introduce you to new ways of thinking about the various choices available to you when you want to express yourself creatively. They will help you to see the vast potential in every kind of material—from linoleum blocks to torn pieces of fabric—and show you how to turn them into unique artistic creations.

37 Drawing with Scissors

Observing and Thinking Creatively

The founder of modern cutout art was Henri Matisse, a Frenchman who lived from 1869 to 1954. Bright, bold colors, interesting patterns, and rhythmic lines are characteristic of his designs. He created **cutouts**, paintings, stained glass windows, architecture, tapestries, book illustrations, and block prints. Although Matisse was successful in using a variety of different art **media**, he is perhaps best known for his vibrant, lively cutouts.

When he was old and could no longer paint because of his failing health, Matisse turned to what he called "drawing with scissors." He often cut a variety of colored paper shapes by trial and error, changing the cutouts and their arrange-

ment as he worked. Sometimes he made figures, but more often he created **abstract** designs that suggested the forms of leaves, fruit, birds, and flowers. In his later years, he was confined to a wheelchair, but continued his artistic creations by showing his secretary-housekeeper where to place and paste the cutouts to form his designs. As an artist, Matisse was extremely hardworking, and created an abundance of artwork up until the time of his death at the age of 85.

Matisse's artwork often reflects a serene, light-hearted feeling, and many pictures show great variety, brilliance of color, and sense of fantasy. In this lesson, you will use some of Matisse's ideas to create your own cutout **collage**.

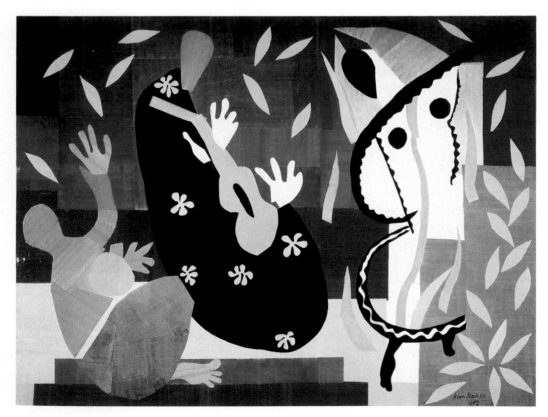

Matisse considered this cutout, created at age 83, equal to the best of his paintings. What do you see in this image to suggest the meaning of its title, *The Sorrow of the King?*

Henri Matisse, La Tristesse du Roi, 1952, Photographie Musée National D'Art Moderne, Centre Georges Pompidou, Paris. All rights reserved.

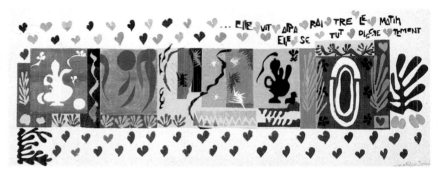

Matisse used cut-paper shapes to suggest rather than realistically depict subjects. Here, intense colors and bold, abstract patterns portray scenes from the tales of Scheherazade.

Henri Matisse, The Thousand and One Nights, 1950. Gouache on cut and pasted paper. Museum of Art, Carnegie Institute, Pittsburgh; Acquired through the generosity of the Sarah Mellon Scaife Family, 1971.

Instructions for Creating Art

1. Decide on a subject for your cutout. You might like to make a picture of birds, plants, or people, or create an **abstract** design. You may prefer to depict a lively scene such as a tropical jungle or the sea. The titles of some of Matisse's works indicate subjects he chose: *Jazz, The Beasts of the Sea,* and *Lagoon.*

2. When you have an idea for your picture, select a color scheme that fits your subject. **Cool colors**—blues, greens, and violets—might be used to suggest serenity or peacefulness. **Warm colors**, such as red, yellow, and orange, suggest sunlight and joyfulness. **Complementary colors**—colors that are opposite each other on the color wheel—add brilliance and contrast to a picture.

3. Using colored paper, begin cutting out shapes and colors that represent the subject you chose. Make your cutouts reflect the **rhythm** and **movement** of your subject. Does your picture call for sharp, straight lines, or soft, flowing curves? Keep in mind that your cutouts do not need to look **realistic**, but can represent your subject in an **abstract** manner.

4. When you have cut out several shapes, begin arranging them on a large sheet of paper. To create a **center of interest**, emphasize one area of your picture by using brighter colors, more detailed designs, or interesting shapes. Overlapping shapes and repeating certain colors also contribute to an effective design. When you are pleased with your arrangement, glue the cutouts to the paper. Then add your name and give your cutout **collage** a descriptive title, as Matisse did.

Art Materials

Brightly colored paper	White drawing paper
Scissors	Newspaper (to cover work area)
White glue	

Strand F: Designing with Different Media

To evaluate your artwork, turn to the Learning Outcomes *section at the back of this book.*

38 *Mixed Media Collage*

Observing and Thinking Creatively

The fun of creating **collages** is that there are unlimited possibilities for the different kinds of materials you can use, including colored construction paper, wallpaper, cloth remnants, cardboard, old magazine pictures, photographs, newspapers, foil, colored tissue paper, and other **found objects**. Notice the different materials used in the collages shown in this lesson. Also note the subjects and art **themes** represented.

Some pictures represent realistic objects, while others are more **abstract** designs.

As you create a collage for this lesson, spend some time collecting various materials and arranging them in different ways before deciding how you want your design. Experiment with your materials by tearing paper edges, overlapping pieces, and moving shapes around. Be as creative and inventive as you like.

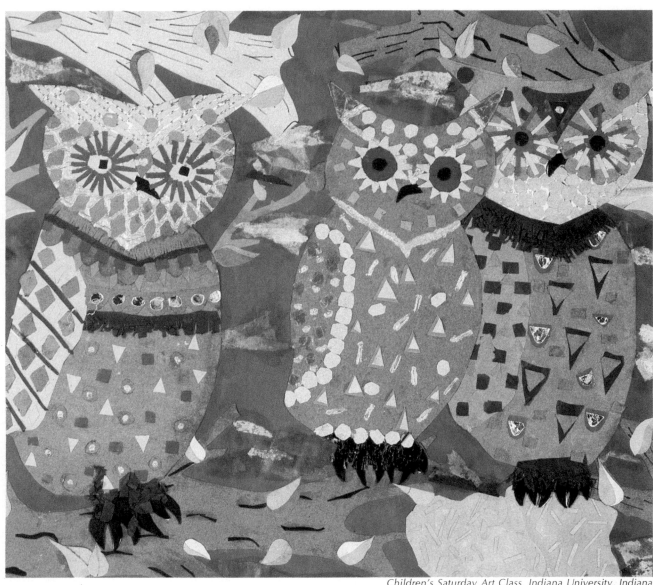

Children's Saturday Art Class. Indiana University, Indiana

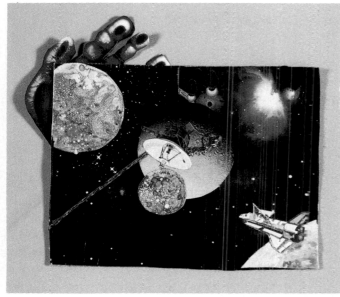

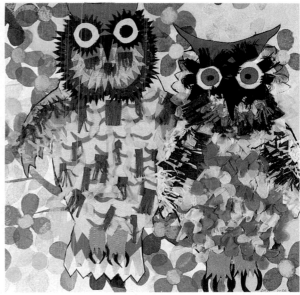

Children's Creative and Performing Arts Academy. San Diego, California

Children's Saturday Art Class. Indiana University, Indiana

Instructions for Creating Art

1. Collect a variety of collage materials, including different kinds of paper, cloth, wallpaper, foil, magazine pictures, newspaper, colored tissue paper, and anything else you think would contribute to your design.

2. Decide on a subject for your collage. You may want to depict an animal, a scene, or a figure. Or you might want to create an **abstract** design. Use your imagination to think of how you can use the materials you have collected to represent an art idea.

3. Make a preliminary sketch and begin to place your materials, experimenting with different arrangements before deciding on your final design. Create a **center of interest** by placing the most colorful or detailed shapes in one area, slightly away from the center of your design. Overlap some materials and repeat certain colors, textures, and patterns to create a **unified** design. Also incorporate empty spaces as an essential part of your picture. When you are pleased with an arrangement, glue the pieces in place. If you are using tissue paper, use a diluted mixture of *white glue** and water to attach the pieces.

4. You can add interesting contrasts and emphasize the center of interest by adding outlines and details with a black felt pen, crayons, or India ink.

*For an explanation, turn to the How to Do It section at the back of this book.

Art Materials

Variety of collage materials: paper, cloth, foil, wallpaper, colored tissue paper, etc.	White glue
	Water, paper towels
	Black felt-tip marker, crayon, or India ink
White drawing paper	
Pencil and eraser	

Strand F: Designing with Different Media

To evaluate your artwork, turn to the Learning Outcomes section at the back of this book.

39 Drawing Distortions

Observing and Thinking Creatively

Have you ever looked into a mirror that **distorted**, or changed, the way you look? People often enjoy this kind of experience because distorted images can be interesting and entertaining. When artists deliberately change the shapes of real things, it is called **distortion**.

One way of making distortions is to draw a **grid** of squares on top of a picture. Another grid is then drawn on a piece of paper, but this time it is made of rectangles. Everything that appears inside the squares in the picture is then drawn inside each of the rectangles, causing the image

to be stretched either horizontally or vertically.

Another way of making distortions is to make a grid of curved lines, rather than rectangles. Everything inside the squares on the picture is drawn to fill the curved shapes. This results in a very unusual, disorted image.

In this lesson, you are to draw two distorted pictures from one original drawing. One drawing is to be a stretched distortion, using rectangles, and the other is to be twisted, using curved lines.

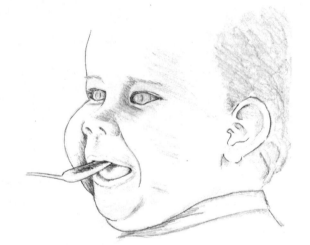

Anita Junior-Senior High School. Anita, Iowa

Anita Junior-Senior High School. Anita, Iowa

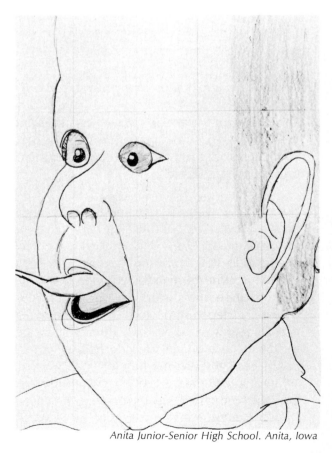

Anita Junior-Senior High School. Anita, Iowa

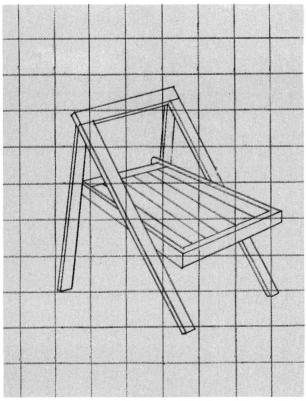

Student Art Workshop. Chicago, Illinois

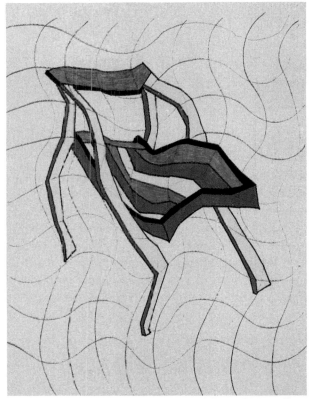

Student Art Workshop. Chicago, Illinois

Instructions for Creating Art

1. Make a drawing of a subject you think would make a good distorted image. Use a pencil and a ruler to divide the completed drawing into one inch squares. Study the artwork in this lesson to see how a grid has been drawn on top of a picture.

2. For your first distortion, make a grid by dividing a piece of drawing paper into rectangles measuring one inch across and two inches down, or two inches across and one inch down. Make the same number of rectangles as there are squares in the original drawing.

3. Draw what appears in each square of your drawing in the corresponding rectangle on your grid. When you finish, your second drawing will appear distorted either horizontally or vertically, depending on how you measured the grid.

4. For the second distortion, mark another piece of drawing paper into the same number of spaces as there are squares on your original drawing, but use curved lines instead of straight ones.

5. Fill in your spaces by drawing in each shape that appears in your first drawing. Be sure to draw each shape so that it fills the curved grid. The picture will appear twisted.

6. To make your distorted images more interesting, shade in or add color to cover most of the grid lines.

Art Materials	
White drawing paper	Pencil and eraser
	Ruler
Colored markers	

Strand F: Designing with Different Media

To evaluate your artwork, turn to the Learning Outcomes section at the back of this book.

40 Slice, Twist, and Stretch

Observing and Thinking Creatively

Artists are always experimenting with unusual media and new methods of creating interesting art. Sometimes they create art from photographs by changing, or **distorting**, the way a picture appears. Notice how student artists have disoriented the photographic images shown here.

In this lesson, you can use photographs in unexpected and imaginative ways. You will cut a photograph in slices and rearrange the parts to create an unusual picture. Another way to make distorted images is to slice two identical photographs and mix them together. You may think of other ways to rearrange sliced photographs to create unusual pictures. No matter how you approach this lesson, you will find that distorting photographs is a creative, fun experience.

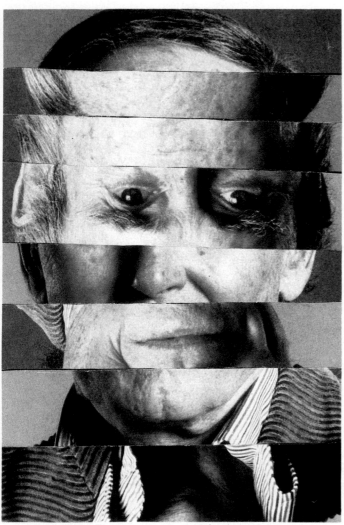

Ironia School. Randolph, New Jersey

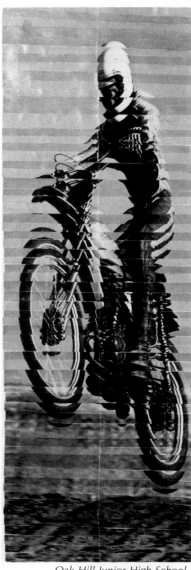

Oak Hill Junior High School. Converse, Indiana

92

Lewis Junior High School. San Diego, California

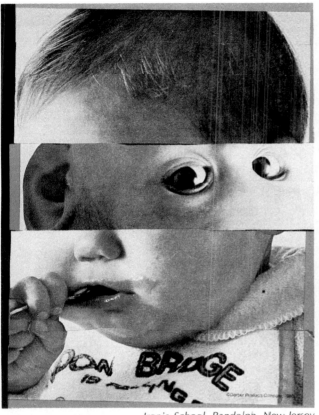

Ironia School. Randolph, New Jersey

Instructions for Creating Art

1. Look through magazines and find a large photograph of a person or a person's face. The photograph should be fairly large. Cut out the picture, and then cut it into slices of different widths. The cuts can be made either across or up and down.

2. Arrange the slices in the proper order on a piece of paper. Then alter the face by changing the arrangement of the pieces. They should not overlap, but they may be moved out of order or turned upside down. Experiment by moving the pieces around in different ways. You may want to leave spaces between slices. When you are finished, the original picture should still be recognizable, even though it will be distorted.

3. When you have decided on the most interesting arrangement, *glue** the pieces in place. The whole picture should now look distorted.

4. Finally, write a title for the picture that describes the subject or expresses the feeling it

suggests. Display your work and compare the different kinds of distortions other students have achieved.

*For an explanation, turn to the How to Do It section at the back of this book.

Art Materials

Magazine pictures of faces and figures

Drawing paper

Scissors

Pencil and eraser

White glue

Strand F: Designing with Different Media

To evaluate your artwork, turn to the Learning Outcomes section at the back of this book.

41 Creating with Stitches

Observing and Thinking Creatively

You may think of a picture as a painting, drawing, print, or photograph. Yet, a picture can also be stitched or woven in cloth. Artists in ancient Egypt and China wove colorful, detailed pictures in long cloth wall hangings, or **tapestries**. Intricate designs were created by adding various stitches to the surface of cloth using colored silk or wool. This kind of needlework art is called **stitchery** or **embroidery**.

Stitcheries may have simple designs or show elaborately detailed scenes, which sometimes fill whole pieces of cloth. A great variety of design is possible, using different stitches, yarns, colors, and materials. Special effects can be created by stitching pieces of cloth to the background fabric. This kind of stitchery is called **applique**.

In this lesson, you will create a piece of stitchery that shows variety.

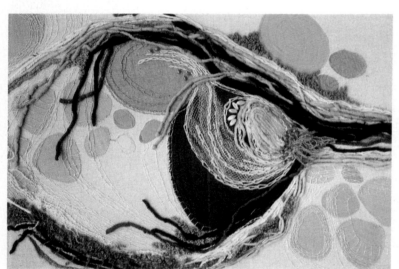
Phyllis Danielson, Dolin. Courtesy of the artist.

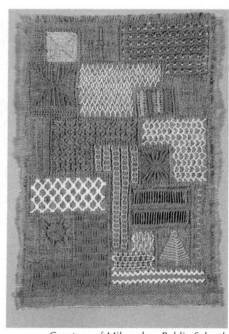
Courtesy of Milwaukee Public Schools

St. Frances Seraph School. Cincinnati, Ohio

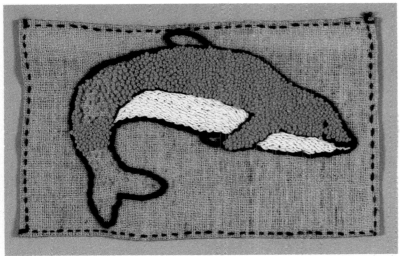

Courtesy of Milwaukee Public Schools

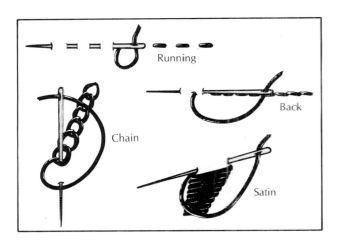

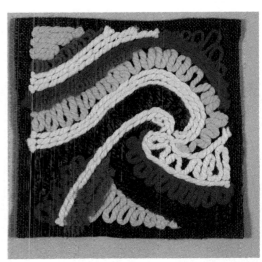

Courtesy of Milwaukee Public Schools

Instructions for Creating Art

1. On a piece of scrap cloth, practice each of the stitches shown in this lesson. Some stitches may work better for you than others. If you know additional stitches, use those also.

2. Use chalk to draw a simple design or shape on a piece of cloth. Thread a needle with a single strand of yarn and knot the end. Experiment with a variety of stitches and with different colors and textures of yarn. If you don't like the way something looks, it can easily be pulled out.

3. Outline the shapes of your design using the back and running stitches. Satin and chain stitches are best for filling in spaces. You may wish to appliqué pieces of fabric to your background material to make your stitchery more interesting. End each strand on the back of the fabric, and knot or tie it securely.

Art Materials

Darning or tapestry needle with large eye	Stitching materials: yarn, embroidery silk, twine, etc.
Background cloth: burlap, linen, poplin, denim, etc.	Scissors
	Assortment of buttons, sequins, found objects, etc.
Chalk	

Strand F: Designing with Different Media

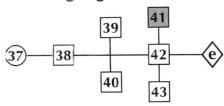

To evaluate your artwork, turn to the Learning Outcomes section at the back of this book.

42 Geometry with a Needle

Observing and Thinking Creatively

Many intriguing designs can be made with very simple materials. For example, notice the variety of **geometric** designs created with needles and yarn on these pages. This kind of art, called **stitchery**, is usually made on cloth.

Geometric stitchery designs are made by stitching various lengths of yarn in straight lines. Curves are produced by placing straight lines next to each other at slight angles, like those

shown here. Interesting and unusual effects can be created by overlapping and interlacing lines of yarn. Areas of solid color can be filled by placing stitches very close together.

In this lesson, you will stitch a colorful geometric design on paper. By experimenting with various stitches, you will be able to create a variety of effects that will add beauty and interest to your stitchery design.

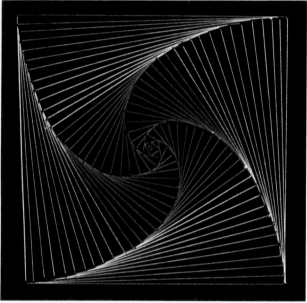

Children's Saturday Art Class. Indiana University, Indiana

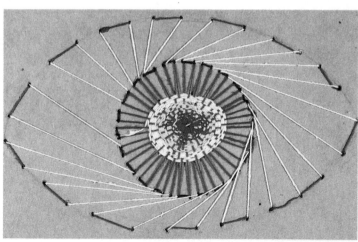

Azalea Middle School. St. Petersburg, Florida

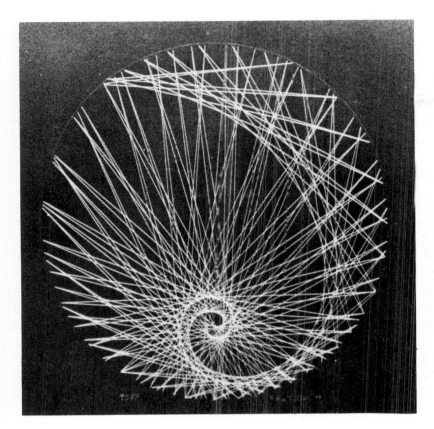

Straight diagonal threads stretched between various points give the illusion of curved lines and form an intriguing spiral-shaped design. Notice the effect created by overlapping lines. Where do you think the artist started the design?

Sue Fuller, b. 1914, String Composition #537. Construction, nylon thread embedded in Plexiglas. Indianapolis Museum of Art, Gift of the Herron Museum Alliance.

Instructions for Creating Art

1. Draw a single geometric shape on very stiff paper or thin, colored cardboard. Your design may be a square, a triangle, or any other geometric shape between six and eight inches across. A simple, geometric design with interesting lines and shapes will be most effective. Look at the examples pictured in this lesson for ideas.

2. About an eighth of an inch in from the edge of your design, use a pencil and ruler to mark off every one-fourth inch around the shape. Then use a large needle to make holes where your marks are. You may wish to make other holes inside your shape.

3. Choose a color of yarn that will look good with the color of your paper. Thread your needle with a single strand of yarn and tie a knot at the end.

4. Starting from the back of the paper, pull the yarn through until it is stopped by the knot. Now push the needle back into the next hole on the front of your paper. The yarn will make a straight line. Continue to stitch around your design, filling in sections towards the middle as well. Pull each stitch against the paper gently, or you may tear your paper.

5. Change the colors and thicknesses of the yarn to make the design more interesting. When you finish a yarn strand, tie a knot on the back of the paper. Strive to make the strands into a unified, geometric design in which all parts work together.

Art Materials

Thick paper, thin cardboard or wire screen for background

Stitching materials: yarn, embroidery silk, twine, etc.

Needle with large eye

Pencil and eraser

Ruler

Scissors

Strand F: Designing with Different Media

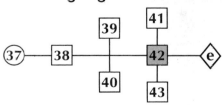

To evaluate your artwork, turn to the Learning Outcomes *section at the back of this book.*

97

43 *Pictures in Cloth*

Observing and Thinking Creatively

Pictures made by attaching pieces of colored paper or cloth to a background of poster board are called **collages**. Another kind of art very much like collage is called **appliqué**. In appliqué, a design is made by stitching pieces of colored fabric onto a larger piece of cloth. These designs may be hung on the wall and are also used to decorate clothing, quilts, and pillows. Notice the varied uses of appliqué shown in this lesson. Colors, patterns, textures, and stitches combine to create unified designs in cloth.

In this lesson, you will design and create an appliqué picture or wall hanging. Bags of fabric scraps can be purchased from many fabric stores, but you can often obtain plenty of scraps from anyone you know who sews.

As you choose your materials, keep in mind that you may want to turn some edges under for your design. To avoid bulk, choose lightweight fabrics for this. Using a variety of textures, patterns, colors, and shapes will make your appliqué design attractive and unique.

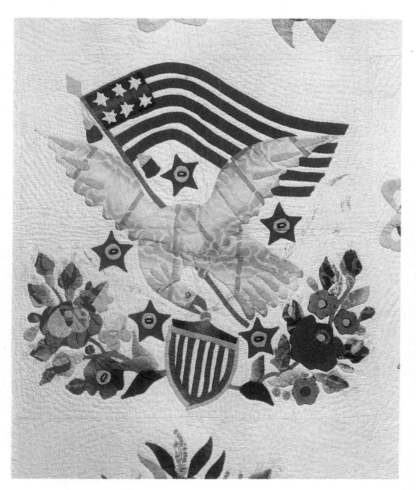

Note how different colors and patterns in the materials have been appliquéd to create flowers, stripes, and feathers in this patriotic quilt. What repeating colors unify the design?

Friendship Quilt (detail), Baltimore, 1848, Quilted and appliquéd cotton, 254 × 251.5 cm. The St. Louis Art Museum; Gift of Mrs. Stratford Lee Morton.

Courtesy of Milwaukee Public Schools

Barbara Kensler, Oregon. Courtesy of the artist.

Instructions for Creating Art

1. Decide whether your appliqué will be used as a wall hanging or a picture. Make a sketch or arrange colored pieces of paper to use as a model for your design. You may depict objects from nature, animals figures, or an abstract design. Appliqué designs usually look best if the shapes and lines are kept simple. Repeating shapes, colors, and textures will **unify** your design.

2. Collect pieces of cloth of varied shapes, colors, and textures to match your design. Cut them into the desired shapes and arrange them on a fabric background. Then draw around the shapes with chalk to mark their location on the cloth.

3. Now thread a needle and tie a knot. Pin a cut-out shape in its proper place on the background and stitch it down. See Lesson 41 for instructions on how to make stitches. Continue stitching each piece until your design is complete. Stitches can also be added to decorate different parts of the cloth pieces and the background. Make your stitches a part of the total design.

4. When the appliqué is complete, finish the edges of the fabric background by turning them under and stitching or taping them down. If you are making a wall hanging, roll the top edge, stitch it down, and run a wooden dowel or stick through it. Sew a loop or metal ring to the center on the back of your appliqué, so that it may be hung on a wall and displayed.

Art Materials

Drawing paper or colored paper	Small, varied pieces of cloth
Penci: and eraser	Needle and different colors of thread
White chalk	
A large piece of cloth	Scissors
	Dowel or stick
Straight pins	Metal loop or ring

Strand F: Designing with Different Media

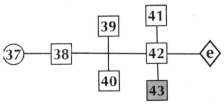

To evaluate your artwork, turn to the Learning Outcomes section at the back of this book.

44 *Weaving on a Natural Loom*

Observing and Thinking Creatively

Weaving is the process of running one set of yarn threads, the **weft**, over and under other fairly taut yarn threads, called the **warp**. By manipulating color and texture, a weaver can create a great variety of designs.

Some of the best weavers in the world are the Navajo Indians, known for their beautiful rug and blanket designs. Navajo legend tells of a mythical loom built by the Spider Man for Spider Woman. The cross poles were made of sky and earth cords, and the warp was made of sun rays. Because spiders came out of the ground in

October, the Navajos taught weaving then.

Weaving can be done by hand or on a hand or machine-driven **loom**. Today, most clothing, linens, draperies, carpets, and upholstery fabrics are woven on machine-driven looms. Some artists and craftsmen, though, prefer to weave by hand. They use their imaginations to create interesting, beautiful, and original designs. These designs are often displayed on walls, to be enjoyed just as paintings are enjoyed.

In this lesson, you will make a weaving on a natural loom—the branch of a tree.

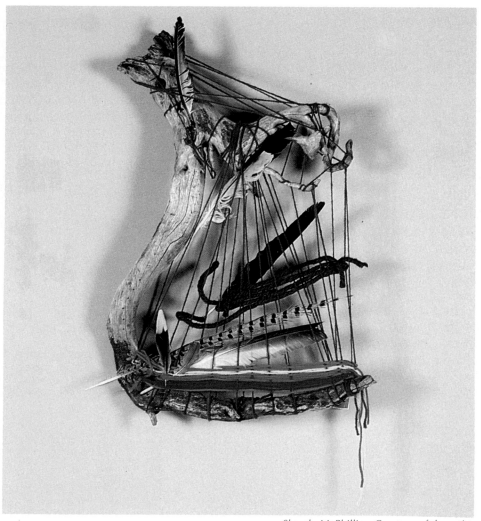

Sherely McPhillips. Courtesy of the artist.

100

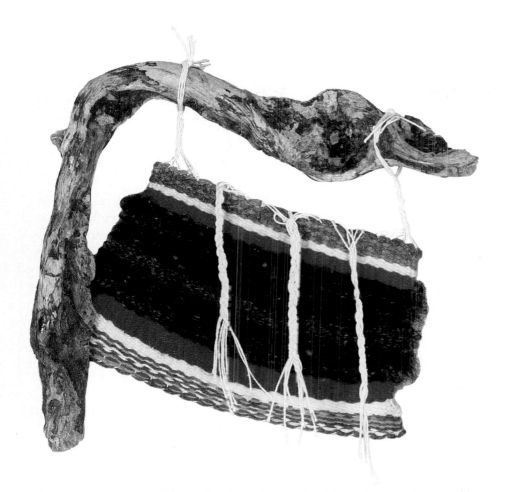

Chilaren's Creative and Performing Arts Academy, San Diego, California

Instructions for Creating Art

1. Find a forked branch that has fallen or been cut from a tree. An interesting piece of driftwood will do, too, as long as there is a gap between branches. The piece of wood should be between one and two feet long, and the area between the forked part should be at least ten to twelve inches wide. Remove small twigs jutting out from the fork.

2. Wind string around the two arms of the branch to make the warp. Your branch is now a loom. Fill in as much of the space as you can and tie the string ends securely.

3. Weave over and under the warp threads with colored yarn, string, or cord. This is the weft, and is the area where you can be creative. Select colors and materials that will add variety and create interesting patterns as you weave. You can add feathers, seed pods, strips of paper, bark, leaves, or anything else that will add texture and interest to the weft.

4. When your woven design is finished, display it by hanging it from the ceiling or on a wall.

Make sure that it is securely attached. What are the most interesting features of your woven design?

Art Materials

A forked branch or piece of driftwood	Weaving materials for the weft: cotton rug yarn, paper strips, grass, feathers, etc.
Colored yarn, string, or cord	
Scissors	

Strand G: Communicating Through Design

To evaluate your artwork, turn to the Learning Outcomes section at the back of this book.

45 The Art of Macramé

Observing and Thinking Creatively

The ancient art of **macramé** involves making designs with knots. It was originally developed by Arabian weavers. Later, sailors on long sea voyages often experimented with tying different kinds of knots to make nets and other items. Today, some of their knotting techniques are used to create belts, wall hangings, handbags, vests, necklaces, plant holders, and many other craft projects.

With a little creative imagination and the knowledge of how to tie a few basic knots, anyone can do macramé. A variety of knotting materials can be used, including twine, cotton, rope, jute, or any other kind of cord. The resulting macramé art may be attached to a holding cord, tree branch, or dowel to form a wall hanging. For additional ideas and information about knots and designs, look for books in your school or community library.

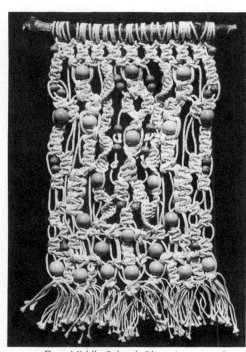

Dyer Middle School. Bloomington, Indiana

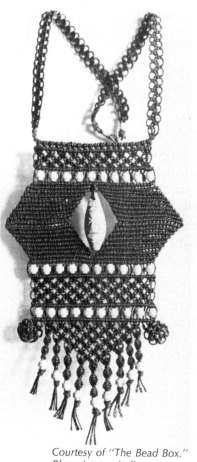

Courtesy of "The Bead Box."
Bloomington, Indiana

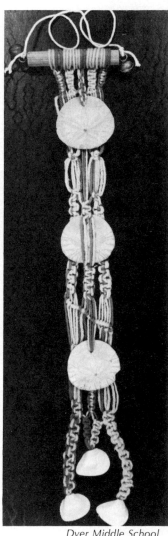

Dyer Middle School.
Bloomington, Indiana

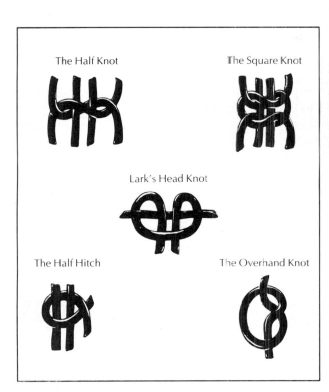

The Half Knot The Square Knot

Lark's Head Knot

The Half Hitch The Overhand Knot

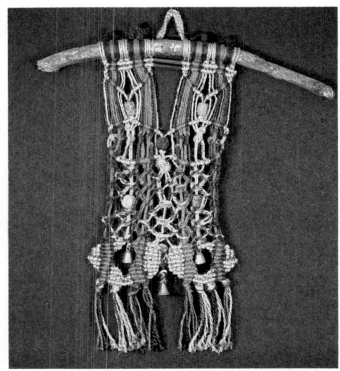

Children's Saturday Art Class. Indiana University, Indiana

Instructions for Creating Art

1. Experiment with tying the five kinds of knots illustrated in this lesson. Practice tying them with both stiff and soft cord. Tie some knots fairly loose and pull others tighter to see the different effects you can achieve.

2. Decide what you would like to make. You might want to begin with a simple project such as a belt, plant hanger, or wall hanging. Loop some cords over a holding cord, branch, or dowel. These cords should be three to four times longer than the finished design is meant to be. Now begin tying a series of knots, using some of the knotting techniques you have practiced. Create knots going from one side to the other so that the design grows downward. Pull together and knot different combinations of hanging strings to form interesting patterns of vertical columns and horizontal rows. If you wish, wooden or ceramic beads, seashells, fired clay pieces, or even feathers can be incorporated into your macramé piece. You may want to leave a fringe at the bottom of your macramé. Your finished piece can be displayed or given as a gift.

Art Materials

Cords of various kinds	Scissors
Dowel, branch, or rope for hanging	Wooden or ceramic beads (optional)

Strand G: Communicating Through Design

To evaluate your artwork, turn to the Learning Outcomes section at the back of this book.

103

46 Creativity with Beads

Observing and Thinking Creatively

What is the most unusual necklace you've ever seen? Necklaces can be made of almost anything that can be drilled with a small hole and strung together with thread. Small shells, nuts, pebbles, teeth, pieces of bone, wood, and porcupine quills are among the materials that have been used as beads on necklaces. Beads have also been made of pearls, gold, precious stones, glass, and ceramics. North American Indians are known for their interesting bead designs. Besides making necklaces, they sew colored beads onto belts, moccasins, and leather clothing.

You may enjoy making your own beads from brightly colored pieces of magazine paper that are rolled up and shellacked. A paper clip can be used as an **armature**, or skeletal form, for making beads with bits of colored paper. These colored paper beads may be built up in layers with shellac or made from papier-mâché.

In this lesson, you will create interesting bead designs and string them together artistically.

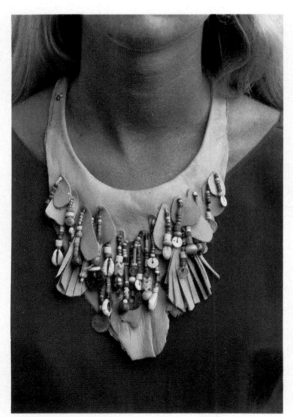

Pat Smiley. Courtesy of the artist.

Pat Smiley. Courtesy of the artist.

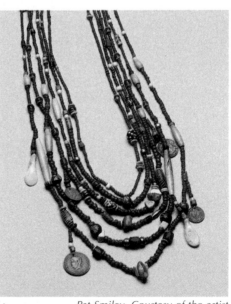

Pat Smiley. Courtesy of the artist.

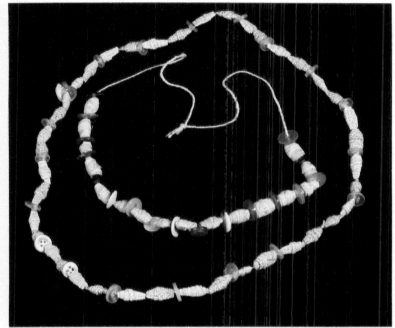

Colonial Junior High School. Memphis, Tennessee

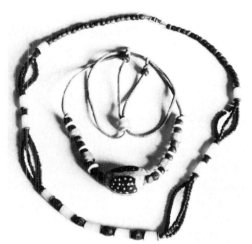

Courtesy of "The Bead Box."
Bloomington, Indiana

Instructions for Creating Art

1. Collect objects that could be drilled and used as beads, or create beads out of magazine paper and shellac or papier-mâché. If you have access to a kiln, you can form beads out of clay in different sizes and shapes, make a hole in each bead, and then fire the beads so that you can make a ceramic necklace. You could also use small parts of clocks and other tiny mechanisms, or use natural objects.

2. Experiment with stringing the beads together in different ways. Look at the pictures in this lesson for ideas, but arrange your beads in your own creative way. Think about how to arrange colors and shapes in novel ways. Some of the most interesting necklaces are those that use beads of different sizes, shapes, colors, and even materials. Generally, larger beads should go in the center of the necklace, and the smallest beads should go at the ends. When your beads are arranged the way you like, tie a knot at each end of the thread. Leave a long strand on each end if you want to tie your beads and wear them as a necklace.

Strand G: Communicating Through Design

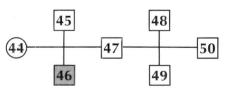

To evaluate your artwork, turn to the Learning Outcomes section at the back of this book.

47 Printmaking with Linoleum Blocks

Observing and Thinking Creatively

When artists first began making prints, they carved or gouged designs into wood. Then the **woodcut** was pressed into dye or ink and the design was printed on paper. Today, thousands of copies of a print can be rapidly produced by printing presses, but making prints by hand remains a valuable art form.

Prints can be made from any surface with a raised area that can be inked. Such prints are called **relief prints**. Pictures or designs made from a woodcut or a linoleum block are two types of relief prints. In the relief process, the unwanted areas are cut away from the block. The part that is to be printed must remain as the raised surface on the block. When paint or colored ink is applied to this surface, and is pressed onto paper, the raised surface appears as a print.

Observe the various prints shown in this lesson. Notice the bold contrasts of light and dark colors. Note also the interesting designs and textures each artist achieved by cutting away certain lines and shapes. The multiple print on page 107 was made by repeating the same print to create a printed pattern.

In this lesson, you will create a design or picture from a linoleum block and experiment with the art of printmaking.

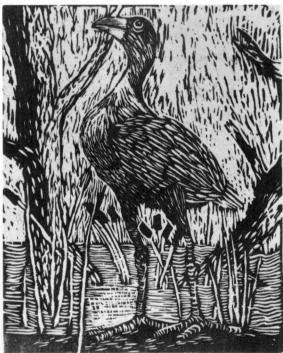

Mexican student art

Memorial Junior High School. Houston, Texas

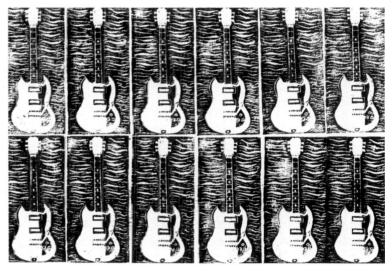

Tuba City Jr. High School. Tuba City, Arizona

Instructions for Creating Art

1. Paint the top of a smooth piece of linoleum with white **tempera** paint. Then sketch a design for your print on a piece of paper. Keep your design fairly simple. Concentrate mostly on the outline shapes and **contours**, adding only a few interesting details. You might hold your drawing in front of a mirror to see how the print will appear on paper, since the design will appear in reverse when it is printed.

2. Next, place a piece of carbon paper with the carbon side down on the dry linoleum. Place your drawing on top of the carbon, and trace over the lines of your picture. The carbon paper will **transfer** your design onto the white linoleum surface. You may simply draw your design directly on the linoleum surface with a pencil, if you prefer.

3. Remove the carbon and your drawing. Using *linoleum cutting tools,** begin to gouge out portions of the linoleum that you do not want to print. Cut out unwanted parts very carefully, always pushing the cutting tool away from you. Be sure not to cut all the way through the linoleum. For variety, cut some of the outlines away and leave others showing.

4. Spread a small amount of dark-colored printing ink in a thin, even layer on a flat surface, such as a metal tray or piece of glass, and roll it out with a **brayer**. When the ink is evenly distributed, use the brayer to roll a layer of ink evenly over your linoleum block design.

5. Practice making several trial prints on newsprint paper before you make your final print.

Lay a piece of white or colored paper on the inked block and rub the paper gently with the bottom of a spoon. Then, carefully peel away the paper to see the print. Practice making prints until you have one you like. A series of the same print repeated on your paper can also produce an effective design.

For an explanation, turn to the How to Do It section at the back of this book.

Art Materials

Drawing paper and pencil with eraser	Plate of glass or metal tray
Carbon paper	Brayer
Thick linoleum, 2″ × 3″ or larger	Linoleum cutting tools
White tempera paint	Newsprint paper for printing
Paintbrush	
Printer's ink	Newspaper (to cover work area)
White or colored paper	Water, paper towels

Strand G: Communicating Through Design

To evaluate your artwork, turn to the Learning Outcomes section at the back of this book.

48 Visual Word Messages

Observing and Thinking Creatively

If you flip through the pages of a magazine, you will notice that certain advertisements and messages catch your eye more than others. **Graphic artists** who design posters, billboards, record albums, and movie advertisements also design lettering and illustrations that will catch people's attention. Sometimes, the style of the letters illustrates the meaning of the words. For example, the word *nervous* might be drawn with squiggly lines and overlapping letters to give the feeling of stress and tension. The word *clown*

may actually incorporate clowns in various positions within the letter shapes.

Designing letters can be fun and creative. Before you begin this lesson, observe the lettering in magazines, advertisements, posters, and brochures. Cut out and collect a variety of lettering styles and designs. Select examples that convey meaning and illustrate the word in the way the letters are designed. Then create your own original letters to illustrate a word of your choice.

Montgomery Junior High School. San Diego, California

Montgomery Junior High School. San Diego, California

Montgomery Junior High School. San Diego, California

Montgomery Junior High School. San Diego, California

Montgomery Junior High School. San Diego, California

Montgomery Junior High School. San Diego, California

Instructions for Creating Art

1. Make a list of five or six words that could be designed to convey a special meaning. Select one word and design a style of lettering that illustrates the meaning of the word. You may incorporate a picture into the lettering as part of the design. The lines, shapes, and picture should work together to create a **unified** design. Make sure the word is carefully lettered and easy to read.

2. When you are pleased with the composition of your letters and design, make a finished drawing of your word on a clean sheet of paper. Use a felt-tip pen or India ink to make your letters stand out. Show a contrast of light and dark areas, and add color to your illustration with colored markers or paints.

Art Materials	
Two sheets of drawing paper	India ink or ⸱tip pen
Pencil and eraser	Paints and ⸱ushes
Colored markers	Water, p⸱ towels

Strand G: Communicating Through Design

To evaluate your artwork, turn to the Learning Outcomes section at the back of this book.

49 Drawing Letter Shapes

Observing and Thinking Creatively

Magazines, newspapers, advertisements, posters, and billboards contain words and messages represented in a variety of different lettering styles. Some letters are bold and thick, while others are light and free-flowing. Most of the letters shown in commercial art are printed by machines, and thousands of copies can be made. But before the invention of the printing press, all lettering was done by hand. Beautiful lettering styles and designs were used in ancient manuscripts, scrolls, and books.

Today, artists continue to design and draw letters by hand. One kind of beautiful lettering is called **calligraphy**. Calligraphers use lettering pens and ink, although some use felt-tip pens specifically designed for lettering. Calligraphy is most often used to letter messages on posters, cards, advertisements, poems, and special messages, quotes, or sayings in books or magazines.

This lesson introduces you to the art of lettering. You will practice making letter shapes using a lettering pen and black ink. It is important to make interesting letter shapes that are **legible**, or easy to read. Once you have learned to letter with a pen nib, you can experiment with various creative ways of lettering.

Fine art is that in which the hand, the head, and the heart of man go together.

Azalea Middle School. St. Petersburg, Florida

Instructions for Creating Art

1. Lettering is best done with a calligraphy pen, using a metal point, or nib, that fits into the end. Nibs vary from extremely broad and flat to narrow and pointed, with almost every variation in between. For this lesson, use a medium nib with a square chisel end.

2. Firmly insert the nib into the pen holder. To fill the nib with ink, dip it into the ink bottle until ink covers the entire nib, and you can see the inside of the nib filled up. Then gently tap it against the bottle to get rid of excess ink, and make a practice line on a piece of scratch paper to eliminate ink blobs and start the ink flowing smoothly.

3. Never press down too hard with the pen nib. Just slide it smoothly over the paper's surface. Hold the pen at a constant angle so the thick and thin lines will occur in the same places. Draw vertical lines from top to bottom, always pulling the pen toward you. If you push it away from you, it may dig into the paper and make a blot or scratchy line.

4. The height of capital letters should be about seven times the width of the pen nib. The height of lowercase letters should be about five times the width of the pen nib. To determine your letter heights, make short marks close together with the pen nib. Practice until you feel comfortable using the pen.

5. Study examples of lettering you like and practice lettering the alphabet in the style you prefer. Then pick a short quote, saying, verse, poem, or message that you like. Using very light pencil lines, copy the words onto your paper. Leave plenty of space between the lines—your finished lettering will take up more space than your pencil guide.

6. Now, carefully letter the words in ink. Practice lettering the verse until you have a copy that pleases you. You may choose to add illustrations around the outside.

Art Materials

Samples of alphabets showing different styles of lettering	Ruler
	Lettering pen (holder)
Fine quality drawing paper	Pen nib with square chisel end
Scratch paper	Black waterproof ink
Pencil and eraser	

Strand G: Communicating Through Design

To evaluate your artwork, turn to the Learning Outcomes section at the back of this book.

50 Designing a Poster

Observing and Thinking Creatively

Recall some of the posters and advertisements you have seen in stores, buses, travel agencies, supermarkets, and around your school or community. Do you remember seeing advertisements that were especially appealing? Posters often advertise products and coming events, such as a circus, sports event, election, or sale. Their messages must be eye-catching and easy to read because most posters are viewed by people on the move. Some posters give information, such as the time and place of an event. Others are meant to persuade the viewer to do some-

thing—attend a sale, buy a product, or vote.

Many people display posters in their homes. Perhaps you have special posters of people, places, important sayings, or poems in your room. Artists who design posters such as these are called **graphic designers**.

In this lesson, you will create a poster about something that is meaningful to you—a special message, organization, product, or event. As you design your poster, combine your letters, illustrations, colors, and message into a **unified**, attention-getting **composition**.

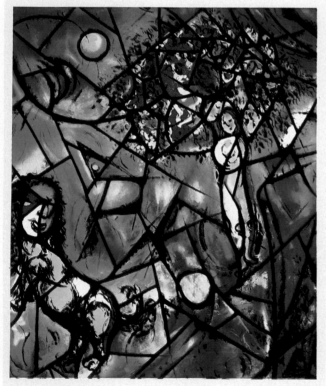

Chagall's fanciful images are often based on fond memories from his childhood in Russia. His works are full of dreamlike symbols and many, like this stained glass window, contain images of floating people and animals. What do you think makes this an effective poster design?

Marc Chagall, Detail of stained glass window in homage to Dag Hammarskjold, United Nations Headquarters, New York. *Courtesy of UNICEF, The Children's Fund of The United Nations.*

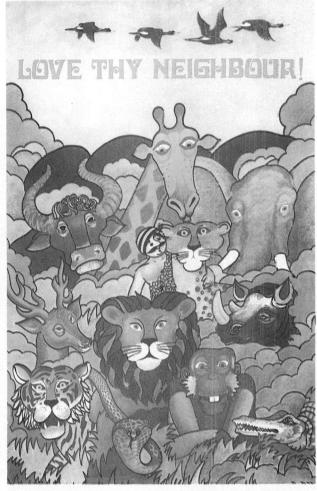

CREATED BY AIR-INDIA FOR 🐼 WORLD WILDLIFE FUND

Courtesy of Air India

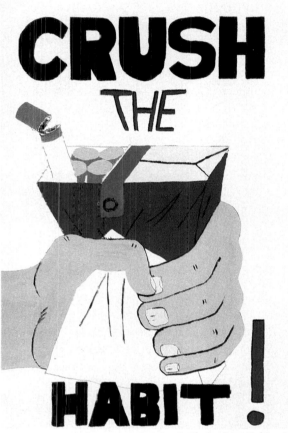

Chula Vista High School. Chula Vista, California

Chula Vista High School. Chula Vista, California

Muirlands Jr. High School. La Jolla, California

Instructions for Creating Art

1. Decide on a subject for your poster. You may want to promote an organization to which you belong, advertise a product or an event, or publicize a meaningful message. Then decide on the words or slogan you will use, and draw a preliminary sketch of your poster.

2. Create a **center of interest** by emphasizing one part of the poster through the use of illustrations, color, or special lettering.

3. Design simple, attractive, easy-to-read letters. Draw your letters in a shape and size that fit the mood of your poster—short and fat, tall and thin, simple, fancy, etc. Lightly pencil in guidelines before you fill in the letters. (See Lessons 48 and 49 for examples of different lettering styles.)

4. Use colors to create a mood or get a response. Bright, cheerful, warm colors such as red, orange, and yellow convey a sense of excitement. Cool colors such as green or blue express a softer, quieter mood. For a very bright poster, use **complementary** colors that are opposite each other on the color wheel, such as orange and blue.

5. Arrange the illustration, message, and lettering into a **unified** design. This can be done by overlapping lettering and illustrations, using one color for the background, or joining items with symbols, lines, or shapes. Be sure to leave enough open space so your poster is uncluttered and easy to read.

6. When you are pleased with your preliminary design, make your final poster on a large sheet of poster paper. Then display it in an appropriate place.

Art Materials

Drawing paper	Additional materials: colored markers, construction paper, scissors, glue, etc.
Pencil and eraser	
Ruler	
Poster paper	Mixing tray
Paints and brushes	Water, paper towels

Strand G: Communicating Through Design

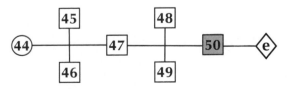

To evaluate your artwork, turn to the Learning Outcomes *section at the back of this book.*

Exploring Art

Advertising Books, Movies, and Music

Advertising art has a powerful influence on the lives of people. Posters, billboards, and magazine, newspaper, movie, and television ads influence what products we buy, places we go, books we read, and how we think and act. You may have had the experience of buying a product or seeing a movie because the advertisement convinced you that it was something you shouldn't miss. If you were disappointed by a product you tried or an event you attended, perhaps you view advertisements more carefully now.

For this activity, you will choose something that you like and feel is worth advertising—a book, movie, or record or tape of your favorite music. Choose something that you enjoyed and want to share with others. Think about how you can **verbalize** and **visualize** your product. Make up a short message or slogan that gets people's attention and can be easily read. Create a **unified** design in which the letters, words, colors, and illustrations combine to create an effective poster. (Read the instructions in Lesson 50 for information on designing a poster.)

When your poster is finished, display it in an appropriate place.

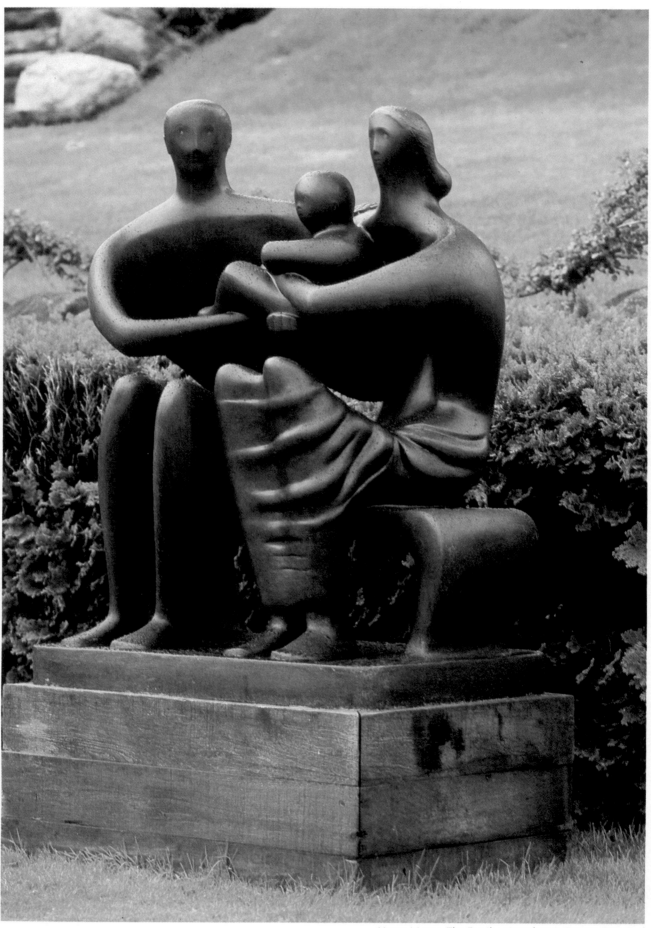

Henry Moore, The Family; *Westchester County, New York.*

Unit IV

Modeling, Carving, and Construction

You begin with a block and have to find the sculpture that's inside it. You have to overcome the resistance of the material by sheer determination and hard work.

Henry Moore

The earliest art objects known to man were sculptured pieces of stones and sticks used by prehistoric hunters. Although these objects were fashioned for survival, they represent the beginnings of an art form that has been highly developed since the first man whittled a stick with a sharp object. Ancient people also modeled pottery from mud and clay, dug from the ground around them. Pieces of early pottery are found all over the world today. These fragmented bits and pieces of ancient art are testaments to man's innate desire to create objects of beauty out of even the most mundane materials. For much of this early pottery is not simply functional, but decorative.

The following lessons introduce you to three-dimensional art forms that have been practiced since the dawn of civilization. You will create sculpture from found objects and ordinary materials. You will model forms and figures from clay, and make pottery using a variety of methods. Lessons on carving provide you with experiences in creating both realistic and abstract sculpture. As you work, you will learn the value of viewing your three-dimensional artwork from every angle to capture its changing contours. The art forms introduced in this unit offer both visual and tactile experiences, for you must both see the artwork and feel its surface texture in order to fully appreciate it.

51 Embossing Shining Images

Observing and Thinking Creatively

For thousands of years, goldsmiths and silver-smiths all over the world have made gold and silver into beautiful jewelry, eating utensils, and art objects. Gold and silver have also been used for some of the most important religious objects in churches and temples.

Because these two metals have always been very expensive, they have had to be used as sparingly as possible, often in very thin layers. One way of using metal more economically is to make it look as though it is solid when it is really hollow. To do this, an artist hammers a design into the back of a thin sheet of metal so that the design stands out from the flat surface in the form of a **relief**. This method of working with metal is called **embossing**.

Embossing is still used today to make precious metals go further. Other metals, such as copper and brass, are also used for embossing. In this lesson, you will emboss a relief using aluminum foil. Foil is easier to shape than thicker metal sheets and is much more economical.

A thin sheet of gold was embossed to make this small plaque, dated around 550-300 B.C., during the Assyrian rule over Babylonia.
OXUS: Gold Plaque of standing Man, *British Museum.*

Lewis Junior High School. San Diego, California

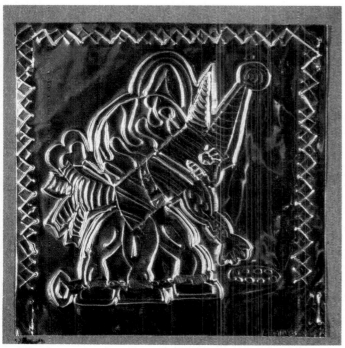

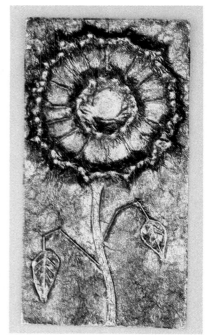

Southport Middle School. Indianapolis, Indiana

*Lewis Junior High School.
San Diego, California*

Instructions for Creating Art

1. Decide on a subject to emboss. Draw a design for a simple shape, such as an animal, person, or object, or sketch a simple scene. Make the design fill a sheet of paper that is the same size as your piece of aluminum foil. Observe the pictures in this lesson for ideas.

2. Choose one of the following two methods for making your relief:

 a) When you have drawn your design, place the paper on top of heavy foil. Work on a pad of soft paper to protect your work surface. Draw over the lines on your paper with a pencil, pressing hard so that the design will show through in the foil. Make the shapes stick out by rubbing the back of the foil with a smooth stick or spoon. Add details such as hair on people or veins on leaves. Rub the relief from the front to keep it from wrinkling.

 b) You can try another method of embossing by finding objects that can be arranged into a design or picture. Select objects of varying sizes, shapes, patterns, and textures to create an interesting design. Then use string or twine to outline shapes and form details, gluing them onto cardboard. Spread aluminum foil over the shapes and objects, gently rubbing the foil until the shapes underneath show through clearly. Spray or brush the finished art with clear

or colored **lacquer**, or brush on India ink and gently rub off some of the ink with paper towels, leaving contrasting light, shining surfaces and dark ridges.

3. Attach the embossed relief to a piece of wood or thick cardboard, and hang it on a wall.

Art Materials

Drawing paper	Aluminum foil
Pencil and eraser	Lacquer (clear or colored) or India ink
Smooth modeling tool (pencil, spoon, etc.)	Solvent for lacquer
	Brush
Water, paper towels	Pins and hammer
Piece of wood or thick cardboard	Newspaper pad (to protect work surface)
White glue	

Strand H: Reliefs, Sculpture, and Ceramics

To evaluate your artwork, turn to the Learning Outcomes *section at the back of this book.*

52 Relief Sculpture

Observing and Thinking Creatively

Unlike paintings, which are flat, sculpture is **three-dimensional**. Halfway between these two art forms is something called a **relief**. A relief is a form of sculpture in which main shapes and details protrude from a surrounding flat background. Some reliefs are modeled in clay or carved in stone. Others are created by arranging and gluing objects on a flat surface.

In this lesson, you will make a relief using found objects, such as pieces of wood, paper clips, sticks, string, or any other interesting materials you can find. As you arrange your materials, try to create a **balanced** design. You may want to make the parts of your design balance each other exactly. This is called **symmetry**, which means that both halves are the same. Another type of balance frequently used in art today is **asymmetry**. In asymmetrical balance, an artist balances unlike parts on both sides of a design to create a sense of equilibrium. You have created asymmetrical balance if you have ever sat on one end of a seesaw and balanced your weight with two smaller children on the other end. Or perhaps you moved in close to the center, with the lighter child out at the very end, to make the two unequal weights balance. In a painting, an artist might use three small, different shapes on one side to balance a single large, dominant shape on the other.

Look around you and locate some examples of symmetry and asymmetry in your environment. Look at the art shown here and on other pages of this book, and discuss how artists have used each of these types of balance in paintings, sculpture, and other art forms.

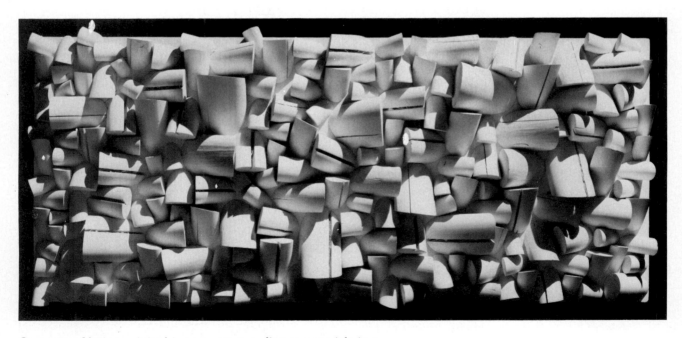

One way of being original is to arrange ordinary materials in a new manner. In this relief, cylinders of wood have been cut into different sizes and placed at unusual angles from one another, then painted white. Notice how the unified design creates a beautiful variety of shapes and shadows.

Sergio de Camargo, Large Split White Relief No. 34/74. *The Tate Gallery, London.*

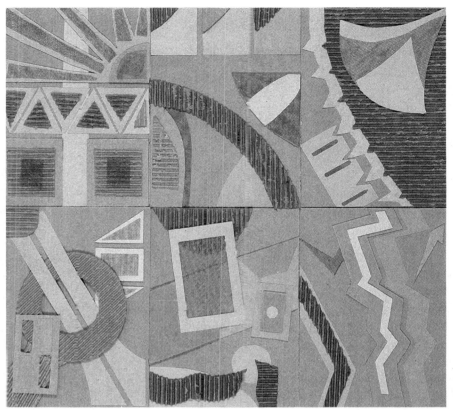

Instructions for Creating Art

1. Collect some small manufactured items such as paper clips, lids, nails, nuts and bolts, toothpicks, spools, boxes, string, Popsicle sticks, and other disposable objects you find interesting. The pictures in this lesson may give you ideas of materials to collect.

2. Choose one type of balance to use in your relief picture. Experiment with arranging your items into a balanced design on a piece of cardboard. Your design can consist of realistic or **abstract** forms. As you work, think about creating an interesting design with a variety of shapes, sizes, and levels. Overlap some of the items, and draw all the parts of your design into a single **unified** whole.

3. When you have discovered a pleasing, well-balanced arrangement, glue your items securely onto the cardboard. Make sure they are attached firmly, so they will not fall off.

4. After the glue is dry, you may want to paint your relief one color so that all the parts will appear as though they belong together. When all the parts are one color, the shadows of the relief show up clearly and emphasize the three-dimensional solidity of the relief.

5. Be prepared to tell about the balance in your design. What type of balance did you use? How do the objects you used, and the way you placed them, create balance and achieve unity of design?

Art Materials

Collection of small manufactured items: bottlecaps, small containers, rubber bands, thumbtacks, etc.	White glue
	Scissors
	Paint and brushes
Cardboard background	

Strand H: Reliefs, Sculpture, and Ceramics

To evaluate your artwork, turn to the Learning Outcomes section at the back of this book.

121

53 Bricks and Beehives

Observing and Thinking Creatively

In nature, many more-or-less identical parts may make up one object. For instance, all the leaves belonging to a particular tree are the same general shape. Seeds and flowers from the same species of plant look alike. So do the cells of a honeycomb in a beehive.

Artists sometimes use objects that are the same to create interesting works of art. Each separate piece is called a **module**. Bricks are good examples of modules. They are very simple objects that have been used since the beginning of civilization to build houses, castles, bridges, and churches. Even though each brick is the same size and shape, buildings made of bricks look different from each other. Can you think of other examples of modules and buildings or objects made from them?

In this lesson, you will have an opportunity to experiment with modules and use them to create your own idea for an original piece of sculpture. The most challenging part of this lesson is to imagine what the finished sculpture will look like. This is called **visualizing**. When you can visualize how different modules will look together, you can design an original piece of sculpture.

Circular brass plates in *Evocation* have been folded, bent, and arranged irregularly to create depth, shadows, and a sense of motion. Our eyes follow the swirls of this 5½-foot long sculpture. Its pieces seem to grow out in spreading clusters from a central core. What tools and materials might the artist have used to assemble the pieces and attach them in this way?

Raymond Rocklin. Evocation. 1958. Brass. 66 x 26 x 19 inches. Collection of Whitney Museum of American Art. Gift of the Friends of the Whitney Museum of American Art. Acq#58.39

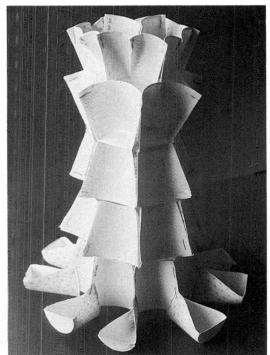

Children's Saturday Art Class.
Indiana University, Indiana

Instructions for Creating Art

1. Decide on a simple object, such as a Styrofoam cup or paper roll, to use as a module for your sculpture. Also observe the pictures of modular sculptures in this lesson. Notice the different materials, shapes, and designs each artist used.

2. Use your modules to build the most unusual piece of sculpture you can imagine. Remember that the pieces must hold together firmly. Also be sure that the sculpture will not tip over easily. Most important of all, the sculpture should look good from all sides.

3. If you wish, paint the finished design to make your sculpture a **unified** work that looks good from all angles. What do you like best about the way you put your modules together?

Art Materials

Solid objects for modules: Styrofoam or paper cups, milk cartons, egg cartons, paper rolls, etc.

Attaching materials: glue, wire, staples, toothpicks, etc.

Spray paint (use only in a ventilated area)

Strand H: Reliefs, Sculpture, and Ceramics

To evaluate your artwork, turn to the Learning Outcomes section at the back of this book.

54 Descriptive Modeling

Observing and Thinking Creatively

Clay is a versatile **medium** that can be used in a variety of ways. Clay is used to make pottery, but it can also be used to make small models for large, finished sculpture. A finished sculpture is sometimes made out of clay, but since dry clay breaks easily, clay sculptures must be turned into **ceramics** or **cast** in metal. Industrial designers create clay models of automobiles, furniture, and other man-made objects before they are manufactured. The model provides the designers with a **three-dimensional** view of the object before it is put into production.

In this lesson, you will test your powers of observation by modeling a clay **replica** of an everyday object. As you work, you will need to observe the overall structure of the object and understand how the parts fit together. You will also need to view the object from different angles, noting its **proportions**, or the size of each part in relation to the others.

Gompers Secondary School. San Diego, California

Gompers Secondary School. San Diego, California

Gompers Secondary School. San Diego, California

Gompers Secondary School. San Diego, California

Gompers Secondary School. San Diego, California

Instructions for Creating Art

1. Choose a man-made object to model, such as a telephone, typewriter, coffee pot, shoe, dish, piece of food—or anything else that has a fairly simple shape. Choose something that does not have any thin or fragile parts that might break easily if modeled in clay.

2. Make a clay model of the object you chose. Study the real object or a photograph of the object as you work. The model should be made to look exactly like the real object in every way—except perhaps in size. Each of the dimensions of width, height, and depth should be accurate, though, so that the model is made to **scale**. If you decide to make a model one-quarter of the size of the original, for instance, divide each measurement of the original by four.

3. When the main proportions are correct, you can begin work on the details. Don't forget that, on a three-dimensional model, every detail must be shown, including those on the back and the bottom.

4. If you are using *water-based clay* * and need more than one class session to finish your model, enclose it in a plastic sack, splash some water inside, and tie the opening securely. The water will help keep the clay from drying out.

5. You may want to **fire** your clay object, if there is a **kiln** in your school. Add colored glazes, if

they are available. Remember that only water-based clay can be fired. When your piece is completed, display it for others to see.

For an explanation, turn to the How to Do It section at the back of this book.

Art Materials

A small man-made object: telephone, typewriter, kettle, blender, coffee pot, radio, television, etc.

Clay (oil-based or water-based)

Table knife or large spatula (for large shapes)

Nail file or small spatula (for details)

Plastic sack and tie (for water-based clay)

Water, paper towels

Newspaper (to protect tabletop)

Strand H: Reliefs, Sculpture, and Ceramics

To evaluate your artwork, turn to the Learning Outcomes section at the back of this book.

125

55 Fancy Pottery

Observing and Thinking Creatively

Working with clay can be one of the most satisfying of all crafts. Your hands are the tools used to press and form the soft, yielding clay into the shape of your choice. When clay is fired in a **kiln**, the result is pottery.

Pots for cooking, flower vases, wall decorations, lamp bases, ceramic animals, masks, cookie jars, and plant holders can all be made out of clay. Containers can be formed with heads for lids, feet for bases, parts of animal bodies for handles and spouts, and so on. The more creative the designer is, the more imaginative the pottery can be.

Creating **textures** for pottery can also show imagination. Items such as nails, combs, sticks, spoons and forks, burlap, bolts, and other objects can be used to make a variety of interesting textures on the surface of clay.

In this lesson, you will create a piece of pottery using one or more of three basic hand-building techniques. Use your imagination to make pottery that is functional, decorative, or both.

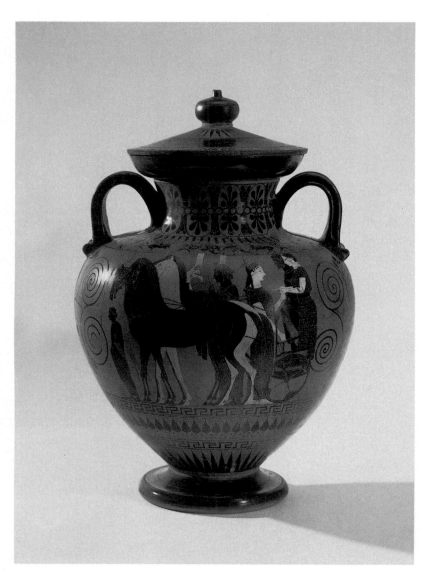

This ancient amphora, or vase, shows the wedding procession of the Greek hero Hercules. Note how the design features added to it accentuate its shape. What other characteristics give this piece its timeless beauty?

Amphora with cover: Marriage procession, perhaps of Herakles and Hebe, *Greek, c. 540 B.C. The Metropolitan Museum of Art, Rogers Fund, 1917. (17.230.14ab) All rights reserved.*

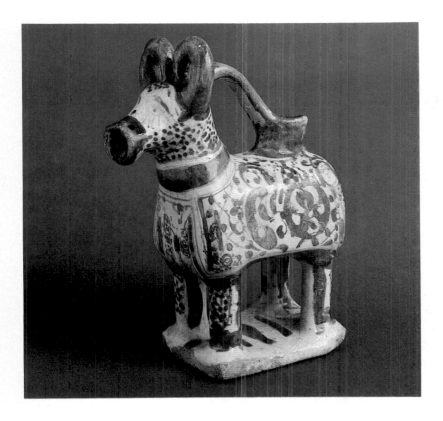

A flat base gives good support to an animal pot with legs. Graceful decorative designs were painted into this glazed surface before firing.

Vessel in the shape of an animal, 12-13th century, Iran, Glazed pottery, H. 14.6 cm. Iranian Aguamanile. Indiana University Art Museum. 60.58

Keystone Middle School. Indianapolis, Indiana

Instructions for Creating Art

1. Observe the different kinds of pottery shown in this lesson. Then read the following instructions for three methods that can be used to make pottery.

 a) **Pinch method**: Begin with a ball of clay about the size of an orange. Press your thumbs into the ball and pull outward, pinching the clay. Form a bowl shape by repeating this process around the ball, keeping the walls between one-fourth and one-half of an inch thick.

 b) **Coil method:** Make a small circular *slab** for a base. Then make a clay rope by rolling the clay between your palms. Put the coil around the edge of the base, and add other coils on top of the first. Build the coils by adding *slip** to both surfaces and then pressing them together.

 c) **Slab method**: With a rolling pin or thick dowel, roll out a lump of clay until it is even and flat. It should be between one-fourth to three-fourths of an inch thick. Use a table knife to cut out shapes for the sides and bottom of your piece. Attach the pieces with slip.

2. Practice using each of these methods to form a pot. Then choose one method, or a combination of methods, to make your own design. Use water-based clay. Fire the finished piece in a **kiln**, if one is available.

**For an explanation, turn to the How to Do It section at the back of this book.*

Art Materials

Clay (water-based)	Modeling stick or other clay tools
Plastic bag (to keep clay damp)	Slip
Objects for creating texture: burlap, small machine parts, pencil, etc.	Rolling pin
	Newspaper (to cover work area)
Table knife	Water, paper towels

Strand H: Reliefs, Sculpture, and Ceramics

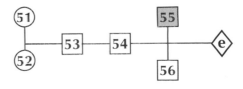

To evaluate your artwork, turn to the Learning Outcomes section at the back of this book.

56 Three-Legged Pottery

Observing and Thinking Creatively

Suppose you lived in a hut or cottage that had an uneven dirt floor. What kind of furniture would fit that setting? Most chairs and tables have four legs because they provide balance, strength, and safety. But objects with four legs will stand properly only if they are placed on perfectly flat surfaces. You may have experienced the wobble of a chair or table on an uneven floor.

Unlike four-legged chairs and tables, objects balanced with three legs will stand firmly on many uneven surfaces. Artists in the ancient civilizations of Egypt, China, and America often made three-legged pots, stools, and lamps because they stood firmly on uneven floors. Three-legged furniture and pottery have also been made more recently in Africa, and are still used in many parts of the world.

In this lesson, you will create and decorate a three-legged pot.

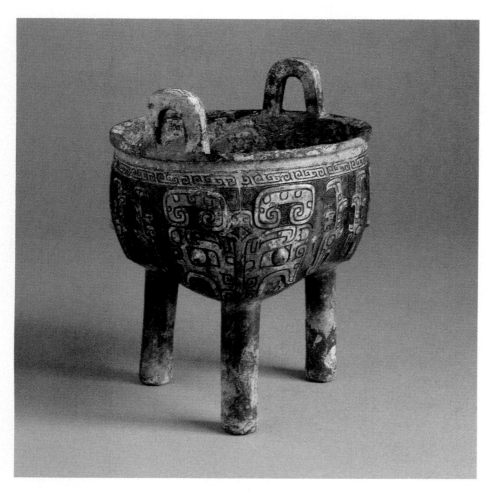

During the 600-year reign of China's first ruling family, the Shang dynasty, bronze sacrificial vessels were cast from clay molds and used in ceremonies for the dead. What do you think might have been placed in this ancient pot?

Chinese Li-ting, *Shang Dynasty, c. 1523-1030 B.C. Bronze. Indiana University Art Museum, William Lowe Bryan Memorial. 58.41*

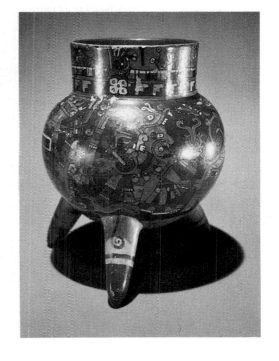

The Chinese have made pottery since prehistoric times. This simple, unglazed pot was created about 2,000 B.C. How do you think its interesting textures were created?

Chinese Li, Late Neolithic, 2nd millenium B.C. Terracotta with impressed design. Indiana University Art Museum, William Lowe Bryan Memorial. 58.40

Mixtec Indians of southern Mexico had an advanced civilization that endured from 650 B.C. to the 15th century A.D. Religious symbols and scenes picturing their life and culture decorate much of their beautiful pottery and impressive architecture.

Mixtec Pottery Tripod Vessel, Mexico

Instructions for Creating Art

1. For instructions on how to use each of the three basic pottery methods, refer to Lesson 55 or the *How to Do It* section at the back of this book. Using one or more of the methods, make a piece of pottery that rests on three legs. It could be an animal, person, bowl, vase, stool, or any other object that can be designed and modeled to sit on three legs or that has three different parts that touch the ground. Design the legs carefully so they fit in with the shape of the pot.

2. When your model balances well, decorate the surfaces, including the legs. You may add decoration using slip and bits of clay, or you may scratch or press objects into the surface of the clay. For inspiration, study the examples of three-legged pots shown here. What did the artists do to make their pots more than merely useful? If a **kiln** is available, you may want to glaze and fire your pot.

Art Materials

Clay (water-based if it is to be fired)	Table knife
	Newspaper (to cover work area)
Objects to scratch or press into clay: small machine parts, comb, saw blade, fork, spoon, chain, buttons, etc.	Water, paper towels
	Plastic bag to cover clay
	Slip

Strand H: Reliefs, Sculpture, and Ceramics

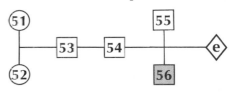

To evaluate your artwork, turn to the Learning Outcomes section at the back of this book.

129

57 Sculpting with String

Observing and Thinking Creatively

Did you ever think of a piece of string as a line? Perhaps you have noticed how string will twist and turn in all directions. However, when it is stretched between two nails, it becomes a straight line. If it is stretched between many nails, it can form interesting sculpture.

We usually don't think of forming sculpture with straight lines, but some artists have discovered how to sculpt original pieces of art using this method. This kind of sculpture is a form of **abstract** art which started in the twentieth century. Before that time, most artists adhered to

more realistic art forms, recreating things exactly as they saw them. Pioneers in abstract art began to improvise and manipulate form using innovative methods and materials. Some artists discovered how to form sculpture with some of the newly invented lightweight metals. Abstract artists sought to create art for the beauty of its form, rather than to depict realistic, concrete objects.

In this lesson, you will create an abstract sculpture consisting of lines of string, wire, or yarn spanning solid forms and spaces.

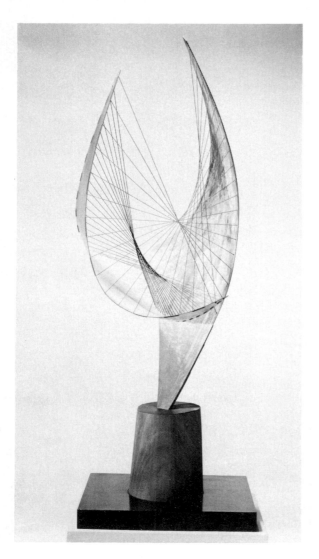

In Greek mythology, Orpheus played such beautiful music on the lyre that animals, trees, and even stones were charmed to follow him, and rivers stopped flowing to listen. This transparent, harp-like maze of intersecting contours lures our eyes to follow and explore its mysteries.
Barbara Hepworth, Orpheus (Maquette 2) *(Version II). The Tate Gallery, London.*

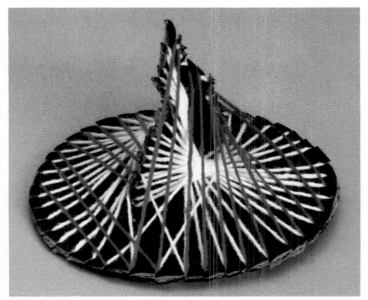

Children's Creative and Performing Arts Academy. San Diego, California

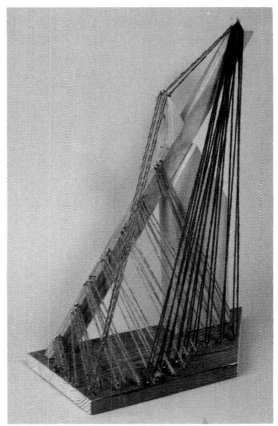

Martinsville East Middle School. Martinsville, Indiana

Instructions for Creating Art

1. Collect or cut some solid pieces of wood that have interesting curved or angular shapes. Nail or glue them in a **balanced** design on a base of plywood.

2. Study your arrangement, and identify how you can connect empty spaces and solid shapes by stretching string, wire, or yarn between them. As you begin to **perceive** a design using shapes and spaces, hammer rows of upholstery tacks or brads along the edges of the solid shapes.

3. Tie string, yarn, or wire to the first tack, stretch it to a tack in an opposite position, and wind it back and forth across the space, keeping your string or wire tight. As you wind, you will see a design beginning to emerge. If you aren't pleased with the design, simply unwind the string and redo it. Experiment with various winding strategies using different patterns, colors, and thicknesses of yarn, thread, or string. Discover how intriguing lines stretched across empty space can be.

4. When you are satisfied with your design, tie the string securely to the last tack. Place a dab of glue where the string winds around each tack to prevent the string from slipping. Display your finished string sculpture.

Art Materials

Plywood base	Box of upholstery tacks or brads
Assorted pieces of wood	Thin wire, yarn, string, thread, or nylon fishing line
Sandpaper	
Hammer and nails	Wire cutter
White glue	Scissors

Strand I: Sculpting, Modeling, and Carving

To evaluate your artwork, turn to the Learning Outcomes section at the back of this book.

131

58 *Art That Balances*

Observing and Thinking Creatively

In the 1930s, a new kind of art called **kinetic sculpture** was pioneered by Alexander Calder. Kinetic sculpture was part of a movement to overcome the limitations of working in two or three **dimensions** by incorporating a fourth dimension into art—motion in time. Alexander Calder experimented with bent wire and arrangements of flat pieces of wood and metal. From these experiments he invented the **mobile**, a form of sculpture that hangs in space and is moved by natural air currents. These mobile sculptures are forms in motion, constantly shifting and changing, assuming new relationships to each other, yet always maintaining a dynamic balance. The examples shown here by mobile-maker John Edwards demonstrate how all the pieces of the mobile are arranged very carefully so that they balance one another.

Symmetry is the simplest type of balance used in making mobiles. To create a symmetrically balanced mobile, you must hang pieces having identical size, shape, and weight at equal distances on both sides. More interesting effects can be achieved with **asymmetrical** balance by varying the sizes, shapes, weights, and positions of pieces. In this way, it is possible to obtain balance in both weight and appearance without having to create two identical sides. In this lesson, you will use interesting shapes to create a mobile that balances in space.

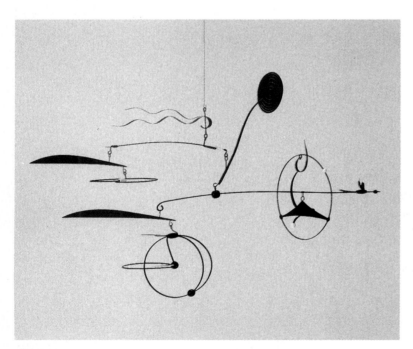

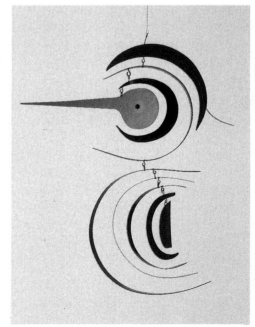

These mobiles capture the balance, fun, and surprise possible in mobile-making. In *Through the Storm,* the forms are rounded on both sides to catch air currents. The design suggests a variety of stormy cloud formations over a mountain, with the sun above. Note the bird scurrying to get out of the storm. In *Big Bird,* two sections of curved forms move in opposite directions from a common base. In a breeze, the sitting bird ruffles its feathers.

(Above) John Edwards, Through the Storm, *Aluminum and enamel. 48" × 32".*
(Right) John Edwards, Big Bird. *Aluminum and enamel. 34" × 34".*

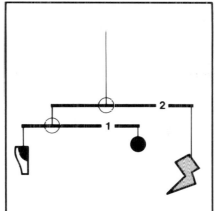

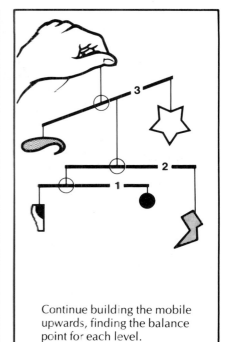

Attach two objects to mobile arm **1**. Loosely tie a string around the arm. Holding the arm by its string, move the string along the arm until you come to the point where the two objects balance. This is called the balance point.

Mobile arm **1** is now a single piece that can be hung from mobile arm **2**. Tie a string around arm **2** and attach another object to balance against arm **1**. Move the string until arm **2** is balanced.

Continue building the mobile upwards, finding the balance point for each level.

Instructions for Creating Art

1. Cut out pieces of cardboard in interesting shapes, or gather a collection of small objects of varying sizes and shapes that go well together. (See the Art Materials list for suggestions.) Use lightweight materials that can be attached to and hung from a wire framework or thin stick, which will form the mobile arm. You may want to make a hole or loop near the top of each piece so that you can hang it.

2. Decide on a fairly simple, interesting design for your mobile. Find a place to work where your mobile can remain hanging while you build it. Starting with the bottom level, build your mobile from the bottom up. Begin by attaching thread or fishing line to this arm of your mobile. Hang two or more of your pieces from the arm so that they look good and balance. Tape your pieces in place temporarily as you experiment with design and balance. Assymetrical balance is usually more interesting than symmetrical balance. When the pieces balance perfectly, attach them securely to complete the bottom level. (Read the directions under the illustrations for further clarification of how to build a mobile.)

3. Build the next level of your mobile, balancing the bottom arm with it. There will be a balance point on every level you add as you build

upwards. Your mobile should have at least three levels. As you work, make sure that the parts of your mobile move freely and do not collide with other parts. When you finish making your mobile, hang it from the ceiling and watch it gently twist and turn.

Art Materials

Stiff wire or straight sticks	Wire cutter
	Scissors
A collection of small, lightweight objects: plastic, aluminum, clay, thin wood, cardboard, or natural objects	Thread, fishing line, or fine string
	Cellophane tape
	Long-nose pliers

Strand I: Sculpting, Modeling, and Carving

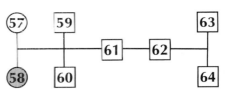

To evaluate your artwork, turn to the Learning Outcomes section at the back of this book.

133

59 Sculpting with Lines

Observing and Thinking Creatively

What do you picture when you hear the term **sculpture**? Perhaps you imagine a large, solid shape, or a delicately detailed carving. Actually, sculpture is simply three-dimensional art, and it can be either solid or hollow.

Many materials besides clay, wood, or other solid substances can be used to make sculpture. The examples shown in this lesson are made with wire. Wire is an interesting medium for making sculpture, because it can be used to create lines in space, giving the illusion of a solid object. In much the same way as you would draw

a line on paper, you can "draw" a **three-dimensional** line sculpture in space using wire that is long and thin, yet stiff enough to keep its shape when it is bent. Such wire can be wound tightly or arranged loosely. Different sculptors have their own ways of working with wire, as you can see from the examples shown.

Here is an opportunity for you to try working with wire to make sculpture in your own way. Every type of art is different, and each example in this book gives you an opportunity to discover new ways of creating your own kind of art.

American artist Alexander Calder studied art and engineering. These influences are evident in his playful studies in balance and design. Brass wire traces this portrait in space.

Alexander Calder, Marion Greenwood, *(1929-30), Brass-wire construction, 12⅝" × 11⅛" x 11⅜". Collection, The Museum of Modern Art, New York. Gift of the artist.*

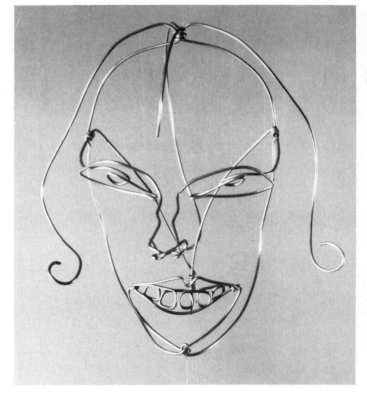

Thin wire wound around many times reinforces this unusual *Torso.* Circles and patterns inside the framework add interest. What do these designs suggest to you?

Harry Krammer, Torso. *The Tate Gallery, London.*

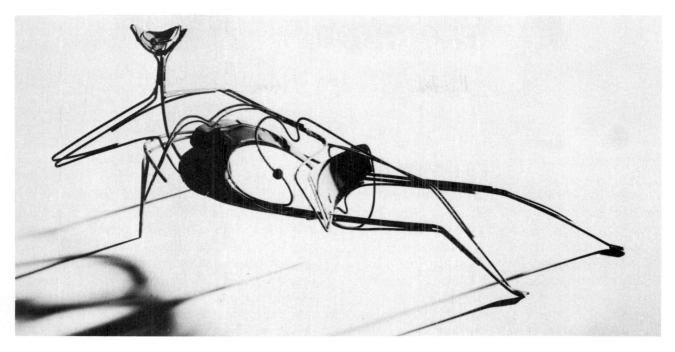

Imagine a relaxed figure resting on an invisible lounge chair. The semi-abstract sculpture above creates this impression, with overlapping wire lines forming the contours of the reclining figure. Notice how the wire sculpture balances at three points.

Reg Butler, Study for Woman Resting, *1950, Bronze. The Tate Gallery, London.*

Instructions for Creating Art

1. Use wire that is thin and soft enough to be pliable, yet holds its shape fairly well. Holding your wire in both hands, imagine it beginning to move. One end of it may coil out from the rest, beginning to form the outline of a familiar shape or abstract design. What shapes can you imagine making from your wire? Try manipulating the wire in various ways to see what interesting shapes you can create.

2. When you have an idea of what you want to make, take one end of the wire and begin forming your design. Any space you can capture within the outlines of your wire "drawing" is yours to use creatively. Sculpt with the wire as if you were drawing without lifting your pencil from the paper. Your main shape will be formed from one continuous length of wire, rather than from attaching short pieces together. Use short pieces of wire as braces for stability, and to help hold your form in place; twist them around like the barbs in barbed wire. You will obtain the best results if you form the main outlines of your shape first and then go back later to fill in details.

3. When the sculpture is about half-finished, hang it from a piece of thread. Look at it

carefully and move it around to make sure it looks good from all angles.

4. Complete your sculpture so that it captures space and directs the eye in a novel and intriguing way, combining openness with the illusion of a solid form.

Art Materials

Wire (aluminum or copper)	Wire cutter
	Thread
Tape (for joining wire)	Pliers

Strand I: Sculpting, Modeling, and Carving

To evaluate your artwork, turn to the Learning Outcomes *section at the back of this book.*

60 Skeleton Sculpture

Observing and Thinking Creatively

Perhaps you have experienced the frustration of making a clay figure whose arms or legs kept drooping because they were heavy and lacked support. Certain kinds of sculpture need something inside to hold them up, just as people need bones to support their flesh. Thus, sculptors will use thick wire or metal pipe to provide an inner skeleton, or **armature**, inside a sculpture to maintain its shape and add support. For smaller sculptures, wadded newspaper or chicken wire

is sometimes used. Once an armature in the basic skeletal form has been made, a sculptor builds it up with clay, plaster of paris, or papier-mâché to form the desired shape.

If you observe the pieces of sculpture shown in this lesson, you will see different styles used in making sculpture. When you make your sculpture, experiment with ways of modeling over the armature. In this way, you will develop your own individual style.

The entire weight of this bucking horse rests on two thin legs attached to a flat base for support and balance. Can you imagine the armature for the clay sculpture this bronze cast was made from? Note the realistic, rugged detail of its surface textures.

Frederic Remington, Bronco Buster, *1905, Bronze, 32¾ x 29¼". Courtesy of The Art Institute of Chicago, Gift of Mr. Burr Robbins. 59.214*

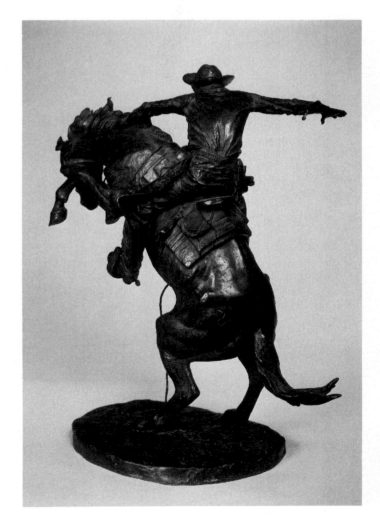

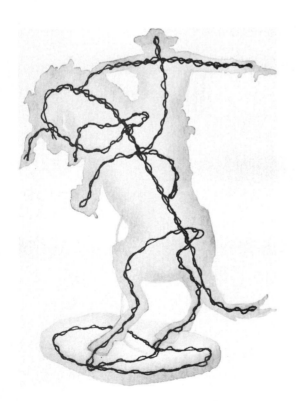

We sense the faltering balance as we see every muscle of this boxer straining to recover from a stunning blow, in the suspense re-created in this dramatic pose.

Mahonri Young. Groggy. 1926. Bronze. 14¼ × 8¼ × 9½ inches. Collection of Whitney Museum of American Art. Acq#31.82

Instructions for Creating Art

1. Think about how people look when they are running, dancing, or throwing a ball. Bend a piece of wire into the shape of a person in motion, forming an armature about ten inches high. Twist or tape other pieces of wire to the main wire to make your armature strong. Nail or staple your finished armature to a piece of wood, so that it will stand up by itself.

2. Cover your armature with clay, *plaster of paris,** or *papier-mâché** until it has been built up to the proper thickness for each part of the body. Model your figure to show the direction of the body movement, keeping in mind the way the body's weight would be balanced above the feet.

3. When you have modeled the main frame of the body, you may begin sculpting the smaller features. Form the face, then the hands and feet. Add details such as clothes, hair, and the expression on the face. At this stage, you should not attempt to bend or move the armature or the main frame of the body. To do so would probably result in permanent cracks in your finished sculpture.

4. Apply necessary surface textures to your nearly finished sculpture. Use textures which enhance the realism, overall feeling, or expression of your piece. The textures you use may be smooth and streamlined, rough and windblown, or coarse, scratchy, and earthy.

*For an explanation, turn to the How to Do It section at the back of this book.

Art Materials

Thick, soft wire	Simple clay tools
Masking tape or string	Wire cutter, pliers
Wood stapler or hammer and nails	Newspaper strips and wheat paste (for papier-mâché)
Wood base	Newspaper or plastic (to cover work area)
Oil-based clay or plaster of paris	Water, paper towels

Strand I: Sculpting, Modeling, and Carving

To evaluate your artwork, turn to the Learning Outcomes section at the back of this book.

61 Portrait in Clay

Observing and Thinking Creatively

When you look at a painted portrait of someone, you see one view of the person's face. Because a sculpture of a head is three-dimensional, though, you can observe it from different angles. Yet, when a sculptor models a **portrait**, the result shows more than just the shape of someone's head. The artist tries to indicate the character of the person who is being modeled. Sculptors also show their special way of working—their **style**—in their portraits. Some of them model the clay so that it looks exactly like human skin and bone. Others leave the surfaces rough. You have probably seen both styles in museums and in photographs of clay portraits.

Portrait sculptures are often originally modeled in clay. But because clay breaks easily when it is dry, clay models must be **cast** in **bronze** or carved in marble. Once sculpture is cast in bronze or carved out of a strong material, it will last for a very long time.

In this lesson, you will make a model of a head that not only shows correct proportions but also captures the person's individual features, personality, and facial expression. As you work, turn the model constantly to make sure that it looks right from all angles.

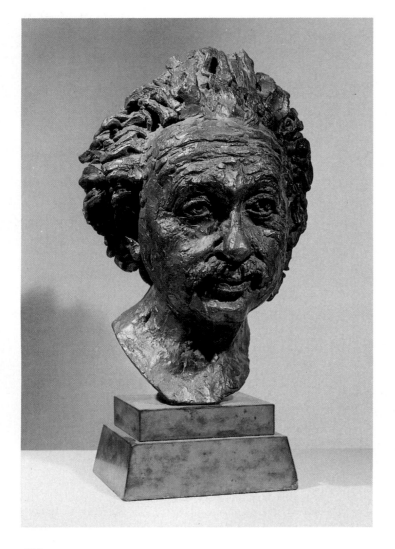

The rough surface of this sculptured portrait reveals that it was made of soft clay before being cast in bronze. Bits of clay were added to emphasize the lines in Einstein's face and capture the thoughtful gaze of the genius when he was an old man.
Sir Jacob Epstein, Albert Einstein. *The Tate Gallery, London.*

Art and culture flourished during the Golden Age in Greece. Sculptures, like this bronze charioteer, portrayed an idealized, classical beauty.

Detail of Auriga Satades, Bronze statue of charioteer, c. 470 B.C., Delphi Museum. Greece. Scala/Art Resource.

Fine details of facial expression and hair were exquisitely carved in marble to portray this Roman emperor.

Anonymous Roman, Bust of Septimius Severus (Detail). A.D. 159-211, Marble. Courtesy of the Indiana University Art Museum.

Instructions for Creating Art

1. Decide whom you are going to use as a model for your clay portrait. Then prepare two or three handfuls of *clay** so that it is ready to work with. If you are using water-based clay, be sure it is well mixed. If you are using oil-based clay, soften it by squeezing it in your hands. Take half of your piece of clay and form it into a large, egg-shaped ball. Add a piece at the bottom for the neck.

2. Study the **proportion** guides for drawing a head in Lesson 8. Also observe the portraits in this lesson and notice the proportions of the heads. Draw light guidelines on your clay head to indicate approximate locations of all the features. Be sure not to trap bubbles of air inside as you add pieces of clay to the nose, forehead, cheeks, and chin. Hollow out the eye cavities, form the mouth, and mold the shape of the ears.

3. Set your work on a turntable or piece of cardboard so that you can turn it around frequently, keeping the proportions correct from all angles. Study the shape and expression of the eyes and eyebrows. Look at the angles of the chin, forehead, cheekbones, and nose. Check the position of the ears. Work the clay to form it into just the right **contours**.

4. If you are using water-based clay and need to keep your sculpture moist so you can

continue working on it later, store it in a plastic bag along with a damp paper towel.

5. When the features are approximately correct, begin applying surface textures, such as hair, eyebrows, wrinkles, smooth cheeks, and lip lines. Use *carving tools,** combs, toothpicks, and other items to create these textures.

**For an explanation, turn to the How to Do It section at the back of this book.*

Art Materials

Clay (water-based or oil-based)	Simple clay tools, knife
	Plastic bag
Newspaper (to cover work area)	Water, paper towels
Piece of cardboard	

Strand I: Sculpting, Modeling, and Carving

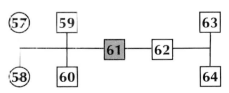

To evaluate your artwork, turn to the Learning Outcomes section at the back of this book.

62 *Hand Sculpture*

Observing and Thinking Creatively

One way to appreciate a fine piece of sculpture is to look at it from all angles, observing how the solid form changes as you view it from different positions. You may also want to reach out and touch its smooth lines or jagged edges. In this lesson, you will create a piece of hand sculpture designed not only for its visual appeal but also for its appeal to your sense of touch.

Sculptors work in two main ways. They may join materials such as wood, clay, or metal together to build their design. This is called **additive sculpture**, because it is formed by *adding* pieces together. Or, they may begin with a solid lump of stone, wood, or plaster and cut or carve pieces away. This is called **subtractive sculpture**. Your sculpture for this lesson will be a subtractive sculpture—cut, carved, or chiseled out of a material of your choice, such as a bar of soap, a piece of plaster, or soft wood.

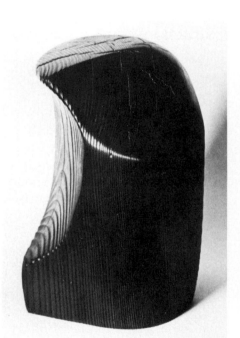

Courtesy of Tya Hanna

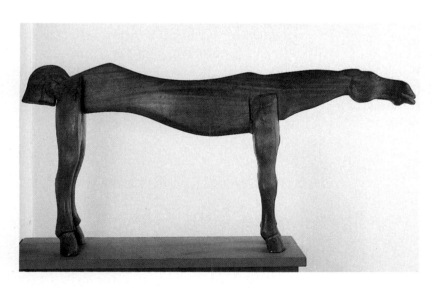

The smooth grain of the wood in Alexander Calder's walnut horse looks irresistible to the touch. Is this an additive or subtractive sculpture? What qualities of the animal are emphasized in this unusual pose?

Alexander Calder, The Horse, *1928, Walnut, 15½ x 34¾". Collection, The Museum of Modern Art, New York. Acquired through the Lillie P. Bliss Bequest.*

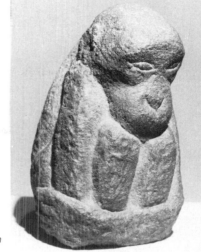

Rough edges have been carved away to form the smooth curves and contours of *Chimpanzee*. Note how the simplified shape captures the essence of the animal's form. How does the hard, stony grain of the granite add to its overall effect?

John B. Flannagan, Chimpanzee, 1938, Granite, 10¾" × 8" × 6¾". Collection of Whitney Museum of American Art, New York. Acq#31.22.

Instructions for Creating Art

1. Select the material you will use for your subtractive sculpture. See the Art Materials box for suggestions.

 Study the texture and grain of your material and cut or *carve** the surface to learn what tools work best with it and how it is likely to chip or break away as you work. You may want to *very gradually* remove sharp corners as you explore your material in this experimental stage. When using a knife or sharp instrument, always be sure to cut *away* from your fingers, and keep them behind the blade. Be careful, and avoid accidents.

2. Begin thinking of a form for your sculpture. You may choose to make a realistic shape, such as an animal, or an abstract form that looks and feels interesting. Feel your material, and imagine the form that could be hiding inside it.

3. When you are ready, begin carving or cutting to create your form. Make small cuts, remembering that you can't put anything back if you accidentally cut off too much. Turn your block around as you work to view your sculpture from all sides. If your material has a **grain**, plan your cuts to go with or against the grain to achieve the effects you want. Imagine that you are allowing the natural form of the material to emerge.

4. Stop often to examine your sculpture from all angles. *Think* in three dimensions, and make sure your carving is equally pleasing, balanced, and interesting from every viewpoint. Remember that your finished sculpture should feel wonderful in your hands.

5. When you have arrived at your basic form, add textures that will make the sculpture even more interesting to touch. You may want to carve lines, holes, pinpoints, crosshatches, or ridges, or you may prefer a smooth, soft surface that is sanded or filed. Finish the surface of your sculpture so that it feels good to the touch. If you wish, add a final finish to your sculpture with paint glaze, shellac, or other finishing polishes.

**For an explanation, turn to the How to Do It section at the back of this book.*

Art Materials

Block for carving: paraffin wax, soap, plaster, clay, soft wood, wet firebrick, soapstone, etc.

Cutting tools: knife, rasp, chisel and mallet, file, etc.

Sandpaper

Polish (if desired) for final finish: paint glaze, shellac, varnish, etc.

Brushes, paint thinner or solvent (optional)

Newspaper (to cover work area)

Strand I: Sculpting, Modeling, and Carving

To evaluate your artwork, turn to the Learning Outcomes section at the back of this book

63 *Abstract Carving*

Observing and Thinking Creatively

Sculptors, more than any other artists, work with surfaces. Sometimes, when they study the real surfaces of forms, they simplify them in their artwork, using flat surfaces called **planes**. Artists who prefer to create using **subtractive sculpture** —carving away unwanted parts of a solid block to reveal the form perceived to be hiding inside —carefully study their subject before they begin. They analyze its physical structure, its unique quality or feeling, and the relationship of the planes which make up its shape. A sculptor studies the planes that might be created and thinks about how they will reflect light to show light and dark areas. When all the planes seem perfectly fitted together, the sculpture is **unified**.

In this lesson, you will carve a sculpture showing a simplified form of an animal or a person. Make the subject of your sculpture clear, so that people can recognize what it is. But rather than trying to make it look realistic, emphasize the design of the planes by simplifying what you see. In this way, you will create a work of **abstract** art.

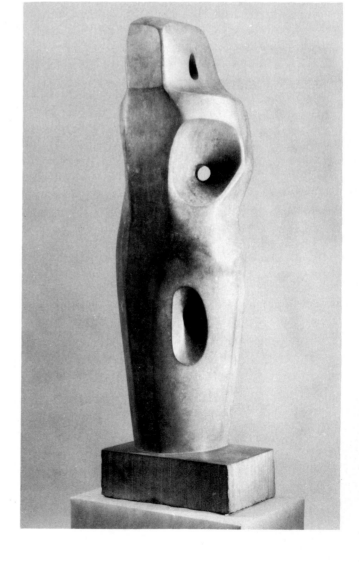

English artist Barbara Hepworth's abstract sculpture could resemble a human figure. What else might it express to you? The holes let us see into the stone to give it a sense of depth, while the smooth surface makes us want to touch it.

Barbara Hepworth, Bicentric Form, *1949, Stone, 12.25" × 62.5" × 19". The Tate Gallery, London.*

The tranquillity of Zen inspired American artist Isamu Noguchi's creation of this pure abstract marble sculpture. What might the form represent?

Isamu Noguchi, Bird C. (Mu). (1952-58). Greek marble, 22¾" × 8⅛". Collection, The Museum of Modern Art, New York. In memory of Robert Carson, architect (given anonymously).

Bedford Junior High School. Bedford, Indiana

Instructions for Creating Art

1. Prepare a block of fairly soft carving material. See the Art Materials list for different materials to carve, and the *How to Do it* section at the back of this book for carving techniques.

2. Decide on a subject for your carving—either an animal or a person. It should be a shape that will take up most of the block. The form you choose should be one that can be carved with flat, simplified planes in an **abstract** style.

3. Draw the side view outline form along the edges of your carving block. Draw guidelines on each side to mark where to carve it. Begin carving slowly and cautiously at first, getting the feel of your material and tools. Whenever carving with a knife or working with any sharp instrument, keep your fingers behind the blade and move the blade *away* from your fingers. Rotate your block as you work, and constantly visualize how your sculpture will look from all angles.

 Gradually develop all the flat and curved planes of your sculpture. Observe how they reflect the light. Angle your surfaces to create interesting patterns of reflected light.

4. When your main surfaces have been formed, work on the smaller features and details. Round off unwanted corners, and smooth the sculpture with sandpaper, if you like.

Art Materials

A block to carve: plaster of paris, soft wood (white pine, balsa, etc.), paraffin wax, firebrick, fairly hard clay, etc.	Pencil and eraser Carving knife Rasp and sandpaper Newspaper (to cover work area)

Strand I: Sculpting, Modeling, and Carving

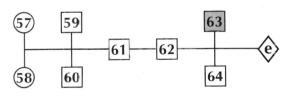

To evaluate your artwork, turn to the Learning Outcomes section at the back of this book.

143

64 The Sculpture of Henry Moore

Observing and Thinking Creatively

One of the most famous sculptors of this century is Henry Moore. He was born and raised in England, where he has continued to study and teach art throughout his life. In his early career, he became intrigued with **abstract** art, especially the relationship of solid forms and spaces, and began to carve simplified shapes based on real objects. The hallmark of his abstract forms is the use of holes, or **voids**, in his designs.

Many of Moore's abstract carvings represent images of people and forms in nature. For most of his life, he collected objects from nature —shells, pebbles, pieces of rock, bones, and the like—to observe and use as creative starting points for his sculptures. If you observe the pictures of his works shown here, you can see how these natural forms are reflected in the smooth, rounded surface textures that beckon to be touched. The simple lines, solid shapes, interesting textures, and use of spaces are interconnected and **unified** in each piece of sculpture.

In this lesson, you will have an opportunity to gather and study natural objects as Henry Moore did. Using these objects as your creative starting point, you will carve a sculpture that is smooth and rounded, in the style of Henry Moore.

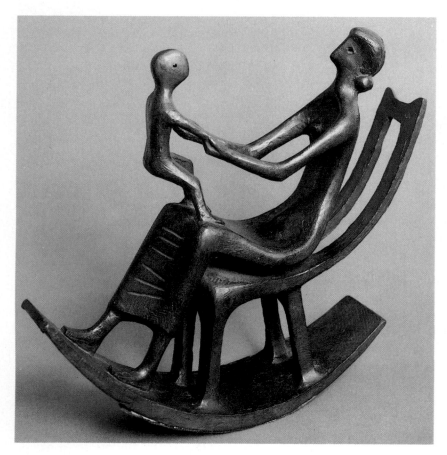

Henry Moore's *Rocking Chair No. 2* was based on a childhood memory. Notice how the position and shape of the head establish proportions for the rest of the sculpture and reveal character.

Henry Moore, Rocking Chair No. 2, 1950, Bronze. Hirshhorn Museum & Sculpture Garden, Smithsonian Institution. Scala/Art Resource, New York.

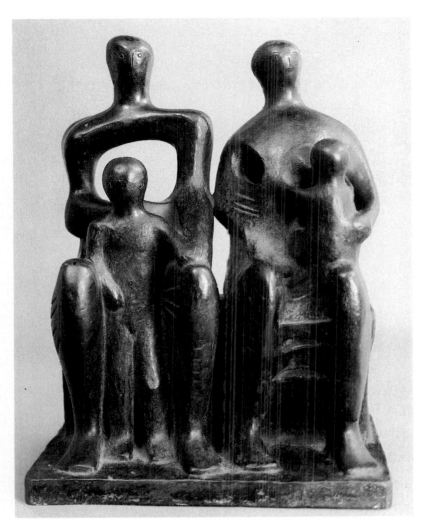

Family Group portrays a warm domestic scene. Moore's use of holes developed from a desire to emphasize three-dimensional forms through creating dramatic spaces. Which forms are emphasized by spaces in this sculpture?

Henry Moore, Family Group, 1946, Bronze. Hirshhorn Museum & Sculpture Garden, Smithsonian Institution. Scala/Art Resource, New York.

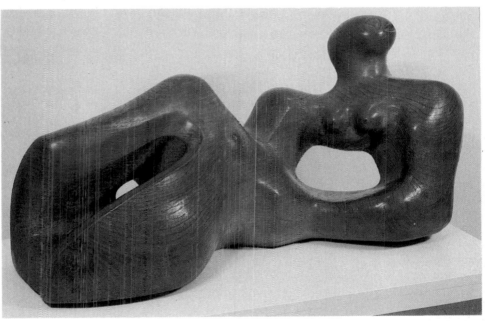

In his *Reclining Figure*, Henry Moore suggests a feeling of confidence and strength. Spaces give definition to the massive figure, and the shiny, smooth wooden surface invites our eyes to glide around the abstract form.

Henry Moore, Reclining Figure, 1935-36, Elmwood, 19" × 35" × 15". Albright-Knox Art Gallery, Buffalo, New York. Room of Contemporary Art Fund, 1939.

Azalea Middle School. St. Petersburg, Florida

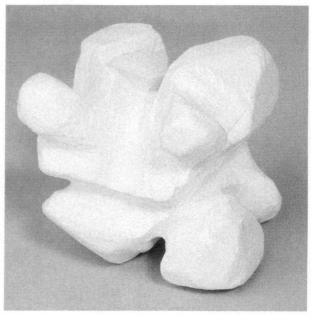

Unionville Middle School. Unionville, Indiana

Instructions for Creating Art

1. Decide on a material to use for your sculpture. You may want to mix *plaster of paris** in an empty milk carton and let it set until it is ready to carve. You can use water-based clay, if you prefer that medium.

2. Collect objects from nature—rocks, pebbles, pieces of wood, bones, etc.—as Henry Moore did. Study their shapes and surface textures. Feel the objects with your fingers. Use your imagination to **visualize** how these forms might represent other real objects. Does a piece of driftwood remind you of a reclining figure? Perhaps a rounded pebble looks like the shape of an animal.

3. Using your natural objects as starting points, decide on a subject to carve. You may want to carve an animal, a person, or an abstract shape that is interesting to look at and feel. Observe the pictures of sculpture by Henry Moore for ideas.

4. Make light guidelines on your piece of plaster or clay, showing the outline shape you want to carve. Begin cutting away only those parts you are sure about. Remember that you cannot replace pieces once they are removed. Be sure to use your *carving tools** carefully so that you are cutting away from your body and your fingers. Gradually cut away more pieces as you become sure about your design.

Consider how to use spaces or voids in your sculpture, after the style of Henry Moore.

5. When you have almost finished, round and smooth all the edges of your sculpture. Be sure that all the elements in the work are unified in your abstract art.

For an explanation, turn to the How to Do It section at the back of this book.

Art Materials

Plaster of paris or water-based clay	Carving tools
	Pencil
Objects from nature: pebbles, rocks, driftwood, shells, etc.	Rasp or sandpaper
	Newspaper (to cover work area)

Strand I: Sculpting, Modeling, and Carving

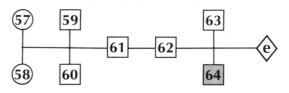

To evaluate your artwork, turn to the Learning Outcomes section at the back of this book.

Exploring Art

A Sculpture for Outdoors

Henry Moore, the famous English sculptor, has created many different kinds of abstract sculptures that vary in size, subject matter, and material. If you observe his work in Lesson 64, you will note that some of his pieces are large and some are small; some are carved out of wood, while others are made from bronze. As with all artists, sculptors strive to use a **medium** that best depicts their subject matter. The size of the art, however, is a matter of preference and depends on where the artist intends the sculpture to be displayed. Henry Moore prefers his large sculptures to be outdoors, displayed against a natural setting. Recently, he has helped to create a "museum without walls" by placing many of his sculptures in various New York City parks.

Other sculptors, such as Picasso, Bufano, Calder, and Vigeland also have designed outdoor sculptures. Some of their works are created to harmonize with natural surroundings. Others are made to enhance man-made structures, such as hotels and skyscrapers.

For this activity, imagine a place where you think an outdoor sculpture could go. This place might be a park, shopping center, playground, or school in your community. If possible, observe the place and make notes about special features of the area, such as the amount of open space, the size of buildings, and the placement of trees. Then make a sketch for the kind of sculpture you envision in this place. Your sculpture can be realistic or abstract. Whatever you design, make sure that it blends in with both the man-made environment and the natural surroundings.

When your sketch is complete, carve a **small-scale** model of your sculpture out of soft *wood, plaster of paris,* or *clay.**

*For an explanation, turn to the How to Do It section at the back of this book.

Pablo Picasso's art is so original and unusual that it was often received with a mixture of public acclaim and controversy. This five-story-high steel sculpture was specially designed for a renovated plaza in Chicago. What does it remind you of?
The Chicago Picasso

Space Needle with Fireworks, *Seattle. Will Landon/Aperture PhotoBank.*

Unit V

Art in the Environment

Those in the modern society who find sky, mountains, earth, water, grass, and clouds lost or distorted because of urban developments must look closer and deeper to find beauty. . . . The world is no less full of wonderment than it ever was.

David Winfield Willson

Do you think of art as being a key part of your environment, or something special and separate that you can see only in books and museums? Art is all around us, in the architecture of a church or skyscraper, the landscape design of a city park, and the smooth curves of an outdoor fountain sculpture.

People throughout the ages have beautified their surroundings with man-made forms, designs, and structures that work in harmony with the natural environment to create pleasant living spaces. In both the ancient and modern cultures of China and Japan, for example, the art of landscaping is a disciplined, creative endeavor as demanding and valued as the arts of painting, sculpture, and calligraphy. In many societies, past and present, the arts of architecture, sculpture, and painting have been used to create temples, churches, and monuments that alter the environment and fill people with a sense of awe. For many reasons, people have used their skills to change the face of their natural surroundings with man-made structures and other additions. When such additions blend in harmoniously with the natural environment, the result is similar to the unity of composition achieved in a successful painting or other work of art.

In this section, you will increase your awareness of the many ways that art can interact with the environment. You will study architecture and see how it can be used to create and enhance new living spaces. In the lessons that follow, you will learn some of the methods people have found for blending art with environment harmoniously, and you will explore how these methods have been used in your own surroundings. Art is everywhere. Look closely and you will find beauty all around you—in your city or town, community park, and even in your own neighborhood.

149

65 Farms and Plantations

Observing and Thinking Creatively

The early American settlers worked hard to clear their lands and establish farms and plantations, and many wanted a picture of their homes and the surrounding countryside. Cameras had not yet been invented, so **landscape** artists were called on to paint these scenes.

No matter how an original scene actually looked, landscape artists would compose a balanced, well-designed view of it. Sometimes they would bring together scattered elements of animals, buildings, and lands so they could all be seen in one view. They showed **foreground** objects by making them larger, more vividly colored, and more sharply detailed. Distant objects,

such as mountains or forests, were only suggested by vague, faint shapes in lighter colors.

Landscape artists would carefully observe the direction of lines made by fences, paths, ponds, roads, and plow and crop patterns in a scene. They would notice whether the soil was composed of clay or red or black dirt, and would record whether the land was rocky, grassy, barren, flat, or hilly. The season of the year, time of day, and appearance of the sky were also important considerations.

In this lesson, you will use line, texture, and perspective, along with your visual memory, to create a landscape drawing or painting.

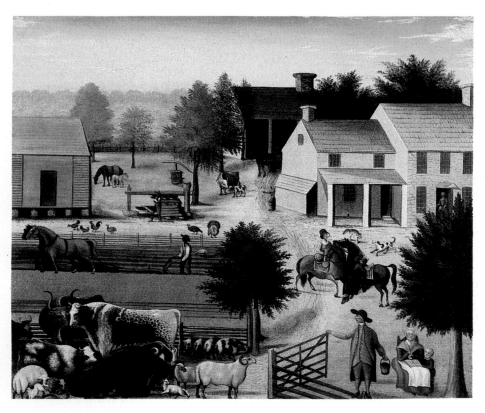

Edward Hicks painted his Pennsylvania childhood home from memory. When his mother died, Hicks was raised by the Twining family. The seated woman is Elizabeth Twining, reading Scriptures to little Edward Hicks. How many techniques of perspective can you identify in this painting? What makes it a good design?

Edward Hicks, The Residence of David Twining 1787, *Oil on canvas, 1845-48. Abby Aldrich Rockefeller Folk Art Center, Williamsburg, Virginia.*

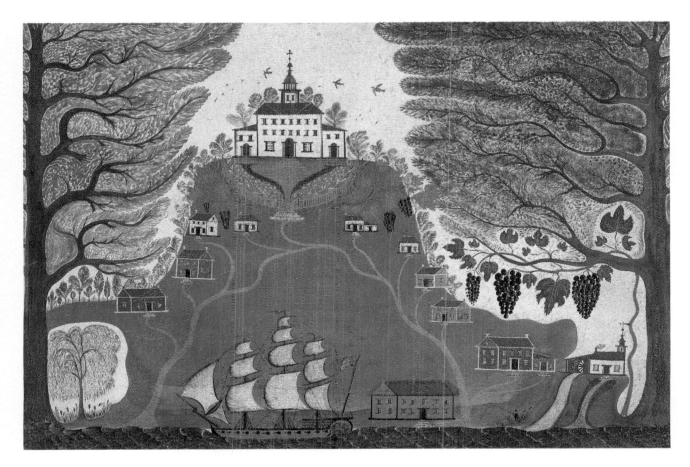

Colonial plantations supported lavish life and luxuriant growth, as the artist has represented symbolically in this stylized painting. This one had its own dock for trade with English ships. What design function do the two trees in the foreground serve?

Unknown American artist, The Plantation, c. 1825, Oil on wood. The Metropolitan Museum of Art, Gift of Edgar William and Bernice Chrysler Garbisch, 1963. (63.201.3)

Instructions for Creating Art

1. Look at the landscapes in this lesson, throughout this book, and in other art books. Choose a picture to study, and try to remember everything in it. When you think you have memorized the picture, put it away.

2. Now, test your visual memory by making a drawing of the picture you just studied. Before you begin, you might wish to make a list of everything you remember about the picture. When you have drawn everything you remember, look at the original painting again.

3. Find any parts you left out of your drawing and study them carefully. Then put the painting away and, from memory, add the missing parts to your drawing. If you wish, add color to your landscape, using a **medium** of your choice. Making pictures in this way will improve your visual memory so that you will remember more about what you observe.

Art Materials

Pictures of landscapes	Your choice: paints and brushes, oil pastels, colored pencils or markers, etc.
Drawing paper	
Pencil and eraser	

Strand J: Studying Places and Buildings

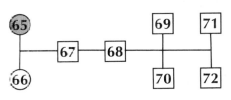

To evaluate your artwork, turn to the Learning Outcomes section at the back of this book.

66 The Wild, Wild West

Observing and Thinking Creatively

The wild West, with its explorers, buffalo hunters, trappers, cowboys, Indians, settlers, rustlers, and U.S. cavalry, has been the setting for hundreds of movies and stories. It has also been a popular subject for many artists, who based their work on actual scenes as well as imagined adventures.

The most famous Western artists include George Catlin, Charles Marion Russell, Charles Wimer, Albert Bierstadt, and Frederic Remington. Wimer visited Indian villages and painted scenes from Indian life. Bierstadt traveled with wagon trains across the prairies and through the Rocky Mountains, recording those experiences in his art. Catlin is famous for his portraits of great Indians. Remington and Russell painted exciting pictures about life on the prairie. The picture showing a wagon train being attacked as it crosses a river is an example of Remington's work. He also produced excellent sculptures showing the action of cowboys on horseback. (See Lesson 60.)

In this lesson, you will use concepts from Western art to paint a picture.

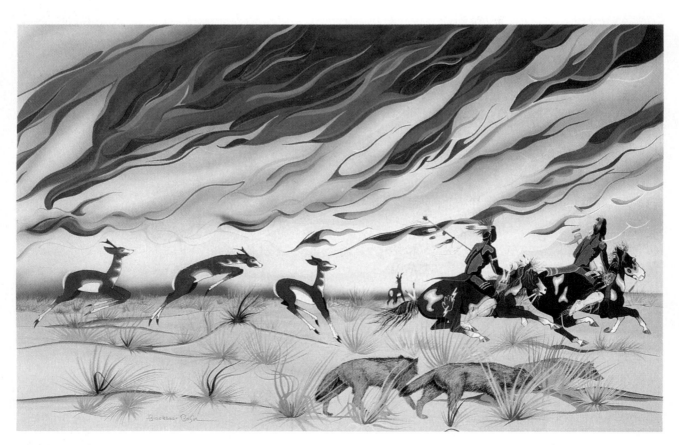

The raging fury of a rampaging *Prairie Fire* and the panic of flight are captured by Indian artist Blackbear Bosin through the use of simple lines, flat shapes, and few colors. Contrast the dull, dry colors of the ground and grass with the wild, flame-filled sky. What does the red haze at the horizon suggest?

Blackbear Bosin, Prairie Fire. *Philbrook Art Center, Tulsa, Oklahoma.*

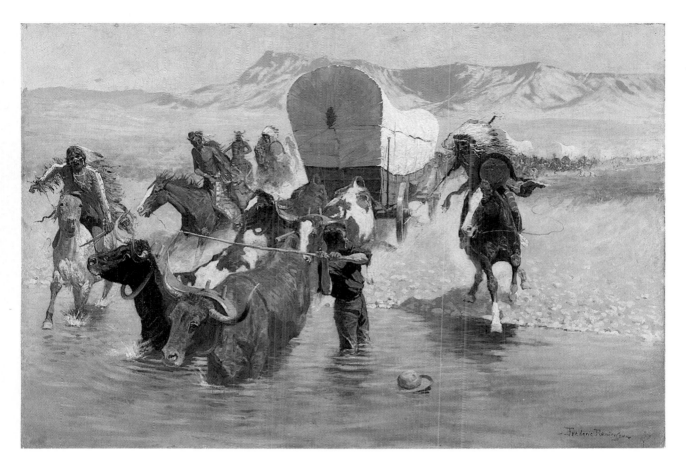

Frederic Remington traveled widely through the West to record a visual history of its vanishing drama. His pictures revel in the swift action and wild adventure of cowboys and Indians on the open range. Note the expert portrayal of accurate detail in the foreground—floating hat, Indian clothing, and splashes of the animals' plunging feet, fading to a blur in the distance. Can you tell the position of the sun from the direction of the shadows?

Frederic Remington, The Emigrants, *1904, Oil on canvas, 30¼ × 45". Museum of Fine Arts, Houston. The Hogg Brothers Collection.*

Instructions for Creating Art

1. Study the examples of wild West art in this lesson and in other books and magazines. Notice the shape of the covered wagon, the clothes people are wearing, the way animals are depicted, and other details you might use in your painting. Observe how rocks and grass are painted, and what techniques are used to make mountains seem distant. Compare and contrast the styles of the two paintings shown here.

2. Now draw your own wild West scene. It can be an action picture or a Western landscape. You may use ideas from paintings you have studied, but the picture should be your own original work. When your drawing is finished, paint your scene.

Art Materials

Scenes of the wild West	Paints and brushes
Pencil and eraser	Mixing tray
Drawing paper	Water, paper towels

Strand J: Studying Places and Buildings

To evaluate your artwork, turn to the Learning Outcomes section at the back of this book.

67 *John Marin's New York*

Observing and Thinking Creatively

When people think of New York, they often think of skyscrapers, the Statue of Liberty, museums, big ships, and Central Park. With its many styles of architecture and sculpture, New York City is rich in different kinds of art and design. John Marin, an important American artist, painted many different views of New York, where he lived for a time.

Artists all over the world have drawn and painted their hometowns or places they especial-

ly liked. Some artists paint in a **realistic** style, reproducing exactly what they see. Other artists portray the idea or feeling they have about what they see; their pictures are more **abstract**, as John Marin's are.

In this lesson, you will make sketches of places in your hometown that are special to you. Then you will develop one sketch into a finished picture that tells about your community.

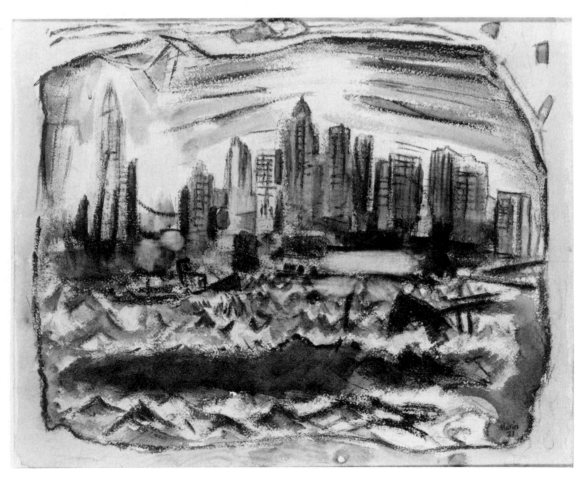

John Marin was one of the first American artists to paint in a modern style, picturing realistic scenes in an abstract way. In this view of New York, he has used quick brushstrokes to portray the movement and energy of wind blowing across the water. What technique has he used to depict buildings in the background?

John Marin, Lower Manhattan from the River, No. 1, Watercolor. The Metropolitan Museum of Art, Alfred Stieglitz Collection, 1949. (49.70.122)

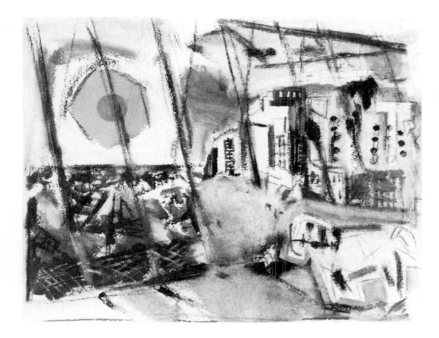

Bold, angular lines are a feature of John Marin's style. Here, the diagonal brushstrokes show the heavy support wires of the Brooklyn Bridge. Notice the area that has been scratched through the watercolor wash to give the impression of a metal grating. What feeling does this painting give you about John Marin's New York?

John Marin, The Red Sun–Brooklyn Bridge, 1922, Watercolor. Courtesy of The Art Institute of Chicago, Alfred Stieglitz Collection. 49.561

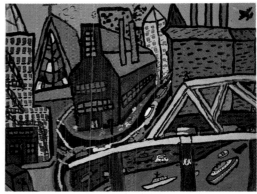

International Collection of Student Art, Illinois State University. Normal, Illinois

Instructions for Creating Art

1. Think about your hometown. What does it look like? Are there factories, railroads, farms, shipyards, docks, famous buildings, or favorite places where people gather? Is it usually quiet, or noisy? Are the people friendly? What kinds of jobs do most people have? What do you like best about your hometown? Explore these and any other questions that might help you create a realistic or abstract picture that tells about your community.

2. Next, make small, quickly drawn **sketches** of ideas you have about your town. Use your sketches to capture what you feel are the important aspects of your hometown.

3. Using the sketch you like best, develop a larger, finished picture. You may use paint, colored markers, pastels, or colored pencils. Add a title to your picture that tells the place you have represented.

Art Materials

Your choice: paints and brushes, pastels, colored markers or pencils

Drawing paper

Pencil and eraser

Strand J: Studying Places and Buildings

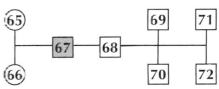

To evaluate your artwork, turn to the Learning Outcomes section at the back of this book.

155

68 *I Know That Place*

Observing and Thinking Creatively

Suppose someone told you something you wanted to remember. What could you do to help yourself remember? You would probably take notes that you could refer to later. A similar approach is used in art. But when you want to remember something you see, you make sketches instead of writing notes. Many well-known artists fill sketchbooks with quick drawings and sketches of the things they observe. Sometimes they make brief notes next to their sketches about specific details such as colors and sizes.

Making sketches helps you learn to observe more closely as you become aware of details in your surroundings. It also improves your **visual memory**, because sketching reinforces what you see and enables you to recall specific details.

It is easy to walk or ride by the same houses, stores, and gas stations every day without really noticing what they look like. In this lesson, you can find out how aware you really are by using your visual memory to draw a place that you think you know well.

This scene is so full of details that it feels like a familiar place. More than a photograph could, Richard Estes' painting emphasizes every exact detail. Notice the reflections on the curved and flat surfaces. Why might an artist create a painting like this?

Richard Estes, Drugstore, 1970, Oil on canvas. Courtesy of The Art Institute of Chicago. Edgar Kaufmann Restricted Gift, 20th Century Purchase Fund. 1970.1100

Japanese student art

Spring Hill Middle School, Knoxville, Tennessee

Instructions for Creating Art

1. Think of the buildings in your neighborhood, school area, or downtown. Choose a building that you think you know well and write down everything you remember about it. It should be a building that you can get to easily.

2. Now fill a piece of paper with a drawing of the place you described. Check your list of details to make sure you have included everything you remember. Make your drawing as complete as you can, relying on memory alone.

3. As soon as possible after you have finished your drawing, go to the place you drew and see if you remembered everything about it. Did you draw the windows and doors accurately? Are there details you left out? Make sketches and take notes so that you can add these details to your drawing later. When you are satisfied with your "corrected" drawing, color it with the **medium** of your choice.

Art Materials

Pencil and eraser	Mixing tray
Drawing paper	Newspaper (to cover work area)
Your choice: paints and brushes, colored markers, or oil pastels	Water, paper towels

Strand J: Studying Places and Buildings

To evaluate your artwork, turn to the Learning Outcomes section at the back of this book.

69 A Greek Temple

Observing and Thinking Creatively

The **Parthenon,** pictured below, was built about 440 B.C., and is one of the most famous of all ancient buildings. It was built in Athens, Greece, as a temple to the Greek goddess Athena. Only the ruins of the temple are left today, but models have been reconstructed to show it as it orginally existed.

The Parthenon was built in the same style as many wooden buildings of that period, but it was made completely of marble. Its slanted stone roof rested on flat beams of stone called **lintels**. This immense weight was held up by marble **columns**, or posts. Joints were secured with

marble pegs. A line of carved figures and statues, called a **frieze**, decorated the space just under the roof and went around the entire building. At each end was a triangular space, the **pediment**, which was also filled with carved figures. All these parts can be seen on the model of the Parthenon shown on the next page.

The Greek style of architecture is still popular and is often used in modern designs. Are there houses or buildings in your town that show the influence of ancient Greek architecture?

In this lesson, you will make a sketch of a building with Greek features.

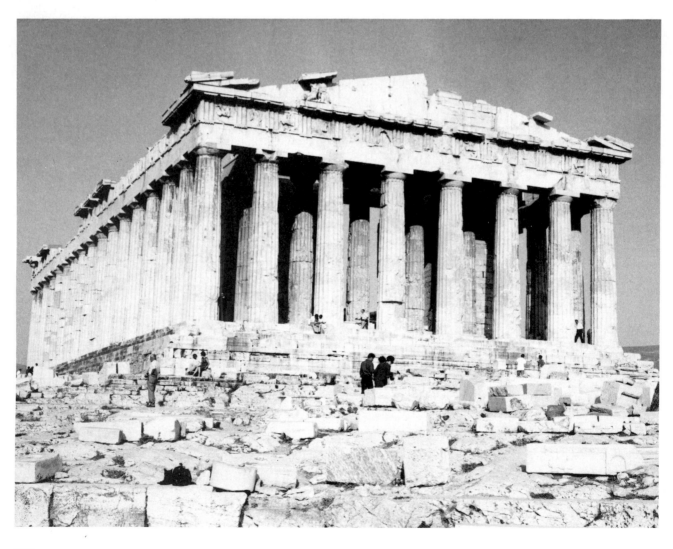

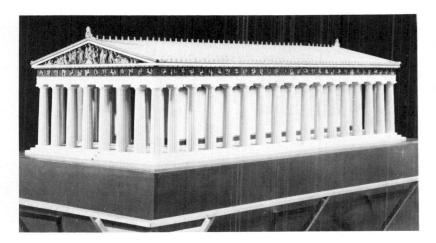

In Greek mythology, Athena was the goddess of warfare and wisdom, and patroness of the arts. At birth, fully grown and dressed in armor, she sprang from the forehead of Zeus. The Parthenon's marble sculptures portrayed this and many other stories of Greek gods. Inside the Parthenon were two main rooms—one a treasury, the other the home for a gold and ivory statue of Athena.

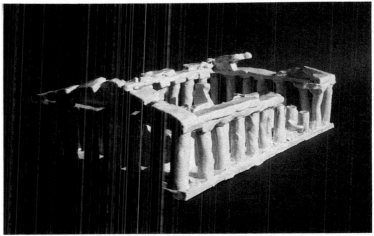

Gompers Secondary School. San Diego, California

Instructions for Creating Art

1. Carefully study the structure and details of the Parthenon in the pictures on these pages. You might want to go to an encyclopedia or another art book so that you can study the details more thoroughly. What features of the Parthenon do you like best? Based on the architectural style of the Parthenon, can you make some statements about the qualities of ancient Greek architecture? Look in books for other examples of Greek architecture.

2. After you have studied the Parthenon and feel that you understand its structure, sketch a plan for a building that includes some of its features. Think of a purpose for your building. It could be a temple, government office, monument, library, fancy home, or any other structure you wish to make.

3. Make a finished drawing of your building, paying attention to the environment in which it would be placed. When you are satisfied with your building and its setting, color it with the **medium** of your choice. Don't forget to add details such as a frieze and carvings around your building. If you wish, you might even try making a model of your building.

Art Materials

Your choice: paints and brushes, colored markers, or colored pencils	Drawing paper
	Pencil and eraser
	Water, paper towels

Strand J: Studying Places and Buildings

To evaluate your artwork, turn to the Learning Outcomes section at the back of this book.

70 Roman Arches, Vaults, and Domes

Observing and Thinking Creatively

About 2,000 years ago, the Roman Empire was one of the most powerful civilizations in the world. The builders of Rome used the **post** and **lintel** from Greek architecture, but they contributed new ideas of their own. The Romans invented concrete and the curved arch, both of which we use today.

Because they were able to change the form of stone by crushing it into cement, the Romans could design buildings with curved frames and ceilings. For the first time, windows, doorways, and roofs could be shaped like half-circles. **Arches** could be joined together in a line to become a **vault**, or corridor. **Domes** were created when

arches joined together at the top of a building, forming a half-ball shape.

The Romans used their inventions to build temples, palaces, sports arenas, monuments, theaters, bathhouses, law courts, triumphal arches, and city gates. These structures were so well made that many of them, built 2,000 years ago, are still standing. Unfortunately, the formula for concrete was lost after the fall of the Roman Empire, and it was not rediscovered until the eighteenth century.

In this lesson, you will draw and color a picture of a building that has an arch, vault, dome, and other features of Roman architecture.

Romanesque (Roman-like) architecture is found in many European countries. This low-angle view of a vault, or arched ceiling, shows the reinforced strength of arches coming together from different angles. What other buildings with arched ceilings and doorways do you recall seeing?

Thomas Sandby (1723-1798), St. Paul's Convent Garden Seen Through the Arches of the Piazza, *Watercolor. Yale Center for British Art, Paul Mellon Collection.*

160

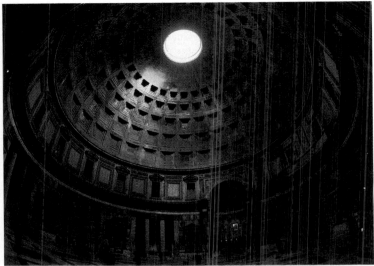

Interior of the Pantheon, Rome, A.D. 125

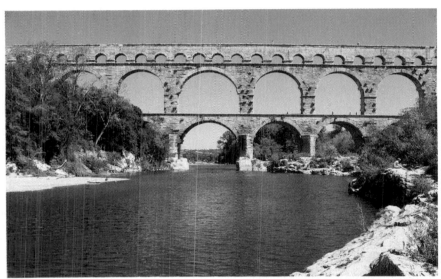

Roman Aqueduct of Pont du Gard. Avignon, France

Instructions for Creating Art

1. Draw a sketch of a building from your imagination that is in the style of Roman architecture. Study the pictures in this lesson and in other sources to get a good idea of the qualities of Roman architecture. Think of the kind of building you want to design. It could be an ancient temple or arena, or a modern office building, courthouse, or restaurant. Your building should include arched windows and doors, and a roof with a vault and a dome.

2. When you are satisfied with your sketch, develop it into a finished drawing. Place your building in an environment. Add details to your building, such as decorations or steps. You may color your picture, using the **medium** of your choice. You might even want to make a model of your Roman structure, using clay or other materials.

Art Materials

Your choice: paints and brushes, colored pencils, colored markers, or oil pastels

Drawing paper

Pencil and eraser

Newspaper (to cover work area)

Strand J: Studying Places and Buildings

To evaluate your artwork, turn to the Learning Outcomes section at the back of this book.

161

71 Buildings in the Middle Ages

Observing and Thinking Creatively

Some of the most interesting and elaborate architecture ever created appeared in Europe during the **Middle Ages**, about A.D. 500-1500. In the early Middle Ages, after the fall of the Roman Empire, many countries and towns were frequently at war, and the arts were temporarily forgotten. Later, though, castles, churches, and cathedrals were built all over Europe, adding beauty to the environment.

Castles were built to be **fortresses**. Their high, thick stone walls, towers, and **moats** were designed to protect their inhabitants from invaders.

The churches and cathedrals were the focus of town life and were often the most visible features of every town. These monumental structures had pointed steeples, towers, stained-glass windows, and much **symbolic ornamentation**. Over hundreds of years, arch shapes had changed from the round Roman style to the pointed **Gothic** style. With pointed arches, taller buildings with thinner walls and larger windows could be designed and built.

In the later Middle Ages, during more peaceful times, landowners and noblemen built palaces and manor houses with large open halls in their centers where large crowds could gather.

In this lesson, you will draw a building that might have existed in the Middle Ages.

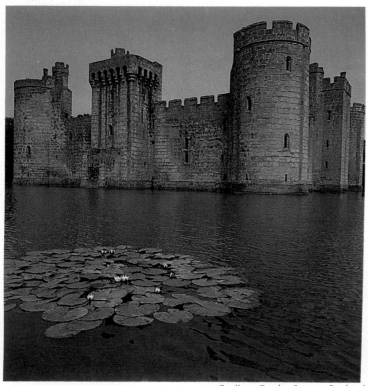

Bodiam Castle. Sussex, England

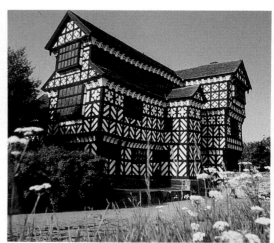

Little Moreton Hall. Cheshire, England

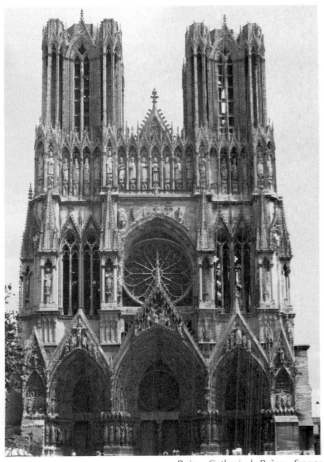

Reims Cathedral. Reims, France

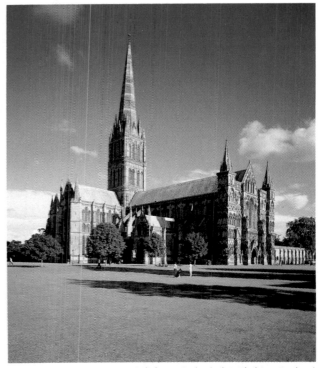

Salisbury Cathedral. Wiltshire, England

Instructions for Creating Art

1. Carefully examine pictures of **medieval** houses, castles, and cathedrals shown in this lesson and in other books. What are some of the qualities of architecture built during the Middle Ages? What features do you like best?

2. Choose a type of building you like and make a list of its special characteristics. Now, sketch your plan for the building of your choice. Indicate all the details you will need to include, such as pointed arches, moats, and stained glass windows.

3. Using your sketch as a plan, draw a finished picture of your house, castle, or cathedral. Include interesting features such as symbolic ornamentation and stained glass windows on cathedrals; moats, drawbridges, and towers on castles; and countryside features near houses. You may want to include figures of people and animals to indicate the scale of the building you have drawn.

Art Materials

Your choice: paints and brushes, oil pastels, colored pencils, or colored markers

Drawing paper

Pencil and eraser

Newspaper (to cover work area)

Strand J: Studying Places and Buildings

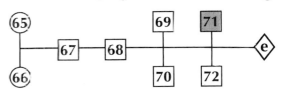

To evaluate your artwork, turn to the Learning Outcomes *section at the back of this book.*

72 *Spanish Influences on Mexican Architecture*

Observing and Thinking Creatively

Between A.D. 250–900, the Mayan Indians built temple **pyramids** in parts of Mexico. These stone structures, some of which still exist, were about 200 feet high. At the top was a **summit** of three rooms, which could be reached by climbing many very steep stairs. Deep inside each pyramid was a burial chamber, similar to those found in Egyptian pyramids.

From the twelfth century to the early sixteenth century, Mexico was dominated by the Aztecs, another Indian people. When the Spanish soldier Hernando Cortez invaded Mexico in 1519, he was able to conquer the Aztecs with a very small army because the Indians thought he was the god Quetzalcóatl. Mexico became a colony of

Spain, and was ruled by her for 300 years. During that time, Mexican art and architecture were heavily influenced by the **Baroque** style popular in Spain. Mission churches and palaces were built with elaborate, curving, dramatic designs. Carved figures decorated ceilings, doors, windows, and towers, and careful attention was given to creating a sense of balance.

Ideas from Mexican colonial art have been used throughout the United States, particularly in the states that border Mexico.

In this lesson, you will design and draw a building that might have existed in colonial Mexico, reflecting the Baroque style of architecture.

Baroque Church. Puebla, Mexico

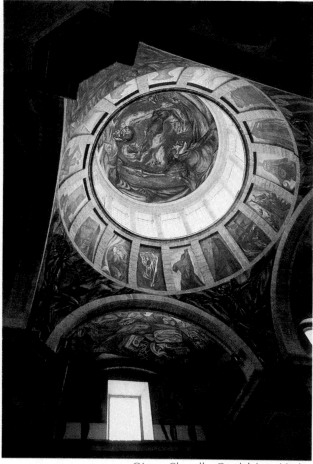

Oiorco Chapelle. Guadalajara, Mexico

164

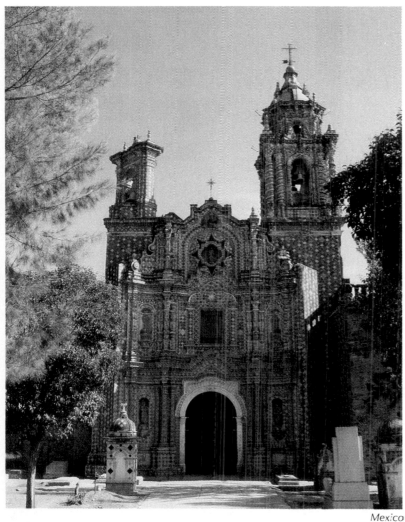

Mexico

Instructions for Creating Art

1. Look at the pictures of Mexican architecture here and in other sources. Find a type of building that you like. It might be a palace, a mission, or a church built during the colonial period in Mexico.

2. Carefully observe the details of the type of building you chose. How are its walls designed? What kind of doors and windows does it have? Notice the shape of the entire structure and any decorations used.

3. Now, using your imagination and the features you have just studied, design and draw a building that might have existed in colonial Mexico. Place your building in a setting which enhances it. Draw environmental details around your building, such as hills, trees, gardens, animals, and streets, making your picture as realistic as possible.

4. If you like, color your picture using a **medium** of your choice.

Art Materials

Pictures of ancient and colonial Mexican architecture	Your choice: paints and brushes, oil pastels, colored markers or pencils, etc.
Pencil and eraser	
Drawing paper	

Strand J: Studying Places and Buildings

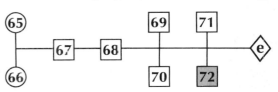

To evaluate your artwork, turn to the Learning Outcomes section at the back of this book.

165

73 Skeleton Architecture

Observing and Thinking Creatively

For thousands of years, buildings were constructed with stones, bricks, or logs. These materials were very heavy, and thus walls had to be thick to support the weight. Because of this limitation, it was impossible to support a structure that was very high.

About a hundred years ago, however, steel beams were invented, and it became possible to build tall structures that did not need thick walls to support their weight. These buildings were called **skyscrapers**, tall buildings of many floors supported by steel frameworks. Today, most modern buildings have steel frameworks that act as skeletons. These steel frameworks are bolted and welded together and then covered with stone, brick, plastic, or glass. Sometimes the steel skeleton is visible underneath.

In this lesson, you will learn how steel skeletons, or frameworks, support the structures that are built around them. Then you will design and draw a small-scale model of a skeleton structure for a building you invent.

Space Needle and Seattle Skyline, Washington

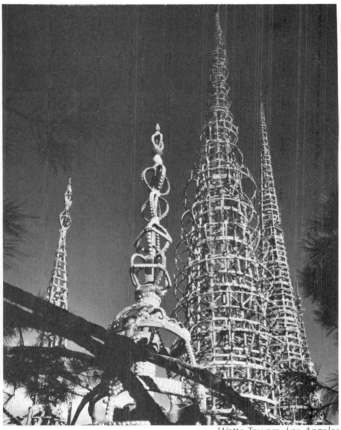

Watts Towers. Los Angeles

Eiffel Tower. Paris, France

Instructions for Creating Art

1. Sketch the shape of a bridge building, tower, skyscraper, or other object that interests you. It could be a structure from your imagination, such as a space station. After you have sketched the basic shape, decide what kind of framework or skeleton would be needed to support your structure. Imagine what your structure would look like if its "skin" were peeled away. Then sketch your idea of the skeleton, showing all parts of the framework. If you like, you can simply create a "skeleton building" like some of the structures shown in this lesson. Your building can be as strange and other-worldly as you like.

2. Use your sketch as the basis for a finished drawing of your structure. Use shading to give the skeleton a sense of solidity and form. Could someone tell by looking at the drawing what the finished building will look like?

3. If you wish, you can create a model of your skeleton framework by gluing together straws, Popsicle sticks, toothpicks, or other materials. Cut the materials to any length that you wish and connect them with glue or other materi-

als so that they don't fall apart. When your model is balanced and complete, cover part or all of it with cellophane or plastic wrap. Doing this will indicate what the solid form looks like while allowing the underlying skeleton to show through.

Art Materials

For model (optional): stick materials, glue and applicator, cellophane or plastic wrap, scissors	Drawing paper
	Pencil and eraser
	Newspaper (to cover work area)

Strand K: Styles of Architecture

73 — 74 — 75 — 77
 76 — 78

To evaluate your artwork, turn to the Learning Outcomes section at the back of this book.

167

74 Designing a Bridge

Observing and Thinking Creatively

What do you suppose the first bridge looked like? It could have been a tree that had fallen across a stream. It might have been a natural arch of rock that spanned a river or stream. An **arch** bridge carries its weight at each of the ends and in the curve of its arch.

The first man-made bridges were **girder** or **beam** bridges, made by laying a tree trunk across a stream. The ends of a girder bridge simply rest on the ground, and its weight thrusts straight down. The next man-made bridge was probably a grass-rope **suspension** bridge. The cables of a suspension bridge pull inward against its anchors, and the weight swings downward. One of the most famous suspension bridges is the Golden Gate bridge in San Francisco. Completed in 1937, it has a span of 4,200 feet.

The main difference in the three types of bridges—arch, girder, and suspension—lies in the way they carry their own weight. These three ways of supporting weight may also be combined to form a bridge that is a mixture of types. Bridges may be constructed of a wide variety of materials. Early bridges were made of timber and stone, while more modern materials include reinforced concrete, iron, and steel.

In this lesson, you will design and build a model of a bridge.

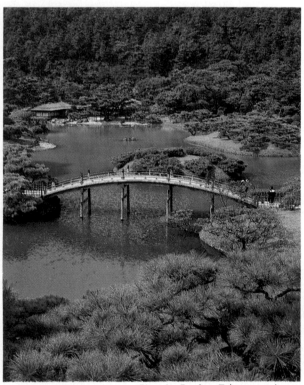

Ritsurin Garden. Takamatsu, Japan

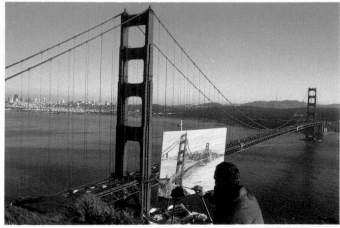

Golden Gate Bridge. San Francisco, California

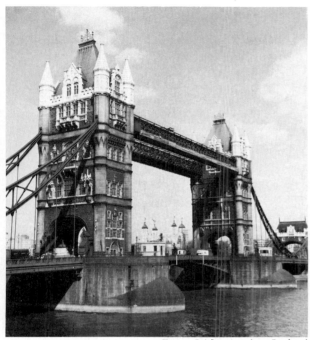

Tower Bridge. London, England

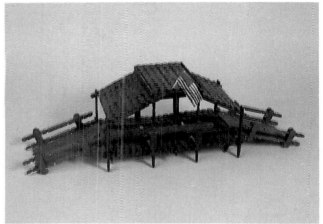

Shelbyville Middle School. Shelbyville, Indiana

Shelbyville Middle School. Shelbyville, Indiana

Instructions for Creating Art

1. Look at pictures of bridges shown here and in other books or magazines. Find examples of different kinds of bridges. Then decide on a type you would like to make, and think about a place where your bridge might fit. You might make a bridge spanning a roadway or river. Perhaps your bridge will join the banks of a lake or pond in a park or garden. If it snows in your area, you could make a covered bridge that protects the road from the elements. Use your imagination to design a bridge for a special place in your community. Make some quick sketches of bridge designs.

2. Now, make a more detailed sketch, or **plan**, of your favorite design. Using this plan, build a model of your bridge. You may use toothpicks, pieces of cardboard, clay, wire, string, Popsicle sticks, or any other material or combination of materials to construct your bridge. Add special features, such as water, roads, trees, bushes, and flowers to show the environment around your bridge.

3. Use glue or another method to securely attach the parts of your bridge. You may wish to paint your bridge or add other decorations.

When your model is completed, write on an index card what type of bridge you have constructed and where you imagine the bridge could be used.

Art Materials

Pictures of various types of bridges	Paper and pencil
	Glue
Materials for model bridge: toothpicks, clay, cardboard, string, wire, Popsicle sticks, etc.	Scissors
	Newspaper (to cover work area)

Strand K: Styles of Architecture

To evaluate your artwork, turn to the Learning Outcomes section at the back of this book.

75 *Different Styles of American Architecture*

Observing and Thinking Creatively

How many different styles of architecture exist in your town? In many communities you will find a variety of architecture representing styles from different periods. For example, Thomas Jefferson designed his home using Greek **columns**, a Roman **dome**, and a Greco-Roman **portico**, or covered entrance. A picture of his home, Monticello, appears in this lesson. In addition to being the third President of the United States, Jefferson was an influential American architect.

Look around your community for buildings that represent different architectural styles. You may find the stately, classical style of Greece, with its graceful columns and careful balance. Perhaps you will see influences from Rome in high, curved ceilings and rounded windows. You may find traces from the Middle Ages in elaborate cathedrals. There may be structures built in the style of the Spanish missions, or ultramodern buildings that seem to have come right out of a science fiction movie.

In this lesson, you will select a style of architecture you like and make a drawing or model of it.

Monticello, Virginia

Washington, D.C.

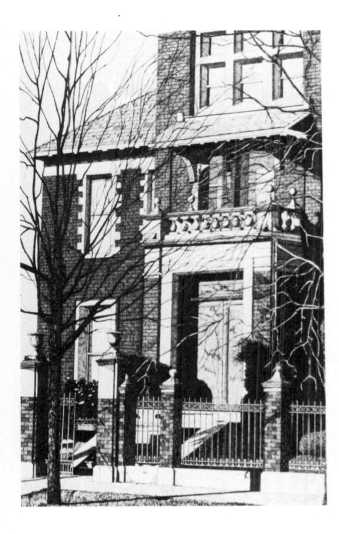

The very skillful, tight rendering of this fine drawing shows close attention to exact detail, light and shadow, and decorative features of the stately home. What other distinctive features do you notice about its architecture?

Jonell Folsom, Sweeney House. *Courtesy of the artist.*

Montgomery Junior High School, San Diego, California

Instructions for Creating Art

1. Observe the various styles of architecture in your community. Look at other examples in books and magazines. What features do you like best? Choose a style you find interesting. You may prefer to combine certain features from different architectural styles.

2. When you have decided on a favorite type of architecture or combination of styles, draw a building in that style. Add any necessary landscaping details, such as sidewalks, gardens, bushes, or a lawn. Color your design when it is complete. You may want to construct a model of your building, using the materials of your choice. On the back of your drawing, or on a separate piece of paper, describe the architectural style you followed and tell how you used its features in your drawing or model.

Art Materials

Pictures of various styles of architecture	Drawing paper
Pencil and eraser	Materials for model: your choice
Your choice: colored pencils pen and ink, charcoal, or pastels	Newspaper (to cover work area)
	Water, paper towels

Strand K: Styles of Architecture

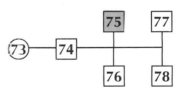

To evaluate your artwork, turn to the Learning Outcomes *section at the back of this book.*

171

76 *Chicago Architecture*

Observing and Thinking Creatively

Perhaps you've heard the story of Mrs. O'Leary's cow that kicked over a lantern and started the Great Chicago Fire of 1871. As a result of that fire, Chicago was almost completely destroyed. There was a need to reconstruct as quickly as possible, and many architects were involved in the rapid building phase that followed. Then, in 1885, the Home Insurance Building went up, a tall building with a steel framework. This first **skyscraper** was designed by William Le Barron Jenney, and others quickly followed.

In 1893, another set of unique buildings was designed to celebrate the 400th anniversary of the discovery of America. Called the World's Columbian Exposition, these buildings were designed by Daniel H. Burnham and Edward H. Bennett, and they combined Greek, Roman, Gothic, and French design.

Since that time, Chicago has become known as the world center for architecture. Architects such as Frank Lloyd Wright, Dankmar Adler, and Henry H. Richardson changed the skyline with their creative, well-designed structures. Buildings all over the world have been influenced by the beautifully designed skyscrapers of Chicago.

In this lesson, you will design your own skyscraper, then draw or build a model of it.

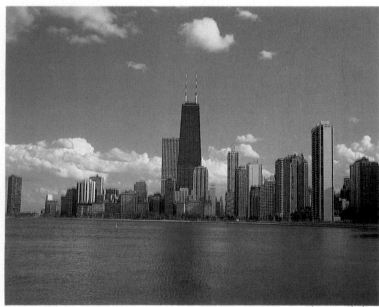

Chicago Skyline

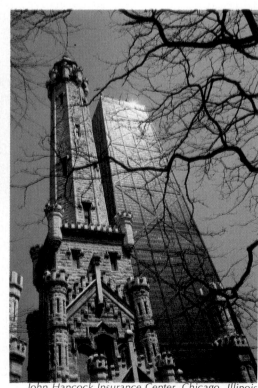

John Hancock Insurance Center. Chicago, Illinois

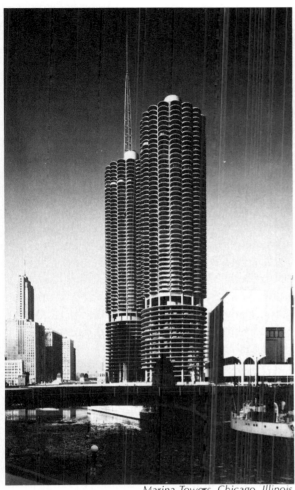

Marina Towers. Chicago, Illinois

Buckingham Fountain. Chicago, Illinois

Salem Middle School. Salem, Indiana

Instructions for Creating Art

1. Look at the pictures of Chicago skyscrapers in this lesson. Notice how they are different and how they are similar. Which skyscraper design do you like best?

2. Make some practice sketches for a skyscraper design of your own. Then, using your favorite sketch as a plan, make a finished drawing of your skyscraper. Include any details that will make your skyscraper interesting and unique. Color your drawing with the **medium** of your choice. Be sure to add environmental details such as clouds and sky, trees, landscaping, other buildings, and cars.

3. If you would like, build a model of your skyscraper. Construct it with boxes or build a stick framework that can be covered with paper or cardboard. Make sure your model balances when it stands. Draw or paint on details such as windows and doors. Then add any other details you would like, such as balconies, ledges, radio masts, flags, sidewalks, stairs, and trees.

Art Materials

Pencil and eraser	Glue
Drawing paper	Your choice: paints and brushes, pen and ink, colored markers, etc.
Materials for building model: long, straight sticks, tongue depressors, toothpicks, etc.	
	Water, paper towels
	Scissors, knife
Paper or cardboard	

Strand K: Styles of Architecture

To evaluate your artwork, turn to the Learning Outcomes section at the back of this book.

173

77 The Architecture of Frank Lloyd Wright

Observing and Thinking Creatively

Frank Lloyd Wright, who lived from 1867–1959, was one of America's greatest architects. He originated the idea of "open planning" to let in natural light and create a sense of flowing space in interior environments.

Wright was influenced by the large, overhanging roofs, openness, and **asymmetrical**, or uneven, balance he saw in the architecture of Japan, where he lived for six years. He believed that a house should fit in with the natural setting of the land it was built on, whether that was a hill, flatlands, or even over a waterfall. He called this blending of structures with their natural environments "organic" architecture. The picture of his Kaufmann House shows how he repeated the shapes of the huge rock outcropping in his design for the house.

Wright enjoyed experimenting with different ways to use space. In the Guggenheim Museum in New York City, he built a spiral ramp from the bottom to the top of the unusual circular building, rather than using conventional floors and ceilings. This design innovation allowed light and space to enhance the art that appears at each level of the building.

Today, Frank Lloyd Wright is famous for structures built in beautiful, dramatic locations, and for his ideas on creating continuous space.

In this lesson, you will draw a design for a house that blends in with a particular setting.

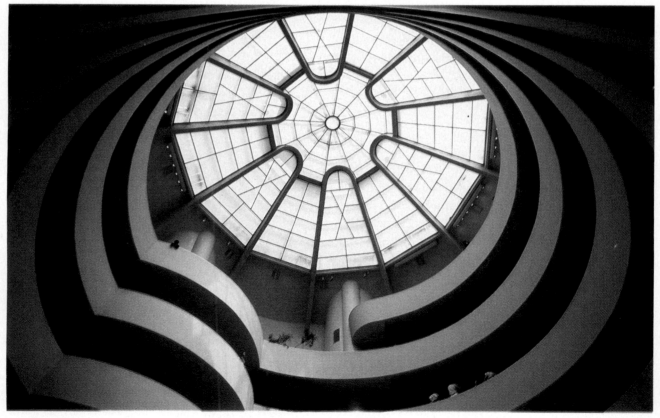

Spiral Staircase in Guggenheim Museum, New York City, 1943-59

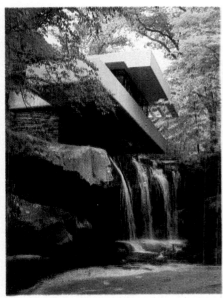

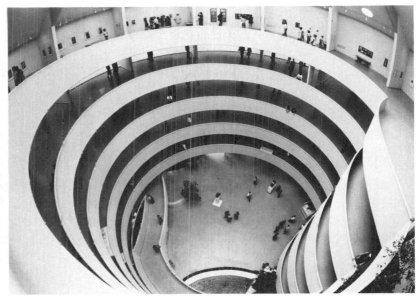

Fallingwater, *House designed for Edgar J. Kaufmann at Bear Run, Pennsylvania, 1936.*

Spiral Staircase. Guggenheim Museum (looking down)

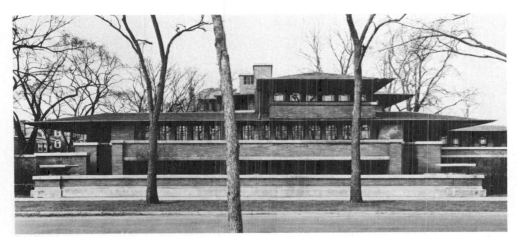

Robie House. Chicago, Illinois

Instructions for Creating Art

1. Imagine a place where you would really enjoy living. It might be a forest, desert, a cliff overlooking an ocean, a meadow, or even a tree. It can be a place you have actually seen or a place you imagine, such as an underwater home, a home on the surface of another planet, or an underground hideaway.

2. Draw a design for a house that would blend in well with the environment you chose. Be sure to draw in the setting as well as the house. You might want to repeat in your design some of the natural shapes of the home's setting, creating truly "organic" architecture in the style of Frank Lloyd Wright.

3. Color your drawing when it is finished. You may also want to make a model of your house, using the materials of your choice.

Art Materials

Pencil and eraser	Mixing tray
Drawing paper	Newspaper (to cover work area)
Your choice: colored pencils, pastels, paints and brushes	Water, paper towels
	Modeling materials: your choice

Strand K: Styles of Architecture

To evaluate your artwork, turn to the Learning Outcomes section at the back of this book.

78 *Modern Architecture*

Observing and Thinking Creatively

What do the very modern buildings in your community look like? Are there any unusual-looking structures? Although modern architecture may have any shape, it sometimes repeats shapes from nature. Look at the picture of the Sydney Opera House in this lesson. What shapes from nature does it suggest to you?

R. Buckminster Fuller, who was an inventor and structural engineer as well as an architect, based his **geodesic dome** on geometric shapes called **polyhedrons**. His goal was to provide maximum advantages with minimum cost—to do more with less. With small, **modular** elements, he built a skeleton structure for the dome's surface. The enclosed space was then covered with weatherproofing and became a strong, practical shelter. The U.S. Pavilion at the Montreal World's Fair, Expo 67, was a geodesic dome, and other such domes have been used for housing, greenhouses, and research facilities.

In this lesson, you will develop a design for a modern building.

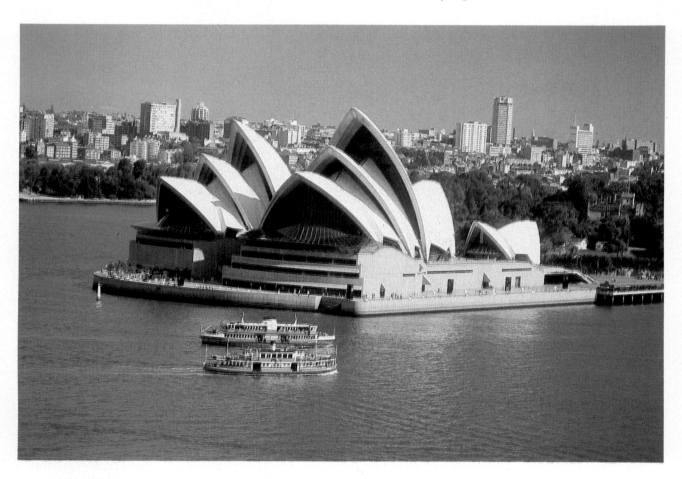

One of the finest buildings constructed in this century, the exterior of the Sydney Opera House was designed for its architectural beauty and striking environmental impact overlooking the harbor. Observe how the towering white concrete shells resemble billowing sails.

Opera House. Sydney, Australia, 1973

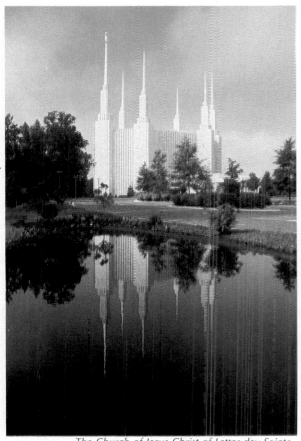

The Church of Jesus Christ of Latter-day Saints.
Washington, D.C.

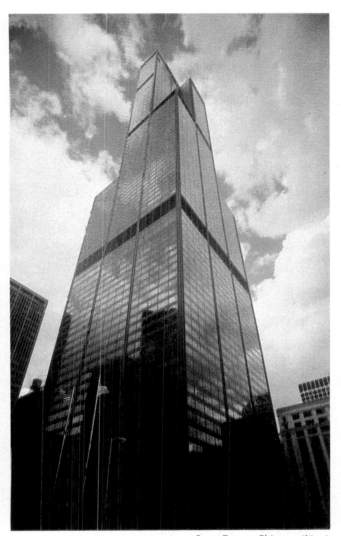

Sears Tower. Chicago, Illinois

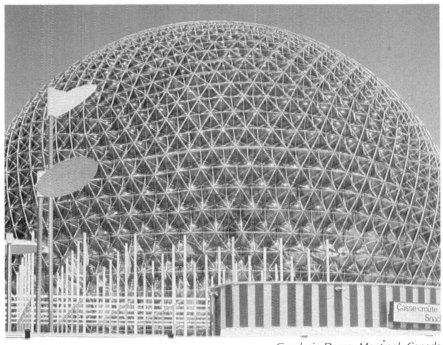

Geodesic Dome. Montreal, Canada

177

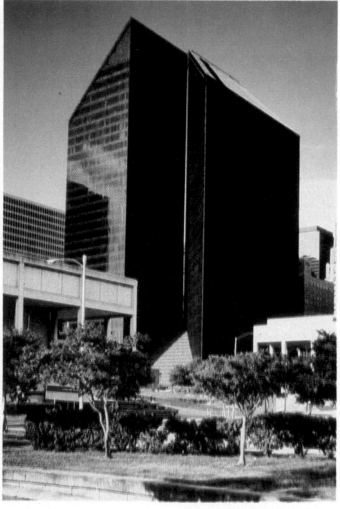

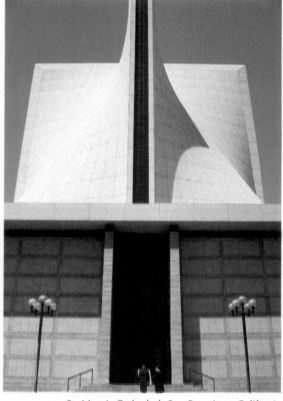

Pennzoil Place. Houston, Texas

St. Mary's Cathedral. San Francisco, California

Instructions for Creating Art

1. Look at examples of modern architecture in books, magazines, and in your community. Note how the lines, **forms,** spaces, and materials contribute to the total design. Find out the function of each building and how the purpose influenced the design. For example, the Sydney Opera House was designed as a concert hall and theater.

2. Now, think about a modern building you would like to design. Decide what the building will be used for—it could be a school, restaurant, skating rink, hospital, art museum, or sports stadium. Draw some practice sketches and then choose your favorite design.

3. Now, draw your structure. Include bushes, trees, and other landscaping details. If you wish, complete your drawing by coloring it. Write the name of your building at the bottom of your paper. You may also wish to make a model of your building.

Art Materials

Pictures of modern architecture

Pencil and eraser

Drawing paper

Your choice: colored markers or pencils, pen and ink, or oil pastels

Modeling materials: your choice

Mixing tray

Newspaper (to cover work area)

Water, paper towels

Strand K: Styles of Architecture

To evaluate your artwork, turn to the Learning Outcomes *section at the back of this book.*

178

Exploring Art

Architecture in Action

What style of architecture do you like best? Most communities have many styles of architecture, from ancient to modern. When an architect decides on the design for a building, he or she must consider what the building will be used for and know where the building will be constructed. Will it be surrounded by skyscrapers? Will its location be flat, or on a hill? How much land is available? How many angles will be visible? What do the other buildings around it look like? The answers to these questions help the architect design a building and select the appropriate size, shape, and materials for its construction.

For this assignment, take your camera or sketch pad and go out to observe different styles of buildings in your community. When you find a structure that really interests you, take pictures of it from the front, sides, and back, from every angle you can think of. If a camera is not available, make quick pencil sketches of the building from several angles.

Next, assume that you are an architect who has been hired to design a structure to be built next to the one you photographed or sketched. This new structure must fit in that environment, look good next to the existing building, and fulfill a purpose. Think about what that purpose might be. Will your design be for a home, business, recreational center, or some other kind of building? When you complete the design for your building, add appropriate landscaping, such as bushes, trees, a fountain, and sidewalks.

Trinity Church, 1877, and John Hancock Tower. 1974. Copley Square, Boston, Massachusetts

179

Marc Chagall, I and the Village, 1911, Oil on canvas, 6'3⅝" × 59⅝". Collection, The Museum of Modern Art, New York. Mrs. Simon Guggenheim Fund.

Unit VI

Explorations in Self-Expression

Every artist dips his brush in his own soul, and paints his nature into his pictures.

Henry Ward Beecher

Throughout this book, you have encountered works of art by various artists, from great masters to students like yourself. All of these artists have unique styles; each one is an individual, with different thoughts, feelings, views, and interests. Artists express their individuality in numerous ways: in their choice of medium or subject matter, their use of color, the way they handle their materials, the rhythm of their lines, and so on. Every work of art, in whatever medium, is an expression of the individual who created it. Thus, there are as many different styles of art as there are artists.

After experimenting with different art forms, you may have discovered that you prefer certain media and subject matter over others. Perhaps you feel more comfortable painting portraits than creating abstract designs, or drawing action scenes rather than landscapes. All of these likes and dislikes are good to know, because they tell you something about yourself that you may not have realized before. The more you experiment with different media and techniques, the more likely you are to discover the kind of artistic expression that you enjoy most.

In the lessons that follow, you may use the medium of your choice and exercise your favorite means of artistic expression. You will be encouraged to use your imagination, creativity, and unique approach to art in ways that express the real you. Experiment freely, and let your artworks represent who you are. Paint your *own* nature into every piece of art that you create.

79 Peace and Tranquillity

Observing and Thinking Creatively

Artists express their creative ideas through their artwork. Often, their styles and the subjects they choose to illustrate also reflect their feelings. One artist may use vigorous brushstrokes with lots of movement. Another will paint in a calmer, more peaceful style. Both show their emotions through the way they work.

The pictures in this lesson show different styles of painting, all reflecting moods of peace and tranquillity. As you can see, each artist has a different way of creating a peaceful scene. One artist may feel inner peace, which may be ex-pressed by the way the paint is brushed onto the paper. Other artists may depict peaceful subjects or make statements about world peace. These diverse ways of creating art are often combined in a single work to express the meaning of peace for the artist.

Peace means different things to each person, and each person can have different feelings about peace at varying times. In this lesson, you · will create your own picture, showing what peace means to you by using any artistic approach that suits you.

Reflections of sunlight on water and grass were important to Impressionist painters like Claude Monet. Dabs of bright paint create the peaceful feeling of gently lapping waves and windblown grass. What other qualities make this a tranquil scene?
Claude Monet, Cliff Walk (Etretat), *1882, Oil on canvas, 25¾ × 32¼".*
Mr. and Mrs. Lewis L. Coburn Memorial Collection. Courtesy of the Art Institute of Chicago.

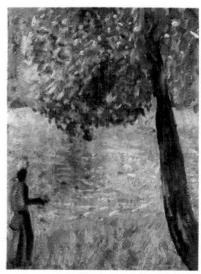

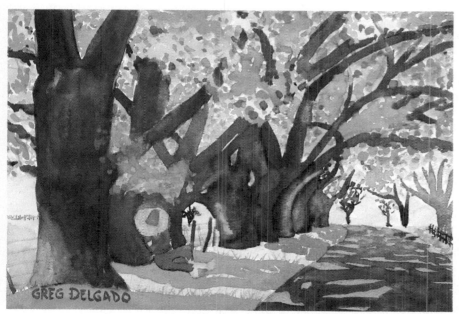

GREG DELGADO

Montgomery Junior High School. San Diego, California

Instructions for Creating Art

1. Be still for a few minutes and think about the word *peace*. Let images come to your mind freely. Whatever comes to mind first is a good clue as to how you are feeling about peace at the moment. Concentrate on that image and allow yourself to experience the feeling of peace and tranquillity. If you wish, jot down words and phrases you associate with peace.

2. Make a drawing that fits your present image of peace. Your artwork should be your personal idea about the word and its meaning. Your picture should fill all the space on the paper. Color your picture, if you wish, using hues that reflect your idea of peace. When you are finished, be ready to explain how you chose your idea for your picture.

Art Materials

Drawing paper

Pencil and eraser

Your choice: paints or oil pastels

Optional materials: mixing tray, paper towels, etc.

Strand L: Messages and Imagination

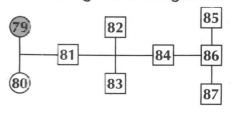

To evaluate your artwork, turn to the Learning Outcomes section at the back of this book.

80 Dream Images

Observing and Thinking Creatively

Everyone dreams. Dreaming is the mind's way of processing information and life experiences. By creating images of escape and fantasy, dreaming helps us handle stress. Sometimes we even work out solutions to problems by dreaming about conflicts we experience.

We dream even when we are awake. Daydreaming is a form of letting the imagination go. Thoughts may fill our minds so completely that we need to stop for a moment and let the images simply come to us. Sometimes daydreams are "wishful thinking"; we create scenes we would like to see happen in our lives.

Whether we are awake or asleep, dreaming intensifies everything. In dreams, colors are often more vivid, action more exaggerated, emotions more powerful. When we awake following a dream, the things we experienced can seem very real to us, and they may leave us with vivid images that we remember for a long time.

Sharing our dream images in art is a way of expressing feelings and thoughts that are often hard to put into words. In this lesson, you will draw or paint a picture of a dream or a daydream that you remember.

In this powerful action painting, unity and emphasis are achieved in a triangular design which peaks at the center of interest. Curves of smoke, grass, and corn compose the main lines of the picture. What features give this work a dream-like quality?

Thomas Hart Benton, The Wreck of the Ole '97, *1943, Egg tempera on panel. Hunter Museum of Art, Chattanooga, TN, Gift of the Benwood Foundation.*

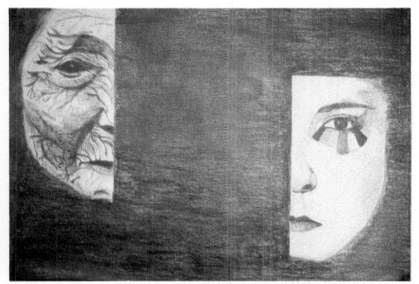

Textured and colored rag paper was torn and arranged to create this semi-abstract image, *Canyon Ghost.* What dream-like feelings do its many levels and subtle colors evoke?

Erian Blount, Canyon Ghost. *Courtesy of the artist.*

Instructions for Creating Art

1. See if you can remember a dream you had recently. Sometimes it is helpful to jot down everything you can remember about a dream. Simply writing it down helps you to recall it better. If you cannot remember any dreams, take a few moments and daydream by looking out a window, letting your mind accept the images that come to it.

2. When you have an idea from a dream, draw or paint a picture of it. Use any **medium** in the Art Materials box; you might try painting your picture on colored paper for a different effect. Remember, it is the feelings from the dream you are trying to convey. Therefore, your picture need not look realistic, but it should be carefully done so that it expresses a mood or feeling to others.

3. You may add pieces of photographs, scraps of colored paper, cloth, wood, aluminum foil, or anything else you like that would make your picture more expressive.

Art Materials

Drawing paper	Pencil and eraser
Construction paper in various colors (optional)	Optional materials: glue, scissors, scrap materials, found objects, mixing tray, etc.
Your choice: paints and brushes, oil pastels, or colored paper	Newspaper (to cover work area)

Strand L: Messages and Imagination

To evaluate your artwork, turn to the Learning Outcomes *section at the back of this book.*

185

81 An Expression of You

Observing and Thinking Creatively

Late nineteenth-century painters such as van Gogh, Gauguin, and Toulouse-Lautrec were interested in intense human emotions and sought to portray them in their art. Their experiments in color, subject matter, and the expression of deep personal feeings had a great effect on the direction of modern art. These artists prepared the way for a twentieth-century European movement called **Expressionism**.

Expressionist art was most concerned with conveying the inner world of the emotions, the intensity and energy of individual human experience. In Expressionist art, inner feelings and views became much more important than the depiction of reality. Thus, the forms of objects and figures were distorted, colors were exaggerated and often not used realistically, and brushstrokes were often abrupt and sweeping. It was as though the artists were so full of intense emotions that they had to "paint out" their feelings in a rush of artistic activity. Because Expressionist art is often critical of the ills of society, it can be a disturbing kind of art to view. However, Expressionism was a powerful movement that brought attention to the inner world of human emotion and how it affects the way people perceive reality. Today, some artists still paint in the Expressionist style.

Study the examples of Expressionist art shown here. In this lesson, you will take ideas from Expressionist art and use them in creating your own "portrait" of your inner world.

Horses and riders gallop across a background of rich, joyful color in this stylized painting by the Russian/German artist who was one of the originators of Expressionism. What effect is created by the distinct brushstrokes?

Vasily Kandinsky, Blue Mountain, 1908–09. Oil on canvas. Collection, Solomon R. Guggenheim Museum, New York.

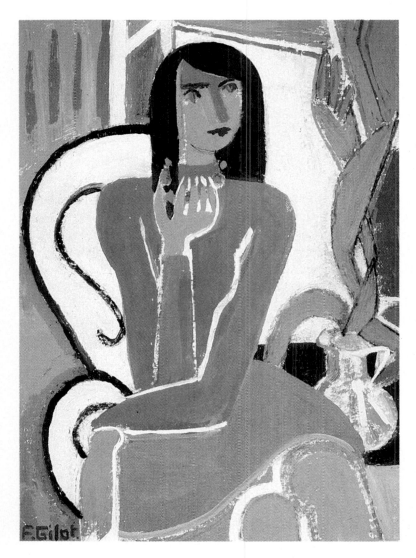

French artist Françoise Gilot now lives and teaches in California. Can you see the influence of Picasso in this interesting self-portrait? What does the artist express about herself? If you pictured yourself as the color orange, what would you be expressing?

Françoise Gilot, A Study for the Orange—Self Portrait, 9½" x 8⅛". Oil. Copyright 1945, Courtesy of Riggs Galleries, San Diego.

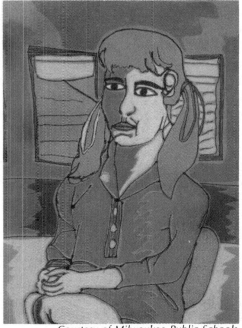

Courtesy of Milwaukee Public Schools

Instructions for Creating Art

1. Study the examples of Expressionist art in this lesson and in other books. What are some of the qualities of Expressionist art? How does this type of art make you feel?

2. After you feel that you understand what Expressionist artists are trying to accomplish, think about how you could express your innermost feelings in a work of art influenced by the Expressionist style. You could draw a self-portrait, for instance, or anything else that makes a statement about who you are and what you deeply feel.

3. Draw and paint your picture in the Expressionist style, using sweeping brushstrokes and exaggerated forms. Mix unusual colors and use them in ways that express your feelings. If you choose to paint a self-portrait, remember that you are not trying to show a realistic picture of yourself that looks exactly as you look, but an honest statement of deep feelings and views that are a part of you. Paint your picture with energy, and give your work an unusual title.

Art Materials

Drawing paper	Water, paper towels
Pencil and eraser	Mixing tray
Paints and brushes	

Strand L: Messages and Imagination

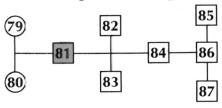

To evaluate your artwork, turn to the Learning Outcomes section at the back of this book.

187

82 *From Real to Abstract*

Observing and Thinking Creatively

Art need not look realistic to be considered good. Some artists create their best art by using their imaginations to express feelings and emotions. About a century ago, before photography was invented, artists were hired to record, as realistically as possible, what people and places actually looked like. Today, artists make their work look realistic only when it communicates their purpose or is truly the style they prefer.

Artists can look at real things and see ideas for new forms in them. They may start with a realistic scene and then change it into **abstract** art.

In this lesson, you will focus on your **creativity** by beginning with a realistic drawing of an object, and then making two more drawings, each one more abstract than the other. By distorting or modifying the elements of design, such as line, shape, color, or texture, you can create a drawing that communicates a unique feeling or expression that is important to you.

The pictures by Dutch artist Piet Mondrian may give you some ideas for your own art, but your drawing should be original.

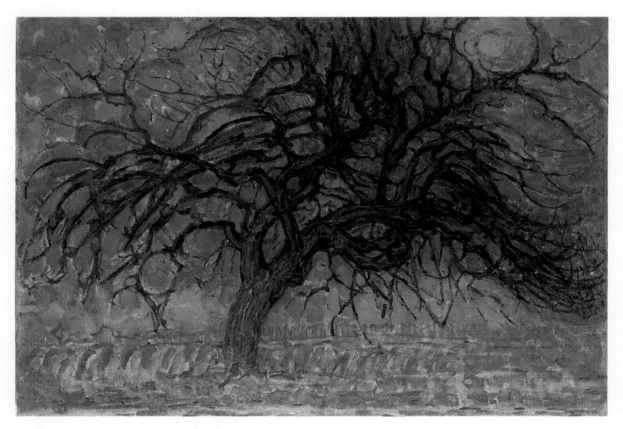

Dutch artist Piet Mondrian developed a unique geometric style as he painted increasingly abstract trees and buildings. His goal was to picture an environment of order and beauty. Here, the tints and shades of two primary colors depict an old overgrown autumn tree spilling its leaves over a foggy twilight landscape.

Piet Mondrian, Red Tree. *Collection Haags Gemeentemuseum—The Hague.*

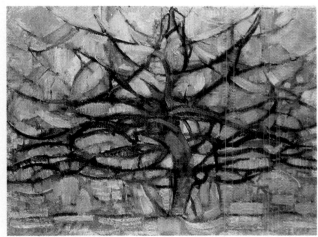

P. Mondrian, The Gray Tree. Collection Haags Gemeentemuseum—The Hague.

Note how the form of the tree above has been changed into abstract lines and shapes, becoming more of a design than a realistic image. In the right-hand painting, the original image is barely visible among the pale leaf shapes and curving lines representing the branches. Compare the three pictures and notice the changes in these images of the same tree.

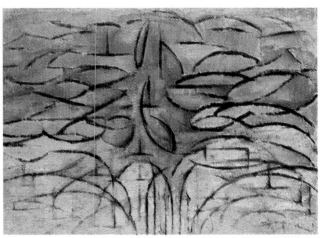

P. Mondrian, Flowering Apple Tree. Collection Haags Gemeentemuseum—The Hague.

Instructions for Creating Art

1. Study the pictures in this lesson. They will help you understand how to change a realistic shape into a new and very different one that emphasizes abstract design. The first step is to draw a figure or object, either from memory, real life, or from a photograph. Make the drawing as realistic as possible.

2. Next, on a new sheet of paper, draw another version of the same subject, making it more abstract by emphasizing basic lines and shapes that recall the original drawing. You can make it simpler or more complex, but it should look less realistic.

3. Draw the same subject a third time, making it look even less realistic. Use ideas that come from looking at your second drawing to make this third one. It should appear very abstract. However, it should still have some elements in common with your first drawing, such as color or basic rhythm of lines.

4. Take your three drawings and *mount** them on a big piece of dark paper. Arrange them so

that they look good on the paper. Give the three drawings one title that describes them.

*For an explanation, turn to the How to Do It section at the back of this book.

Art Materials

Photographs or pictures	Large sheet of construction paper
Drawing paper	Pencil and eraser
Tape	Glue

Strand L: Messages and Imagination

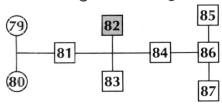

To evaluate your artwork, turn to the Learning Outcomes section at the back of this book.

189

83 Be Your Own Picasso

Observing and Thinking Creatively

Pablo Picasso is regarded as one of the greatest artists of this century. He was born in Spain, but lived in France for most of his life. He was ninety-two years old when he died in 1973.

One of Picasso's most unique qualities was his ability to greatly change his art styles throughout his lifetime. Unlike many artists, who discover one style that is best for them and never change, Picasso was always searching for new and better ways of expressing himself through art. When he was only fourteen years old, he was already painting realistic pictures like an art master. Throughout his career, Picasso successfully used every style of art, from classical to abstract,

to express his meaning. He painted and sculpted works that showed the entire range of human emotion, from sadness and loneliness to tranquillity and joy. His drawings, paintings, sculptures, and other works changed so much over his lifetime that looking at a collection of his works is like looking at the work of several very different artists.

As you study the works by Picasso in this lesson, look for the abstract shapes he emphasized in his work. In this lesson, you will use Picasso's style of art to make an abstract composition showing objects that have meaning for you.

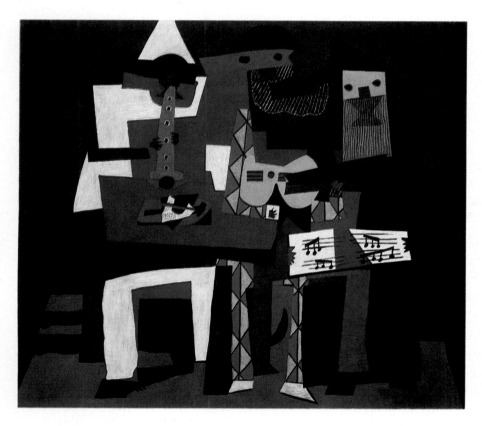

An originator of the cubist art style, Picasso used simple shapes and bold colors to picture the legendary French comedy characters Pierrot (white) and Harlequin (center). A third masked musician and a dog complete this abstract composition.

Pablo Picasso, Three Musicians, 1921, Oil on canvas, 6'7" × 7'3¾". Collection, The Museum of Modern Art, New York. Mrs. Simon Guggenheim Fund.

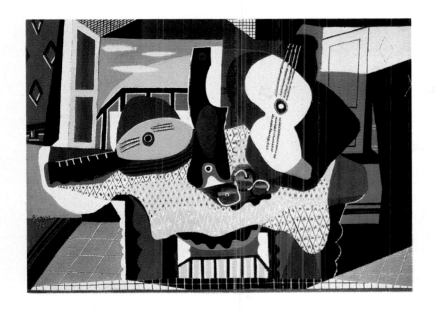

African sculpture, with its simplified planes, influenced Picasso's cubist style. The artist was unconcerned with traditional ideas of beauty. Instead, he forged his own new frontier of art.

Pablo Picasso, Head of a Woman, *1909, Gouache and black crayon. Courtesy of The Art Institute of Chicago, The Charles L. Hutchinson Mem. Collection. 45.136*

Instructions for Creating Art

1. Study the works by Picasso shown in this lesson. What are some of the qualities you see in these works?

2. Think of things in your life that are very important to you and express the kind of person you are: hobbies, objects you own, pets, articles of clothing, or items that represent talents you have. Write a list of these items. You will use them in a "self-portrait" of objects that are important to you and express who you are as a person.

3. From your list, select several objects that you want to compose into a picture. Draw a composition that includes these objects. Remember that you are not showing the objects in a realistic way, but instead are emphasizing their abstract qualities of line and shape. After you have drawn your basic design, add details and color using the **medium** of your choice, or one that your teacher suggests.

4. Instead of painting a picture, you might want to create an **assemblage** that looks similar to a sculpture Picasso might have made. An assemblage is constructed by combining various materials, mostly **found objects**, into an artistic composition. Create abstract shapes out of cardboard, heavy paper, aluminum pie pans, or other materials of your choice. Arrange these shapes into an interesting sculpture. When you are satisfied with the composition of your sculpture, you may paint it all one color to give it a sense of **unity**.

Art Materials

Your choice of art materials

Strand L: Messages and Imagination

To evaluate your artwork, turn to the Learning Outcomes *section at the back of this book.*

84 Impossible Imaginings

Observing and Thinking Creatively

Imagination is one of the most valuable gifts we possess. Whether we are man or woman, young or old, our imaginations give us gifts of fantasy that help us to figure out solutions to problems, see hidden beauty in commonplace objects, and go beyond our ordinary lives to the realm of the impossible. The imagination is an important tool in the creation of all kinds of art. Some of the best and most exciting artistic ideas deal with things that could not possibly happen in reality. Yet, when we see such ideas given concrete form, we believe in these impossible worlds that artists have created for our enjoyment.

One modern artist known for using his imagination to create truly impossible scenes that defy the laws of nature and logic is Dutch artist M.C. Escher. Escher's drawings and prints are compli-

cated visual puzzles that fool the eye. Many of them take keen observation and thought to really figure out. The strange scenes he created from his imagination often seem quite real until you look at them closely. Then you realize that the things he is showing could never happen at all.

Many other artists have succeeded in depicting impossible scenes and situations in their art. If you look through this book, as well as other art books, you will find many examples of artists, such as Hieronymus Bosch, René Magritte, and Salvador Dali, who have successfully created truly impossible scenes in their art.

In this lesson, you will study some of these "artists of the impossible" and use their examples to help you create your own strange scene or object out of your imagination.

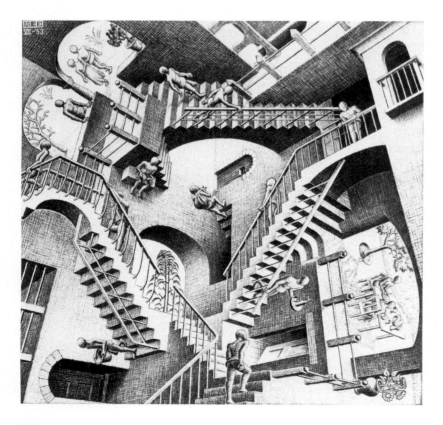

Follow the pathway of any one of the faceless figures to see what happens. Observe how the light source changes gradually from one area to another, and how the outside of this strange building becomes the inside, then the outside again. Would this building be possible on a planet where there was no gravity?

B-26,958 Relativity, M.C. Escher; 1953; National Gallery of Art, Washington; Gift of Mr. C.V.S. Roosevelt.

Summer's bountiful harvest was the inspiration for this imaginative portrait. Can you identify the fruits and vegetables? Look closely at the coat of wheat and you will see the artist's name and the year he painted this amusing piece.

Giuseppe Arcimboldo, Summer, 1563. Kunsthistorische Museum, Vienna.

Gompers Secondary School. San Diego, California

Instructions for Creating Art

1. Study the examples shown in this lesson and in other art books. You might look through books that feature the theme of fantastic art. Using such artworks to inspire your own imagination, draw a picture of something that could never happen, or an object that could never exist. You might try doing a drawing in the style of M.C. Escher, creating a shape or scene that is impossible in some way, like Escher's two-sided stairways. Look in books on optical illusions and visual puzzles for inspiration, but use your own ideas. How could you depict an impossibility in a picture of a building, factory, art museum, living room, or other seemingly ordinary setting? As you look through books for impossible scenes, notice how many of them have a strange element of reality and seem almost, but not quite, normal. How do artists transform the ordinary into the extraordinary, making everyday things seem strange?

2. When you have an idea for your impossible scene or object, draw it. Finish your picture by coloring it with the **medium** of your choice, or one that your teacher suggests. If you prefer, create a **three-dimensional** artwork, using clay, found objects, or cardboard shapes. Think up a title for your artwork and share your impossible scene or object with others.

Art Materials

Examples of fantastic artworks	Your choice of art materials

Strand L: Messages and Imagination

To evaluate your artwork, turn to the Learning Outcomes section at the back of this book.

85 *Unexpected Ghosts*

Observing and Thinking Creatively

What kind of picture do you see when you hold a negative up to the light? How is it different from a regular photograph? A photograph in which all the dark parts are light, and all the light parts are dark, is called a **negative**. Regular photographs are called **positives**.

Have you ever drawn a picture in which you made all the dark parts light, and the light parts dark? This approach gives a ghostly quality to pictures because most pictures have more dark than light parts. Artists and designers carefully arrange the light and dark parts of their work to create **unity**, the feeling of a picture being one whole thing. Unity can also be achieved in a negative drawing or painting. Remember, though, that while shapes stay the same, the **balance** of a picture may change when a positive photograph or painting becomes a negative.

In this lesson, you will arrange light and dark parts of a picture to create a well-balanced, unified negative.

Instructions for Creating Art

1. First, choose a photograph or picture you would like to reproduce. It could be a subject that would look particularly ghostly in negative form, such as a strange old house or a gloomy landscape. Then, on your drawing paper, draw the outlines of your subject.

2. Next, carefully shade your drawing so that you create a negative effect. You should depict all the light parts of the original picture with various degrees of shading. The darker parts of the original picture should be left light.

3. When you finish the drawing, examine it for balance. Does it seem too light or too dark in places? You might want to add other objects to the picture. If you do, reverse the shading on the objects that you add.

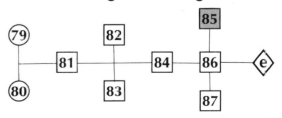

Art Materials

Pictures or photo-graphs

Pencil and eraser

Drawing paper

Strand L: Messages and Imagination

79 — 81 — 82 — 84 — 86 — 85

80 — 83 — 87 — e

To evaluate your artwork, turn to the Learning Outcomes *section at the back of this book.*

86 The Land of Lilliput

Observing and Thinking Creatively

The famous author Jonathan Swift wrote *Gulliver's Travels* over 250 years ago. The story tells about the fantastic adventures of Lemuel Gulliver, who travels to strange lands. One land that Gulliver visits is Lilliput, an imaginary country whose people are only six inches high.

Although imaginary worlds such as Lilliput often give artists ideas for very good pictures, this lesson is about *real* miniature worlds that can only be seen with the help of a microscope. The shapes of objects and organisms, such as snowflakes or cells, seen through a microscope, demonstrate the same elements and principles of design as things that can be observed through normal vision.

The photographs in this lesson show some objects seen through a very powerful electron microscope. By magnifying an object so that it appears thousands of times larger, microscopes reveal fascinating shapes, forms, textures, and patterns that otherwise go unobserved. These tiny, often brilliantly colored designs from nature can inspire ideas for art.

This lesson will give you an opportunity to discover how to use your observation of microscopic worlds to create a work of art.

Tartaric Acid

Connective Tissue

Crystal Pattern of Acetanilide

Buds on a Plant

Naphthalene

Instructions for Creating Art

1. Find pictures of very small objects that have been enlarged. Look for photographs from your science book showing parts of a rock, a leaf, an animal, or any other tiny object that has been greatly magnified. What shapes and forms does the enlarged object suggest to you? A field of mushrooms? Bits of broken glass or some tangled roots? A view of life on another planet? If possible, actually look at different objects or organisms under a microscope, and record your observations.

2. After you have studied the photograph or the object under a microscope, draw a picture or a design suggested by the microscopic view. Do not copy exactly what you see, but use it as a reference to create your own idea. You can use any art materials you like. You might try using various media together in a new way. Title your work and explain what you used as the basis for your picture.

Art Materials

Photographs of objects seen through a microscope

Drawing paper

Pencil and eraser

Microscope (optional)

Objects to observe (optional)

Your choice: paints and brushes, crayons, colored markers, etc.

Newspaper (to cover work area)

Strand L: Messages and Imagination

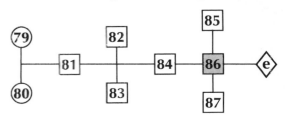

To evaluate your artwork, turn to the Learning Outcomes section at the back of this book.

87 Night and Day

Observing and Thinking Creatively

Everything looks different at night. Sometimes you cannot recognize a place at night, even though you may have been there many times during the day. Perhaps you have arrived at a strange place when it was dark, and have been surprised when you saw it the next morning. Shapes and forms appear different at night, though we know they are not as they seem.

Moonlight and streetlights reflect off objects, casting dark shadows.

This lesson will help you observe and think about the differences in how places look at night and in the daytime. You will create two pictures of the same scene, one showing the scene in the daylight and one showing it at night.

Strange dream-world images characterize Belgian surrealist René Magritte's paintings. Here we have a mystery: a cloudy, daytime sky with dark night below. Note how objects in the darkness are portrayed in shades of brown and gray, with yellow tints close to the lights.

René Magritte, The Empire of Light, II. *1950. Collection, The Museum of Modern Art, New York. Gift of D. and J. de Menil.*

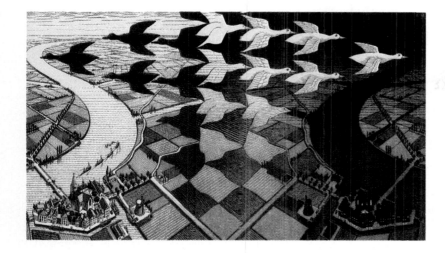

Diamond shapes gradually transform from a patchwork of fields into interlocking birds in this ingenious woodcut design, in which the night scene on the right is a reverse image of the day scene on the left.

Day and Night; Maurits Cornelis Escher; 1938; Two-color woodcut; National Gallery of Art, Washington; Cornelius Van S. Roosevelt Collection 1974.

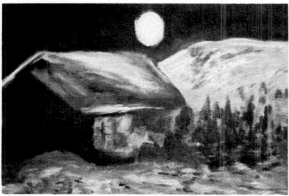

Gompers Secondary School. San Diego, California

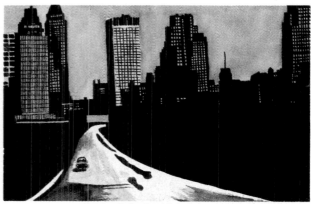

Muirlands Junior High School. La Jolla, California

Instructions for Creating Art

1. Decide on a subject for a daytime and a nighttime picture. It may be the community where you live or a place you imagine. Make a drawing, adding details such as cars, people, trees, or buildings. Design it well, so that it has a **center of interest**, and organize your shapes into a unified whole. If you are drawing buildings, be sure they are drawn in correct **perspective**. (See Lesson 16 for detailed instructions on drawing perspective.)

2. On another sheet of paper, draw your picture a second time, exactly the same as the first.

3. Turn one drawing into a daylight picture, using paints, crayons, oil pastels, or colored markers. Select a color scheme with many lively colors for a bright, sunny day.

4. Turn your second drawing into a nighttime picture. Remember that nighttime darkness is more like blue than black. Also remember that lights are not always white or yellow. Dull your colors with their **complementary colors**, or darken them with black.

Art Materials

Two sheets of drawing paper	Your choice: paints, crayons, colored markers, oil pastels, etc.
Pencil and eraser	
Water, paper towels	

Strand L: Messages and Imagination

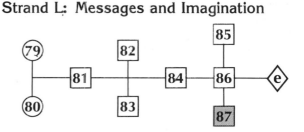

To evaluate your artwork, turn to the Learning Outcomes section at the back of this book.

199

88 Art in Motion

Observing and Thinking Creatively

Most people are fascinated by things in motion —waves smashing against a rocky cliff, horses running wild, an eagle soaring with the winds, race cars whirling by in a blur of color. Showing something in motion presents a challenge to the artist. Observe the examples in this lesson and notice how these artists have portrayed movement and action. What techniques does Thomas Hart Benton use to make the train seem to move right off the paper? Notice how he **distorted** the shape of the locomotive to show a stronger sense of motion. The clouds, smoke, and the slanting lines of the telephone poles also create a feeling of speed. Study the other works shown here and note how artists portray people or animals in motion.

Drawing or modeling the body in a state of action is a particular challenge. Even though the **body proportions** do not change, it is more difficult to show the body twisting, turning, lunging, and leaping.

The object of this lesson is to depict an action scene showing movement and excitement. Your action subject might include people, animals, machines, or things in nature.

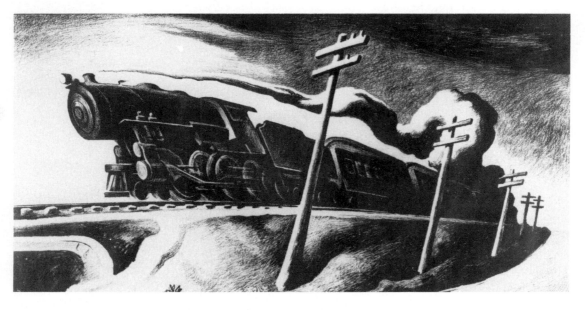

In this motion-filled picture, Benton suggests speed in several ways. The tracks are at eye level, making the forward-leaning train appear to race by right in front of our eyes. The perspective is exaggerated by the telephone poles and train cars, which are greatly reduced in size as they recede into the distance. Notice how the distorted shape of the smoke and train wheels and the angle of the telephone poles also emphasize speed.

Thomas Hart Benton. Express Train. 1927. Lithograph. Edition: 19/50. 12⁵/₁₆ × 23¼ inches (composition); 20⅜ × 26½ inches (sheet). Collection of Whitney Museum of American Art. Acq#31.604

Gompers Secondary School. San Diego, California

200

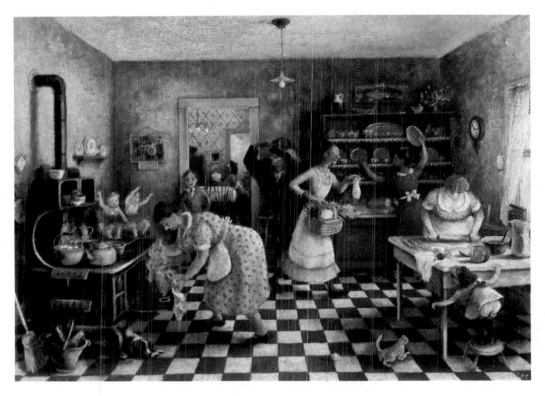

Doris Lee recorded her fond memories of *Thanksgiving, 1935* as a scurry of bustling activity. How many kinds of motion are pictured here? How is the movement represented?

Doris Lee, Thanksgiving, 1935, Oil on canvas. Courtesy of The Art Institute of Chicago, Mr. & Mrs. Frank G. Logan Purchase Prize. 1935.313

Instructions for Creating Art

1. Choose the kind of action you would like to show, either in sports, nature, or a man-made object such as a car or motorcycle. Choose a subject that interests you and one with which you are familiar. You may also want to collect pictures or photographs from magazines and other sources to look at as you draw. Use the art material you enjoy working with most. You can make a drawing, painting, collage, linoleum print, piece of sculpture, or any other kind of art you enjoy.

2. First, make a sketch showing as much action as you can. Movement can be shown through the use of slanted lines, strong **rhythmic** curves, and **distorted** shapes. In the art examples shown in this lesson, parts of the shapes have been twisted and bent to give them extra power. Concentrate more on showing movement of the main shapes and figures in your picture than on drawing details. Make sure that the body proportions are correct, even if the body is in an unusual position.

3. When you are satisfied that your sketch shows plenty of action, complete a finished piece of art based on your sketch, using a **medium** of your choice. If you add color to your art, select colors that contribute to the overall feeling of motion and excitement.

Art Materials

Photographs from magazines or books	Pencil and eraser
Drawing paper	Your choice of art materials

Strand M: Visual Discoveries

To evaluate your artwork, turn to the Learning Outcomes section at the back of this book.

89 Robots in Art

Observing and Thinking Creatively

New inventions are being created every day. One of the most fascinating inventions of the modern age is the robot. You have probably seen robots in science fiction movies and on TV programs. Even though you may not realize it, robots have become part of everyday life. They are used to assemble automobiles and electronic circuits, and to perform many other jobs ordinarily done by humans. One robot, called the Turtle, even draws designs with a pencil.

Robots are really computers whose memories contain information that has been programmed by people. Although they are machines, they are sometimes constructed to look and sound like human beings.

Artists have created their own imaginative depictions of robots. Notice the different kinds of robots in the pictures shown here. One artist even created a robotic dog.

In this lesson, use your imagination to design and construct a robot. Your robot can look like anything you want it to, but, like a piece of sculpture, it should be designed to look interesting from all sides.

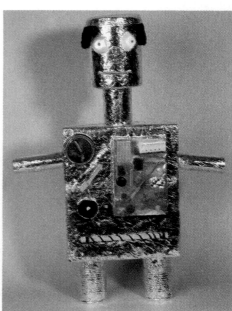

Greensburg Middle School. Greensburg, Indiana

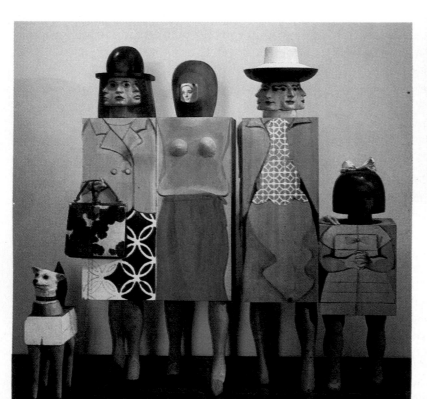

Marisol has added everyday objects, plaster casts of faces and hands, and painted designs to these life-size wooden block figures, creating a mannequin-like effect. In what ways do these figures resemble robots?

Marisol. Women and Dog. 1964. Fur, leather, plaster, synthetic polymer, wood. 72 x 82 x 16 inches. Collection of Whitney Museum of American Art. Gift of the Friends of the Whitney Museum of American Art. Acq#64.17

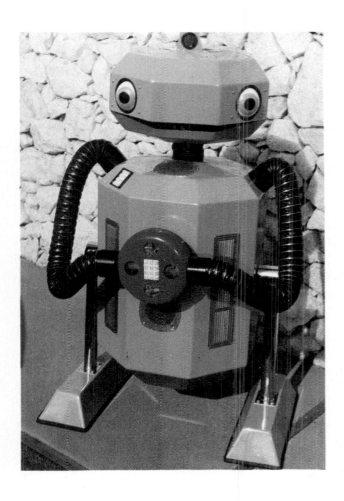

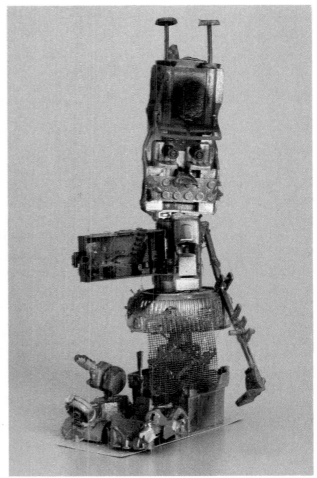

Instructions for Creating Art

1. Decide what you want your sculpture to look like—a human or animal form, an alien from another world, or something from your wildest imagination. Make a sketch of your robot. The pictures in this lesson may give you some ideas, but make your robot an original. Think about the function you want your robot to perform as you design it. Perhaps it will clean your room, wash dishes, do your homework, mow the lawn, or shovel snow.

2. When you have a sketch that you like, construct a robot sculpture. Use boxes, containers, cans, paper rolls, and other materials to make your robot. Add dials, lights, antennas, levers, buttons, foil, and any other materials you like to make it unique. Paint your final product, using the **medium** of your choice.

3. Give your robot a name and write a brief description of the job or function your robot is to perform. Attach your description to the robot and display it in an appropriate place.

Art Materials

Drawing paper	Paints and brushes or spray paint
Pencil and eraser	Masking tape
A collection of cartons, boxes, containers, paper rolls, colored cellophane, aluminum foil, construction paper, pipe cleaners, etc.	Glue
	Newspaper (to cover work area)

Strand M: Visual Discoveries

To evaluate your artwork, turn to the Learning Outcomes section at the back of this book

90 Pets and Their People

Observing and Thinking Creatively

For thousands of years, people have kept and cared for pets. Even very ancient art objects show evidence that man enjoyed the company of tame animals. The ancient Egyptians kept pet cats and regarded them as sacred beasts. And horses and dogs have long worked in partnership with man.

If you are around pets very often—either your own or other people's—you know that each animal has its own individual personality. Sometimes it is amusing to observe pets acting in ways that remind us of ourselves. A cat may slink along guiltily after it has done something wrong, or a dog may act silly if it is happy about something. Although animals may not think and react exactly the way people do, it is true that their behavior often resembles ours. They can act jealous, overjoyed, or depressed, and sometimes seem to have human facial expressions.

It can be instructive for an artist to search for the similarities between people and animals, especially between pets and their owners. You may have noticed that sometimes pets and their owners resemble each other. These similarities are often very funny to see, and can result in marvelous ideas for **caricatures**. Have you ever seen a "bulldogish" man walking a bulldog on a leash, or a tall blonde woman with an elegant blonde Afghan hound? Finding similarities between animals and people requires you to really study two very different forms and discover the features they have in common.

In this lesson, you will think about a pet you own, a pet you know, or a pet you would like to own, and depict that pet in a portrait that shows its true personality. Use your imagination and think of ways to portray an all-too-human pet —and perhaps its all-too-animal owner as well!

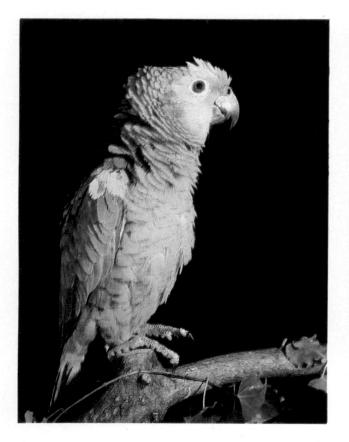

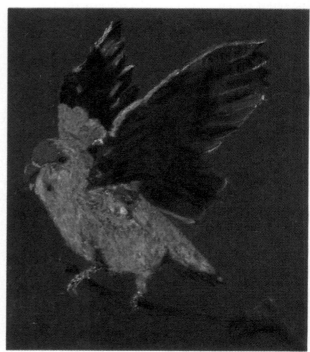

Muirlands Junior High School. La Jolla, California

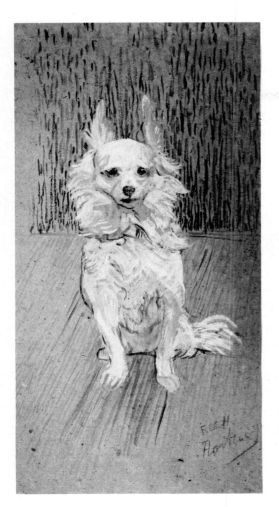

Notice the dog's posture, the texture of its fur, and the position of its ears. How has the artist captured Follette's character? How does the style of drawing and way the background is drawn add to the overall effect of this animal portrait?

Henri de Toulouse-Lautrec, Follette, 1890. Philadelphia Museum of Art: Bequest of Lisa Norris Elkins (Mrs. William M. Elkins).

Gompers Secondary School. San Diego, California

San Diego High School. San Diego, California

Instructions for Creating Art

1. Think of a pet you would like to depict in an artwork—perhaps an unusual pet such as a gorilla, dolphin, or mountain lion. When you have decided on the pet you want to portray, make some practice sketches of the animal performing a characteristic action. If you can use the actual pet as a model, do so.

2. After you feel that you know how you want to depict your pet, make a finished portrait in the **medium** of your choice, or use one that your teacher suggests. It may be a painting clay sculpture, or even a piece of needlework. If you like the idea of showing humor in your art, you might try drawing a caricature that shows a pet with an owner who looks a lot like it. Or, if you are in a serious mood, you might want to make a realistic portrait of your pet, perhaps including yourself interacting with the pet in some way. Be sure to capture all the things about your pet that make it special and different: a certain gleam in the eyes, a drooping ear, or a favorite pose. You could even

create a comic portrait of your pet, showing its true personality by placing it in a special scene or role: an elegant female cat dressed as a queen, an adventurous hound disguised as a detective, etc. Be as creative as you wish, showing the animal's uniqueness.

Art Materials

Your choice of art materials

Strand M: Visual Discoveries

To evaluate your artwork, turn to the Learning Outcomes section at the back of this book.

91 Creatures That Never Were

Observing and Thinking Creatively

Animals have always been a favorite subject of artists. But artists have never limited themselves to depictions of real creatures that exist in our world. Indeed, many works of art from all periods of history show creatures that never existed in reality. Some of these creatures are figures from myth: Pegasus, the winged horse; the Minotaur, half man and half bull; the Chimera, a combination of lion, goat, and serpent; and the Sphinx, half woman and half lion. Mythical creatures remain popular subjects for artists.

In the Middle Ages, a kind of illustrated book called a **bestiary** became very popular. These books showed various animals and told about their natures and habits, often through stories that had a moral. Many, if not most, of the "facts" in the bestiaries were not true, however. Bestiaries, and later "natural history" books, were full of strange creatures that never existed in reality: the manticore, with the head of a man, the body of a lion, and the tail of a scorpion; the unicorn, possessing the features of both horse and goat; and the dragon, a frightening winged serpent. Other creatures, odd combinations of man and animal, were also included, though many did not become part of established legends.

In this lesson, you will depict a fabulous creature that interests you, using any **medium** you choose. Your creature may be from myth or legend, science fiction or fantasy, or from your own imagination. Study the examples in this lesson, and let your imagination run free.

Surrealists believe a magical world more fantastic than the real one can be created in art. Dali has invented elephants with spindly birds' legs and a giraffe with flames erupting from its back. What else is unusual in this picture? Note the effect produced by vertical lines and angles.

Salvador Dali, Spanish, b. 1904. The Elephants, 1961. Pencil, watercolor and gouache on board. 74.67 Indianapolis Museum of Art, Gift of Mr. and Mrs. Lorenzo Alvary.

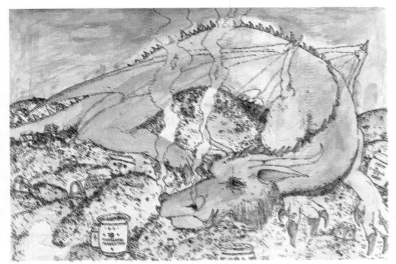

University City High School. San Diego, California

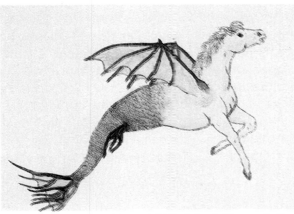

Warsaw Middle School. Warsaw, Indiana

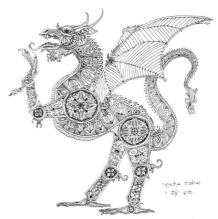

University City High School.
San Diego, California

Instructions for Creating Art

1. Look at the examples in this lesson and in other books. Think about the various kinds of strange creatures you have seen in books and movies or read about in stories. Which creatures are from myth or legend, and which are the creations of individual writers or artists? Are all imaginary creatures scary and frightening beasts, or are some quite beautiful in their own way? Think about the kind of creature you would like to depict. You could combine "bits and pieces" of animals that really exist. Make some practice sketches of your imaginary creature. You may use other pictures for ideas, but do not copy them.

2. Once you have decided on a creature to portray and have decided how it will look, think about whether you would like to draw, paint, or sculpt it. You could even make a papier-mâché model, a piece of jewelry, or needlework that shows a picture of the beast. Decide on a good art **medium**, or use one that your teacher suggests. Create a creature from myth or legend, your favorite fantasy or science fiction book, or your own imagination. Name your creature and be ready to tell about its nature and habits.

Strand M: Visual Discoveries

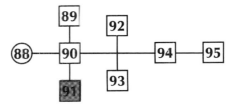

To evaluate your artwork, turn to the Learning Outcomes section at the back of this book.

92 *Images of Heroes*

Observing and Thinking Creatively

People have always had a need for heroes, and the gods and heroes of myths and legends have provided popular subject matter for artists since ancient times. Ancient pottery, sculpture, and painting offer numerous examples of gods and heroes engaged in epic struggles of good and evil. Today, heroes are still depicted in every imaginable art form, but the range of heroes we idolize is much broader than ever before. Some are fantastic, larger-than-life characters, fictional creations like Superman and Indiana Jones. Others are real people whom we admire and might wish to be like, such as famous athletes, astronauts, rock stars, and television and film personalities. Still others are people whom we respect for their human qualities and social accomplishments. Heroes can serve as models for our attitudes and behavior. That is why people like to be reminded of their heroes and often depict them in art. You can find images of heroes everywhere: in paintings, book illustrations, and sculpture; on billboards, posters, and record album covers.

In this lesson, you will depict a real or imaginary hero whose qualities you especially admire. Perhaps the hero you choose symbolizes strength, intelligence, compassion, bravery, or some other quality that is important to you. He or she may be a creation from your own imagination, an historical figure, or a fictional character whom you especially like. Perhaps your hero is someone you know personally. You can depict your hero in a drawing, painting, or sculpture, showing exactly what he or she is like.

San Diego High School. San Diego, California

Standley Junior High School. San Diego, California

Standley Junior High School, San Diego, California

Mabel E. O'Farrell School of Creative and Performing Arts. San Diego, California

Instructions for Creating Art

1. Think about a hero—man, woman, or child, real or imaginary—whom you like and admire. What are this person's heroic qualities? What is he or she most known for? If you are interested in myths and legends, you could research a Greek or Roman god or hero who especially interests you. Does he or she look human, or are there some features that are not human at all? Find out all you can about your god or hero so that you can formulate a picture that really looks like him or her. If you are depicting an historical figure, comic book or movie character, or famous entertainment personality, refer to illustrations or photographs of the person, but do not copy the pictures. Let your depiction be entirely your own, emphasizing the heroic qualities that are most important to you.

2. When you are ready to create your artistic interpretation of your favorite hero, think about the form your artwork will take. You can draw, paint, model in clay, or use an art medium that your teacher suggests. Try designing a record album cover that features a famous figure from history, a billboard that depicts a god from mythology, or a magazine cover that features an exclusive interview with your favorite fictional character.

Art Materials

Your choice of art materials

Strand M: Visual Discoveries

To evaluate your artwork, turn to the Learning Outcomes section at the back of this book.

209

93 Larger Than Life

Observing and Thinking Creatively

Michelangelo, one of history's greatest artists, lived over 400 years ago in Rome and Florence, Italy, during the Italian **Renaissance**. Like Leonardo da Vinci, the other great Italian artist of his age, Michelangelo was skilled in many aspects of art. He carved magnificent marble sculptures, created grand, sweeping paintings showing epic scenes, and designed buildings. He was also a poet. Famous even in his day, Michelangelo is regarded as one of the most important artists of all time, and a master of the human form.

Michelangelo's paintings and sculptures show how well he understood the structure of the human body—perhaps better than any artist who came before him. He was constantly making sketches of hands, **torsos**, faces, and full figures, all in various positions. He studied the bones and muscles underneath the skin and, more important, understood how they worked. This in-depth knowledge of human **anatomy** made his figures, all muscular, powerful, and larger-than-life, seem like real flesh and blood. In their massive strength and nobility, the figures Michelangelo created show a heroic sense of human greatness. In this lesson, try to capture this sense of greatness in an artwork of your own.

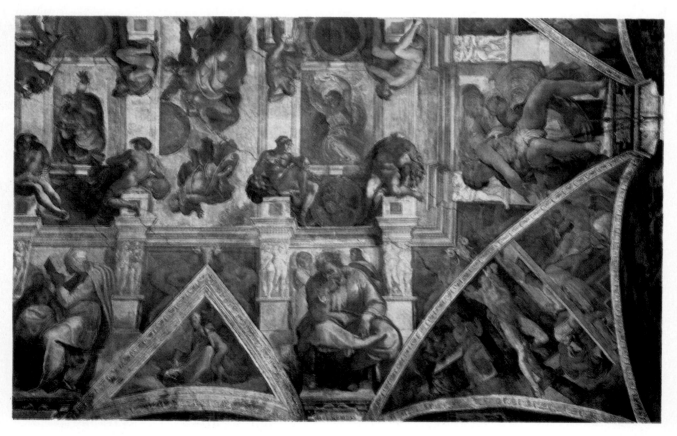

Michelangelo painted this spectacular fresco on the Sistine Chapel ceiling, more than 60 feet above the floor. The fresco depicts the creation, fall, and redemption of mankind in numerous scenes.

Michelangelo, Sistine Chapel Ceiling (Detail), The Vatican, Rome.

Michelangelo's drawings, paintings, and sculptures reveal an extraordinary perception of human anatomy, as well as sensitivity to human character and emotion. The intensity of a strong creative drive is evident in all his work.

(Below): Michelangelo, Moses, c. 1513–15, Marble, approx. 8' 4" high. Chiesa S. Pietro in Vincoli, Rome.
(Right): Michelangelo Buonarotti. Studies for the Libyan Sibyl on the Sistine Chapel ceiling, c. 1508. Red chalk. 11⅜" × 8⅜". The Metropolitan Museum of Art, New York. Purchase (1924), Joseph Pulitzer Bequest.

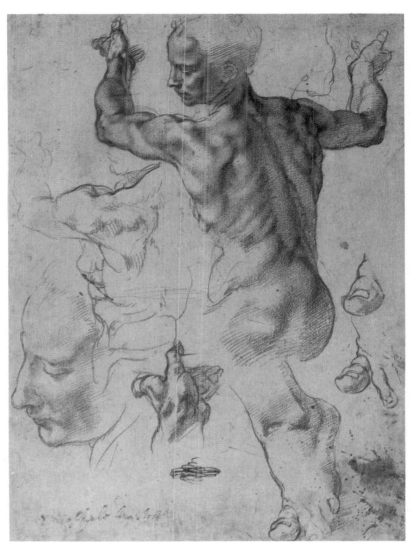

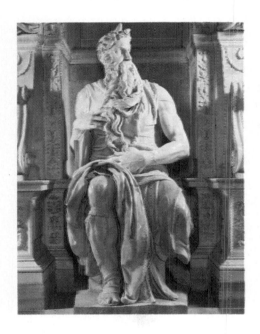

Instructions for Creating Art

1. Study the works by Michelangelo on these pages and, if possible, in other books. What are some of the qualities of Michelangelo's works? How do they make you feel? What can you say about the way he depicted people? What do you think he was trying to show?

2. Think about an artwork you would like to create in the style of Michelangelo. It can be a drawing, painting, or sculpture. If you like, you can simply make studies of human features, such as faces and hands, as though you were drawing in Michelangelo's sketchbook. The subject of your artwork is up to you, but it should include the features that made Michelangelo's artworks so successful: an understanding of human form, an attempt to get the feeling of bone and muscle structure underneath the skin, and a truly heroic sense of human greatness, shown in the solidity and strength of the figure. You will probably want to make a few practice sketches of your chosen subject before you begin to work on your finished piece.

Art Materials

Your choice: paints and brushes, charcoal, or clay

Drawing paper

Pencil and eraser

Strand M: Visual Discoveries

To evaluate your artwork, turn to the Learning Outcomes section at the back of this book.

94 *Visualizing with Words*

Observing and Thinking Creatively

Ideas for art often come from various sources —feelings, experiences, dreams, hopes, observations, and imagination. They may come from something you have seen, heard, or read. Words can also inspire a piece of art. These same words may even become part of the title for a picture. Certain words create **images** which can become sources for artwork. Unforgettable experiences that create lasting impressions can also be inspirations for art. Perhaps you have had an experience that you can still **visualize** vividly because of the impression it made on you.

If you observe the art shown here, you will see different images that had meaning for each artist. Each picture shows a unique style and way of painting. Each picture also captures a single experience or impression of importance to that particular artist.

In this lesson, you will recall a memorable experience that you want to picture on paper. One way to visualize an idea is to jot down words that describe the images in your mind, and then use these words and images as starting points for the creation of your own art.

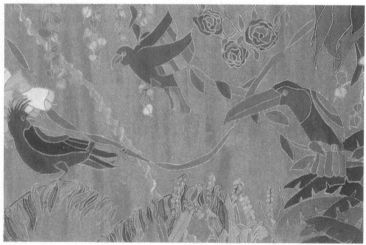

Memorial Junior High School. Houston, Texas

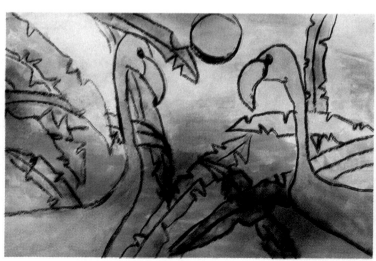

Gompers Secondary School. San Diego, California

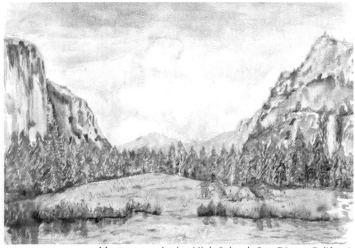
Montgomery Junior High School. San Diego, California

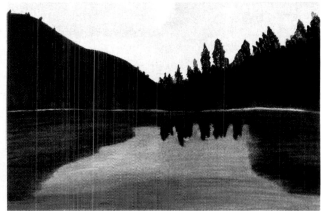
Muirlands Junior High School. La Jolla, California

Instructions for Creating Art

1. Take a few minutes to think about special times in your life that have left an impression on you. Choose one memorable experience to use as the basis for a picture. In the middle of a sheet of paper, write a word or phrase that summarizes your experience. Circle the word or phrase, and then jot down other words that describe or tell about specific details of the experience, such as colors, setting, people, objects, or feelings you had at the time. These words will make up a word picture that will help you to visualize the experience more fully. After you have written all the details you can think of, circle only those words that you want to portray in a picture. Be selective. Don't try to show everything in one picture. Choose only those items that you think will make the best picture.

2. Make a sketch of your picture, based on the words you circled on your paper. Compose your sketch carefully so that it is balanced and has a **center of interest.** Then make a final

drawing. Add color, if you like, using the **medium** of your choice. When your picture is finished, give it a title, perhaps using some of the words you wrote.

Art Materials

Writing paper	Your choice: paints and brushes, oil pastels, pen and ink, etc.
Drawing paper	
Pencil and eraser	

Strand M: Visual Discoveries

To evaluate your artwork, turn to the Learning Outcomes section at the back of this book.

213

95 Songs, Poetry, and Art

Observing and Thinking Creatively

Poets, composers, and artists are all people who are sensitive to the world around them. They are also keenly aware of their feelings and express them in their work. Poets express their feelings, observations, and experiences through words; composers, through music; and artists, through **images**. Because these three art forms—music, literature, and art—are so closely related, art in one form may serve as a valuable source of inspiration to an artist working in another form. For example, visual arts, such as painting or sculpture, give poets and composers ideas, and artists may get visual ideas for their pictures from poetry and songs. Poetry can be particularly helpful in art because its **symbolism** and **imagery** often help people **visualize** pictures in their imaginations. These images then become sources for their artwork.

The poems in this lesson may give you some good art ideas. Reading a poem several times, then sitting quietly for a while with your eyes closed, often enables your mind to create pictures that might fit the poem. In this lesson, you will illustrate a favorite peom or song using images that the work brings to your mind.

To Look at Any Thing

To look at any thing,
If you would know that thing,
You must look at it long:
To look at this green and say
'I have seen spring in these
Woods,' will not do—you must
Be the thing you see:
You must be the dark snakes of
Stems and ferny plumes of leaves,
You must enter in
To the small silences between
The leaves,
You must take your time
And touch the very peace
They issue from.

John Moffitt

Swift Things Are Beautiful

Swift things are beautiful:
Swallows and deer,
And lightning that falls
Bright-veined and clear,
Rivers and meteors,
Wind in the wheat,
The strong-withered horse,
The runner's sure feet.

And slow things are beautiful:
The closing of the day,
The pause of the wave
That curves downward to spray,
The ember that crumbles,
The opening flower,
And the ox that moves on
In the quiet of power.

Elizabeth Coatsworth

Mabel E. O'Farrell School of Creative and Performing Arts.
San Diego, California

Muirlands Junior High School. La Jolla. California

Muirlands Junior High School. La Jolla, California

215

Giraffes

Stilted creatures,
Features fashioned as a joke,
Boned and buckled,
Finger painted,

They stand in the field
On long-pronged legs
As if thrust there.
They airily feed,
Slightly swaying,
Like hammer-headed flowers.

Bizarre they are,
Built silent and high,
Ornaments against the sky.
Ears like leaves
To hear the silken
Brushing of the clouds.

Sy Kahn

Muirlands Junior High School. La Jolla, California

Instructions for Creating Art

1. Read the poems in this lesson or poems that you especially like in other books. Or you may want to listen to the words of your favorite song. Saying the poem or singing along with the song may help you think of an interesting idea that could be made into a picture. Listening for the rhythm of the words or the beat of the music will also influence your interpretation of the message. Your art could be a design that doesn't show anything real, but expresses the feeling of the poem or song.

2. Paint a colorful picture or design expressing your ideas and feelings about the poem or song. Use colors, shapes, and lines that reflect the words and the rhythm. Your picture may be realistic or **abstract**. Write the name of the song or poem on the front of the paper next to your name. This will be your title. You may also write the particular words that inspired your picture on another sheet of paper and display it next to your picture.

Art Materials

Poetry or music	Mixing tray
Pencil and eraser	Glue
Drawing paper	Water, paper towels
Paints and brushes	

Strand M: Visual Discoveries

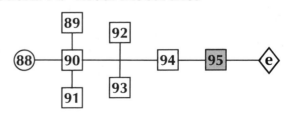

To evaluate your artwork, turn to the Learning Outcomes *section at the back of this book.*

216

Exploring Art

Writing and Illustrating Haiku

A poem, like a picture, is an especially compact image of an idea. A good poet selects every word in a poem very carefully. Each word and phrase must help the reader visualize the thought being expressed. Artists create pictures in a similar way; each line, shape, color, pattern, or texture in the artwork must portray the artist's idea.

For this activity, you will combine poetry and art to express a memorable experience. You will write your poem in **haiku**, a Japanese verse form.

Haiku, which does not rhyme, is written in three lines with a total of seventeen syllables. The first and third lines each contain five syllables, and the second line has seven syllables. Because haiku is so short, it is often used to capture a single memorable experience from nature.

Read the following haiku, visualizing what the poets are describing in their images from nature. Then write a haiku of your own and illustrate it with a picture or a painting.

A river leaping,
tumbling over rocks roars on . . .
as the mountain smiles.

Meisetsu

A cautious crow clings
to a bare bough, silently
watching the sunset.

Basho

Butterfly, these words
from my brush are not flowers,
only their shadows.

Soseki

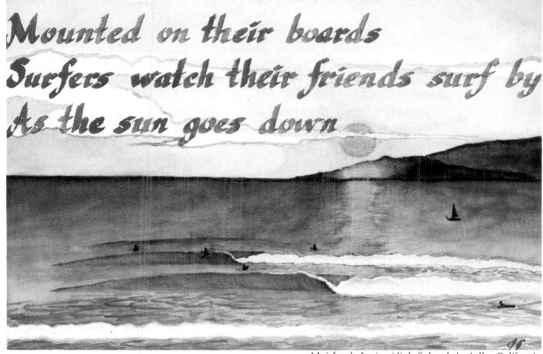

Muirlands Junior High School. La Jolla, California

217

How to Do It

DRAWING

Drawings may be done with light or heavy lines and shading, depending on the artist or the choice of subject. While many drawings are done in great detail, other drawings are made with a few simple lines. Yet another kind of drawing is the *sketch*, a quick, undetailed drawing that indicates only the main features of a person, object, or scene. A sketch is often used as a reference for a later drawing or other work.

Drawing instruments useful for drawing include pencils, pen and ink, crayons and oil pastels, felt or plastic-tipped colored markers, and charcoal, as well as brushes. Drawing instruments such as rulers, set squares, and compasses are useful for drawing exact shapes and dimensions.

Drawing Tools and Techniques

Pencils

Many different effects can be created with a pencil, depending on how it is held and how much pressure is exerted. Pencil lead varies from 6B, which makes the darkest, softest mark, to 9H, which makes the lightest, hardest mark. Note that very soft lead breaks and smears easily. Several pencils of different degrees of hardness can be used in one drawing if desired. Details are best made by medium-range, harder pencil leads, such as regular number 2 or 2½ pencils.

Shading is a technique of showing gradations of light to dark values in a picture by darkening areas in shadow and leaving other areas light. Various shading methods can also help to make objects and figures appear three-dimensional as well as show textures. The picture below illustrates different ways of using a pencil to achieve shading.

Colored pencils are most effectively used by first making light strokes, building up to darker tones.

Pen and Ink

Pen and ink are useful for creating line drawings, silhouettes, and calligraphy.

Ink is available in waterproof, or permanent, and non-waterproof varieties and colors. Permanent inks come in the deepest and longest-lasting colors. They produce better effects, but their stains are extremely difficult and sometimes impossible to remove from clothing and skin.

- **Safety Precautions:** Both permanent and non-waterproof inks stain badly. It is a good idea to wear old clothing or a bibbed apron when working with these inks.

When diluted with water, ink is useful for making washes. To get a lighter value, add more water to the ink. Inks can be put down with steel, reed, or bamboo pens, brushes, or pen nibs.

Pen nibs are small metal points that attach to a holder. They range in shape from very flat and broad to extremely narrow to make different kinds of lines.

- **Helpful Hints:** Pushing the pen *away* will cause it to dig into the paper and splatter ink. Press the tip against the lip of the ink bottle to remove excess ink. Ink flows more evenly if drawing is done on a sloped surface.

Pen Nibs

Shading and Texture Techniques

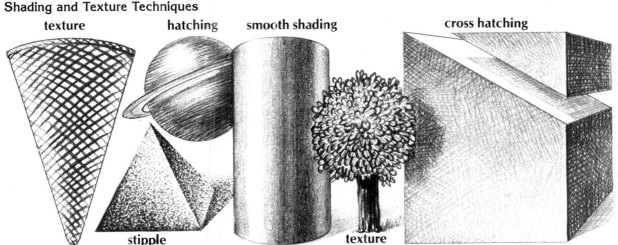

texture hatching smooth shading cross hatching

stipple texture

Crayons and Oil Pastels

Crayons. Made of hard wax, this medium is available in a great variety of colors. When applied with a heavy pressure, crayons produce rich, vivid colors. Strokes can be blended or softened by rubbing them with a cloth or paper towel. Preliminary sketches are better made with white chalk or a light-colored crayon because pencil lines will often show through the crayon color. Newspaper padding under the paper to be colored insures an even application of color.

Oil pastels are softer than wax crayons, similar to chalk, and produce bright, glowing color effects. They smudge more easily than crayons. As with crayons, drawing can be done with the points or with the unwrapped sides. Note: Oil pastels break easily once the wrapping is removed. Pressing hard creates rich, vibrant color; less pressure produces a softer color. Colors can be mixed by adding one over another, or by placing different colors side by side and smudging them. Rough paper makes the color lighter, and smooth paper makes the color appear brighter. (See illustrations below.)

Colored Markers

These felt or plastic-tipped instruments are easy to use and clean, and they are available in a wide range of colors and sizes. They are useful for sketching outdoors, making contour drawings, and for just about every art assignment imaginable. They dry out easily, so be sure to keep a cap on the tip when the markers are not in use.

Mechanical Drawing Instruments

Ruler. Hold the ruler firmly in place and measure a line of the desired length. Then put dots to mark the beginning and end of the line and connect them by drawing a line against the ruler's edge.

Set Square. This triangle has straight edges and may be set at any desired angle with the edge of a drawing board. It is used with a T square to draw lines at right angles.

Protractor. This instrument is a half-circle used to draw and measure angles.

T square. This instrument is a straight edge with a crosspiece or head at one end. The crosspiece is held against the edge of a drawing board to position the straight edge for drawing parallel or horizontal lines. It is also used as a support for a set square in drawing vertical lines at right angles.

Pencil Compass. This instrument is useful for making circles. First, be sure the legs are tight and will not move easily. When the pencil is securely attached to the holder on one leg, it should be the exact length of the pointed leg. Press the metal point into the paper, with the two legs apart. Hold the pencil at the top and turn the pencil leg around the pointed leg. This creates a perfect circle. Vary the size of the circle by spreading or closing in the legs of the compass. The measurement from the center of a circle to the outside edge is called the *radius*.

Using a Pencil Compass

Charcoal

This material is made from charred twigs or vine and is available in natural sticks, pencils, and compressed sticks. Its effects range from soft and dark to hard and light. Edges can be softened and light and dark tones blended by smudging with a finger or soft cloth. Changes can be made with a rubber kneaded eraser. Because it is dry and easily smeared, the final charcoal drawing should be sprayed with a fixative to preserve it.

PAINTING

Two of the most popular and readily available paints are tempera and watercolor.

Tempera

This paint works best when it has the consistency of thick cream. It is available in powder, liquid, and solid blocks of color. Tempera is opaque—the paper beneath cannot be seen through the paint.

Powder. Available in cans or boxes, tempera powder is mixed in small amounts. Water and powder are mixed to the desired consistency until there is sufficient paint. Only mix as much as is needed; dried tempera paint cannot be used again.

Liquid. Available in a jar, tube, or plastic container, tempera liquid is in a ready-to-use condition. Stir well if it has been stored for a long time. Make sure that any sticks, brushes, or spoons you use for stirring are clean so that the paint will remain clean and opaque. Keep the lid on when paint is not being used, and keep paint cleaned out of the cap to prevent sticking. Stuck bottle caps will usually loosen in warm water.

Blocks or cakes. Available in large, separate blocks or small blocks of different colors in paint boxes, it is made to dissolve easily when rubbed gently with a wet brush.

Watercolor

Watercolor paints come in tubes or small, solid pans or cakes. The solid paint dissolves very easily when it is rubbed gently with a wet brush. This kind

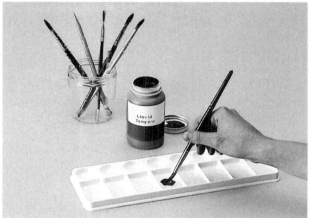

Tempera Paints

of paint is to be used with plenty of water and has a thin consistency. Because it is transparent, it is possible to see through it to the paper underneath.

Watercolor Paints

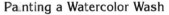
Painting a Watercolor Wash

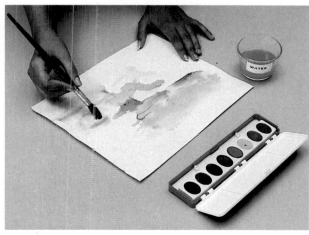

Color-mixing Tips

Be sure to keep the water in the rinsing container clean, and rinse the brush before dipping it into a new color.

1. With tempera paint, always begin mixing with light colors and add darker colors a little at a time. Never add a lot of black.
2. Never try to lighten tempera paint that has become too dark. The color will have to be used as it is or thrown away.
3. To make green, add blue to yellow.
4. To make orange, add red to yellow.
5. To make violet, add blue to red.

6. To make brown, try putting these colors together. Each combination will make a shade of brown.
 a. red and green
 b. red, yellow, and black
 c. red and black

7. To make gray, add black tempera to white. With watercolors, just thin down black paint with water. All grays look better with a dab of another color added.

8. To make watercolors lighter, add water.

9. To darken watercolors, use less water.

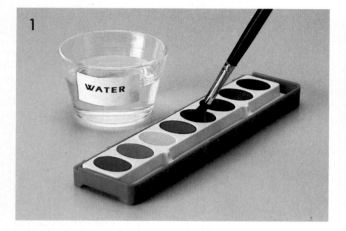

Painting with watercolors:
1) add clear water to moisten paint
2) clean the brush after applying paint
3) fill the brush with another color
4) mix paints to achieve desired color
5) apply mixed colors to picture

PRINTMAKING

Linoleum Techniques

1. Begin with a mounted or unmounted pliable block of linoleum.
2. Paint the block white and let it dry.
3. Draw a design on the linoleum.
4. Cut out unwanted areas with a U-shaped or V-shaped cutting gouge.

 • **Safety Precaution:** Use linoleum cutting tools carefully. Always cut away from the body to prevent accidents.

5. Pour printing ink on an inking surface, such as a glass sheet, metal or plastic tray, or cookie sheet.

 • **Safety Precaution:** Be sure to use printing inks in a well-ventilated room.

6. Roll the brayer over the ink to spread it so the brayer can pick up an even coat.
7. Roll the ink-coated brayer over the block of linoleum until the whole surface is evenly covered with ink. Roll first in one direction, then in another at right angles.
8. Turn the block over and lower it carefully onto the paper to be printed. Press it down firmly along all four edges. If there are textures or details in the design, turn the block over and press the paper onto it. Rub the paper against the textures with a covered finger or the back of a spoon to pick up all the details.
9. Peel the paper away from the block. The print is ready to dry.

Making a linoleum print:
1) cutting away parts from the design
2) applying paint with a brayer
3) printing the design

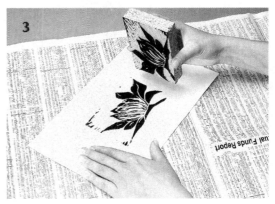

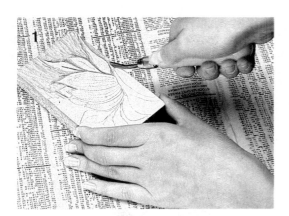

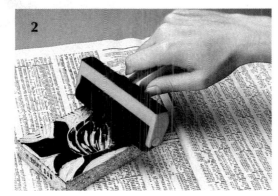

Other Printing Materials

Other materials recommended for making prints include man-made objects, natural objects, string designs glued to cardboard, roots, and wood.

Inks

Printing ink may be water or oil-based. Oil-based ink produces the best results but it dries slowly, has an unpleasant odor, and is difficult to clean up. Water-based ink dries quickly, needs thinning to keep it from becoming tacky, and cleans up easily.

Paper

Recommended paper for printing includes newsprint, construction paper, butcher paper, and tissue paper. Avoid using paper with a hard, slick finish because it absorbs ink and paint poorly.

Clean-up

If oil-based ink is used, use turpentine to thoroughly clean the roller, inking surface, and linoleum block when printing is completed. Ink that dries cannot be removed from these surfaces.

SCULPTURE

Sculpture refers to three-dimensional art. It is usually made by carving, modeling, casting, or construction. Sculptures can be created by adding to or taking away from a block of material. Materials appropriate for subtractive sculpture in school include firebrick, clay, chalk, soap, wax, soft salt blocks, plaster of paris, and soft wood. Materials recommended for adding on to a piece of sculpture include clay, papier-mâché, wood, and almost anything else that can be joined together. Specific *carving techniques* appear in the discussion of each medium.

Clay

Clay comes from the ground and usually has a gray or reddish color. It is mixed with other materials so that it is flexible and yet able to hold a shape.

Oil-based clay. This clay is mixed with an oil, usually linseed, and cannot be fired or glazed. It softens when it is molded with warm hands. As it becomes old and loses oil, it becomes difficult to mold and will eventually break apart. Oil-based clay is available in many colors.

Water-based or *wet clay.* This ceramic clay comes in a variety of textures and can be fired so that it is permanent. It should be kept in a plastic sack or covered with a damp cloth to keep it moist until it is used. If a piece begins to dry out, it may be kept damp with a fine spray of water.

Clay Methods

Clay can be molded and formed using the pinch, slab, and coil methods, or a combination of these.

With the *pinch* method, a chunk of clay is molded into a ball. Holding the ball in one hand, press the thumb in and carefully squeeze the clay between thumb and forefinger. Begin at the bottom and gradually work upward and out. Continually turn the ball of clay as it is pinched.

To make a *slab,* use a rolling pin to roll a chunk of clay into a flat slab about an inch thick. Shapes can be cut from the slab and joined together to form containers or sculpture.

To create a *coil,* use the palm of the hand to roll a chunk of clay against a hard surface until it forms a "rope" of clay of even thickness. Coils can then be scored, attached to each other with slip, and built into a shape or a base.

Textures can be created by pressing combs, coins, bolts, burlap, buckles, keys, chains, utensils, sticks, shells, straws, toothpicks, pencils, buttons, bottle caps, old jewelry, and other interesting objects into the clay.

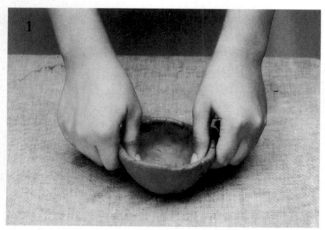

Carving Techniques

Use wire and wooden clay tools or an old table knife to cut away unwanted clay.

Preparing Clay

If clay is reused or made from a powder mix, it will be necessary to remove air pockets in the clay before it is molded. Clay that has air pockets in it can explode during firing in a kiln. Getting rid of air pockets may be done by wedging or kneading the clay thoroughly.

Wedging. Take a large chunk of clay and form it into a ball. Then use a wedging wire to cut the ball in half. Put one hunk on a hard surface and slam the other half down on top of it. Repeat this process until the cut clay has an even consistency. It should feel fairly soft and pliable.

Kneading. Take a large chunk of clay and press it down with the palms of both hands against a hard surface. Turn clay around, and press hard again. Keep turning and pressing in this manner until the clay has a smooth, even texture.

Joining Clay Together

Oil-based clay can be pressed together. Water-based clay pieces should be scored, painted with slip, and then pressed together.

Slip is a creamy mixture of clay and water. If clay has dried out, use vinegar instead of water to make the slip. Slip works like glue to adhere pieces of clay together.

- **Safety Precaution:** Check with your teacher on how to dispose of unused slip. It can block piping if it is poured down drains.

Scoring is done by roughening the surfaces that are to be joined with a fork, comb, or pointed instrument. Apply slip to the scored surfaces, press together, and smooth.

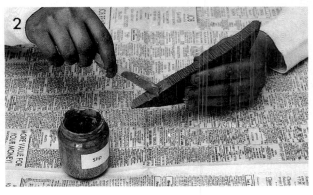

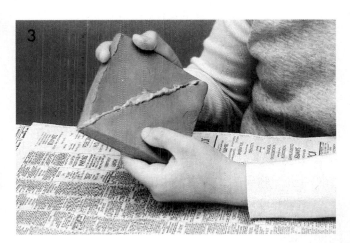

Drying, Glazing, and Firing Clay

Finished clay pieces should be allowed to dry naturally and completely for several days in a warm place until they no longer feel cold to the touch. The firing temperature required to mature various types of clays differs. You should select clay and glazes that mature at the same temperature— which may be determined by the capability of your kiln.

Firing is a two-stage process. Dried, unbaked clay (known as "greenware") may be stacked and loaded as closely as possible for the first firing. This firing will be to approximately cone 015, or 1500

degrees F., and will bring the clay to a "bisque" stage where it is halfway matured, but still porous enough to absorb liquid glaze.

Coat the base, or foot, of bisque ware with commercial *wax resist* or melted paraffin, or simply avoid getting glaze on areas that will touch the kiln shelf, to prevent pieces from fusing to the shelf. Bisque ware may be glazed either by dipping or pouring the glaze on, or by evenly painting on three coats with a soft brush. Glazed pieces must be loaded in the kiln so they do not touch anything for the very hot glaze firing.

Papier-mâché

This art material is made from mixing paper pulp or strips with paste or glue. It can be molded into various three-dimensional shapes when it is wet, and painted and shellacked when it is dry.

Preparing Pulp

Shred pieces of soft paper, such as newsprint, paper towels, newspaper, or facial tissue, into small bits or thin strips. Soak several hours in water. Then drain, squeeze out the extra water, and mix the pulp with prepared wheat paste to the consistency of soft clay. Let the mixture stand for an hour before working with it.

Preparing Strip

Tear newspaper or newsprint into long, thin strips about an inch wide. Dip the strips into prepared

wheat paste, and then put down a layer of wet strips over the shape to be covered. Continue putting strips on the form until there are five or six layers. This thickness is strong enough to support most papier-mâché projects.

Sculpting Forms

Good forms that can be used as foundations for papier-mâché include the following: rolled newspapers secured with string or tape, blown-up balloons, plastic bottles, paper sacks stuffed with newspapers and tied with string, and wire or wooden armatures used as skeletal forms.

Pulp Papier-mâché

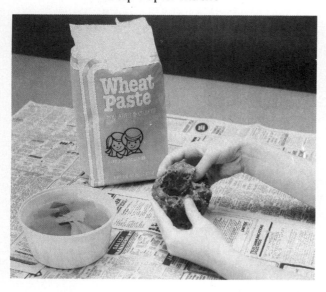

Strip Papier-mâché

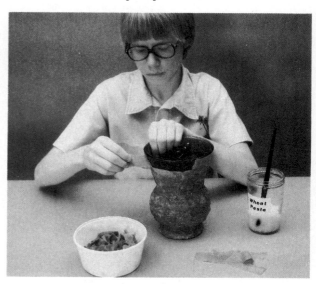

226

Plaster of Paris

This very white powder comes in large paper sacks and must be kept dry before use. It quickly turns solid when it is mixed with water and feels warm to the touch as it dries. Let the plaster dry two or three hours before working with it. It is relatively soft and easy to carve and can be colored while drying or after it has hardened. The finished piece should be coated with an art spray or shellac to preserve and protect it.

How to Mix Plaster

1. Put as much water in a bowl or bucket as the teacher directs.
2. Quickly sprinkle plaster into the water until it begins to show through the surface of the water.
3. Mix the plaster and water together by hand or with a wooden spoon.
4. When the plaster begins to thicken, it is ready to pour.

Carving Techniques

1. Pour the plaster into a mold or directly onto a wooden board. Use hands to shape it as it hardens, forming it in the approximate shape desired.
2. Use a simple wood chisel and hammer to cut away large unwanted areas.
3. Use a small chisel, file, rasp, Sloyd utility knife, or an old table knife to further define shape.
4. Use a nail, nut pick, or dental tools to carve lines and descriptive details.

 Carving Hint: Proceed slowly and cautiously when removing plaster. Once a piece has been cut off, it cannot be reattached to the form.

- **Safety Precautions:** Always put plaster that is to be thrown away in a special newspaper-lined wastebasket, *never* down a drain. If plaster powder ever gets in your eyes, immediately flush eyes with water and go to the school nurse.

Wood

Wood is a material whose grain, texture, and color may vary from piece to piece. It is available in a variety of thicknesses and forms for craft projects. Solid blocks about two to four inches thick are suitable for carving. Woods recommended for carving include pine, balsam, cypress, walnut, cherry, apple, mahogany, and rosewood.

Carving Techniques

1. Secure the wood to a surface so that both hands are free for woodworking.

Mixing and Pouring Plaster of Paris

2. Use a mallet and chisel to remove large areas of unwanted wood.
3. Use a saw to cut away areas close to the edges.
4. Use a pocketknife, gouge, or chisels to define shape.
5. Use sandpaper to smooth wood surface.

- **Safety Precaution:** Use sharp blades cautiously, always cutting *away* from your body.

227

BASIC MATERIALS AND PROCEDURES

Types of Paper

Butcher paper. Available in wide rolls and several colors, this paper is useful for murals and other large art projects.

Construction paper. Available in different colors, this fairly stiff paper is useful for tempera painting, collage, and paper sculpture.

Drawing paper. This fairly thick, slightly rough paper is useful for drawing and paper sculpture.

Newsprint. This thin, blank paper is used for printing newspapers. Inexpensive and easily torn, it is good for sketching, printing, and making papier-mâché.

Tissue paper. Very thin and strong and available in many bright colors, it is especially good for making collages and stained glass windows.

Watercolor paper. This thick, textured paper is especially suited to watercolors. Because it is expensive, it is seldom used in schools.

Techniques for Using Paper

Folding

Bend the paper so that one edge is exactly on top of the other, holding the two edges together. Smooth the paper until it creases at the center, then press the crease in between finger and thumb.

Tearing

Paper may be torn apart by hand, causing the edges to look ragged or fuzzy, or it may be folded, creased, and then torn along the creased fold, which gives a neater tear.

Cutting

Cutting may be done with scissors, a paper cutter, or an X-acto knife.

Scissors. If cutting a piece from a large sheet, cut what is needed from the edge, not the center.

Paper cutter. Several sheets may be cut at the same time with a paper cutter. Hold the paper down firmly and be sure fingers are out of the way when the blade is lowered. Pull the blade down slowly and firmly. Do not hack at the paper. If it does not cut smoothly, try cutting fewer sheets at a time. When finished cutting, always lock the blade in the closed position.

X-acto knife. Press this very sharp blade slowly and carefully when cutting.

- **Safety Precautions:**
 - Use caution when using sharp instruments.
 - Always keep sharp ends pointed away from your body.
 - Cardboard underneath materials to be cut will protect furniture.
 - Do not leave loose blades lying around.
 - Store blades in a safe place.
 - *Never* point a blade at anyone, even in play.

Scoring

With a pointed instrument, such as a scissors blade tip, press into but not through a piece of paper or cardboard. The paper will then easily bend or fold on that line.

Scoring Paper

228

Glue, Paste, and Cement

Glue

White glue is a creamy liquid that comes in plastic squeeze bottles and in larger containers. It is useful for sticking cardboard, wood, cloth, styrofoam, and pottery. It will cause wrinkling when used with paper, especially if too much is used.

Water and white glue are recommended for making tissue paper collages. It should be mixed to a thin, water consistency.

Paste

School or library paste is thick, soft, and white and usually comes in jars. It is good for sticking paper and cardboard, but will often dry out so that the paper comes loose.

Wheat paste is a powder that comes in a package and must be mixed with water. Mix only as much paste as needed because it doesn't store well. This paste is good for sticking paper and cardboard, and for making papier-mâché.

Cement

Rubber cement is a clear, slightly thick liquid that comes in tubes, bottles, and cans. It dries quickly, so always keep the cap on tightly. It is a good idea to keep a can of solvent available to add to the cement so the proper consistency is maintained. It gives glued paper a smooth, unwrinkled look, and excess is easily removed by rubbing.

Applying Rubber Cement

How to Stick Things Together

Spread out some newspaper. Place the artwork to be glued face downward. Spread the glue, paste, or cement outward from the center. Use a spreader, brush, or finger. Be sure the edges and corners are all covered. Lift the paper up and carefully lay it in the desired place. Smooth the paper flat with clean hands. Place a sheet of paper over the top and smooth down on top of that, using the palm of the hand.

Always clean up thoroughly after using glue, paste, or cement with art projects.

- **Helpful Hints:**
 1. Always use the least amount of glue possible. Too much will spoil the appearance of the artwork.
 2. If a brush is used, be sure to wash white glue out of it before it dries. Rubber cement brushes will become stiff if allowed to dry with glue in them, so keep them in the cement bottle to keep them soft. They can be washed in special thinners if necessary.
 3. Both rubber cement and white glue dry very quickly. Don't put glue on until ready to attach the artwork to a surface.

- **Safety Precaution:** Be sure the room is well ventilated when you use rubber cement, and that you store it in a safe place away from open flames.

Attaching a Picture to the Background

Framing Artwork

Frames almost always improve the appearance of artwork and make attractive displays.

Mounting

The simplest kind of frame is a mount. It is made by putting a small dab of paste at each corner of an artwork. The artwork is then placed on the center of a sheet of construction paper or cardboard that is two to three inches bigger than the work on all sides. The border may be slightly narrower at the top and slightly wider at the bottom, for a well-balanced appearance.

Mounting a Picture

Matting

A mat is a frame with a cut-out center. A picture is taped in place behind it, with the mat forming a border. To make a mat, take a piece of fairly thick cardboard, or matboard, that extends two or three inches beyond the picture on all sides. Measure the picture to be matted. Then, on the back of the matboard, mark the position where the art is to be placed. The mat will look balanced if the bottom margin is a little larger than the other sides. Then measure one-fourth inch in and mark it all around the frame. This will make the picture overlap the cut-out window on all sides.

Now take an X-acto knife and cut along your inside measurements. Cut very carefully when a corner is reached so the matboard is not cut beyond the mark. When all four sides have been cut, the center will come out. Fasten a picture to the back with tape, and the mat is complete.

- **Safety Precautions:** Work slowly and use caution when using an X-acto knife. Keep the blade pointed away from your body, and be sure to retract the blade or return the knife to its container when not in use. Place a pad of newspaper underneath the object to be cut so that you will not cut the table.

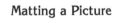

Matting a Picture

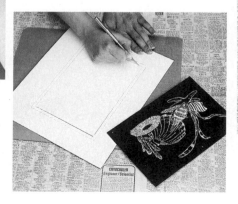

Learning Outcomes

Note: See page 2 for information on using the **Learning Outcomes.**

Unit I Line, Tone, and Value

1 Contour Drawing

Understanding Art

1. Define the term *contours.*
2. Two essential art skills are keen observation and use of lines in drawing. Explain why these skills are so important.

Creating Art

3. Did you make a blind contour drawing and a modified contour drawing? Explain the difference between the two.

Appreciating Art

4. Tell what you like about the way Hokusai used contour lines effectively in *A Maid Preparing to Dust* shown in this lesson.

2 Outside and Inside Shapes

Understanding Art

1. Define *internal contours.*

Creating Art

2. Did you draw the contours of an object wrapped with string? How did the string help you in making your drawing?
3. Did you draw the same object again, using shading to show the internal contours? How did you know which parts should be shaded?

Appreciating Art

4. Point out the parts of your drawing that give the best sense of the object's actual three-dimensional shape.

3 Shading Round Surfaces

Understanding Art

1. Define the term *gradation.*
2. Explain how differences in *value* and *tone* are created in art.

Creating Art

3. Did you show gradual shading on the contours of three objects?
4. How did you indicate where light hits each of the objects?

Appreciating Art

5. Tell which student drawing in the lesson shows curves most effectively. Explain why you think so.

4 Dots . . . Dots . . . Dots

Understanding Art

1. Define *pointillism.*

Creating Art

2. Did you use dots to draw your subject?
3. Explain how you used dots to create a three-dimensional effect.

Appreciating Art

4. Describe the effects you can achieve by using dots in a drawing. Explain what you like or dislike about this method.

5 Drawing Details and Close-ups

Understanding Art

1. Define the term *visuals.*

Creating Art

2. Did you carefully observe and draw a man-made object?
3. Which object did you draw? Describe the details you drew on your close-up drawing.

Appreciating Art

4. Look at van Gogh's *Three Pairs of Shoes* in the lesson. Point out some of the details he portrayed and tell how he achieved them.

6 Sketching and Drawing Natural Objects

Understanding Art

1. Define *texture* and give two examples of objects with contrasting textures.
2. Explain how texture adds interest to a drawing.

Creating Art

3. Did you make a detailed drawing of something from nature, based on one of your sketches? List the details you added to your drawing.
4. Did you draw the same object again, using only visual memory?

Appreciating Art

5. Compare your second drawing of a natural object to your first drawing. How are they alike? How are they different? Tell which one you prefer, and explain why.

7 Train Your Visual Memory

Understanding Art

1. Define *visual memory*.

Creating Art

2. Did you study a subject and then draw it, using only what you remembered as a starting point?
3. Did you practice sketching details before making a final drawing from memory?

Appreciating Art

4. Tell which of your two drawings you think is best, and explain why.
5. Did your visual memory improve in your second drawing?

8 A Three-Quarter View Portrait

Understanding Art

1. Describe how a *three-quarter view portrait* is different from drawing a front view of the face.
2. Explain the relationship of the various parts of the head & face to each other.

Creating Art

3. Did you draw a three-quarter view portrait? Describe features that show the uniqueness of the person you drew.
4. Did you shade light and dark areas of the portrait? Tell where you added shading.

Appreciating Art

5. Which part(s) of a three-quarter view portrait did you find most difficult to draw? Explain why.

9 Old and Young People

Understanding Art

1. Explain why it might be valuable to study the faces of the young and the old.

Creating Art

2. Did you make a drawing of a child's face and a drawing of an old person's face?
3. Tell what you did to show the youth of the child and the age of the old person.

Appreciating Art

4. Choose one of the pictures in the lesson, either van Gogh's *A Peasant of the Camargue* or Cassatt's *The Bath,* and tell what you like about the way it shows youth or age.

10 Sketching in the Style of Leonardo da Vinci

Understanding Art

1. Explain how Leonardo da Vinci learned to draw figures so well.
2. Leonardo da Vinci was a scientist and engineer as well as an artist. Name three things he invented or designed.

Creating Art

3. Did you make several sketches of a subject from different angles?
4. Did you make a finished drawing filled with many different details, based on one of your sketches? Tell what medium you used to best express the subject you chose for the drawing.

Appreciating Art

5. Explain why you chose the particular sketch you used to develop your finished drawing.

11 Exaggerated Drawings and Caricatures

Understanding Art

1. Define the term *caricature*.

Creating Art

2. Did you draw a caricature of a person, based on a photograph? Which features did you distort?

Appreciating Art

3. Choose one or two caricatures done by classmates and explain what makes them effective caricatures.

12 Portrait of Hands

Understanding Art

1. Describe the *modified contour drawing* method.

Creating Art

2. Did you make a finished, detailed drawing of your hand, based on your contour drawing?
3. Tell what you did to make your drawing of a hand look three-dimensional.

Appreciating Art

4. Describe the features of your finished work that make it an effective design.

13 Human Measurements

Understanding Art

1. Explain the meaning of *proportions*.
2. Discuss the relationship of various parts of the body to each other.

Creating Art

3. Did you draw a figure with the body parts in proportion so that it looks balanced?

Appreciating Art

4. Which part of the figure you drew looks most natural and convincing?

14 People in Action

Understanding Art

1. Explain *gesture* drawing.

Creating Art

2. Did you make a drawing of someone in action? Tell what you did to show action.
3. Did you make the parts of the body in the proper proportions?
4. Did you practice gesture drawing?

Appreciating Art

5. Look at the pictures by Daumier and Goya in the lesson, and explain how each artist has portrayed action effectively.

15 Geometric Shapes

Understanding Art

1. Name three drawing instruments that can be used to make geometric art.
2. Explain the meaning of *abstract* design.

Creating Art

3. How did you transform the shapes and forms in your drawing into your own geometric design?
4. In what other ways did you make the picture appear abstract?

Appreciating Art

5. Contrast Benton's and Marin's pictures in this lesson. How are they different? Which do you prefer?

16 Showing Depth and Distance

Understanding Art

1. Define the term *perspective*.
2. Explain the difference between *vertical* and *horizontal* lines.

Creating Art

3. Did you draw perspective lines on a photograph? Describe what happened to the lines of horizontal objects.
4. Did you make a freehand drawing of another building? Describe what happened to the vertical lines in your picture.

Appreciating Art

5. Look through this book for an example of a drawing or painting of buildings that shows good use of perspective. Write the name of the artist and the picture, and state what you like about it.

17 Bird's-Eye View

Understanding Art

1. Define the term *horizon*.

Creating Art

2. Did you make a drawing of a scene from a bird's-eye view?
3. What did you do to show perspective in your drawing?

Appreciating Art

4. Select one picture from this lesson, and tell what qualities you like best about it.

18 Unusual Angles

Understanding Art

1. Explain the meaning of *distorted*.

Creating Art

2. Did you draw an unusual view of an object or place? Describe the view you chose.
3. How did you emphasize the peculiar qualities of the object or place you chose?

Appreciating Art

4. Identify the artwork in this lesson that you think is the most effective picture of an unusual angle. Describe the features you like best about it.

19 Different Styles of Drawing

Understanding Art

1. Define the term *media*.
2. Explain what is meant by *drawing styles*.

Creating Art

3. Did you make a drawing in the style of one of your favorite artists? Which artist did you choose?
4. Describe the characteristics of that artist's style you used in your drawing.

Appreciating Art

5. Compare and contrast the drawing styles shown in the pictures you see in this lesson.

20 Drawing Animals

Understanding Art

1. Explain how studying an animal's bone structure can help you make a better drawing.
2. Define *texture* and name three textures found on animals.

Creating Art

3. Did you make a finished drawing of an animal? How did you begin your drawing?
4. Explain how you indicated textures.

Appreciating Art

5. Look at the pictures in this lesson and identify which animal drawing you like best. Explain why you prefer it.

Unit II Color and Composition

21 A Study in Color

Understanding Art

1. Name the *secondary colors* and describe how to make them.
2. Explain how *repetition* of contrasting colors creates dramatic effects.

Creating Art

3. Did you make an abstract design with geometric shapes? Did you paint your design with complementary colors?
4. Explain what you have learned about mixing complementary colors.

Appreciating Art

5. What are the most exciting contrasts you created in your design?

22 Colors, Tints, and Shades

Understanding Art

1. Explain the difference between *value* and *intensity* in art.
2. Explain the difference between *tint* and *shade* in color.

Creating Art

3. Did you create a geometric design painted with primary and secondary colors and their tints and shades?
4. Explain how you used *hard-edge painting* to color your design.

Appreciating Art

5. Which colors in your design are the boldest? Which are the dullest? How do sharp contrasts in color add interest to a design?

23 A Monochrome Painting

Understanding Art

1. Define the term *monochrome*.
2. Describe how *tints* and *shades* are made.

Creating Art

3. Did you make a monochrome painting?
4. Explain how you indicated distant and close-up objects in your picture.

Appreciating Art

5. Observe the paintings in this lesson and tell how the use of color helps create certain moods or feelings in art.

24 Showing Distance with Color

Understanding Art

1. Explain the difference between *linear* and *atmospheric perspective*.
2. Explain how color is used to achieve *atmospheric perspective*.

Creating Art

3. Did you draw a scene using atmospheric perspective? In what part of your picture do the brightest colors appear?
4. What other methods did you use to show what is distant and what is close up in your finished drawing?

Appreciating Art

5. Tell what you think Hassam was trying to communicate in his painting of a parade shown in this lesson.

25 A Tempera Batik Landscape

Understanding Art

1. Define the term *batik*.
2. Explain how to make a *tempera batik* picture.

Creating Art

3. Did you draw a landscape and paint it, using the tempera batik technique? How did you indicate distance in your landscape?
4. Describe special effects you created with your use of color or line.

Appreciating Art

5. Describe how your tempera batik picture is different in appearance from other pictures you have created, and tell what you like about it.

26 Using Watercolor Paints

Understanding Art

1. Define the term *transparent*
2. Describe how to make a watercolor *wash.*

Creating Art

3. Did you make a watercolor painting? Describe the special effects you were able to achieve using this medium.
4. Explain the differences between the colors and paint you used in the background and those you used in the foreground of your picture.

Appreciating Art

5. What are the main differences between using watercolors and other kinds of paint? Which kind of paint do you prefer?

27 Painting from Back to Front

Understanding Art

1. Define *atmospheric perspective.*
2. Explain the difference between *opaque* and *transparent.*

Creating Art

3. Did you paint a landscape using linear and atmospheric perspective? Which type of perspective did you create first?
4. Describe how you made the sky of your picture, noting process and use of color.

Appreciating Art

5. Identify the parts of your painting where you most successfully used watercolors to show distance.

28 Dry-Brush Painting

Understanding Art

1. Explain how to do the dry-brush method of painting.

Creating Art

2. Describe some effects you created in your painting using dry-brush techniques.
3. Explain how you indicated objects in the foreground of your picture.

Appreciating Art

4. Study Hiroshige's painting of *The Cat* shown in this lesson. How does he use space and simple lines effectively in his composition?

29 Shadows and Silhouettes

Understanding Art

1. Explain the meaning of *cast shadow.*
2. Define the term *silhouette.*

Creating Art

3. Did you paint a dimly lit scene with silhouettes?
4. Describe the shadows you drew in your picture, and explain how you mixed your colors to paint the shadows.

Appreciating Art

5. Study the pictures by Burchfield and Hopper shown in this lesson. Compare and contrast the techniques these two artists used to create effective shadows in their pictures.

30 Showing Reflections

Understanding Art

1. Explain how reflections can add to the beauty of a picture.

Creating Art

2. Did you paint a view of a lake or river, showing reflections in the water?
3. Tell how you achieved the effect of reflections on the water.
4. What word did you use as the title of your picture?

Appreciating Art

5. Describe how your color scheme expresses the feeling or mood of your scene.

31 Oriental Art Styles

Understanding Art

1. Name three characteristics of Oriental art.

Creating Art

2. Did you paint a picture in an Oriental art style? What did you choose for a subject?
3. Explain what you did to create a picture in an Oriental art style, including how you used line, space, and color.

Appreciating Art

4. Tell the features you like best about your picture. What part would you like to improve?

32 The Renaissance

Understanding Art

1. Define *Renaissance* and name one of the important changes in art that took place during this period.

Creating Art

2. Did you draw a flowing garment or piece of material draped over a chair?
3. What was the most difficult part of drawing and painting the draped piece?

Appreciating Art

4. Study the Renaissance art shown in this lesson. Point out the specific features you like most in these paintings.

33 Great Mexican Artists

Understanding Art

1. Define *mural* and name one of the outstanding Mexican mural artists.
2. Name two characteristics of Mexican mural art in either theme or style.

Creating Art

3. Did you paint a picture or mural in a Mexican art style?
4. Tell which Mexican art ideas you used in your picture or mural.

Appreciating Art

5. Choose one of the paintings by a Mexican artist in this lesson. Explain what message or statement you think the artist is making concerning the social conditions of the Mexican people at the time.

34 American Painters

Understanding Art

1. Give an example of how two different artists might paint the same scene in different styles.

Creating Art

2. Did you paint a picture using ideas from American artists, expressed in your own way? Describe how you adapted their ideas and styles of painting to fit your own style.
3. Tell whether the shapes in your picture harmonize or clash.

Appreciating Art

4. Discuss the major characteristics of your own artistic style that you have developed thus far.

35 Picturing a Part of America

Understanding Art

1. Explain the meaning of *path of vision.*
2. Define the term *center of interest.*

Creating Art

3. Did you paint a landscape with a carefully designed path of vision? Describe the path of vision you intended.
4. Did you create a center of interest in your painting? What is it?

Appreciating Art

5. Observe the three pictures shown in this lesson and describe the feelings you get from each of the paintings. Which place would you most want to visit?

36 The Fathers of Modern Art

Understanding Art

1. Name three artists who introduced new art styles in the nineteenth century.
2. Describe the characteristics of the Post-impressionist style of art.

Creating Art

3. Did you paint a picture using some of the techniques of the Post impressionist artists?
4. Did you experiment with different brushstrokes using pure colors?

Appreciating Art

5. Compare and contrast the styles of Gauguin, van Gogh, and Cézanne.

Unit III Design, Media, and Technique

37 Drawing with Scissors

Understanding Art

1. Name three kinds of art created by the French artist Henri Matisse.
2. Explain what Matisse meant by "drawing with scissors."

Creating Art

3. Did you make a collage of cutouts from colored paper?
4. How did you emphasize the center of interest of your collage?

Appreciating Art

5. Explain how your choice of colors and shapes fits the idea you chose for your collage.

38 Mixed Media Collage

Understanding Art
1. Define *collage*.

Creating Art
2. Did you create a collage out of a variety of materials? List the materials you used.
3. Tell how you created a center of interest for your collage.

Appreciating Art
4. Tell what you did to unify your design.

39 Drawing Distortions

Understanding Art
1. Define the term *grid*.

Creating Art
2. Did you draw two different distortions, using your drawing and a grid?
3. Explain how you used the grid to make one of your distortions.

Appreciating Art
4. Tell which type of distortion worked best for the picture you drew, and explain why.

40 Slice, Twist, and Stretch

Understanding Art
1. Explain the meaning of *distortion*.

Creating Art
2. Did you rearrange the pieces of a photograph to create a distorted face?
3. Did you draw a distorted face based on your arrangement? Describe how you altered the face.

Appreciating Art
4. In one or two words, describe the feeling expressed on the face in your finished drawing.

41 Creating with Stitches

Understanding Art
1. Define *stitchery*. Name two kinds of stitches.

Creating Art
2. Describe the stitchery design you made, telling how you used colors, textures, and stitches.
3. Did you *applique* fabric to your stitchery to make it more interesting?

Appreciating Art
4. Explain which kinds of stitches were most useful for making your stitchery.

42 Geometry with a Needle

Understanding Art
1. Explain the meaning of *stitchery*.

Creating Art
2. Did you make a stitchery design based on geometric shapes?
3. Describe the designs you made, noting colors, variety in yarn thickness, and other aspects of your design.

Appreciating Art
4. Identify what you like best about your geometric stitchery design.

43 Pictures in Cloth

Understanding Art
1. Explain the meaning of *appliqué*.

Creating Art
2. Did you design and make an appliqué picture or wall hanging?
3. Identify colors, shapes, and textures you repeated to unify your design.
4. Tell how you used stitches in your design.

Appreciating Art
5. Select the appliqué that you like best in this lesson and tell what you like about it.

44 Weaving on a Natural Loom

Understanding Art
1. Define *warp* and *weft* in weaving.

Creating Art
2. Did you create a weaving on a forked branch?
3. List materials you added to make your weaving truly creative.
4. Tell how you achieved variety in your woven design.

Appreciating Art
5. Describe the specific features of your weaving that you think are the most interesting.

45 The Art of Macramé

Understanding Art
1. Define the term *macramé*.

Creating Art

2. Did you create a piece of macramé, using a variety of knots?
3. What kind of macramé project did you make?

Appreciating Art

4. Tell whether or not you enjoyed working with macramé, and describe the parts you made that were most successful.

46 Creativity with Beads

Understanding Art

1. Define *armature* and explain how it can be used for making beads.

Creating Art

2. Did you string together a strand of beads? What materials did you use?
3. Describe the design you created. What special features make your necklace unusual?

Appreciating Art

4. Describe what you like about the combination of materials you chose.

47 Printmaking with Linoleum Blocks

Understanding Art

1. Explain how *woodcuts* were used to make the first prints.

Creating Art

2. Did you make a linoleum block print design?
3. Describe how you used spaces and shapes in your design.

Appreciating Art

4. Identify the linoleum print in the lesson that you like best. Tell why you prefer it.

48 Visual Word Messages

Understanding Art

1. Name three different kinds of work *graphic artists* do.

Creating Art

2. Did you illustrate the meaning of a word with an original style of lettering?
3. Describe how you used lines and shapes to illustrate the word you chose.
4. Did you incorporate a picture into the lettering or design of your word?

Appreciating Art

5. Explain how the letters, shapes, and color work together to create a unified design.

49 Drawing Letter Shapes

Understanding Art

1. Define the term *calligraphy.*
2. Name three uses for calligraphy.

Creating Art

3. Did you letter a quote or message in the alphabet style of your choice? Describe the lettering style you chose.
4. Did you hold the pen at a constant angle so the thin and thick lines occurred in the same places in each letter?

Appreciating Art

5. Tell which of your letters and words have the best shapes.

50 Designing a Poster

Understanding Art

1. Define *center of interest.*
2. Explain two ways of creating a *unified* design.

Creating Art

3. Did you create a center of interest for your poster? What did you do to emphasize that part of your poster?
4. Tell how your choice of colors and lettering style fits the message and the mood of your poster.

Appreciating Art

5. Tell what you like best about your poster, and explain how the design communicates your message.

Unit IV Modeling, Carving, and Construction

51 Embossing Shining Images

Understanding Art

1. Define the term *relief* as it is used in art.
2. Explain how *embossing* is done.

Creating Art

3. Explain which method of embossing you used to create your design.
4. Describe the details and materials you included in your picture.

Appreciating Art

5. Describe the special effects achieved with embossing that can't be created with other art materials.

52 Relief Sculpture

Understanding Art

1. Tell how a *relief* is like sculpture.
2. Explain the difference between *symmetry* and *asymmetry*.

Creating Art

3. Did you create a balanced relief picture? What kind of balance did you portray?
4. Explain specific ways in which you achieved a unified design.

Appreciating Art

5. Tell which kind of balance you think looks more interesting, symmetrical or asymmetrical. Explain why you think so.

53 Bricks and Beehives

Understanding Art

1. Define the term *module*.
2. Explain how *visualizing* is useful in art.

Creating Art

3. Did you create a unified piece of sculpture from modules? What did you use for your module units?
4. Describe what you did to make your sculpture look interesting from different angles.

Appreciating Art

5. Explain what you like best about the design of your module sculpture.

54 Descriptive Modeling

Understanding Art

1. Define the term *replica*.
2. Explain the meaning of *three-dimensional*.

Creating Art

3. Did you make a clay model of a man-made object? What object did you model?
4. Explain how to make a model to scale.

Appreciating Art

5. Describe the details you included on your model that make it look as much like the original object as possible.

55 Fancy Pottery

Understanding Art

1. Explain how *pottery* is made.
2. Name and describe the three basic methods of making clay pots.

Creating Art

3. Did you build a clay pot using one of the three clay building methods? Which method(s) did you use?
4. Describe the shape of your pot and any details you added.

Appreciating Art

5. Identify the pottery method you prefer and describe what you like about it.

56 Three-Legged Pottery

Understanding Art

1. Name the principal advantage of a three-legged object.

Creating Art

2. Did you make a three-legged pot? Describe the shape of your pot.
3. Describe details, textures, and special features of your pot.
4. Tell whether your pot is meant to be decorative, functional, or both.

Appreciating Art

5. Identify the piece of three-legged pottery in the lesson that you like best, and tell what you like about it.

57 Sculpting with String

Understanding Art

1. Define the term *abstract*.

Creating Art

2. Did you create an abstract sculpture using wire or string and pieces of wood? Tell how you achieved balance with your wood pieces.
3. Describe different patterns, colors, and yarn, thread, string, or wire thicknesses you included in your sculpture design.

Appreciating Art

4. Identify solid forms, lines, and spaces you included in your total design.

58 Art That Balances

Understanding Art

1. Define *mobiles* and explain how they incorporate the fourth dimension in art.
2. Explain how mobiles may be either *symmetrical* or *asymmetrical*.

Creating Art

3. List the materials you used to create your mobile.
4. Name the type of balance you used with your mobile, and tell how you achieved it.

Appreciating Art

5. Explain how creating mobiles is different from creating other kinds of sculpture. Which form of sculpture do you prefer?

59 Sculpting with Lines

Understanding Art

1. Define the term *sculpture.*

Creating Art

2. Did you create a wire sculpture? Describe the shape of your sculpture.
3. What details did you add to make your sculpture appear more interesting?

Appreciating Art

4. Choose the sculpture in the lesson that you like best and explain ways in which it is novel and interesting.

60 Skeleton Sculpture

Understanding Art

1. Define the term *armature.*
2. Name three ways of creating sculpture with an armature.

Creating Art

3. Did you create a sculpture of a person in motion, based on an armature?
4. Tell what you did to achieve the impression of action in your artwork.

Appreciating Art

5. Identify the sculpture in this lesson that you like best and give your reasons for preferring it.

61 Portrait in Clay

Understanding Art

1. Define the term *portrait.*

Creating Art

2. Did you create a clay portrait of a person's head?
3. Did you turn your work frequently checking the *proportion* of its features from all angles?
4. Describe textures you added to give your clay head a natural appearance.

Appreciating Art

5. Express your feelings about how well you were able to show the personality of the person you modeled.

62 Hand Sculpture

Understanding Art

1. Explain the difference between *additive* and *subtractive* sculpture.

Creating Art

2. Did you carve a subtractive sculpture? What kind of shape did you carve?
3. Describe the texture(s) of your sculpture.

Appreciating Art

4. Identify the qualities you especially like in the Calder and Flannigan sculptures.

63 Abstract Carving

Understanding Art

1. Define the term *planes* as it is used in art.

Creating Art

2. Did you carve a sculpture showing a simplified form of an animal or person?
3. What materials did you use to create your sculpture?

Appreciating Art

4. Explain how creating abstract sculpture differs from more realistic forms. Which do you prefer?

64 The Sculpture of Henry Moore

Understanding Art

1. Tell what Henry Moore has used as creative starting points for his sculptures.

Creating Art

2. Did you carve a piece of rounded, smooth sculpture based on the shape of a natural object? What natural object did you use?
3. Describe the form of your sculpture, pointing out how you used space in your design.

Appreciating Art

4. Compare the way you felt about Henry Moore's sculpture before you created your own piece with the way you felt afterwards. Did you change your mind?

Unit V Art in the Environment

65 Farms and Plantations

Understanding Art

1. Define the term *foreground.*

Creating Art

2. Did you draw a landscape, based on your memory of a landscape picture?
3. Describe how you used color and details in your drawing.

Appreciating Art

4. Select one painting shown in this lesson and describe the artist's style.

66 The Wild, Wild West

Understanding Art

1. Name three well-known Western artists.

Creating Art

2. Did you make a drawing of a scene from the wild West?
3. Tell which features of Western art you included in your picture.
4. Identify the center of interest in your drawing, and tell how you emphasized it.

Appreciating Art

5. Compare and contrast the styles of the two paintings shown in this lesson.

67 John Marin's New York

Understanding Art

1. Explain the difference between *realistic* and *abstract.*

Creating Art

2. Did you make a picture that expresses your feelings about your hometown?
3. What part of your hometown did you choose to represent in your picture?
4. Name the art medium you used to create your picture, and tell why you chose it.

Appreciating Art

5. Explain how your picture expresses your feelings about your hometown.

68 I Know That Place

Understanding Art

1. Explain the meaning of *visual memory.*

Creating Art

2. Did you make a list of details about the place you chose to draw? What place did you choose?
3. Did you draw the place you chose from memory?
4. Did you observe the place you drew and add missing details? What changes did you make in your final drawing?

Appreciating Art

5. Describe the features in your picture that best portray the place you drew.

69 A Greek Temple

Understanding Art

1. Define the terms *frieze, lintels,* and *pediment.*
2. Identify the *Parthenon.*

Creating Art

3. Did you make a drawing of a building that includes Greek features? Identify the Greek features in your drawing.
4. Describe special details you included in the setting for your building.

Appreciating Art

5. Explain the most important thing you learned about Greek architecture when you designed your building.

70 Roman Arches, Vaults, and Domes

Understanding Art

1. Name special features in architecture the Romans were able to make with cement.
2. Define the terms *vault* and *dome.*

Creating Art

3. Did you make a drawing of a building that includes Roman architectural features?
4. Describe the features of Roman architecture you used in your building design.

Appreciating Art

5. Tell what you like or dislike about the Roman architectural style.

71 Buildings in the Middle Ages

Understanding Art

1. Name three characteristics of the *Gothic* style of architecture.

Creating Art

2. Did you draw a building that might have existed in the Middle Ages? What kind of building did you draw?
3. Describe interesting features of the building you drew.

Appreciating Art

4. Identify which building pictured in the lesson you find most interesting to look at, and explain why.

72 Spanish Influences on Mexican Architecture

Understanding Art

1. Name three characteristics of the *Baroque* style of art.

Creating Art

2. Did you design and draw a building that might have existed in colonial Mexico?
3. Describe the Mexican architectural features you included in your building.
4. Describe details you added to make the setting of your building realistic.

Appreciating Art

5. Tell whether or not you like Mexican Baroque architecture, and explain why.

73 Skeleton Architecture

Understanding Art

1. Explain how a *skyscraper* is built.

Creating Art

2. Did you draw a framework or skeleton for the object or building you designed?
3. Identify the strongest part of your framework. How did you indicate the strength of this part of the framework as you drew?

Appreciating Art

4. Identify the example of skeleton architecture in the lesson you find most interesting. Tell what you like about it.

74 Designing a Bridge

Understanding Art

1. Name the three basic types of bridges, and explain how they are different.

Creating Art

2. What type of bridge did you design and build?
3. Describe the place your bridge is meant to fit.
4. What materials did you use to construct your model?

Appreciating Art

5. Explain some facts you would need to know in order to design a bridge.

75 Different Styles of American Architecture

Understanding Art

1. Define *portico* and name a building that has one.

Creating Art

2. Did you make a drawing or model of a building constructed in your favorite style of architecture? What style did you choose?
3. Tell which architectural ideas you included in your building design.
4. What landscaping details did you include?

Appreciating Art

5. Describe the features of a building you particularly like, either one shown in this lesson or another American building you have seen.

76 Chicago Architecture

Understanding Art

1. Name the first skyscraper and the year it was completed.

Creating Art

2. Did you design and draw a skyscraper?
3. Describe special features you included in your architectural design.

Appreciating Art

4. Tell how your skyscraper is similar to other skyscrapers. Tell how it is unique.

77 The Architecture of Frank Lloyd Wright

Understanding Art

1. Name two characteristics of Japanese architecture that Wright used.

Creating Art

2. Did you design a house that blends in with the environment? Describe the setting you chose.
3. Describe how the house you designed fits in with the setting you chose.

Appreciating Art

4. Explain your views on Frank Lloyd Wright's style of designing architecture to fit the environment.

78 Modern Architecture

Understanding Art

1. Describe the *geodesic dome* and name its inventor.

Creating Art

2. Did you design a modern building? What is your building to be used for?
3. Describe unique features of your design.

Appreciating Art

4. Explain how the purpose of your building influenced your design.

Unit VI Explorations in Self-Expression

79 Peace and Tranquillity

Understanding Art

1. Explain how different people might interpret the word *peace*. How do you define it?

Creating Art

2. Did you draw a picture that illustrates your meaning of the word *peace*?
3. Tell how you illustrated your feeling of peace, and explain why you chose to illustrate it that way.

Appreciating Art

4. In your own words, describe how a sense of peace and tranquillity is achieved in one of the pictures in this lesson.

80 Dream Images

Understanding Art

1. Explain how dream images in art can express deep feelings.

Creating Art

2. How did you prepare to create a picture expressing a dream or daydream?
3. Tell how you expressed your dream idea in your artwork.

Appreciating Art

4. Describe the dream-like qualities in the works by Benton and Blount.

81 An Expression of You

Understanding Art

1. Describe the painting style of *Expressionism*.
2. Name some of the concerns of Expressionist artists.

Creating Art

3. What subject did you choose for your Expressionist work, and why is it a true "expression of you"?
4. Tell which Expressionist ideas you used in your picture.

Appreciating Art

5. Explain why the Expressionist style is particularly suited to conveying the inner world of the emotions.

82 From Real to Abstract

Understanding Art

1. Explain how *abstract* art can be made from a realistic picture.

Creating Art

2. What realistic subject did you choose to change into an abstract work? Why did you choose that subject?
3. In what ways are your abstract drawings and your realistic drawing still alike?

Appreciating Art

4. Identify which of the three Mondrian paintings in the lesson you like best, and explain why.

83 Be Your Own Picasso

Understanding Art

1. Give some reasons why Picasso is regarded as one of the greatest artists of this century.

Creating Art

2. What qualities of Picasso's works shown in this lesson did you include in your own composition?
3. What items did you choose to put in your art composition? Why did you choose those particular items?
4. Describe how you made your picture abstract.

Appreciating Art

5. Explain your views on Picasso's abstract works. Now that you have completed this lesson, do you like his work more or less than before?

84 Impossible Imaginings

Understanding Art

1. Explain why the M.C. Escher work can be described as a visual puzzle.

Creating Art

2. How did you come up with your idea for a picture of something that could never happen or exist?
3. Describe what is impossible about the picture you drew.
4. Tell what part of your picture looks real at first glance.

Appreciating Art

5. Explain how the "artists of the impossible" represented in the lesson render ordinary things in extraordinary ways.

85 Unexpected Ghosts

Understanding Art

1. Explain the meanings of *positive* and *negative* as they are used in photography.

Creating Art

2. Explain how you created your negative picture.
3. Identify any adjustments you made to balance your picture. Did you add objects, shading, or reverse shading?

Appreciating Art

4. What kinds of subjects look best rendered in negative form, and why do you think so?

86 The Land of Lilliput

Understanding Art

1. Explain how looking through a microscope might give an artist ideas for creating artwork.

Creating Art

2. Did you enjoy drawing a design based on a microscopic design from nature? What object or organism did you use as the basis for your idea?
3. Describe the shapes, textures, and patterns you included in your artwork.
4. Identify the art materials you used in your artwork.

Appreciating Art

5. Give the title of your work and explain why it fits your artwork.

87 Night and Day

Understanding Art

1. Name two ways shapes and forms appear different at night.

Creating Art

2. What subject did you choose to show in a daytime and nighttime scene?
3. Describe the ways in which you made your nighttime scene different from the daytime version.

Appreciating Art

4. Tell whether you prefer the Magritte picture or the Escher picture, and explain why.

88 Art in Motion

Understanding Art

1. Explain some techniques artists use to show motion.

Creating Art

2. Did you draw an action scene that shows movement or motion?
3. Describe what you did to give the impression of movement in your picture.
4. If you drew people, are their body proportions correct? How did you keep correct proportions in twisting, turning bodies?

Appreciating Art

5. How do Benton and Lee achieve a sense of movement in their works shown in this lesson?

89 Robots in Art

Understanding Art

1. Define *robot* and name three things robots can be programmed to do.

Creating Art

2. What materials did you use to construct your robot?
3. What special features and details did you give your robot sculpture? How did you make it look good from all sides?

Appreciating Art

4. Describe the job or function you would like your robot to perform.
5. Give the name of your robot and explain why you chose it.

90 Pets and Their People

Understanding Art

1. Define the term *caricature*.
2. Explain how studying pets and their owners might be a good exercise to help you improve your art.

Creating Art

3. What pet did you choose for your artwork, and what medium did you use?
4. Describe how you expressed the special features of the pet you portrayed.

Appreciating Art

5. Describe the scene, setting, or pose you selected for your pet "portrait," and explain why you chose it.

91 Creatures That Never Were

Understanding Art

1. What is a *bestiary?*

Creating Art

2. What medium did you choose for the portrayal of your imaginary creature? On what did you base your idea for your beast?
3. Describe textures and colors you used to depict your beast.

Appreciating Art

4. Give the name of your creature and describe its nature and habits.

92 Images of Heroes

Understanding Art

1. Explain why people enjoy seeing pictures of their heroes.

Creating Art

2. What medium did you use to present your hero in your artwork?
3. What features of your hero did you emphasize in your artwork? How did you emphasize them?
4. Describe the pose you chose for your hero and explain why you chose it.

Appreciating Art

5. Name the hero you portrayed and explain why you admire him or her.

93 Larger Than Life

Understanding Art

1. Name several reasons why Michelangelo is considered one of the greatest artists of all time.

Creating Art

2. Did you create an artwork incorporating elements of Michelangelo's style?

3. Tell which features of Michelangelo's art you included in your picture.

Appreciating Art

4. Identify what you think are the best features of your artwork, and explain why you think so.
5. Tell what qualities of Michelangelo's style you like best, and why.

94 Visualizing with Words

Understanding Art

1. Define *visualize* and explain how this ability is valuable in creating art.

Creating Art

2. Did you write words and phrases that express the details and feelings you had about a special experience? Which of these ideas did you use in your picture?
3. Give the title of your picture and describe how you portrayed your experience.

Appreciating Art

4. Explain how your picture expresses your feelings about this special experience.

95 Songs, Poetry, and Art

Understanding Art

1. Define *symbolism* and *imagery.*

Creating Art

2. Did you paint a picture based on a poem or song? What poem or song did you use as the basis for your art?
3. What specific words, phrases, or images in the poem or song inspired your picture?

Appreciating Art

4. Describe how you expressed your feelings and ideas about the poem or song in your artwork.

Glossary

abstract A style of art that uses shapes, designs, textures, and colors in a way that may not look real but that emphasizes moods or feelings. Abstract art often uses geometric lines and shapes and bold, bright colors.

additive sculpture Sculpture made by adding, combining, or building up materials. Modeling with clay and welding steel parts together are ways of making additive sculpture.

advertising Printed, painted, or spoken art that communicates positive aspects of a product or idea to an audience in order to persuade them to do or buy something.

analogous colors Colors that are closely related, such as blue, blue-violet, and violet—all of which have the color blue in common. Families of analogous colors include the warm colors (red, orange, and yellow) and the cool colors (blue, green, and violet).

anatomy The structural makeup of the human body, including the muscles, bones, and flesh.

appliqué A design made by stitching pieces of colored fabric onto a larger piece of cloth. Appliqué is used for wall hangings and as decoration on clothing, quilts, and pillows.

arch A curved structure over an opening such as a door or window. An arch may either stand alone or support the walls around the opening.

architect A person who designs buildings and gives advice to builders about construction.

architecture The art of designing and constructing buildings.

armature A skeleton-like framework used to support constructions of clay or papier-mâché. It can be made of wire, piping, metal rods, rolled paper, or similar materials.

assemblage /ə-sem′-blij/ A piece of art made by combining a collection of three-dimensional objects into a whole. It can either be a free-standing sculpture or be mounted on a panel, and is usually made from scraps, junk, or various man-made or natural objects.

asymmetry A type of balance in which the two sides of a work of art are not exactly alike, but are still visually balanced.

atmospheric perspective A way of showing depth and distance in a painting by using fading colors and hazy details in distant objects. (*See also* linear perspective.)

background Parts of an artwork that are in the distance and lie behind objects in the foreground.

balance A principle of design that refers to the arrangement of elements in a work of art. There are three kinds of balance: symmetrical (formal balance); asymmetrical (informal balance); and radial (from the center). (*See also* symmetry, asymmetry, and radial balance.)

Baroque /bə-rōk′/ A style of art that stresses fancy swirling curves, large works of art, elaborate detail and ornamentation, and dramatic contrasts of light and shade. The Baroque period followed the Renaissance in Europe during the 1600s.

batik /bə-tēk′/ An Indonesian method of hand-printing fabric by covering parts of the fabric with wax. When the fabric is dyed, color does not adhere to the waxed areas. The wax is then removed, leaving a design made by the undyed areas.

beam A horizontal supporting unit of a structure, usually made of steel or wood.

bestiary /bes′-chē-er-ē/ An illustrated book in the Middle Ages that showed various real or imaginary animals and told stories about their natures and habits. The stories often ended with a moral.

blind contour drawing A kind of drawing done in one continuous line, in which the pencil is kept moving while the eyes remain on the object, never looking down at the paper. (*See also* modified contour drawing.)

block In printing, a piece of thick, flat material, such as cardboard, wood, or a potato, with a design on its surface, used to print repeated impressions of that design. In carving, a large solid piece of a material, such as wood or stone, from which parts are cut away to form a sculpture.

block relief printing A means of making prints by creating a raised design on a flat surface. The design is inked or covered with color and stamped on paper or another surface.

body proportions The relationship of the sizes of one body part to another and to the rest of the body. For example, the head usually makes up about one-seventh of a person's total height.

brayer /brā′-ər/ A small, hand-held rubber roller used to spread printing ink evenly on a surface before printing.

bronze A mixture of copper, tin, and other metals. Because it is very strong and hard, bronze lasts for a long time and is commonly used in cast sculpture.

calligraphy /kə-lig′-rə-fē/ The art of writing letters and words in an ornamental style using brushes or pens.

caricature /kar′-i-kə-chər′/ A picture in which a person's distinctive features, such as nose, ears, or mouth, are distorted or exaggerated.

carve To cut away unwanted parts from a block of wood, stone, or other material, using carving tools such as a chisel, knife, or file. *Carving* is a way of making sculpture by cutting away unwanted parts.

cast To copy a solid object by pouring a liquid, such as melted metal, clay, wax, or plaster, into a mold and letting it harden. The mold is then removed and a copy, or *cast*, is left in the shape of the mold.

cast shadows Shadows made on the ground by objects.

center of interest The most important part in a work of art. All the other parts should center around, provide background for, or draw attention to the center of interest.

ceramics The art of making and decorating objects of clay that are fired in a kiln.

chisel A metal tool with a cutting edge at the end of a handle. Chisels are used by sculptors for carving stone, wood, and other materials. In calligraphy, a chisel is a pen nib having the square, flat shape of a sculptor's chisel.

clay A powdery kind of earth that becomes pliable and can be molded when it is mixed with water or oil. Clay is used to make pottery and sculpture.

coil method A way of making pottery by winding rows of clay "ropes," one on top of another, on a flat clay base. When the walls of the pot reach the desired height, they are shaped and smoothed by hand. Much of the pottery of early cultures was made with this simple method, which does not require complicated tools.

collage /kə-läzh'/ A work of art created by gluing bits of paper, fabric, scraps, photographs, or other materials to a flat surface.

color The hue, value, and intensity of an object. The *primary colors* are red, yellow, and blue; every color except white can be created by combining these three colors. Color is an important element of design.

column A large round pillar or post supporting part of a building.

compass A mechanical tool with two hinged, adjustable legs for drawing different sizes of circles and arcs. One of the legs has a sharp steel point that is placed on one spot on the paper. The other leg holds a pencil that rotates around the pointed end, making a circle.

complementary colors Colors that are opposites on the color wheel and contrast with each other. For example, orange is the complement of blue, violet is the complement of yellow, etc. When two complementary colors are mixed together, they make brown or gray. When they are used side by side in a work of art, they create interesting contrasts. Adding a little of a color's complement to it makes it duller.

compose To create or form by putting together and arranging.

composition The arrangement or design of elements of an artwork to achieve balance, contrast, rhythm, emphasis, and unity and to make it an effective expression of the artist's idea. The term also refers to any work of art.

contour The outline or edge of a figure or object. In contour drawing, a single, continuous line is used to draw the outline of an object.

contrast A large difference between two things; for example, hot and cold, yellow and purple, and light and shadow. Contrasting patterns or colors add excitement, drama, and interest to a picture.

converge To come together at a single point. Parallel horizontal lines appear to converge on the horizon in a painting.

cool colors The family of related colors ranging from the greens through the blues and violets. (*See also* analogous colors.)

creativity The ability to design or make something new and original, using the imagination rather than imitating something else.

critique To analyze and evaluate an artwork, making judgements of its merit, value, meaning or relevance, technique, and design. The word also refers to such a written or spoken evaluation.

cross-hatching Shading done by drawing closely set parallel lines that crisscross. Cross-hatching is used to show light and shadow in drawings, paintings, and engravings.

cutouts In art, pieces of paper or other material cut into realistic or abstract shapes and arranged on paper to form designs and pictures.

depth The third dimension of front to back or near to far, represented in an artwork by the actual or apparent distance from bottom to top or front to back. *Techniques of perspective* are used to create the illusion of depth in a two-dimensional painting.

design An organized and creative arrangement of the elements of an artwork, including lines, shapes, textures, spaces, and colors.

detail A small part of a work of art, enlarged to show a close-up of its features. Also, a distinctive feature of an object or scene which can be seen most clearly close up.

dimension A measurement of either length, width, or depth. Two-dimensional art, such as a painting, has length and width. Three-dimensional art, such as sculpture, includes depth.

distance The third dimension of front to back or near to far, shown in a two-dimensional painting by using techniques of perspective.

distort To change the way something looks by twisting it out of its proper or natural form or by exaggerating some of its features. A work of art that is made in this way is *distorted*.

dome A round roof shaped like half a sphere, supported by a circular or many-sided base.

dominant The part of a design that is most important, powerful, or has the most influence. A certain color can be dominant, and so can an object, line, shape, or texture.

drawing A major art form in itself, drawing may be either an artwork that stands on its own, having shapes and forms sketched and/or shaded on paper, or it may be the basis for a painting or sculpture.

elements of design Basic parts which are put together to compose an artwork. These include line, shape, space, texture, color, and value.

embossing A method of creating a raised design or relief on a flat sheet of metal by hammering a design into the back side.

embroidery Decorative designs sewn on cloth with a needle and thread or yarn.

emphasis Accent, stress, or importance of a part of an artwork. Opposing sizes, shapes, and lines, contrasting colors, closer detail, and intense, bright color are all used to emphasize, or draw attention to, certain areas or objects in a work of art. Emphasis is a principle of design.

etching A picture made by coating a paper, metal, or plastic plate with wax and cutting or scratching a design into the wax. A print of an etching can be made by covering the plate surface with ink and pressing it onto paper or another flat surface to transfer the design.

Expressionism A style of art in which the artist communicates highly personal and emotional feelings by using strong colors, distorted forms, and bold, simplified lines. The style originated in Europe in the late nineteenth and early twentieth centuries.

eye level An imaginary line marking the level of a person's eyes. The horizon line always appears to be at a person's eye level.

fantasy Something unreal that is invented by the imagination.

fiber arts The range of handicrafts created with such materials as yarn, thread, and cloth. Stitchery, macramé, and weaving are among the common fiber arts.

fibers Threads or strands that make up a material and give it texture.

fire To bake shaped clay in a hot kiln to make it into hard pottery.

fixative A thin liquid that is sprayed over pastels and drawings to keep them from smudging or rubbing off the paper.

foreground The part of a work of art that appears to be in front, nearest to the viewer.

form The organization of masses, shapes, or groups of elements in an artwork; the plan or design of a work of art; unit in an artwork that is defined or set apart by a definite contour; to give shape to an artwork.

fortress A place that is fortified, or strengthened and secured, by strong walls and sometimes artillery.

found object An object not originally intended to be used as art, but treated as art or included in an assembled work of art by an artist. A found object may be natural or man-made. The use of found objects is a twentieth-century art form.

fourth dimension Motion in time, a dimension in addition to length, width, and depth, which became a focus in twentieth-century art. A mobile uses the fourth dimension because the mobile is designed to show movement.

free-form Irregular; asymmetrical; not formed according to any preset rules or standard design.

freehand Drawn or sketched by hand without measuring, and without using tracing paper, ruler, compass, or any other drawing instruments.

frieze Decorative relief of figures carved in a horizontal band around a building. Friezes were popular in Greek architecture.

functional Practical or useful.

geodesic dome /jē-ə-dēs´-ik/ A dome built by joining straight, lightweight bars into interlocking geometric shapes. This system for building domes was developed by R. Buckminster Fuller, an American architect and engineer.

geometric Based on simple shapes such as squares, triangles, or circles.

gesture Quick, scribbled drawing to capture the basic form and indicate the main movement of lines in a figure. Also, body positions and expressions shown in a work of art.

girder A horizontal piece that supports weight in a structure such as a bridge or building.

glaze A glasslike coating applied to the surface of pottery or ceramics by dipping or painting it on, and then fired in a kiln to produce a hard colored shiny or matte surface.

gouache /gwäsh/ An opaque paint that can be dissolved in water, or a painting using this type of paint.

Gothic An architectural style developed in Western Europe in the twelfth through fifteenth centuries, characterized by pointed arches, tall buildings with thin walls and large windows, and airy interior space. Cathedrals are often built in this style.

gouging Cutting or scooping out a hole or groove in a surface such as wood or linoleum to make a design for printing.

gradation /grā-dā´-shən/ A gradual, smooth change from light to dark, rough to smooth, or one color to another.

grain The lines or markings that run through wood, stone, or other material, making up its natural pattern and texture. Sculptors study the grain of material when deciding how to carve it.

graphic designer A person who designs art for commercial purposes, including packages, advertisements, signs, books and magazines, pamphlets, and correspondence.

grid A network of horizontal and vertical lines forming squares or rectangles, used as a guide for reproducing accurate drawings.

haiku An unrhymed Japanese verse form of three lines containing 5, 7, and 5 syllables respectively.

hard-edge painting A style of modern art that uses even, flat colors and shapes defined with sharp, clean edges. This technique is often used in advertising art.

horizon A level line where water or land seems to end and the sky begins.

horizon line An actual or imaginary line in a work of art that represents the place where the sky and earth appear to meet. Vanishing points are located on the horizon line.

horizontal Straight, level, and parallel to the horizon.

hue Another word for *color*, such as red, yellow, or green.

illustrator An artist who creates designs and pictures for books or magazines to explain the text or show what happens in a story.

image A mental picture, idea, or impression of a person, thing, or idea that can be represented in art.

imagery The imaginative expression of objects, feelings, ideas, and experiences in art. Imagery can depict both physical and nonphysical things.

Impressionist An artist who tries to show the effects of light on different things, especially color. Impressionists use unblended dots of pure color placed close together to create a mood or *impression* of a scene.

intensity The brightness or dullness of a hue or color. For example, the intensity of the pure color blue is very bright; if a lighter or a darker color is added to blue, the intensity is less bright.

internal contours Curves or angles of an object that lie inside its outline. Angles are drawn with lines; curves are shown with shading.

intersected Cut across by or divided with crossing lines or planes.

invent To create something new that has never been made before by using imagination and creativity.

jewelry Ornaments such as rings, necklaces, bracelets, or earrings, often made of precious metals and gems.

kiln /kiln or kil/ A special furnace that reaches very high temperatures and is used to bake, or *fire*, clay to produce pottery.

kinetic sculpture /kə-net'-ik/ A kind of art introduced in the 1930s that expresses motion in time by including elements that are moved either by natural forces, such as wind (as in a mobile), or by devices such as motors and cranks.

landscape A view of natural outdoor scenery, such as mountains, rivers, fields, or forests.

lacquer A liquid coating or varnish that dries to form a hard, shiny, protective surface.

legible Able to be read.

line An element of design that refers to a path of a moving point through space which can vary in width, direction, length, curvature, and color. Lines can be two-dimensional or implied, or they can define three dimensional contours.

linear perspective /lin'-ē-ər pər-spek'-tiv/ Showing depth and distance in a picture with converging lines. In linear perspective, lines that are parallel in nature get closer together and objects get smaller in the distance. (*See also* atmospheric perspective.)

lintel /lint'-əl/ A horizontal beam over an opening, such as a window or door, that supports the structure above it.

lithograph A printing process invented in 1798, in which a picture or design is drawn on a smooth stone or metal plate with a special wax or grease crayon. The surface is then treated with a chemical that allows ink to adhere only where the crayon has been used. Finally, the surface is inked and the crayon design is printed on paper.

lithographic crayon A special crayon made of wax, grease, or a similar material, used to draw a design that is made into a lithograph.

loom Any type of framework used for weaving fibers at right angles to make cloth.

macramé /mak'-rə-mā'/ The art of knotting coarse twine or cord in a geometric pattern. Macramé is used to make such things as plant hangers, wall hangings, jewelry, and handbags.

Mannerism An art style in which invention, imagination, and refinement were considered more important than realism. The style is characterized by distorted perspective, scale, and proportion, especially in long, stretched-out figures, and by exaggerated colors. Mannerism was developed in Europe in the late sixteenth century as a reaction against the focus on realism in the preceding Renaissance period.

mat A cut-out cardboard border placed around a picture to frame and display it.

material Substance from which something is made. Clay, plaster of paris, and wood are examples of materials.

media Materials, such as paint, charcoal, and clay, used to produce art. Also the techniques, like painting, sculpture, or collage, used with these materials. Plural form of *medium*.

medieval /mid-ē′-vəl/ From or characteristic of the Middle Ages in Europe, A.D. 500–1500.

medium The material an artist uses—oil, watercolor, pen and ink, chalk, and so on. (*See also* media.)

Middle Ages The period of time between A.D. 500 and A.D. 1500 in Europe. (*See also* medieval.)

middle ground The part of a work of art that lies between the foreground and the background.

moat A deep, wide trench around a fortress or castle, often filled with water.

mobile /mō′-bēl/ A type of sculpture in which objects are suspended and balanced so that they are moved by currents of air. The mobile as an art form was introduced by Alexander Calder in the 1930s.

modified contour drawing A line drawing made by looking at an object and drawing it with one continuous line, occasionally glancing down at the drawing to check the lines and proportions. (*See also* blind contour drawing.)

modular Constructed out of standard units or pieces, such as bricks or prefabricated elements.

module In architecture, one of many identical units that are part of a total structure. A module may be used as a measurement standard to determine the proportions of the entire building.

mold A hollow shape that is filled with a material such as plaster or metal and removed when the material hardens into the shape of the mold. A mold is used to make one or many copies of an object.

monochromatic color scheme Variations of one color in an artistic composition. A pure hue is combined with varying amounts of white or black, producing tints and shades respectively. (*See also* tints, shades, *and* monochrome.)

monochrome A painting done in variations of a single color, made by adding black or white to the basic hue to create its shades and tints.

monotype A kind of printmaking in which a picture or design is painted on a nonabsorbent surface, such as metal or glass. The design is then pressed onto a piece of paper. Usually, only one transfer can be made this way.

mount To attach a picture to a larger piece of paper or cardboard, leaving a wide border around it.

movement A principle of design that refers to the arrangement of elements in an artwork organized in such a way to create a sense of motion.

mural A large painting that covers a wall. It can be painted directly on the wall, or on wood, paper, or canvas to be attached to the wall.

mythical Made-up, invented, or imaginary. Mythical animals, people, and objects usually originated in ancient legends or myths.

negative A photograph in which areas that were light in the original image appear dark, and those that were dark appear light.

nib A point that fits on the end of a calligraphy pen and regulates the flow of ink. Nibs come in many sizes from very thin or fine to broad and flat.

nonfunctional Created mainly for decoration rather than practical use.

opaque /ō-pāk′/ Something that cannot be seen through; the opposite of transparent.

original Unusual, different, or creative, such as original art or ideas. Original can also mean the actual or initial work of art, rather than a copy.

overlapping One shape or part covering up some part or all of another. Overlapping objects appear closer, and this is a perspective technique used to show distance in pictures.

painting Artwork made using oil, tempera, watercolor, acrylic, or other kinds of paint, applied with a brush or other tool. The term also refers to the act of creating such an artwork.

papier-mâché /pā′-pər-mə-shā/ An art material made of paper torn into strips or made into pulp and mixed with paste or glue. It can be molded into various shapes when wet and produces a solid material that is quite strong when it dries. It is used to make molds of decorative and functional objects.

parallel Two or more lines that are the same distance apart at every point, extend in the same direction, and never converge, or meet.

Parthenon A marble building constructed about 440 B.C. in Athens, Greece, as a temple to the Greek goddess Athena. It is perhaps the greatest masterpiece of Greek architectural style.

path of vision Imaginary route the eyes follow when viewing a work of art. It usually begins at a bottom edge, moves clockwise, and ends at the center of interest.

pattern The repetition of shapes, lines, or colors in a design. The pattern can also be a model or mold designed to be copied.

pediment /ped′-ə-mənt/ A triangular shape at the end of a building formed between the peak of the sloping roof and the top edge of the wall. In Greek architecture, pediments were often decorated with carved relief figures.

perceive To become aware of through sight, sound, taste, smell, or touch.

perspective The representation of three-dimensional objects on a flat, two-dimensional surface.

Perspective is achieved by creating a sense of depth and distance. There are two types of perspective: linear and atmospheric.

photography The process of creating art with a camera and film. Photography may be used to capture exact, realistic images or to create more abstract or impressionistic moods.

pigment Fine colored powder that, when combined with various liquid mixtures (water and a binding agent, for example), makes paint.

pinch method A method of making pottery in which a ball of clay is pressed, pulled, and pinched into a shape with the hands.

plan A detailed drawing that shows how the parts of something are to be arranged. A builder follows an architect's plan when constructing a building.

plane Any surface that is flat. Most sculpture surfaces are made up of many tiny planes that are joined together to form flat or curved sides.

pointillism A method of painting developed in France in the 1880s in which tiny dots of color are applied to a canvas. When viewed from a distance, the points of color appear to blend together to make other colors and to form shapes and outlines. Pointillism was part of the *Postimpressionist* movement.

polyhedron /päl-i-hē′-drən/ A solid geometric form with flat, joining faces. A cube, which has six faces, is an example of a polyhedron. The polyhedron is the basis of the geodesic dome design.

Pop art A style of art based on the everyday, popular things around us, including comic strips, popular foods, and brand-name packages. The style developed in the 1950s and 1960s, mainly in New York and London.

portico /pört′-i-kō/ A covered walkway or entrance to a building, often having a row of columns supporting the roof.

portrait A painting, sculpture, drawing, photo, or other work of art showing a person, several people, or an animal. Portraits usually show just the face, but can include part or all of the body, as well.

positive A photograph that shows light and dark in the same way as the original image.

post A pillar, column, or similar structure that supports a roof or beam. Posts were commonly used in Greek-style architecture.

Postimpressionists French painters at the end of the nineteenth century who tried to express emotion as well as form in their paintings. They reacted against the formlessness and unfeeling objectivity of Impressionism and are considered to be the fathers of modern art. Gauguin, van Gogh, Matisse, and Cézanne were Postimpressionists.

pre-Columbian Belonging to the time before the arrival of Columbus in the Americas.

preliminary sketch A sketch made to plan or determine the basic arrangement of a design or a more complete artwork. A preliminary sketch is simpler and often smaller than the final piece of art, but contains the same outlines and proportions.

primary colors The hues red, yellow, and blue, which in different combinations produce all other colors except white. The primary colors cannot be produced by mixing any other colors together.

principles of design Guidelines that aid in effectively arranging and composing designs. These include balance, contrast, variety, pattern, rhythm, emphasis, and unity.

print A shape or mark made from a printing block or other object that is covered with wet color and then pressed on a flat surface, such as paper or cloth. Most prints can be repeated by reinking the printing block. Prints can be made in many ways, including using an engraved block or stone, transfer paper, or a film negative. *Printing* is the art of making many copies of one image.

printing press A machine that can make printed copies by pressing an inked or colored metal plate containing lines of type or an image onto sheets of paper that are threaded through the machine. Printing presses are used to make books and newspapers, as well as copies of original art.

printmaking Designing and producing prints using a printing block, woodcut, etching, lithographic, or photographic negative. (*See also* print.)

profile An outline of an object, usually a drawing or painting of the side view of a person's face.

proportion The relationship of the size of one part to another or to the whole. In painting and sculpture, for example, an artist tries to achieve the right size or *proportion* of a nose to a head, and a head to a body.

protractor /prō-trak′-tər/ A piece of wood or plastic shaped in a half or full circle and used to measure angles.

pyramid An ancient building design found in Egypt and Central America, usually having a square base and four triangular sides that meet in a point at the top. Pyramids were used as tombs and for religious worship and ceremonies.

radial balance Balance achieved when parts of a form radiate from a center (like spokes on a wheel). Radial balance may be symmetrical, forming a perfect circle, or asymmetrical, forming a spiral. (*See also* symmetry and asymmetry.)

ratio /rā′-shē-ō/ The relationship in size or quantity between two or more things. For example, the ratio in

height of an object two feet tall to an object one foot tall is 2 to 1.

realistic Looking like real people, objects, or places as we actually see them. Realistic art portrays lifelike colors, textures, shadows, proportions, and arrangements.

relief An art mode halfway between solid sculpture and flat painting, in which figures rise up from a background that is flat or has hollowed-out parts.

Renaissance /ren′-ə-säns/ A period that began in Italy after the Middle Ages and lasted from about A.D. 1400 to 1600. The period was characterized by a renewed interest in ancient Greece and Rome and their philosophies, including an emphasis on human beings, their environment, science, and philosophy.

render To reproduce or represent by artistic means, such as drawing, painting, or sculpture.

replica An exact copy or reproduction of an artwork, sometimes made on a smaller scale than the original.

repetition Repeating lines, shapes, colors, or patterns in a work of art.

resist A type of art in which oil or wax, which will not mix with water, is used to block out certain areas of a surface that the artist does not want to be affected by paint, varnish, acid, or another substance.

rhythm Regular repetition of lines, shapes, colors, or patterns in a work or art.

scale Ratio of the size of parts in a drawing or artwork to their size in the original. If a picture is drawn *to scale*, all its parts are equally smaller or larger than the original.

scale drawing A reproduction of a drawing in which the dimensions and sizes are in the same ratio as in the original. Scale drawings are usually made by using a grid and can be smaller, larger, or the same size as the original.

sculpture A carving, model, or other three-dimensional piece of art.

secondary colors Colors created by combining two of the three primary colors, red, yellow, and blue. The secondary colors are orange, green, and purple: orange is a mixture of red and yellow, green a mixture of blue and yellow, and purple a mixture of red and blue.

set square A wood or plastic triangle used in technical drawing to make angles, shapes, and lines.

shade A color to which black or another dark hue has been added to make it darker. For example, black added to red produces a darker *shade* of red. (*See also* tint.)

shading Showing gradations of light and darkness in a picture by darkening areas that would be shadowed and leaving other areas light.

shape A spatial form depicted in two-dimensions and outlined by lines or a change in color, shading or materials. Shape is an element of design.

silhouette /sil-ə-wet′/ An outline of a solid shape without any details inside, like a shadow. Most silhouettes are of a person's profile, done in black or another dark solid color, and attached to a light background.

simplify To make simpler or more basic by removing details, ornamentation, or complex lines or parts. Realistic shapes may be simplified into geometric ones to make abstract art.

sketch A simple, quick, rough drawing done without a lot of detail but catching the chief features and a general impression of an object or scene. Sketches are usually made in preparation for a later, more detailed work.

sketchbook A notebook or pad of paper used for making quick drawings to capture the general outline, action, or impression of something. These sketches may be used as a basis or reference for a later artwork.

skyscraper A very tall building with many floors supported by a steel framework. The first modern skyscraper was the Home Insurance Building in Chicago, designed in 1883 by William LeBaron Jenney.

slab method A method of making pottery in which a thick, flat plate, or slice, of clay is cut into shapes which are joined to form an object.

slip A creamy mixture of clay and water or vinegar used to cement two pieces of clay, such as a handle and cup, together, or for dripping on pottery as decoration.

slogan /slō′-gən/ A short, attention-getting phrase used in advertising or to promote a product.

small-scale Having dimensions and sizes in the same ratio as the original, but being much smaller in size. Small-scale models are often made of buildings and sculptures before the actual object is made.

solidity The quality of having bulk and being three-dimensional. Shading and texture show the solidity of an object in a drawing or painting.

space An element of design that refers to the visual or actual area within and around shapes or forms. Positive space defines the contents of a shape or form, bound by edges or surfaces. Negative space refers to the area around a shape or form.

stained glass Pieces of brightly colored glass held together by strips of lead to form a picture or design. Stained glass was first used in churches during the Middle Ages.

statue A carved, modeled, or sculpted three-dimensional figure, especially of a person or animal, that stands up by itself.

still life A drawing or painting of an arrangement of nonmoving, nonliving objects, such as fruit, flowers, or bottles. Usually, a still life is set indoors and

contains at least one man-made object, such as a vase or bowl.

stitchery A kind of artwork in which designs or pictures are made by stitching yarn, thread, string, or other materials to a fabric backing.

style An artistic technique or way of expressing, using materials, constructing, or designing that is characteristic of an individual, group, period, or culture. For example, the style of Egyptian art is different from the style of the Japanese.

subtractive sculpture Making sculpture by removing material from a large block or form. Marble, wood, and soap carving are some types of subtractive sculpture.

summit A structure of several rooms built at the top of Mayan pyramids in Mexico and used for religious ceremonies.

Surrealism A style of painting based on dreams, the fantastic, and the irrational. In Surrealism, artists picture unusual or impossible combinations of objects painted in a realistic way.

suspension A type of bridge with a roadway that hangs, or is suspended, from cables or chains strung between towers, such as the Golden Gate Bridge in San Francisco.

symbol Something that stands for something else, especially a letter, figure, or sign that represents a real object or idea.

symbolic ornamentation Decoration that uses symbolic figures to represent a story or idea, often found in buildings, stained glass windows, and other art forms of the Middle Ages.

symbolism The use of a figure or design to stand for something else. Something concrete, such as a lion, is usually used to represent an abstract quality, such as courage.

symmetrical /sə-me-tri-kəl/ Having a kind of balance in which things on each side of a center line are identical. For example, the two halves of a person's face are symmetrical. The principle of *symmetry* is important in drawing portraits.

symmetry A form of balance in which parts on both sides of a center line are the same.

tactile Relating to the sense of touch; the way an artwork feels to the touch.

tapestry /tap'ə-strē/ A picture or design woven or stitched in cloth and hung on a wall.

tempera /tem'-pə-rə/ An opaque, water-soluble paint available in liquid or powder form. It is also called showcard or poster paint.

tempera batik A way of making a *batik* using heavy paper, tempera paints, and ink rather than fabric, wax, and dye. (*See also* batik.)

textile /tek'-stīl/ A piece of woven cloth; fabric. Cotton, velour, silk, polyester, and burlap are examples of textiles.

texture The way a surface looks and feels—rough, smooth, silky, and so on.

theme A subject or topic in an artistic work. A theme may be concrete—such as a realistic painting of a landscape—or abstract, such as a painting using symbols of change.

theme and variations A series of artworks composed on a single subject showing several interpretations or versions of it. The picture of the basic subject is the theme, and the later forms or versions are the variations.

three-dimensional Having length, width, and depth. A sculpture is three-dimensional, but a drawing is only two-dimensional since it is flat and has only length and width, not depth.

tint A color to which white has been added. For example, white added to blue makes a lighter blue *tint*.

title The name given to a picture, sculpture, or other piece of artwork, reflecting the main idea of the work.

tone The tint, shade, brightness, or value of color.

torso The trunk, or main part of the human body, not including the head, arms, and legs.

transfer To print or copy a drawing or design from one surface to another by bringing the two surfaces into contact.

transparent Allowing light to pass through so that objects can be clearly seen underneath; the opposite of opaque. Window glass, cellophane, and watercolors are transparent.

T square A long, flat ruler that is attached to a short crosspiece, making a T-shape. The crosspiece slides along the edge of a drawing board to position the ruler so that parallel lines can be drawn.

two-dimensional Having height and width, but not depth; flat. Paintings, drawings, and stitchery are examples of two-dimensional art forms.

unified Having all parts look as if they belong together in a complete whole.

unity A principle of design whereby all parts of a work of art are interrelated, balanced, and organized to achieve a quality of oneness.

value The lightness or darkness of tones or colors. For example, white and yellow have a light value and black and purple have a dark value. Value is an element of design.

vanishing point In linear perspective, the place on the horizon where parallel lines seem to meet or converge.

variety An assortment of lines, shapes, or textures in a work of art. Variety is a principle of good design.

vault An arched ceiling or roof made of stone, cement, or brick.

verbalize To express or describe something in words.

vertical Straight up and down; perpendicular to the horizon.

viewpoint The position or place from which an artist views the subject to be represented. Different viewpoints of the same scene or object can produce totally different pictures.

visual Able to be seen. For example, visual advertising includes TV commercials, billboards, magazine ads, and posters.

visualize To form a picture of something in the mind by using the imagination.

visual memory Being able to remember exactly what something looks like. A good visual memory is important to an artist, who may not always have the object to be drawn available as a guide while working.

void An opening, gap, hole, or empty space, often used in modern sculpture. Voids are an important feature in the sculpture of Henry Moore.

warm colors The family of related colors ranging from the reds through the oranges and yellows. (*See also* analogous colors.)

warp The vertical threads that are attached to the top and bottom of a loom, through which the weft is woven. (*See also* weft.)

wash The background of a watercolor picture, prepared using thin, watery paint applied quickly with large, sweeping brushstrokes.

watercolor A transparent paint made by mixing powdered colors with a binding agent and water. The term also refers to a painting done with watercolors.

wax resist A type of art in which wax, which will not mix with water, is used to block out certain areas of a surface that the artist does not want to be affected by paint, varnish, acid, or other substances.

wedging Cutting, pounding, and kneading clay to mix it and get rid of air bubbles until it has a smooth and even texture and is ready to use.

weft The threads or strands of yarn that are woven back and forth across the warp threads to make a solid textile. (*See also* warp.)

woodcut A wooden surface on which a picture or design has been cut to form a relief used for printing. The use of woodcuts for printing began as early as the fourteenth century.

Artists' Reference

All the works by famous artists presented in this book are listed here. Use this list to locate particular paintings, drawings, sculptures, and other artworks and to find works by artists who especially interest you.

Index

Acknowledgments

We gratefully acknowledge the generous efforts of the art supervisors, consultants, teachers, and students all over the country and other parts of the world who have helped to make this book possible. Although it is impossible to list all of the contributors to this project, we express special thanks to the following individuals: Kay Wagner, Fine Arts Specialist, and Lou Moody, Fine Arts Resource Teacher, San Diego City Schools; Claire Murphy; Mary Lou Heilman; Sam Bonacci; Charlotte Gardner; Bob Long; Margie Kleinman; Sue Anello; Dorothy Tucker; Monique McNutt; Rebecca Crandall; Don Guentner; Billie Golden; Roberta Harmon; Mar Gwen Land; Penny Felton; Sherely McPhillips; Margaret Mardis; Allan Caucutt; Tom Convoy; Antony Guadadiello; Barbara Beattie; John Benitez; Charles Bonnett; Barbara List; Debbie Ewing; Mary Howell; Gene Wozniak; Lee Riggs; Fred James; Robert Marriott; John Edwards; and Marjorie Hughes.

We especially appreciate the students from the following schools who contributed the student art reproduced in this book: Lenape Jr. High School, Doylestown, Pa.; Alexandria Jr. High School, Fort Wayne, Ind.; Rancho San Joaquin Middle School, Irvine, Calif.; Benton Central Jr. High School, Oxford, Ind.; Tecumseh Jr. High School, Lafayette, Ind.; Edmonton Art Gallery Classes, Edmonton, Alberta, Canada; Children's Creative and Performing Arts Academy, San Diego, Calif.; Children's Saturday Art Class, Indiana University, Ind.; Azalea Middle School, St. Petersburg, Fla.; Montgomery Jr. High School, San Diego, Calif.; San Diego High School, San Diego, Calif.; Holy Ghost School, Rochester, N.Y.; Maple Dale School, Maple Dale, Wisconsin; Lewis Jr. High School, San Diego, Calif.; Tuba City Jr. High School, Tuba City, Ariz.; Spring Hill Middle School, Knoxville, Tenn.; Southside Jr. High School, Columbus, Ind.; Boone Junior/Senior High School, Boone, Iowa; Lewis Cass School, Walton, Ind.; Bedford Jr. High School, Bedford, Ind.; Martin Luther King Jr. High School, Jersey City, N.J.; Shelbyville Jr. High School, Shelbyville, Ind.; Standley Jr. High School, San Diego, Calif.; Whittle Springs Middle School, Knoxville, Tenn.; Ahlya Intermediate School, Khartoum, Sudan; Woodside Middle School, Fort Wayne, Ind.; Northside Jr. High, Columbus, Ind.; St. Joseph Hill Academy, Staten Island, N.Y.; Meridian Middle School, Indianapolis, Ind.; Gompers Secondary School, San Diego, Calif.; Eastwood Jr. High School, Indianapolis, Ind.; Keystone Middle School, Indianapolis, Ind.; Powell Jr. High School, Mesa, Ariz.; Westland Jr. High School, Indianapolis, Ind.; Southport Middle School, Indianapolis, Ind.; Madison High School, San Diego, Calif.; American Fork Jr. High School, American Fork, Utah; Homecroft School, Indianapolis, Ind.; Salem Middle School, Salem, Ind.; Pershing Jr. High School, San Diego, Calif.; Oak Hill Jr. High School, Converse, Ind.; Martinsville East Middle School, Martinsville, Ind.; Christenberry Middle School, Knoxville, Ind.; Muirlands Jr. High School, La Jolla, Calif.; Warsaw Middle School, Warsaw, Ind.; Memorial Jr. High School, Houston, Tex.; Evans School, Evansville, Ind.; Thompkins School, Evansville, Ind.; Calexico High School, Calexico, Calif.; Albert Einstein Jr. High School, San Diego, Calif.; Steven V. Correia Jr. High School, San Diego, Calif.; Chula Vista High School, Chula Vista, Calif.; and Mabel E. O'Farrell School of Creative and Performing Arts, San Diego, Calif.